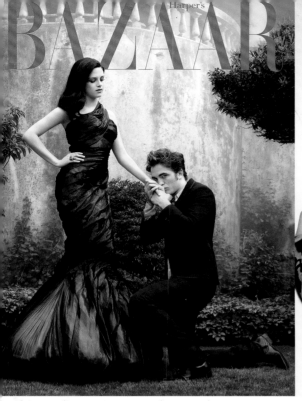

Harper's
BAZAAR

Harper's
BAZAAR

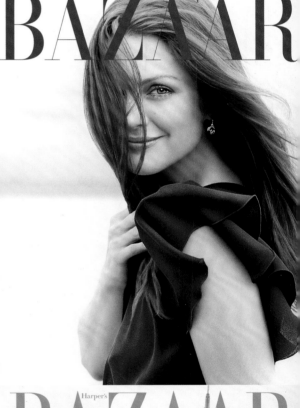

Harper's
BAZAAR

W9-DET-619

Harper's
BAZAAR

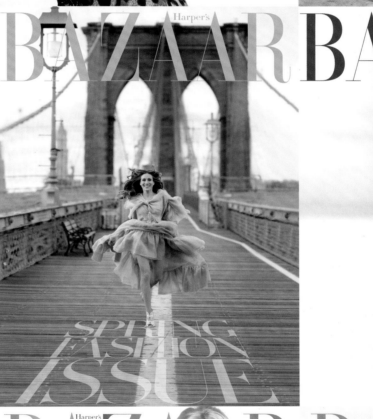

Harper's
BAZAAR

SPRING FASHION ISSUE

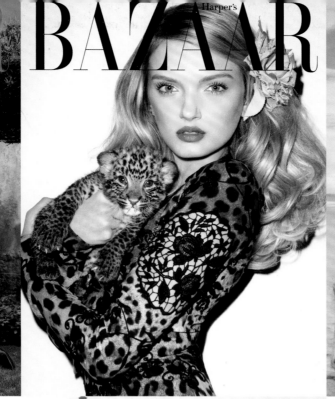

Harper's
BAZAAR

Harper's
BAZAAR

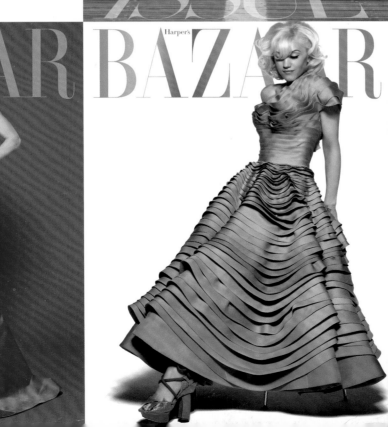

Harper's
BAZAAR

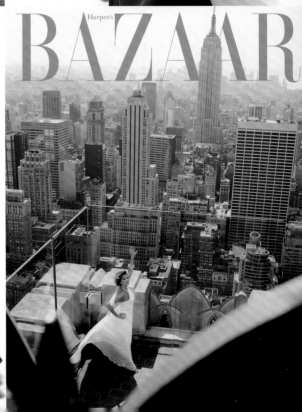

Harper's
BAZAAR

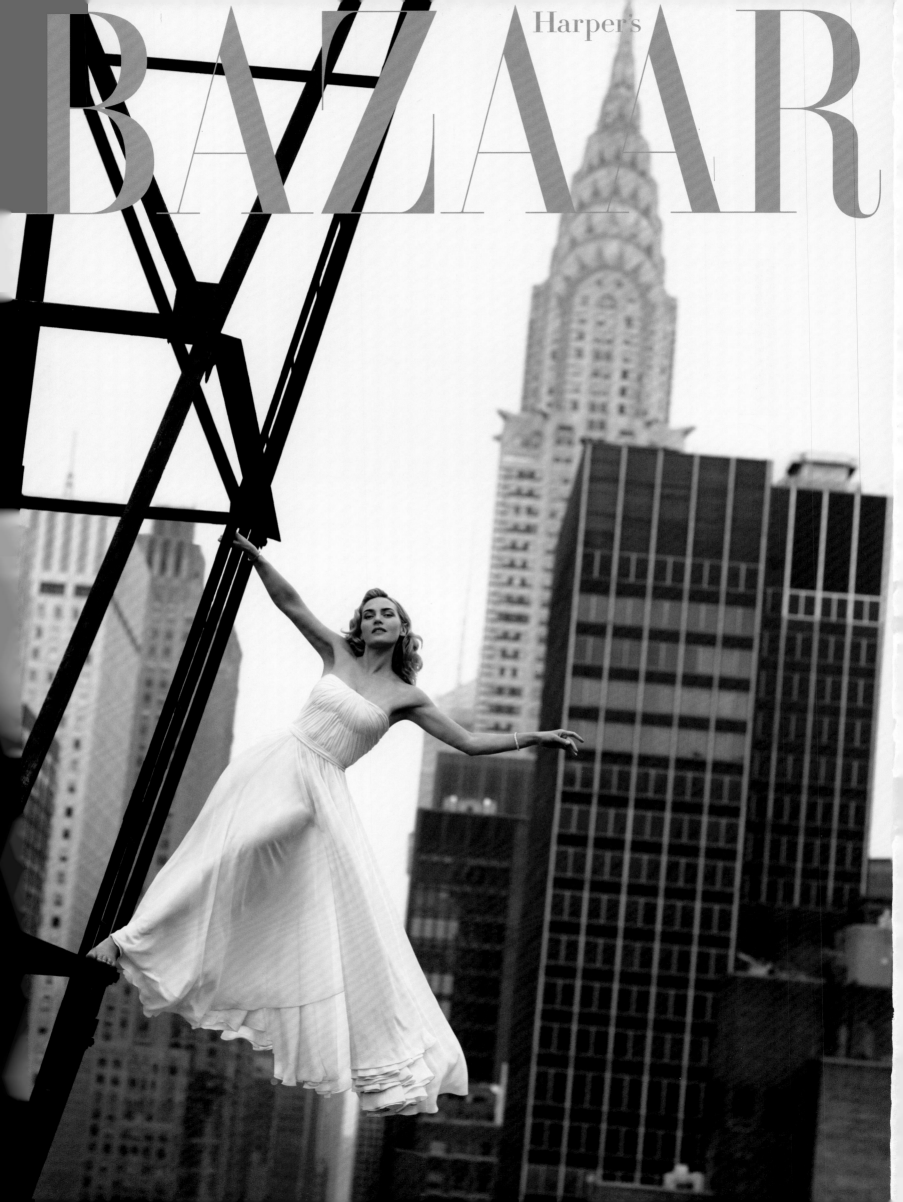

Harper's BAZAAR GREATEST HITS

A DECADE OF STYLE

GLENDA BAILEY

FOREWORD BY
STEPHEN GAN

ABRAMS, NEW YORK

Harper's
BAZAAR

CONTENTS

SPOTTED

Lily Donaldson in Dolce & Gabbana, photographed for the January 2011
issue by Terry Richardson, styled by Julia Von Boehm. *Previous spread:* Kate Winslet in Ralph Lauren Collection,
photographed for the August 2009 issue by Peter Lindbergh, styled by Aleksandra Woroniecka.

WHAT AN ADVENTURE

BY GLENDA BAILEY

I'LL NEVER FORGET WHEN STEPHEN GAN and I met with Cathie Black, then the president of Hearst Magazines, to unveil our debut issue of *Bazaar*. It was September 12, 2001.

In a deserted Manhattan, we presented our vision for the future of America's longest-running fashion magazine (founded in 1867). Our immediate change was reinstating *Bazaar*'s celebrated Didot-font logo, originally innovated by legendary art director Alexey Brodovitch. You can't move forward without staying true to your past.

That was apparent our first day on the job, when Stephen took me to visit Richard Avedon, one of the greatest icons of photography. To coincide with the release of the book and exhibition *Richard Avedon: Made in France*, Dick invited us to publish some of the original engraver's prints of images he'd shot at the couture collections in Paris in the 1950s. The untouched prints ran in our inaugural issue, November 2001.

The photographs were accompanied by descriptions from *Bazaar*'s then editor in chief, the inimitable Carmel Snow. Snow's editorial staff dreamed up some of the most iconic magazine pages ever. Soon after she was hired by William Randolph Hearst in 1933, Snow recruited Brodovitch, the cutting-edge Russian-born graphic designer known to command, "Astonish me!" Brodovitch brought in talked-about artists like Man Ray, as well as then-young talents Irving Penn, Lillian Bassman, and Hiro. Diana Vreeland joined the fashion department after Snow saw the stylish socialite dancing on the rooftop at the St. Regis Hotel in New York in 1936.

The dream quartet stayed together until Snow and Brodovitch retired in the late '50s. But Vreeland and Avedon worked for several years under their successors, editor in chief Nancy White and art director Henry Wolf. During White's tenure, the magazine's seminal covers captured the energy of the '60s youthquake.

In the '70s and '80s, editor in chief Tony Mazzola conveyed the glossy decadence of the era by commissioning photographers like Bill King and Francesco Scavullo. And he was one of the first magazine editors to see the success of regularly featuring celebrities on the cover.

When editor Liz Tilberis and creative director Fabien Baron arrived in 1992, their premiere issue invited readers to "enter the era of elegance." Baron's design delivered. Who can forget the cover with Linda Evangelista, clad in beaded black, tipping the third *A* in *Bazaar*?

That *A*. It first appeared in 1929. (Before that, the covers read *Harper's Bazar*.) I've often said that it stands for *aspirational* but also *artistic* and *accessible*. And over the last 10 years, I've added *adventurous* to the list.

I think of my job as hosting a can't-miss party where everyone's invited. *Bazaar* puts the fun back in fashion and serves it up with a healthy dash of humor. In this era of 24-hour tweeting, our stories capture a meme and make it memorable. What sets *Bazaar* apart is that not only do we get the scoop, we also create the story. Consider Terry Richardson's steamy pictures of Sting and Trudie Styler, which made the cover of the *New York Post*, or when Peter Lindbergh and Chloë Sevigny satirized rehab culture. And the power of *Bazaar* is permanent: After seeing our *Simpsons* fashion story, Marc Jacobs got his cartoon self tattooed on his arm.

My editorial philosophy is that good is the enemy of great. This translates into a never-give-up attitude and the thrill of achieving the impossible. I'm allergic to standard magazine fodder, where every issue looks the same regardless of year. Our aim is to make ideas iconic. Fashion reflects what's going on in our world, and *Bazaar* makes pop culture fashionable. In the process, we've cast fashion's most intriguing talents in unexpected scenarios. I have so many favorites, but a few highlights include when we photographed Karl Lagerfeld as a rapper, turned Domenico Dolce and Stefano Gabbana into superheroes, and painted Donna Karan gold.

I suppose it's only fitting that I met Stephen at a party at Iman and David Bowie's home. I knew his work as the cofounder and editor in chief of *Visionaire* and *V* and recognized him to be among the most creative minds of our time. He has the vision of a mystic, the talent of an artist, and the charisma of a rock star. Not to mention, he's fast. Stephen can do more in five minutes than most people achieve in a week. I became inspired by his passion and energy. Ten years on, I still am.

Since joining forces, we've put on great parties together, starting

with our launch party in New York, where Sting gave a fabulous performance. The reveling continued when we went to Paris for the couture collections. It was Yves Saint Laurent's final season as a designer, and it was truly moving to witness history in the making. After the show, Karl hosted a ball for Stephen and me.

The celebration didn't stop there, though. Through the years, our events have included serenades by Deborah Harry, Gloria Gaynor, Eartha Kitt, and Patti Smith. And the unparalleled Stevie Wonder surprised the crowd at our 140th anniversary party in 2007.

One of my simplest ideas was to institute separate newsstand and subscriber covers, giving photographers an opportunity to produce commercially successful and artistically arresting images. The peerless Peter Lindbergh has a knack for both. We have also been blessed to collaborate with Patrick Demarchelier, Terry Richardson, Mario Sorrenti, and Sølve Sundsbø. We were among the first American magazines to feature the work of photographers Camilla Akrans, Daniel Jackson, and Alexi Lubomirski. We've also showcased a pantheon of world-class writers, including Lisa Armstrong, Candace Bushnell, Carrie Fisher, Robin Givhan, Cathy Horyn, Arianna Huffington, Ashton Kutcher, Suzy Menkes, Susan Orlean, James Reginato, Patti Smith, and Rita Wilson.

There's a special place in my heart for old-school virtuosos. We've had the honor of working with Hiro and Melvin Sokolsky. Sometimes it's taken a little convincing. I stalked William Klein for three years to break his 30-plus-year embargo on appearing in a fashion magazine. The result: an epic designer portfolio that ran in March 2007.

Another of our triumphs has been convincing some of film's greatest directors, like Pedro Almodóvar, Tim Burton, David Lynch, and Mike Nichols, to collaborate with *Bazaar* on film-meets-fashion portfolios.

I thank Stephen for bringing Karl Lagerfeld's photography to *Bazaar*. Karl is a one-and-only yet is so brilliant at so many things. Another great Stephen introduction was that of his longtime friend Jean-Paul Goude, whose pictures have a kinetic energy that leaps off every page. As my good friend Alber Elbaz says, "I look at fashion today and I can see it is a fantasy, but it must also be real. Our job is to make women feel they can fly."

I couldn't agree more. Fashion should make women look good and feel fabulous. Many of our ideas start with the incredible creativity we see on the runways. Thank you to all of the designers for inspiring us season after season. And thank you to all of the stylists, models,

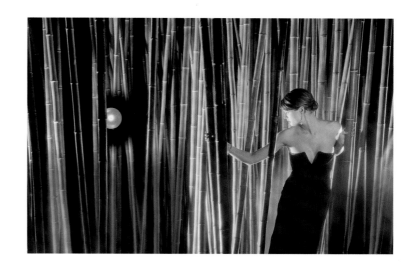

celebrities, and hair and makeup artists who helped turn inspiration into great images. You make our pages soar.

A magazine needs both authority and artistry. *Bazaar* has the best of both. Stylists Brana Wolf and Melanie Ward make our shoots a must-see, Anamaria Wilson and Elisa Lipsky-Karasz make our stories a must-read, and Nicole Fritton and Ana Maria Pimentel make our pages a must-shop. Laura Brown has produced some of our greatest coups. Elizabeth Hummer has created memorable covers and layouts. Alexandra Parnass, Zoë Bruns, Avril Graham, and Karin Kato make sure *Bazaar* gives good face. And I am grateful to Andrea Rosengarten, Nancy Gillen, and Jennifer Dixon, whose eyes are on the bottom line while we look to the runway. Sarah Strzelec, Victoria Pedersen, and Jil Derryberry vigilantly dissect every word. Ten years is a long time, and Kristina O'Neill has been a force for all 10 of them. I must also recognize the work of past staffers Jennifer Alfano, Sarah Bailey, Preston Davis, Kerry Diamond, Allison Fabian, Cary Estes Leitzes, Amanda Ross, Danko Steiner, and Mary Alice Stephenson.

I would be entirely remiss if I didn't mention Susan Boyd, who has been by my side for almost my entire career and truly has a beautiful—and brilliant—mind, and Jenny Barnett and Michele Lavery, the duo of wickedly clever editors with whom I began to hone my editorial instincts more than 20 years ago.

And last but not least, a special thanks to Jenna Gabrial Gallagher, who was instrumental in writing this book.

It's all these people who have helped make the last decade such a success. And it is you, *Bazaar* readers—with your incredible love of fashion, not to mention your fabulous style—who have made them such a celebration. Enjoy the book.

DARE TO DREAM

Malgosia Bela in Ralph Lauren Collection, directed by David Lynch, photographed for the December 2001 issue by Sean Ellis, styled by Mary Alice Stephenson.

DIRECTOR'S CUT

BY STEPHEN GAN

SHORTLY AFTER I MET Glenda Bailey at Iman's birthday party, I became the new creative director of *Harper's Bazaar*. It happened that fast. The press described it as "the unexpected Bailey–Gan cocktail," and I remember thinking how appropriate that we met at a party, and whether delicious or lethal, who doesn't love a cocktail?

Looking back, I'm not surprised. What I've discovered over this past decade is that Glenda knows exactly what she wants. She loves to hear ideas, but she can tell you immediately whether they will work or not. That summer afternoon, she was so convincing and had so much conviction about bringing the magazine back to life. Her passion inspired me. I immediately thought, I want to fight for this woman's cause.

We both agreed that the most obvious thing was to bring back the old Didot logo that Alexey Brodovitch had started. I recall looking at the first issue that we put it on and thinking that it felt like repairing an institution. You had the feeling you were doing something proper. It was the same feeling I had on my first day at *Bazaar* when I received a handwritten note from Dick Avedon, congratulating me and asking Glenda and I to come by his studio. It felt like visiting the godfather, like you needed his blessing if you were going to be doing this job. And in a way, he did give us his blessing by allowing us to republish engraver's prints of couture pictures he had done for *Bazaar* in the '50s.

From the beginning, Glenda wanted the magazine to be sophisticated but playful. It couldn't just be this beautiful thing that didn't speak to anyone. It had to touch readers. Glenda loves to laugh and has a great sense of humor. We've had so much fun coming up with the front and back covers, the Swarovski crystals, the logo treatments—whether they were neon, gradiated, or in rainbow shades—which were devised at first to brighten up a too-dark-for-summer black bathing suit on a Gisele Bündchen cover.

I've really seen that playfulness come alive in Jean-Paul Goude's and Karl Lagerfeld's pictures. Jean-Paul's couture shoot with Linda Evangelista remains my favorite thing I've ever worked on at *Bazaar*. I just kept wishing I had a video camera on set. I think that's the stuff that fashion dreams are made of. And with Karl, you never feel as if you're there to create art, in quotation marks, as he calls it. Every shoot is a fun exercise to see what you come up with. There's also the first and only time Karl ever shot Gisele, for a couture story (pictured at right). She was running toward the camera in a Chanel bridal number when in walks Tom Brady, who had secretly come to Paris with her; they had just started dating. That certainly felt like a moment.

I also love the story featuring *The Simpsons*. It was probably one of the least expensive fashion stories in the history of the magazine, but it's one of my favorites. I always think that a good idea is the easiest and the most difficult thing to come by. Speaking of art, every time I see Patrick Demarchelier's "Artistic License" story, I do a doubletake when I come across Stephanie Seymour as a Warhol silk screen. It's eerie how it looks so real. Although it's just a simulation, it feels like it came off one of her home's art-filled walls.

Mostly I want to thank every photographer and every stylist who contributed to the images you see in this book. They make the magazine. We just lay it out. A good image makes your job bliss. But a bad one can make a director's life a living hell!

This book starts with Gisele and ends with Lady Gaga, and to me, that sums up the decade. (I like to think what Avedon and Brodovitch would have thought of Gaga.) It makes you feel as if you're living at a special time. The world is constantly evolving, and a magazine has to be a reflection of that. The next decade will have its own Gisele and Gaga, and it makes me excited wondering what's next and how we'll put that into the pages of *Bazaar*.

GRAND ENTRANCE
Gisele Bündchen in Chanel Haute
Couture, photographed for the June 2007
issue by Karl Lagerfeld, styled by
Amanda Harlech and Panos Yiapanis.

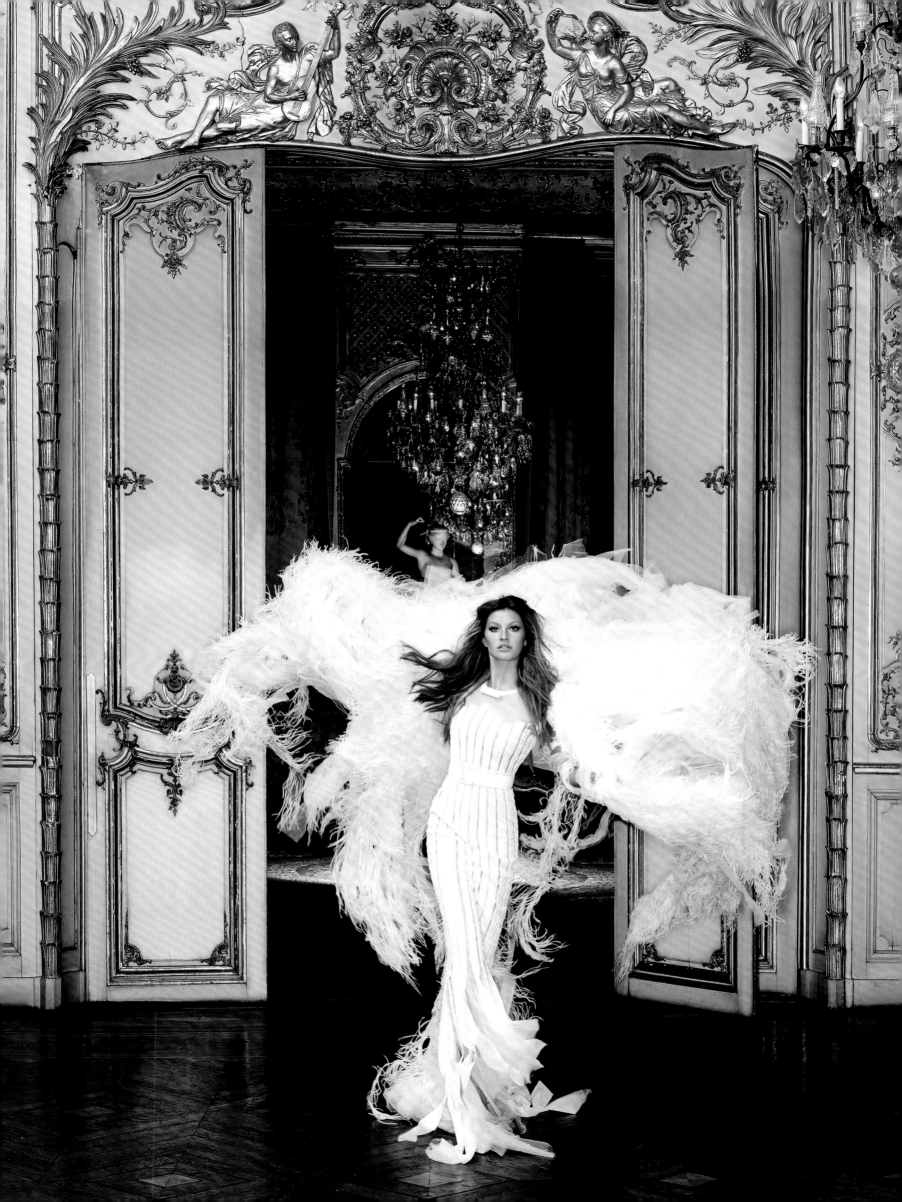

2001

GLAM SLAM

Gwyneth Paltrow in Versace, photographed for the November issue
by Patrick Demarchelier, styled by Mary Alice Stephenson.

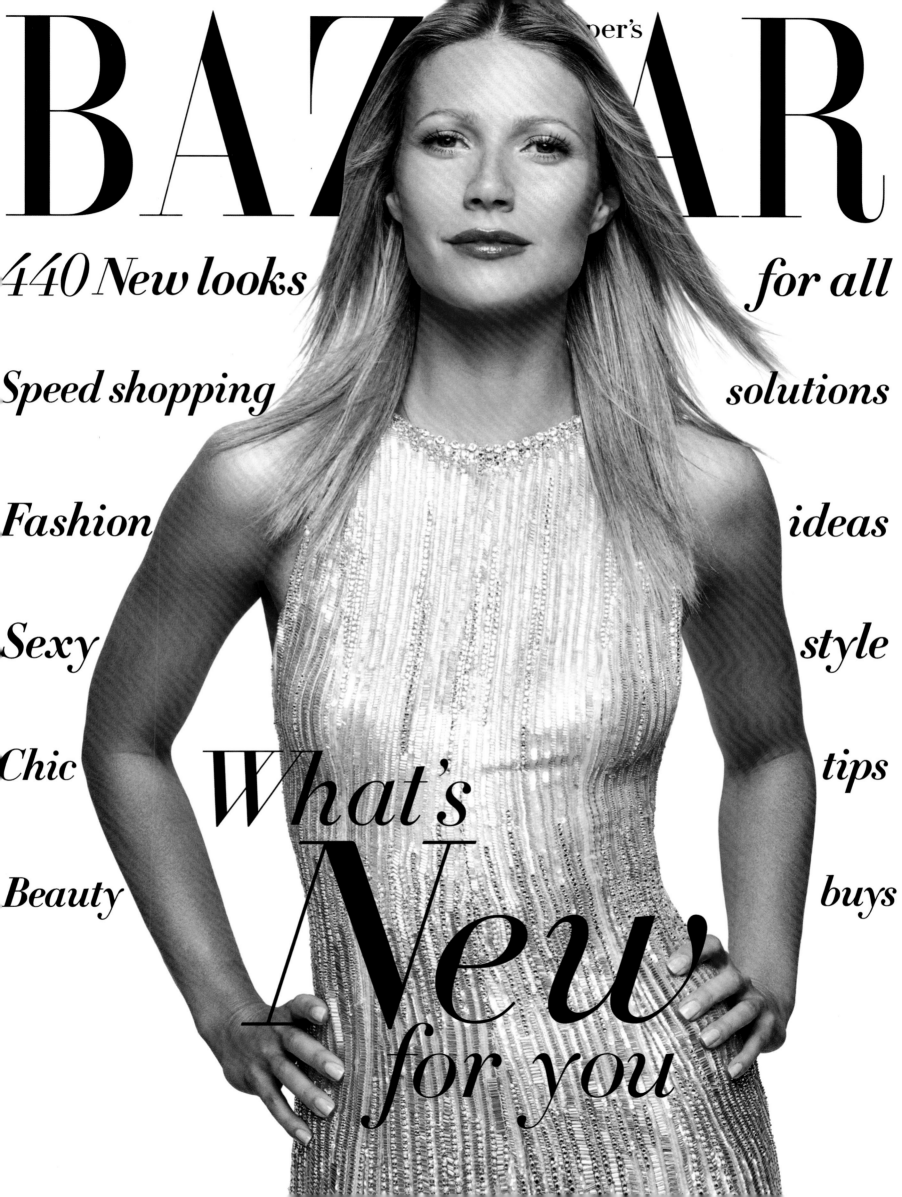

BAZAAR

per's

440 New looks

for all

Speed shopping

solutions

Fashion

ideas

Sexy

style

Chic

tips

Beauty

buys

What's New for you

A DASH
OF
DARING

THERE'S NO WAY AROUND IT: Fall 2001 was a somber moment to kick off a new regime at America's first fashion magazine.

But Glenda Bailey and Stephen Gan were determined to map out a bright future for the magazine that billed itself from its very first issue, November 2, 1867, as a "repository of fashion, pleasure, and instruction." (*Bazaar*'s first editor, Mary Louise Booth, was well educated, spoke multiple languages, and had an independent spirit that set her way ahead of her time.) After all, this too would be another chapter in a nearly 135-year history that had weathered two world wars, the Great Depression, and the countercultural turmoil of the '60s.

They also found strength in knowing they were taking the baton from dynamic duos Carmel Snow and Alexey Brodovitch, Nancy White and Henry Wolf, and Liz Tilberis and Fabien Baron.

Bailey and Gan harked back to *Bazaar*'s core tenets: a solid foundation of clever service pieces in the front of the book, a fashion well of pulse-quickening images, and razor-sharp written features. And all of it would tap into the cultural zeitgeist.

They produced their debut issue (November) over the summer. Each did double duty, Gan at *Visionaire* and *V* magazines (both of which he still edits today) and Bailey as the editor in chief of *Marie Claire*. Bailey even asked Gwyneth Paltrow, who had guest-edited an issue of that magazine, to be on her premiere cover. Paltrow said yes.

Shot by Patrick Demarchelier, the cover embodied the iconic elegance that Bailey and Gan sought to bring back to *Bazaar*. Paltrow's portrait was crowned by the magazine's venerable Didot-font logo, which was restored to the cover after an absence of nearly two years.

The issue was going to press on the day of the World Trade Center attacks, so the content reflected a pre-9/11 world. And yet a story featuring Richard Avedon's original engraver's prints from his days covering the couture collections for *Bazaar* in the '50s—annotated in his own hand on the mounts—was a reassuring nod to a triumphant past. In Bailey's editor's letter, revised at the very last minute, she noted that the tragedy made *Bazaar* even more determined to celebrate life in its pages.

But the overarching message of 2001 was one of coming together. As Bailey put it, "We were all in the dark, reaching for the light." This point was poignantly envisioned by David Lynch in a shoot featuring a girl seeking a pearl in a stygian bamboo garden. Using a film director to conceptualize a fashion story underscored a cinematic element to which Bailey would perennially return.

Tying it all into *Bazaar*'s illustrious legacy, the photographer Hiro, a contributor since 1958, shared some of his own favorite early images. In the accompanying essay, he mused, "History is obvious. I want to know: What is tomorrow?" It wasn't long before Bailey and Gan's answer to that question was revealed.

LEAP OF FAITH
Carmen Kass in an Elizabeth Gillett cape and a Calvin Klein dress, photographed for the November issue by Patrick Demarchelier, styled by Melanie Ward.

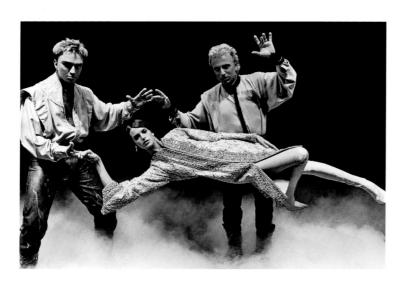

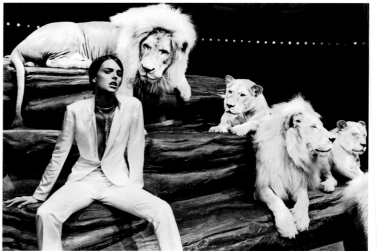

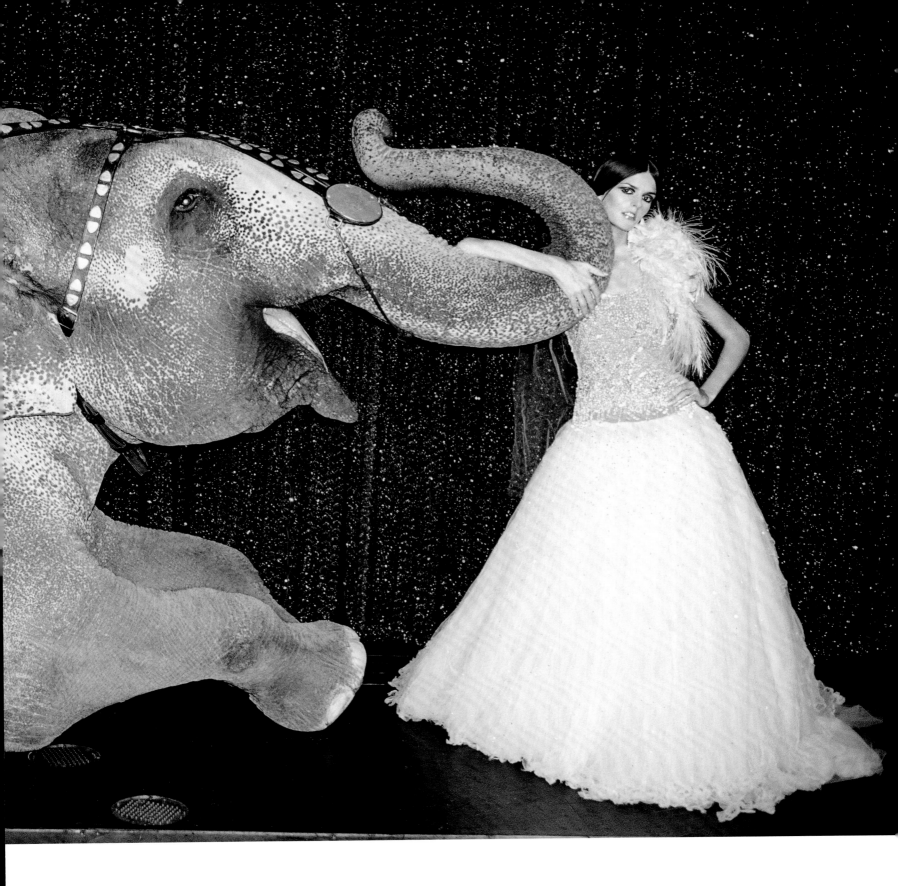

TRUNK SHOW

Jacquetta Wheeler in Emanuel Ungaro Haute
Couture (above), Gianfranco Ferré (far left),
and Emporio Armani (left), photographed with
Siegfried and Roy for the December issue by
Terry Richardson, styled by Mary Alice Stephenson.

2002

FACING THE FUTURE

Kate Moss, photographed for the April issue by Sølve Sundsbø, styled by Brana Wolf.

Following spread: Gisele Bündchen in Giorgio Armani, photographed for the February issue by Patrick Demarchelier, styled by Mary Alice Stephenson.

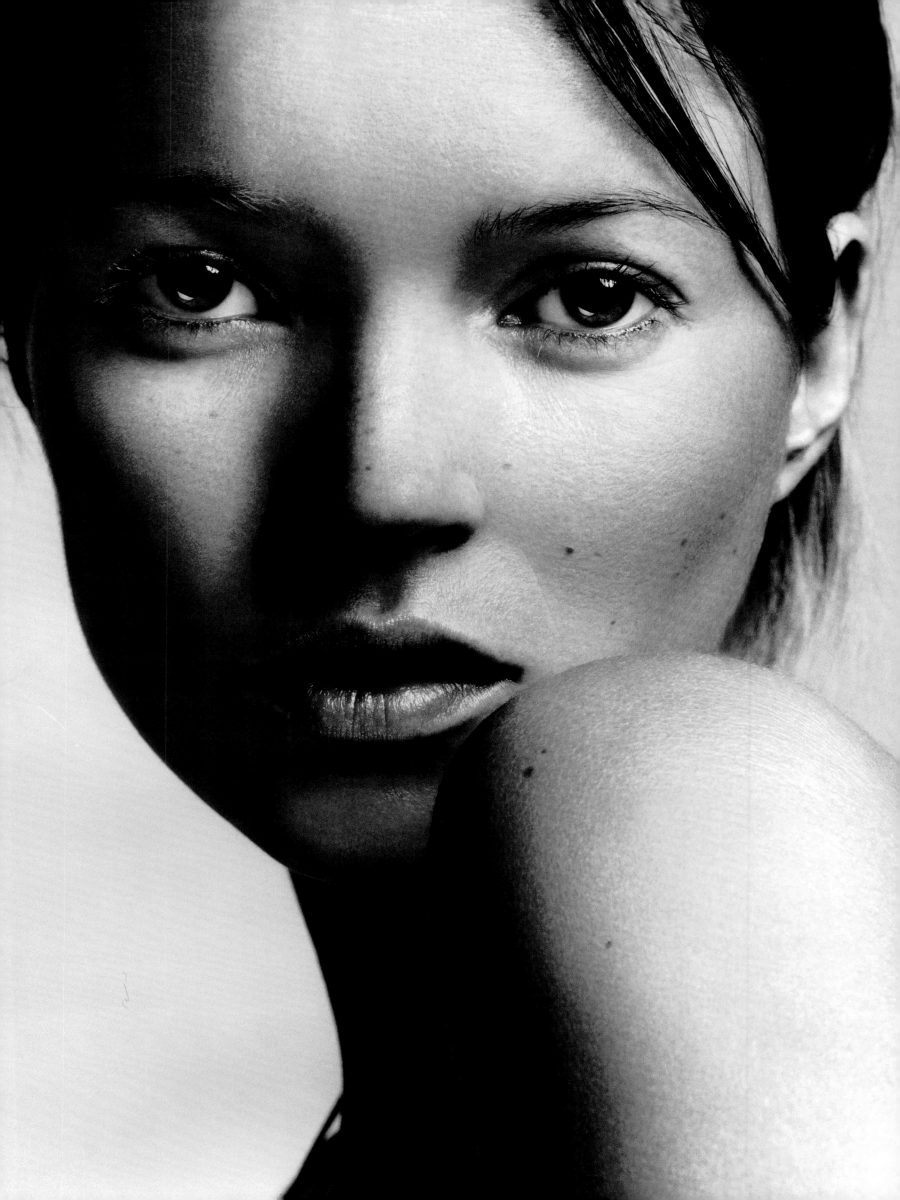

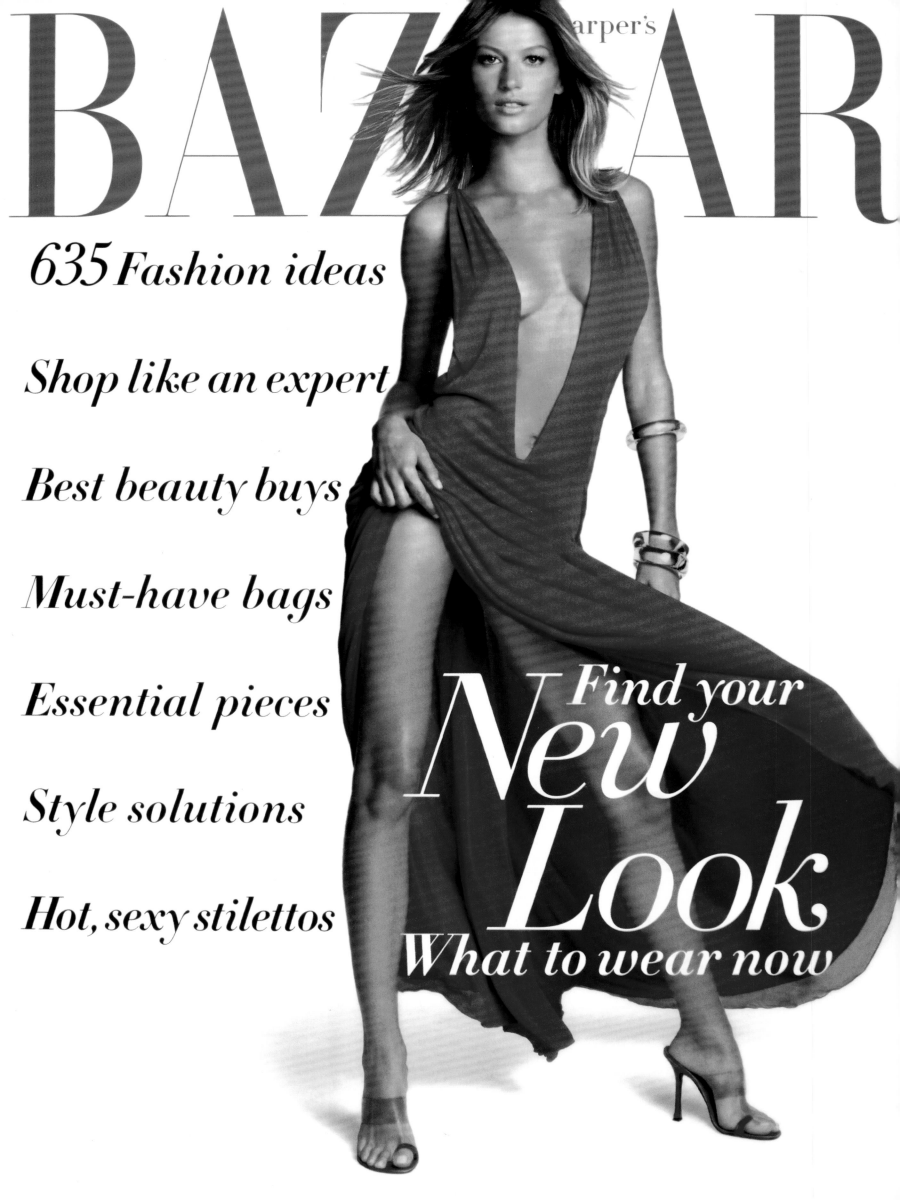

BAZAAR

arper's

635 Fashion ideas

Shop like an expert

Best beauty buys

Must-have bags

Essential pieces

Style solutions

Hot, sexy stilettos

Find your
New
Look
What to wear now

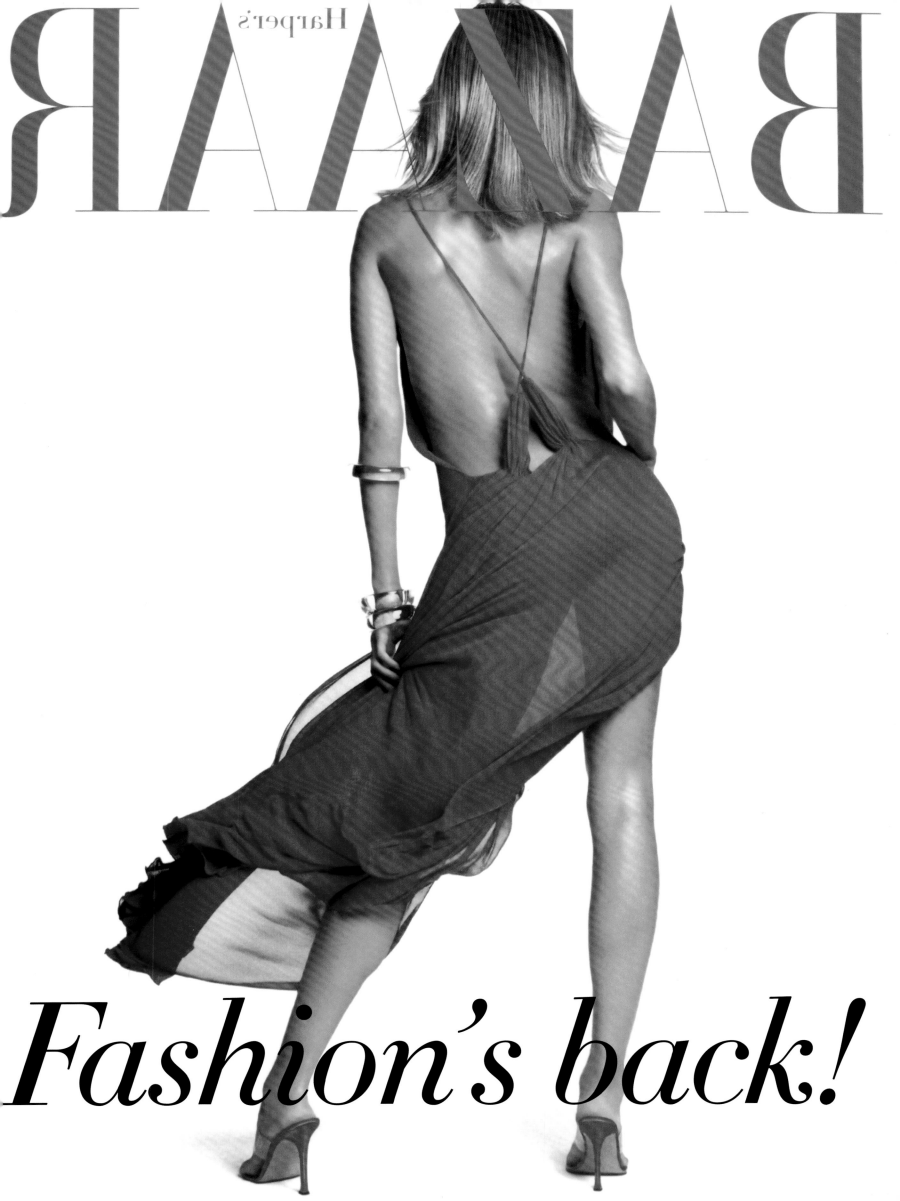

Fashion's back!

A NEW
ERA
BEGINS

FEBRUARY 2002 MARKED the official dawn of the Bailey–Gan years. In a preview of the boldly innovative cover treatments that were to come, Bailey gave a 360-degree perspective on the new fashion era. Literally. She commissioned Patrick Demarchelier to shoot Gisele Bündchen in Giorgio Armani for the front cover … and from behind for the back, accompanied by the cheeky cover line FASHION'S BACK!

Fashion, indeed, was priority one. Bailey turned the concept meta with a witty portfolio of model Carolyn Murphy as a *Bazaar* staffer. It opened with Murphy being snapped by illustrious *New York Times* photographer-about-town Bill Cunningham and set the playacting supermodel into Bailey's real-life office.

The hawkeyed reader will notice that those layouts visible in the pictures of Bailey's office are from the "Artistic License" story in the same issue (which was conceived by Gan). In an editorial nod to the intersecting histories of art and fashion, Demarchelier paired famed works of art with famous fashion faces, like Stephanie Seymour screened as Andy Warhol's Elizabeth Taylor and Karen Elson as a Toulouse-Lautrec showgirl.

And yet fashion can itself be art. Consider the magic of '60s-era innovator Melvin Sokolsky, whose famed "Bubble" series appeared in *Bazaar* in 1963 and who returned to shoot for the magazine in January. And think of the exquisite efforts behind the haute couture. In April, *Bazaar* shared a voyeuristic view into the windows of the Parisian ateliers of designers like Valentino Garavani, Jean Paul Gaultier, Christian Lacroix, and Yves Saint Laurent, a poignant image that captured the designer's final season. To further mark Saint Laurent's deeply felt departure from fashion, *Bazaar* exclusively published Hedi Slimane's behind-the-scenes photographs from the emotional and epic last show. The intimate, fly-on-the-wall portfolio really captured a true moment of fashion history.

September marked the one-year anniversary of the fateful events of 2001. *Bazaar* commemorated the occasion with a mix of sensitivity and style. Launched in December 2001, Just Like a Woman, a series that paired works from great writers and artists, among them Nora Ephron, Jay McInerney, Rick Moody, Jeff Koons, Tracey Emin, and Nan Goldin, continued through the new year and was published as a calendar sold to benefit victims of terrorism. And Peter Lindbergh's return to the magazine after a long absence brought a new brand of glamour, shot appropriately on a Hollywood soundstage.

As always, September shone a spotlight on fall fashion. What a difference a year makes. In 12 months, the cool-chick silhouettes of the '90s had given way to a new romanticism—the fashion equivalent of comfort food. The feminine takes on tough chic at Prada and Balenciaga, along with the bohemian-inflected, urban-warrior layers at Dior and Stella McCartney, were evidence that fashion was ready to take whatever the world might throw at it.

Enter the early days of clothing as protective armor, a trend that continued throughout the decade.

BOW REGARD

Erin Wasson in Viktor & Rolf,
photographed for the February issue by Patrick
Demarchelier, styled by Melanie Ward.

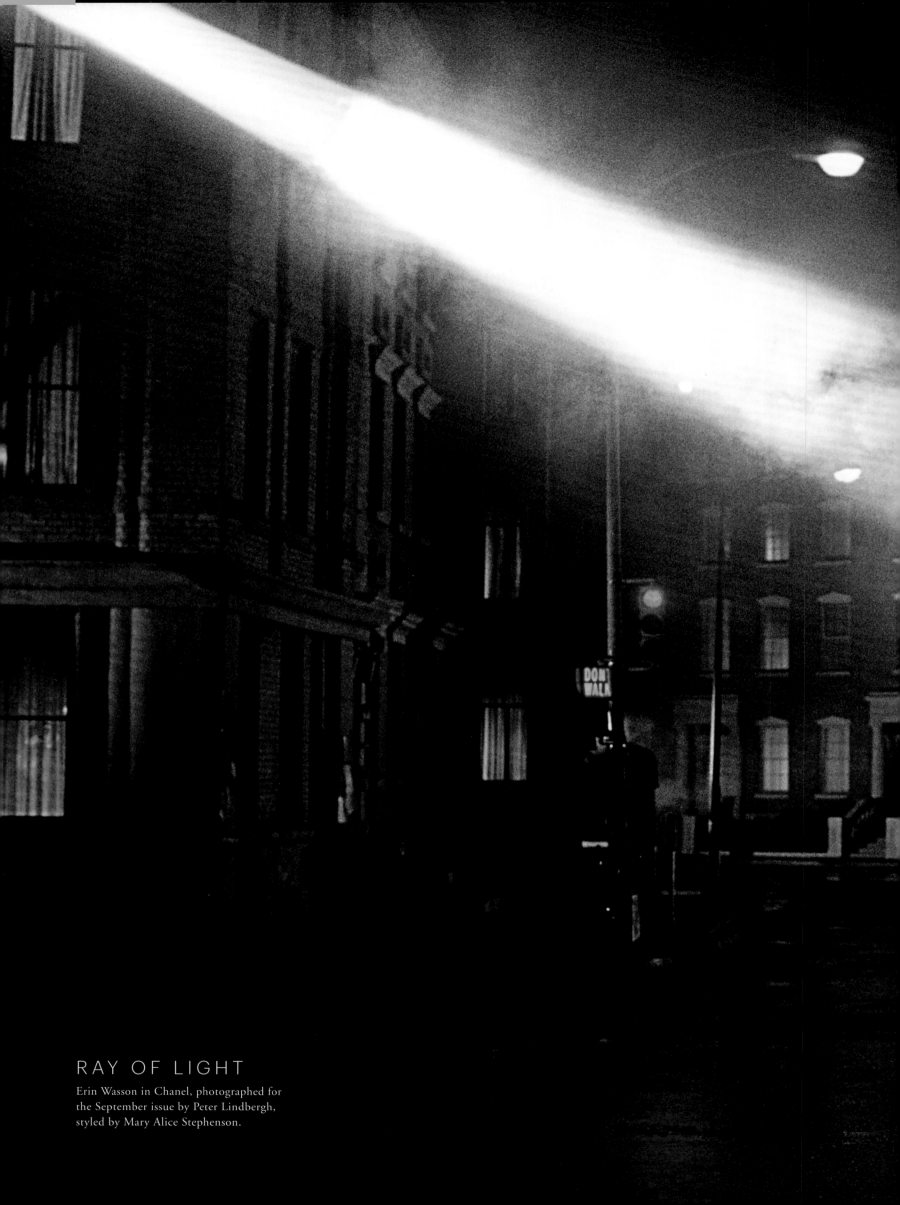

RAY OF LIGHT

Erin Wasson in Chanel, photographed for
the September issue by Peter Lindbergh,
styled by Mary Alice Stephenson.

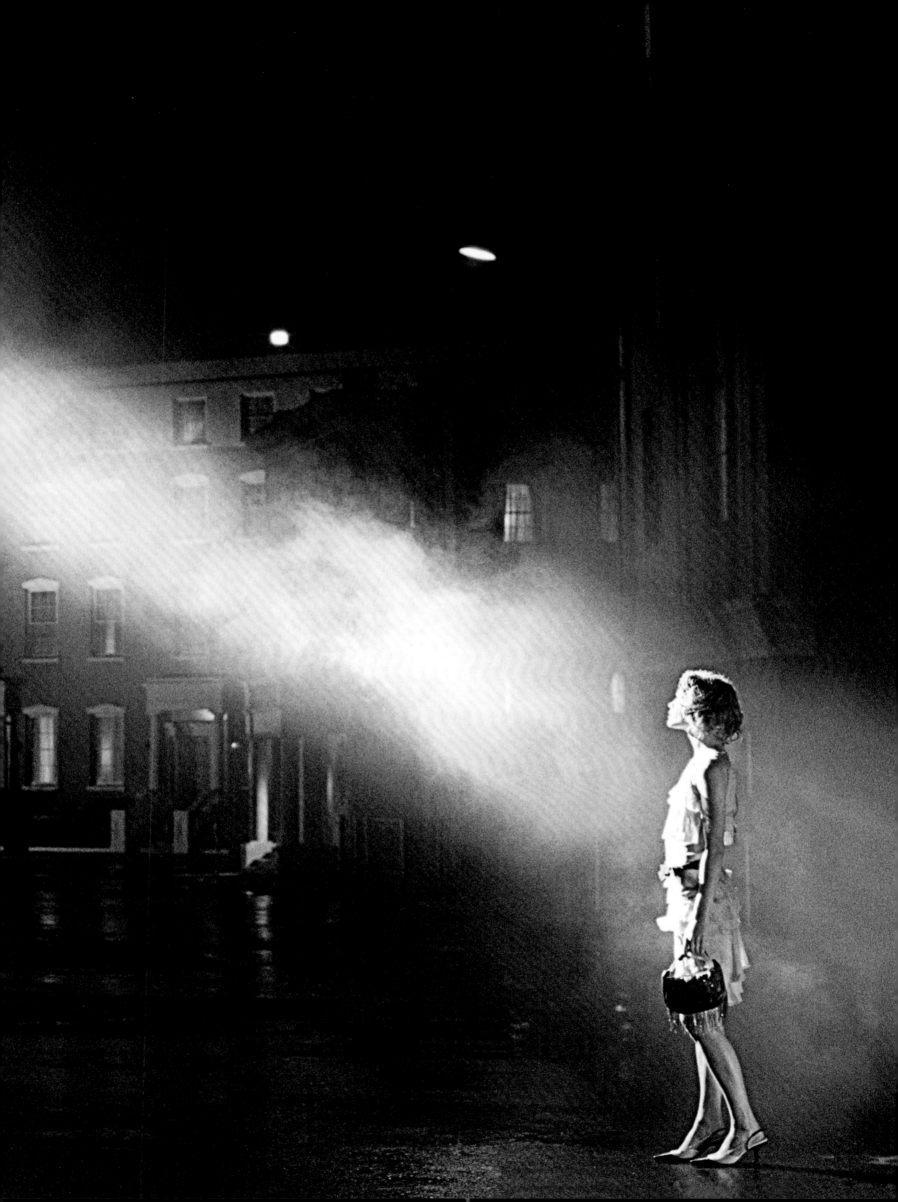

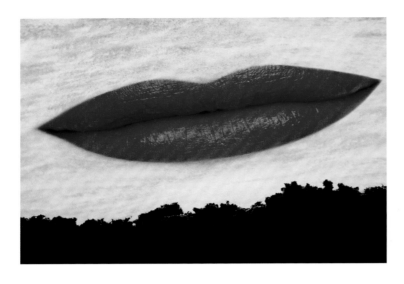

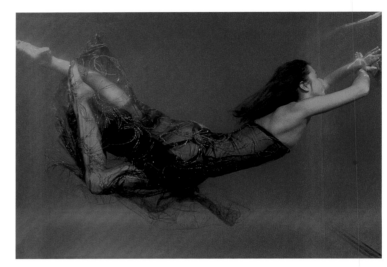

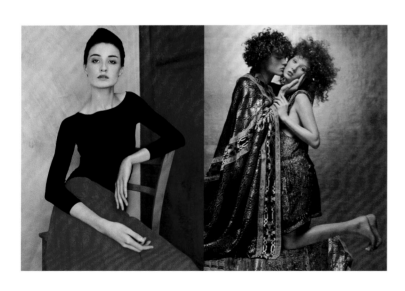

ARTISTIC LICENSE

Photographed for the February issue by
Patrick Demarchelier, styled by Jillian Davison.

The art world's great masterpieces serve as fashion's inspiration.
This page, clockwise from top left: Man Ray's floating lips; shades of
Sandro Botticelli's *Primavera;* Bridget Hall is pretty in (Roy
Lichtenstein's) benday dots; a stroke of Josef Albers; Karen Elson as an
Henri de Toulouse-Lautrec showgirl; a Koonsian cuddle; Maggie Rizer
receives Gustav Klimt's kiss; Erin O'Connor sits for Amedeo Modigliani;
deconstructing Pablo Picasso's *Les Demoiselles d'Avignon;*
Mariacarla Boscono solos as an Edgar Degas dancer. *Opposite
page:* Stephanie Seymour screens Andy Warhol's Elizabeth Taylor.

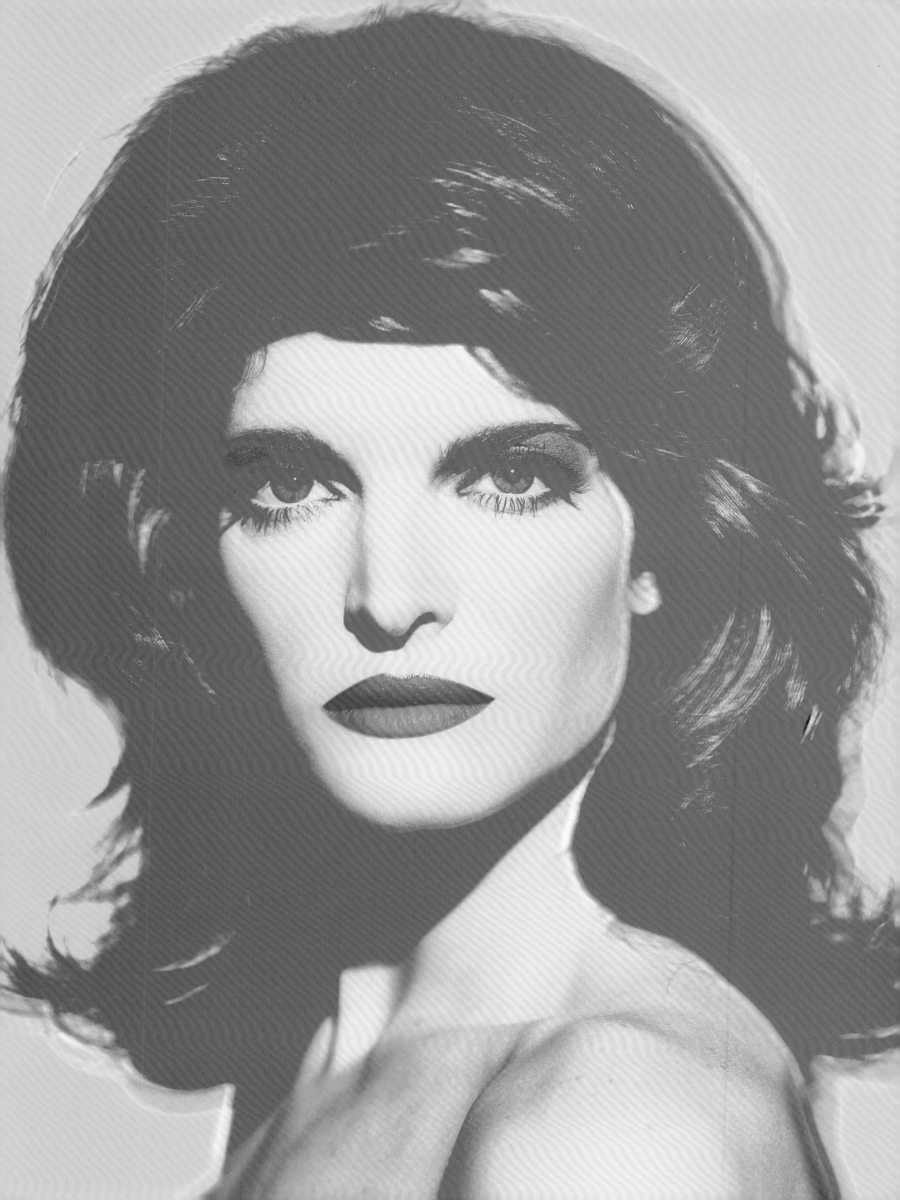

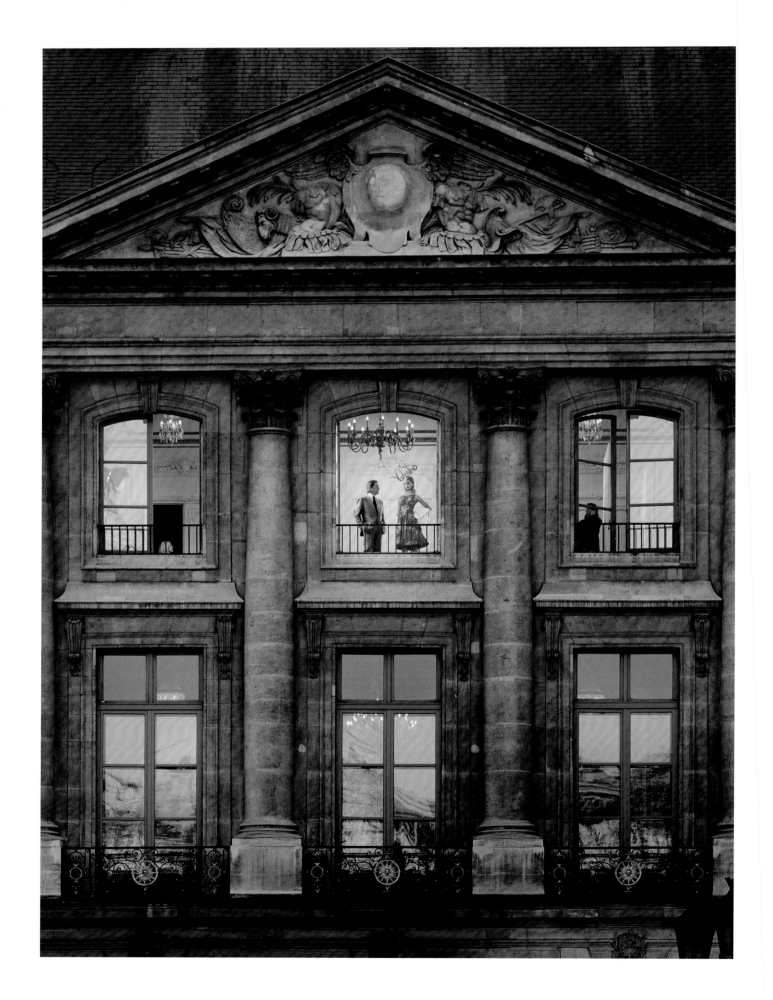

ATELIER ATTITUDE

Photographed for the April issue by Jason Schmidt, styled by Charlotte Stockdale. *This spread:* Valentino Garavani (above) and Jean Paul Gaultier at work. *Following spread:* Christian Lacroix and a bird's-eye view of the work of Yves Saint Laurent.

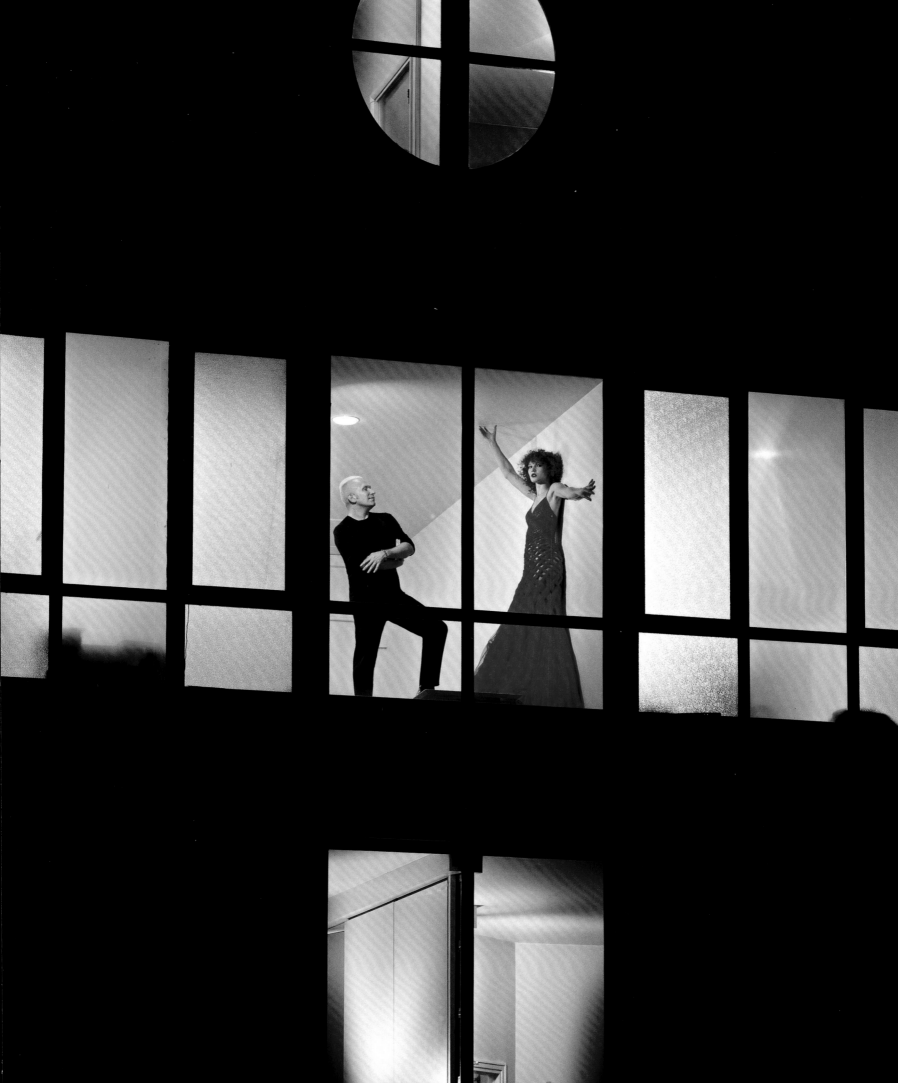

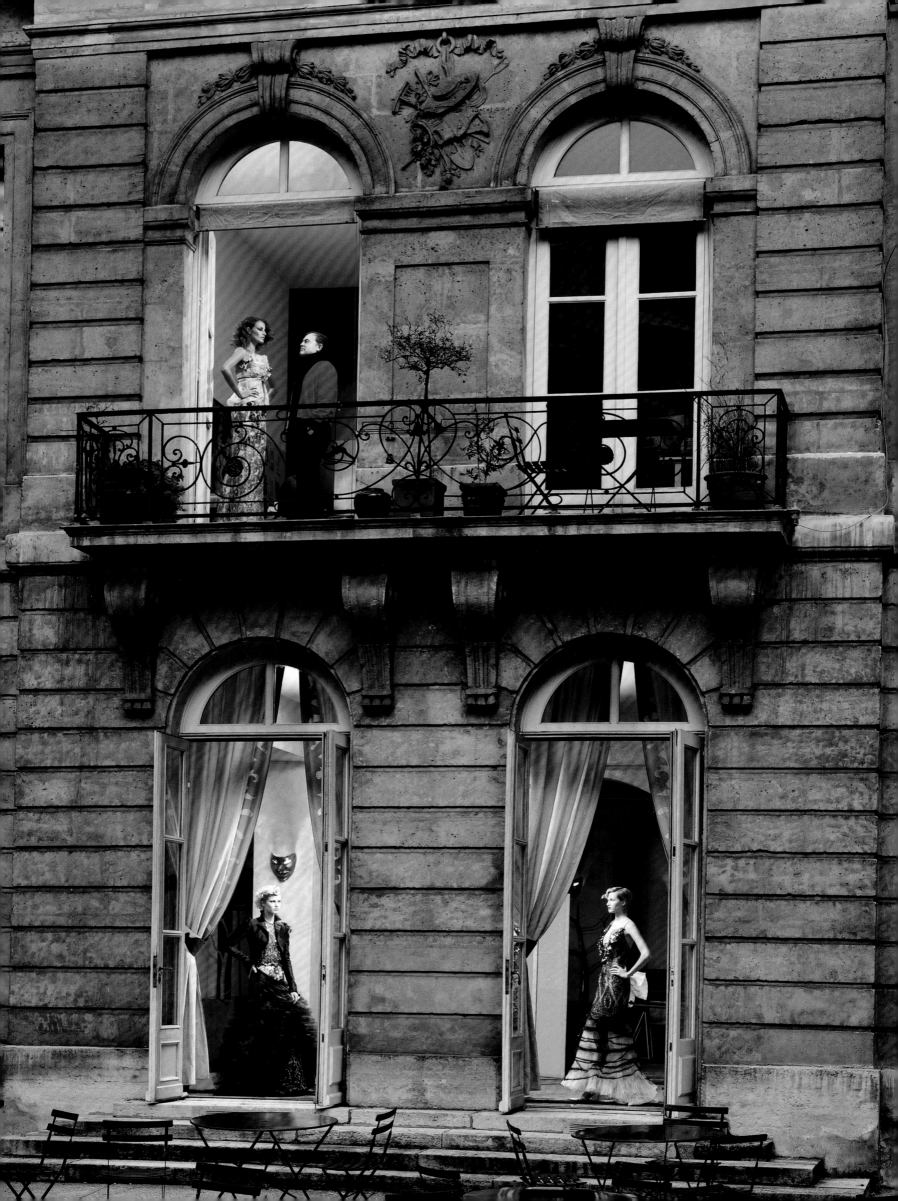

GENIUS TAKES A BOW

Photographed for the April issue by Hedi Slimane.

Bazaar readers got an exclusive behind-the-scenes look at Yves Saint Laurent's final show when then–Dior Homme designer Hedi Slimane shared his photographs from backstage. *Clockwise from top left:* Saint Laurent's friend and muse Loulou de la Falaise waits in the wings; Saint Laurent oversees it all; Jerry Hall in white satin; Pierre Bergé waits with a model.

FIREPOWER

Photographed for the July issue
by Hiro, styled by Jillian Davison.

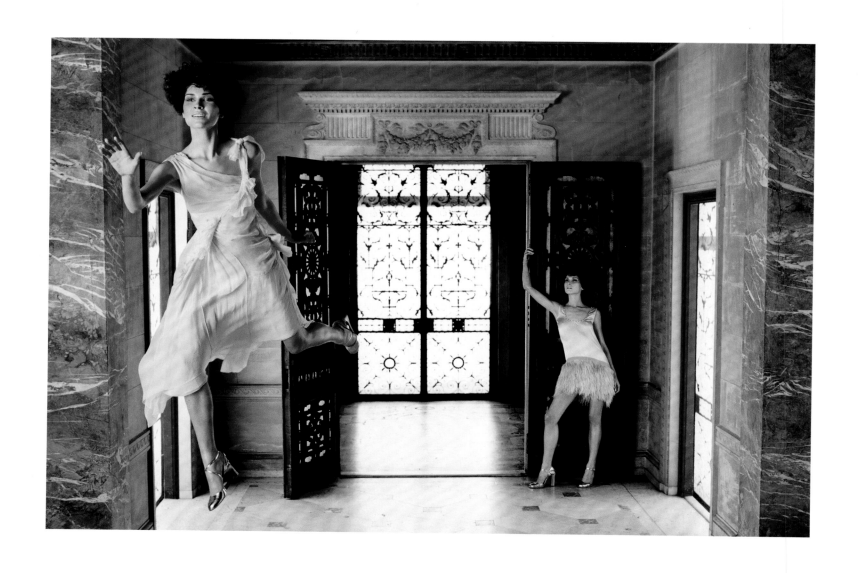

FASHION MAGIC

Erin Wasson in Alberta Ferretti (above left), Anna Molinari (above right), and Tom Ford for Gucci (opposite), photographed for the January issue by Melvin Sokolsky, styled by Brana Wolf.

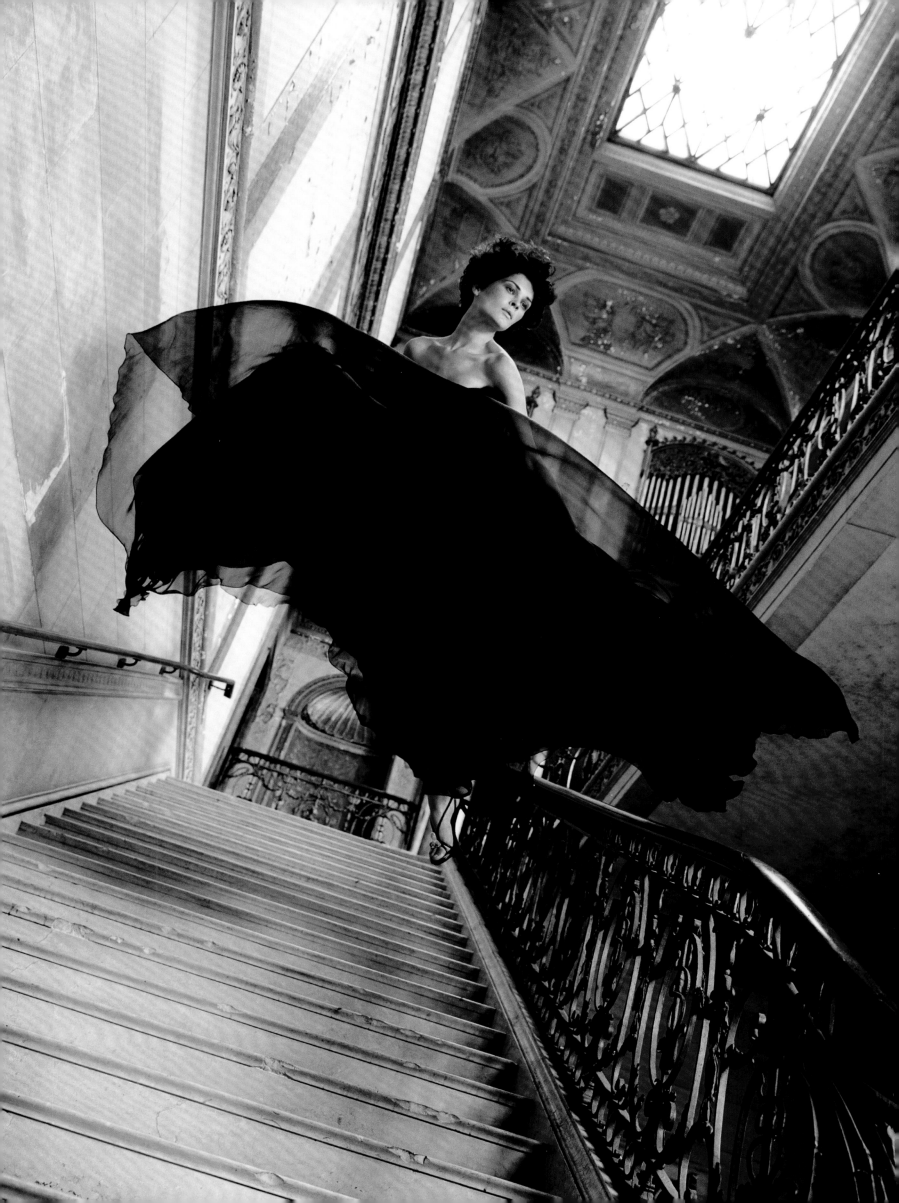

"I WAS DIANA VREELAND'S ASSISTANT"

BY ALI MACGRAW

Excerpted from the February issue

I READ *HARPER'S BAZAAR* VORACIOUSLY all through college, and at the time I thought I wanted to work in fashion. When I graduated from Wellesley, the wife of one of my husband's friends worked at *Bazaar,* and she was kind enough to set up an interview for a $54-a-week job. By chance I was assigned to work for Diana Vreeland: I didn't realize what a piece of luck it was.

Diana Vreeland was a force of nature. She had an unbelievable eye, the likes of which we may never see again. The level of freedom of expression and fantasy with her was incredible, and the experiences I had daily in her office were life-changing. I was this little Ivy League girl, safe and nice in a little Lanz dress—but all that stuff rubbed off on me. She taught me how to see.

I remember funny things: her husband's Rigaud candles at their apartment—who had ever heard of candles that smelled? I would walk to her apartment on Park Avenue every morning to pick up her portfolio. I was intimidated by her red-paisley living room and the thought that this whirlwind was in that apartment somewhere taking a bath. I would see her husband, T. Reed Vreeland, every morning; he was so beautiful and gentle. (She was mad about her husband and two boys, and that was a big deal to me.) Her portfolio was a list of things her secretary, Pat, and I, her "assistant," were to accomplish by the time she came into the office at 11:00 A.M. There were always dramatic one-liners on a yellow ruled notebook: More candles! Sharpen pencils! Call Jackie Kennedy! In the office she was a tornado; she was a very hands-on editor. Then, at 1:00, she would go have a snappy lunch with someone famous like Truman Capote or Isak Dinesen. When she did eat in the office, which I don't remember being very often, she ate a real working girl's lunch—maybe a light chicken sandwich. She lived on glass-bottled Evian water, and she kept herself in racehorse condition. Once a week she would go to Elizabeth Arden to have her nails lacquered a brilliant Chinese red.

I was in charge of organizing the clothes and accessories for the photo run-throughs—things such as the perfect white kid-leather gloves in every length to be worn by the latest newly minted beauty (meaning she had married a rich husband) and whose portrait was to be shot by Richard Avedon. I envied the great women who came to those sittings: It must have been like playing dress-up fairy princess. There was always a lot of drama involving people who were mythic to me. (Once I was sent to a boutique to pick up evening bags for the then-senator's wife Jackie Kennedy.)

Mrs. Vreeland's *Bazaar* was like nothing I'd ever seen. It was pulsing with over-the-edge energy. The magazine was the great marriage of a personality and a decade. Fashion on the street was pushing originality, and her fantasy was based on travel and the exotic. She was passionately interested in czarist Russia and India—not just the clothes but the food, architecture, music, and art. Her appreciation spoke of civilizations. The reserves she could draw on were an education in themselves: the color of a coat, a book jacket, a particular work of art. Hearing her bellow down the halls: "More ostrich feathers!" and then seeing her idea transposed onto the pages of the magazine was magical. I never understood real luxury before I came to *Bazaar:* the detail of a suede dress, Porthault sheets, a perfect piece of luggage. But for all the gushing and carrying on that was in the magazine, Mrs. Vreeland wore the same uniform every day: a little black sweater, a black Mainbocher skirt, and her handmade black T-strap shoes—boot-blacked daily on the soles. She had that practical streak—starting her day with oatmeal and a head-stand—but then there would be the shot of the outrageous, like her fingernails.

I remember once she asked me to accompany her home to carry her portfolio (of course!) from La Côte Basque, where she had just had lunch with Cecil Beaton. She was carrying a bouquet of freesias he had given her. I had never heard of freesias, and

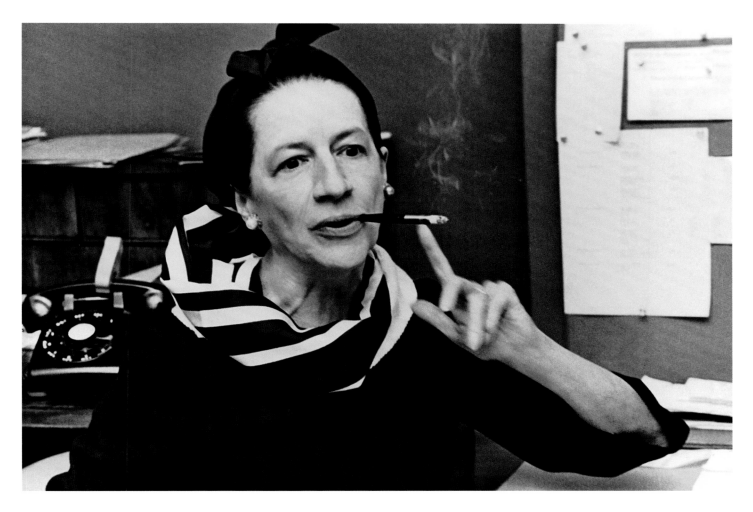

I remember her smelling them as though she were a schoolgirl holding her first corsage. She was an Actress at all times, and she often said things for theatrical effect—with a certain glee. But there was something touching about her too.

And she could be tough: She occasionally scared the shit out of everybody. I remember once, I was on all fours arranging accessories for a shoot, when she came waltzing into the room with the editor Gwen Randolph—both in their designer coats. Mrs. Vreeland literally threw hers at me, and I threw it back at her—it was a knee-jerk reaction. She said, "That is the *rudest* girl!" But it was okay because her vision outweighed everything else. When I told her that I had been offered a job that paid more, working for the photographer Melvin Sokolsky, she told me, "You don't know enough yet." She was probably right, but I wasn't like so many of the other girls, who seemed to be biding their time while waiting for some enormously wealthy Mr. Right to come along. I needed to pay the rent.

I would have loved to have been counted as one of her friends, to have been invited to her house for dinner. It was never "You're such a wonderful girl; come have dinner with me and Mick Jagger." Instead it was "Girl, go get the pencils." But her impact on me was enormous. As the years go by, layers of her fantasy have seeped into my life; her fascination with India, Morocco—so many other places and things—has affected me subliminally.

Fashion is not the same anymore. Now they can bring back a hemline, or show pieces inspired by the '60s, but under Mrs. Vreeland's reign it was all authentic.

Years later, after I had become a movie star, I had one last amazing contact with her. I was meant to do the movie *The Great Gatsby,* and I knew she would have been aware of the details of ladies' behavior in the '20s. I went to see her at her apartment, and I asked her how women behaved then. I'll never forget her answer. "You know," she said, as she shifted her body to demonstrate, "ladies of that time sat on the edge of the chair as if they were listening in on another conversation." And with that one tiny perception, she nailed an era. There's never been anyone quite like her.

Top: Vreeland in her *Bazaar* office; above: MacGraw illustrates her days at *Bazaar.*

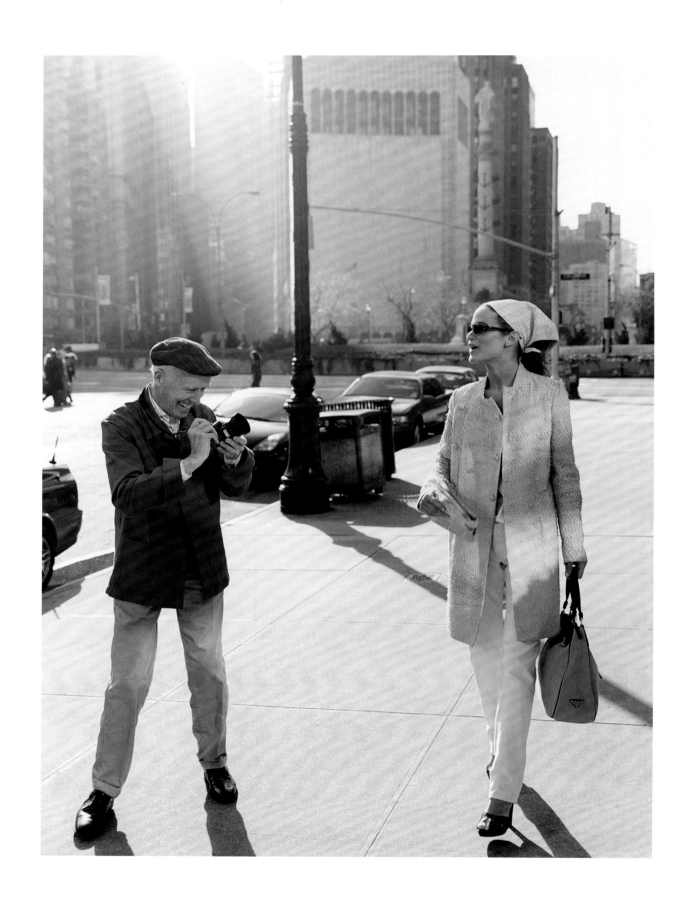

PICTURE-PERFECT

Carolyn Murphy in Helmut Lang (above)
and Chanel, photographed for the February issue by
Patrick Demarchelier, styled by Brana Wolf.

This page: To celebrate Bailey and Gan's official debut issue,
Caroline Murphy embarked on a day in the life as a *Bazaar*
editor and was gamely snapped by legendary *New York Times*
fashion photographer Bill Cunningham. *Opposite page:*
Murphy surveys fashion layouts in Bailey's actual office.

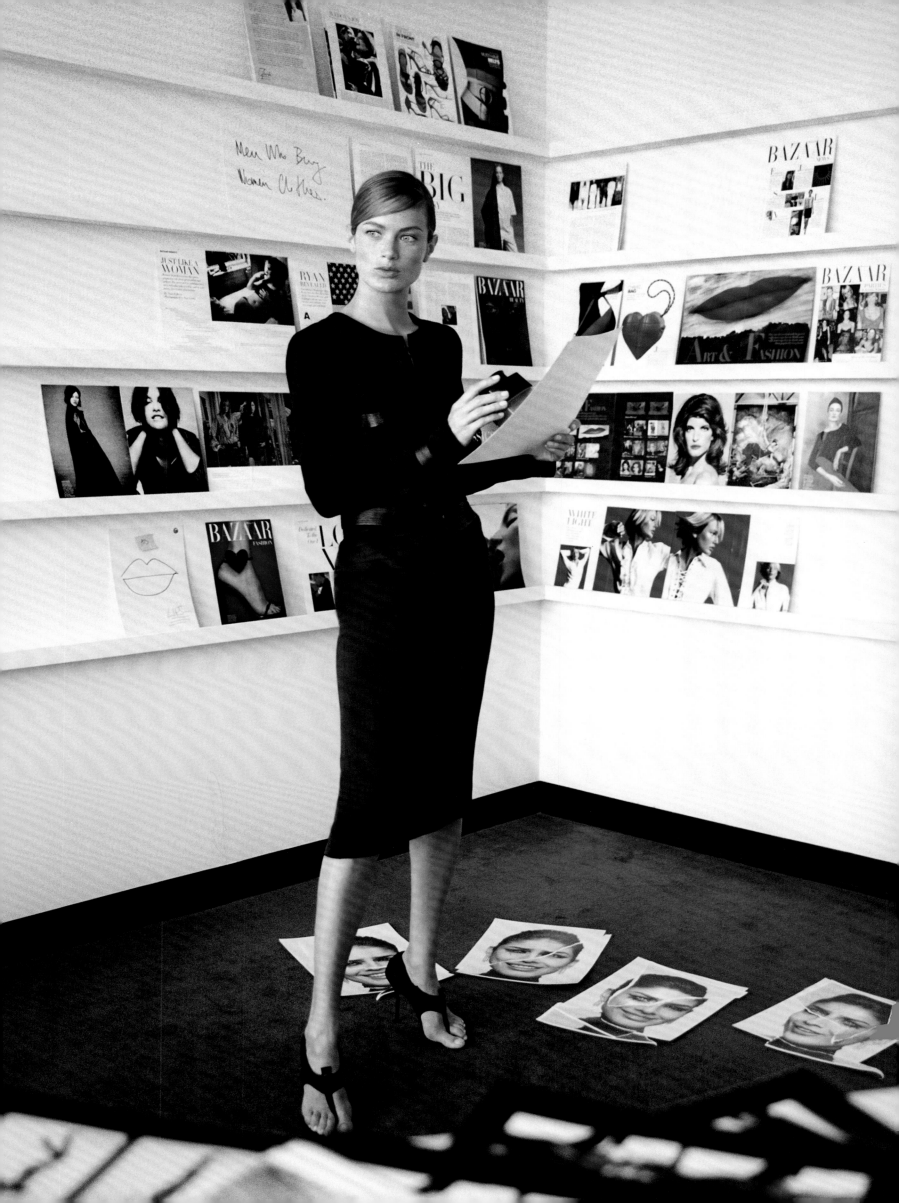

PARTY TIME

Above: Photographed for the March issue by Max Vadukul, styled by Mary Alice Stephenson.

Trudie Styler and her husband, Sting, helped Bailey ring in the new by doing what they do best. Sting gave a private concert at the magazine's relaunch celebration, while Styler art-directed a decadent night-out photo shoot for the pages of *Bazaar*. The result, inspired by Noël Coward's lyrics, was a blithely spirited affair starring Sting and party guests Robert Downey Jr., Hugh Jackman, and Anjelica Huston, among others.

LET'S DANCE

David Bowie, photographed for the August issue by Inez van Lamsweerde and Vinoodh Matadin, styled by GK Reid.

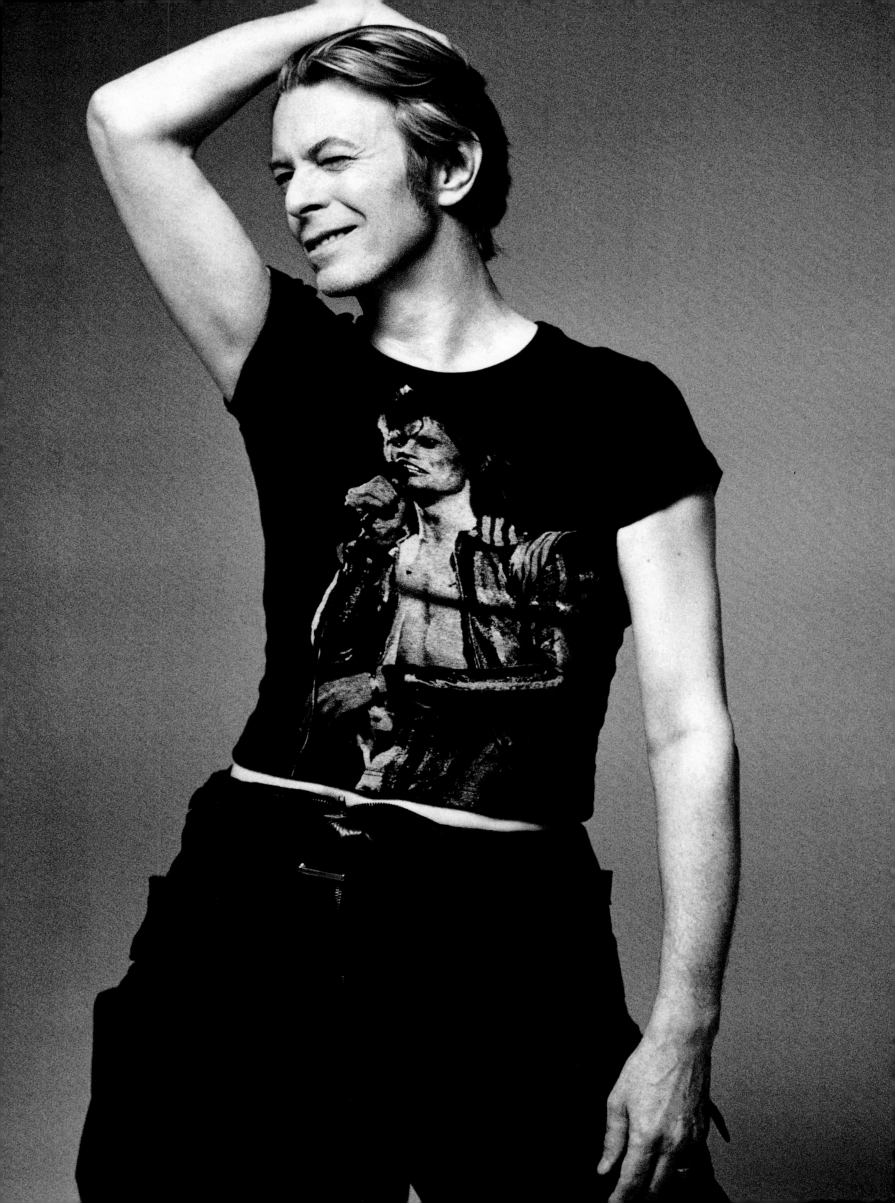

2003

BELL CURVE

Daria Werbowy in Balenciaga by Nicolas Ghesquière, photographed for the July issue
by Mert Alas and Marcus Piggott, styled by Brana Wolf.

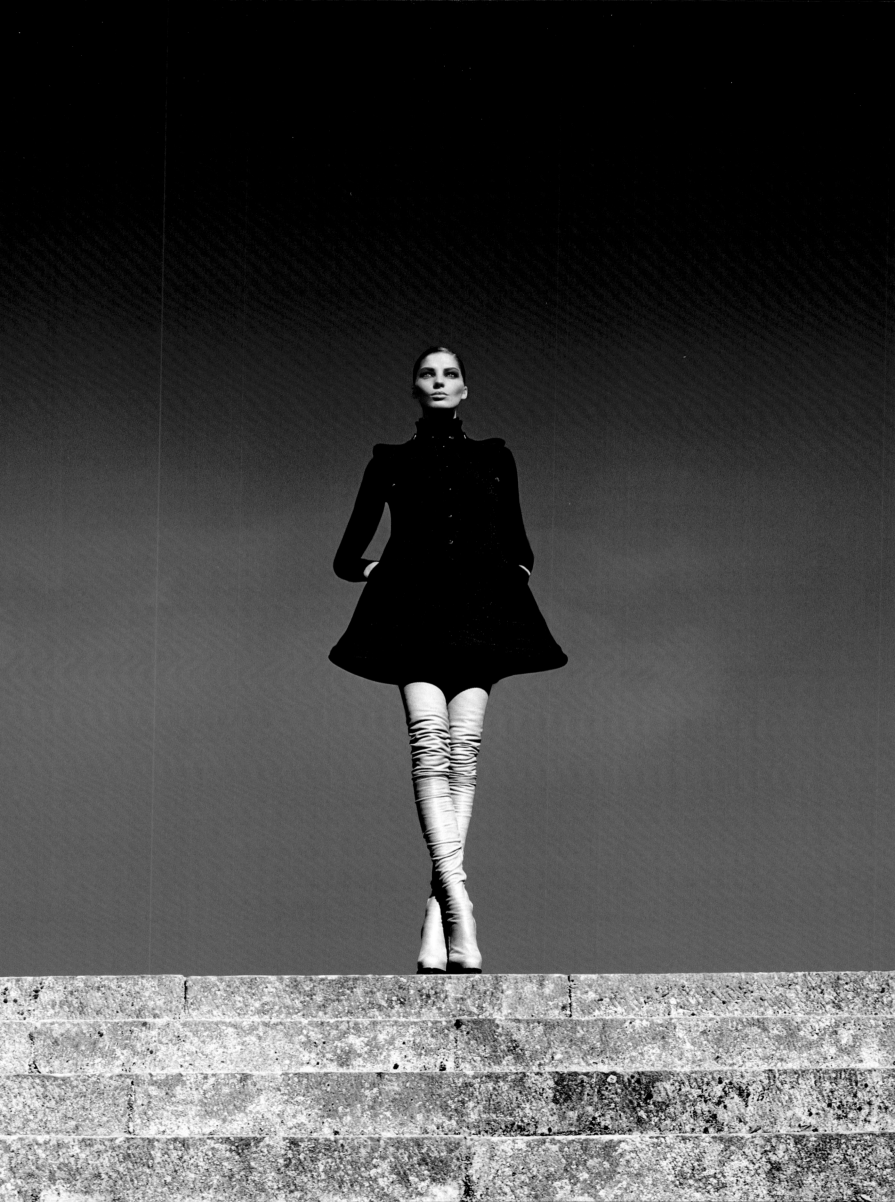

BOLD
AND
BRIGHT

ONE OF THE MOST ENDURING and stylish metrics for measuring the severity of hard times is sales of red lipstick. First noted during the dark days of World War II, when the popularity of the glamorous but relatively inexpensive pick-me-up skyrocketed, it has proven to be a surprisingly accurate barometer ever since. But it goes beyond makeup. Time and time again, when the going gets tough, the tough get glowing.

In 2003, as the U.S. prepared for war in Iraq, bright colors and metallics took center stage. If it wasn't incandescent, it wasn't on the radar. Of course, when everything is shining, only the truly brilliant stand out. Karl Lagerfeld easily fits that bill. In March, he imagined himself in conversation with Coco Chanel. Amid the highly amusing bavardage, Mademoiselle reminded her successor that in her day, "we were not youth-obsessed like people now." Lagerfeld later made the conversation into an audiotape with Jeanne Moreau as the voice of Coco.

As if to underscore the wealth of options, the March issue was also graced with Peter Lindbergh's "Age of Innocence" story, a study in lace and chiffon that was a softly romantic counterpoint to the prevailing high glamour.

Certainly, women of all ages could appreciate the May story featuring workwear shot by Inez van Lamsweerde and Vinoodh Matadin,

starring Stephanie Seymour. Surrounded by the adoring working men of New York's bustling streets, Seymour was the office-bound queen of the sidewalk. Also in May, fashion maverick Azzedine Alaïa posed for Patrick Demarchelier and summed up this woman as such: "She may look fragile, but she can snap you in two."

In July, photographers Mert Alas and Marcus Piggott captured the sophisticated polish of the new Paris collections with their architectural shapes, pumped-up volume, and flashes of red.

But while the latest clothes are nice, the greatest luxury is being comfortable in one's skin, as Cathy Horyn explained in a September feature titled "Celebrate Your Beauty." The piece profiled scene-stealers like Tilda Swinton and Chloë Sevigny, women who embrace their unconventional looks.

The year ended with Jean-Paul Goude's fabulous first shoot for the magazine, thanks to Gan. For the December issue, Goude cast Linda Evangelista playing Donatella Versace's doppelgänger, making magic with Jean Paul Gaultier, holding court with Valentino and his army of pugs, and being held aloft by Karl Lagerfeld while Gan and Goude himself took part, sprinkling confetti, showing how important the industry's luminaries had become in our culture.

At *Bazaar,* designers *are* the celebrities.

RED HAUTE
Daria Werbowy in Dior by John Galliano, photographed for the July issue by Mert Alas and Marcus Piggott, styled by Brana Wolf.

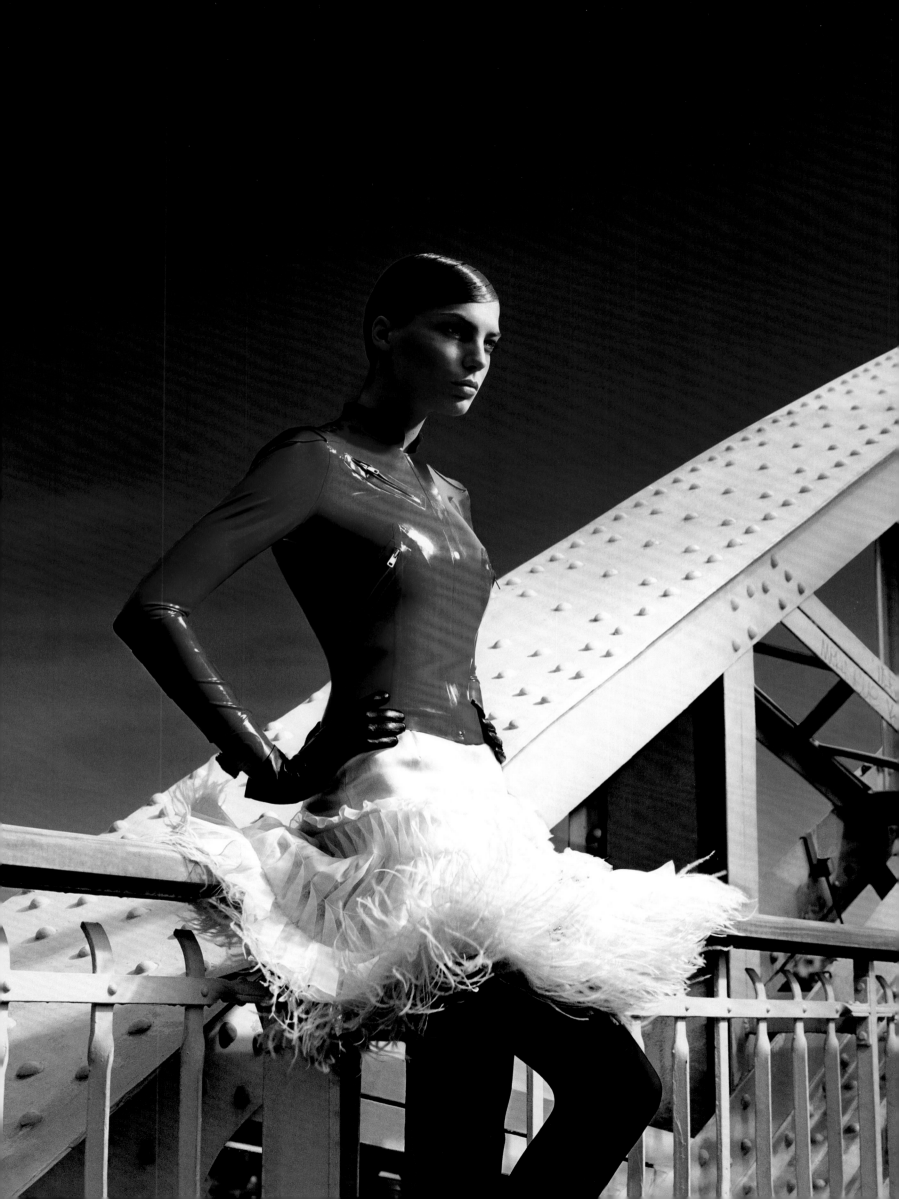

COUTURE COUNCIL

Linda Evangelista, photographed for the December issue by Jean-Paul Goude, styled by Jean-François Pinto.

This page: Evangelista dons a blonde wig with Donatella Versace. *Following spreads:* The supermodel gazes into Christian Lacroix's mirrored cross, performs alchemy on the head of Jean Paul Gaultier, and offers a pretty pucker for Valentino and his pugs.

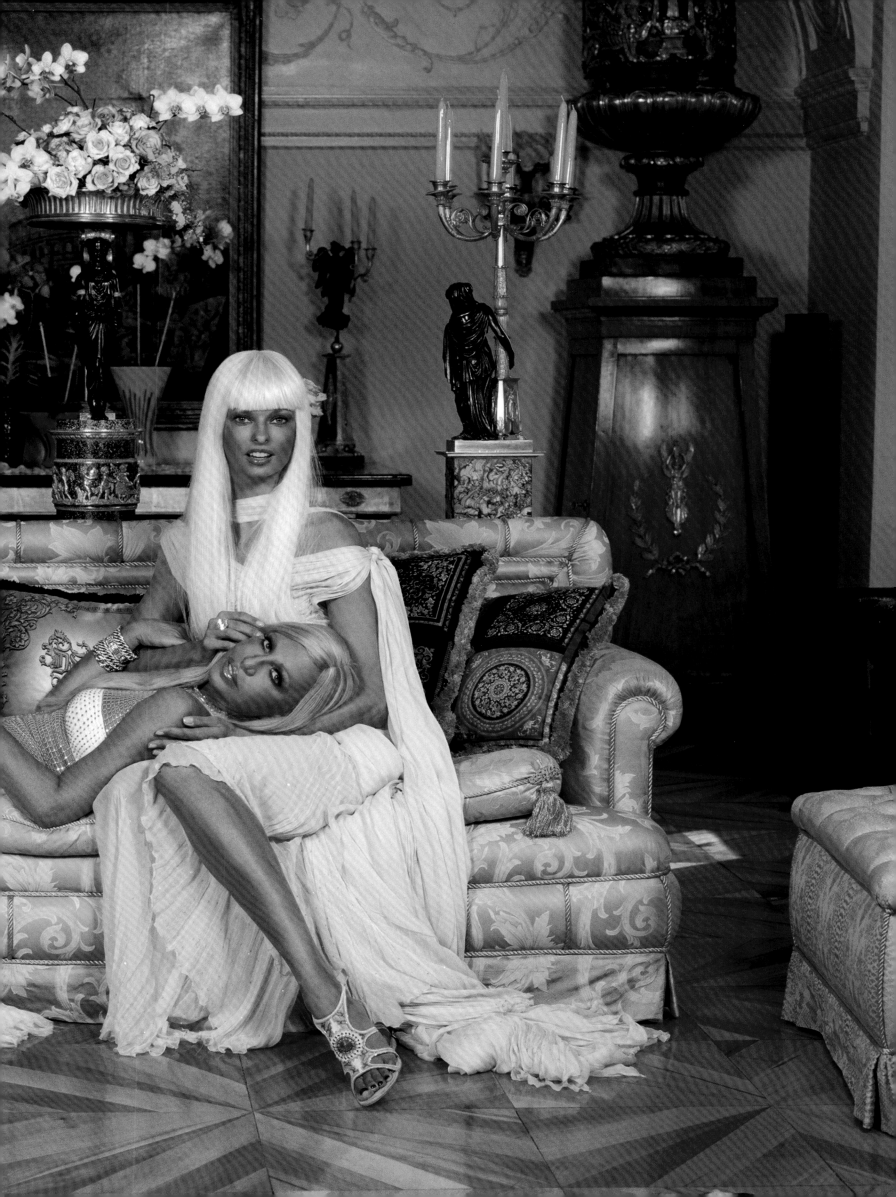

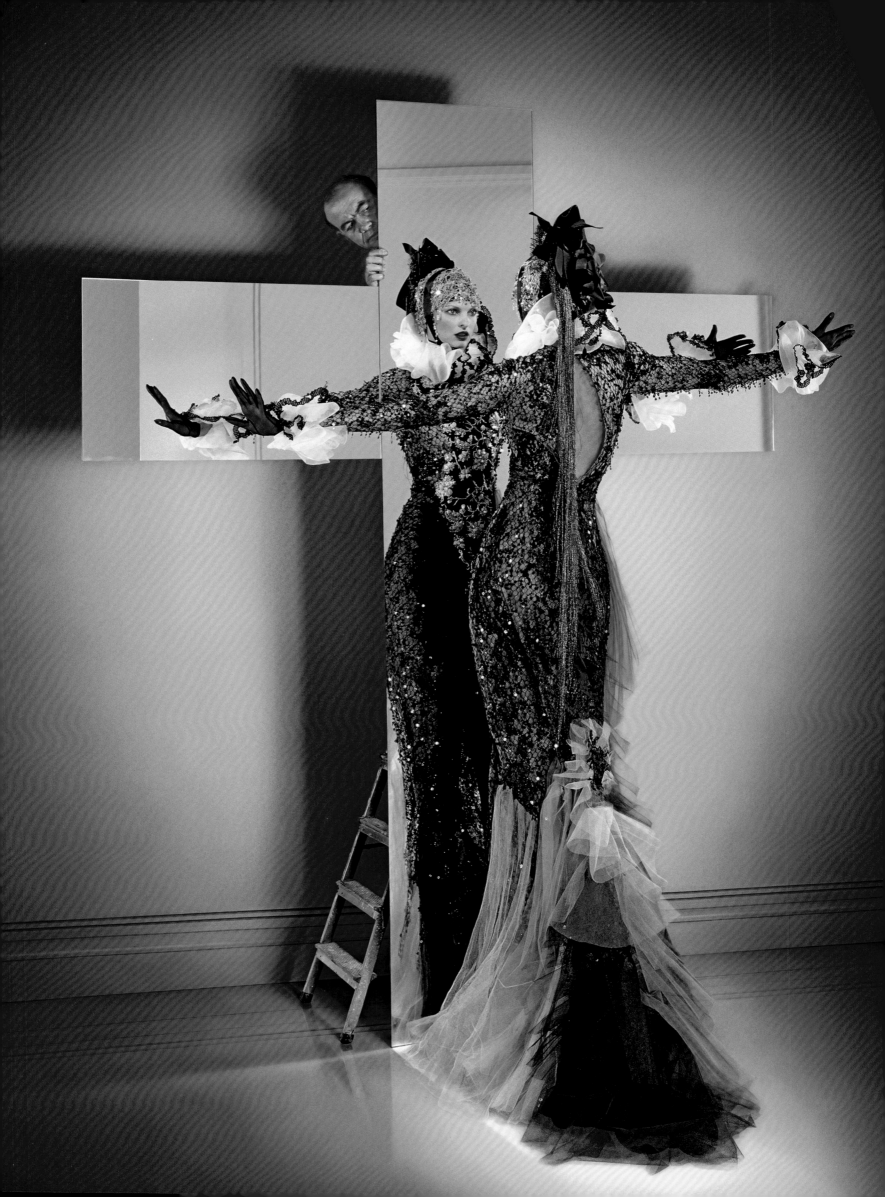

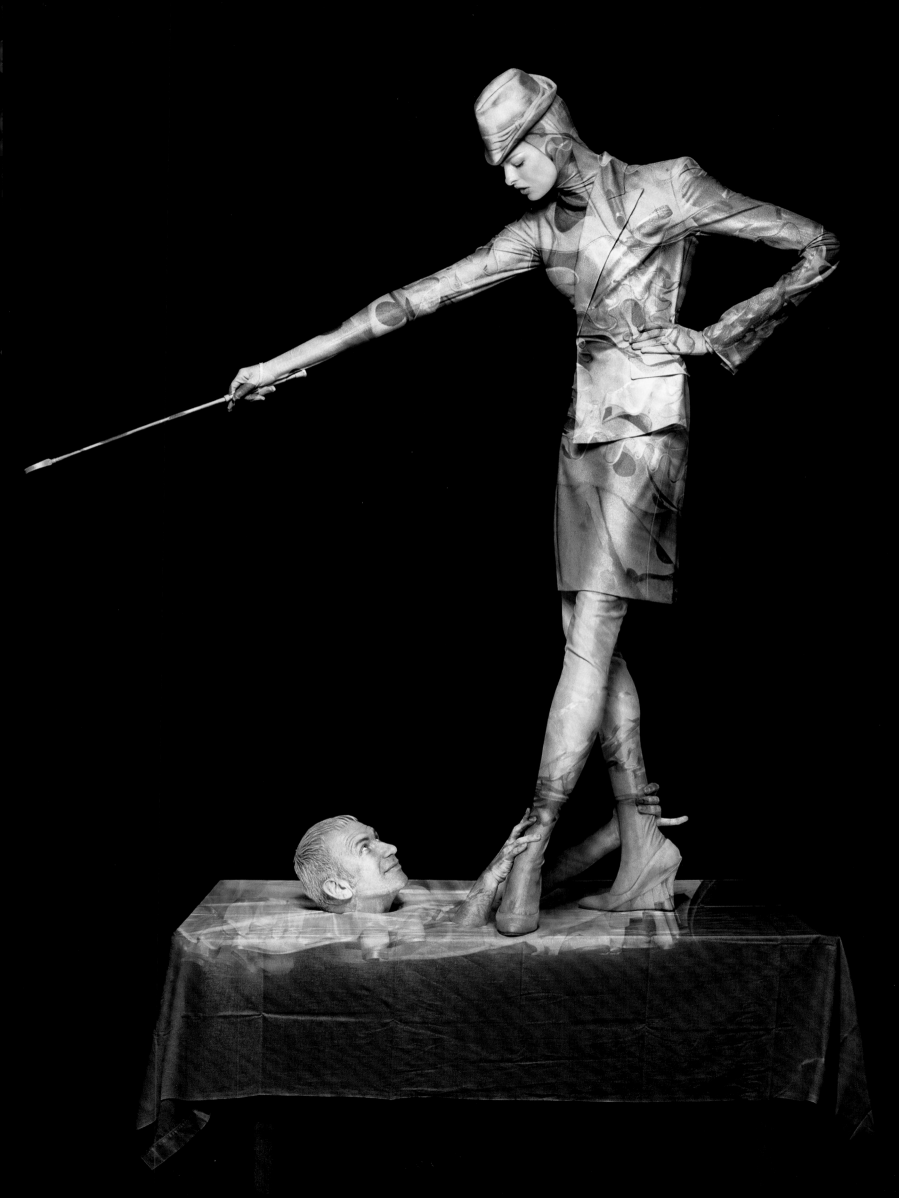

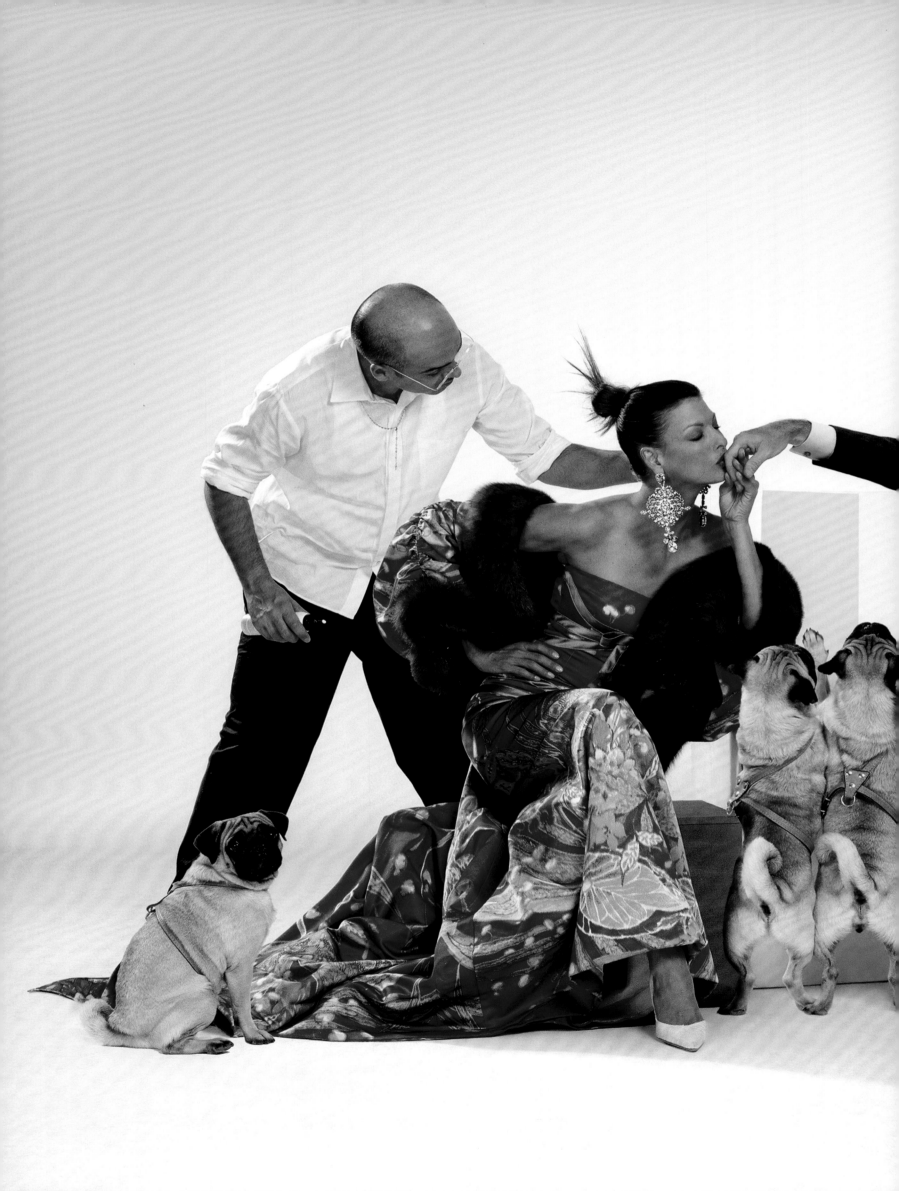

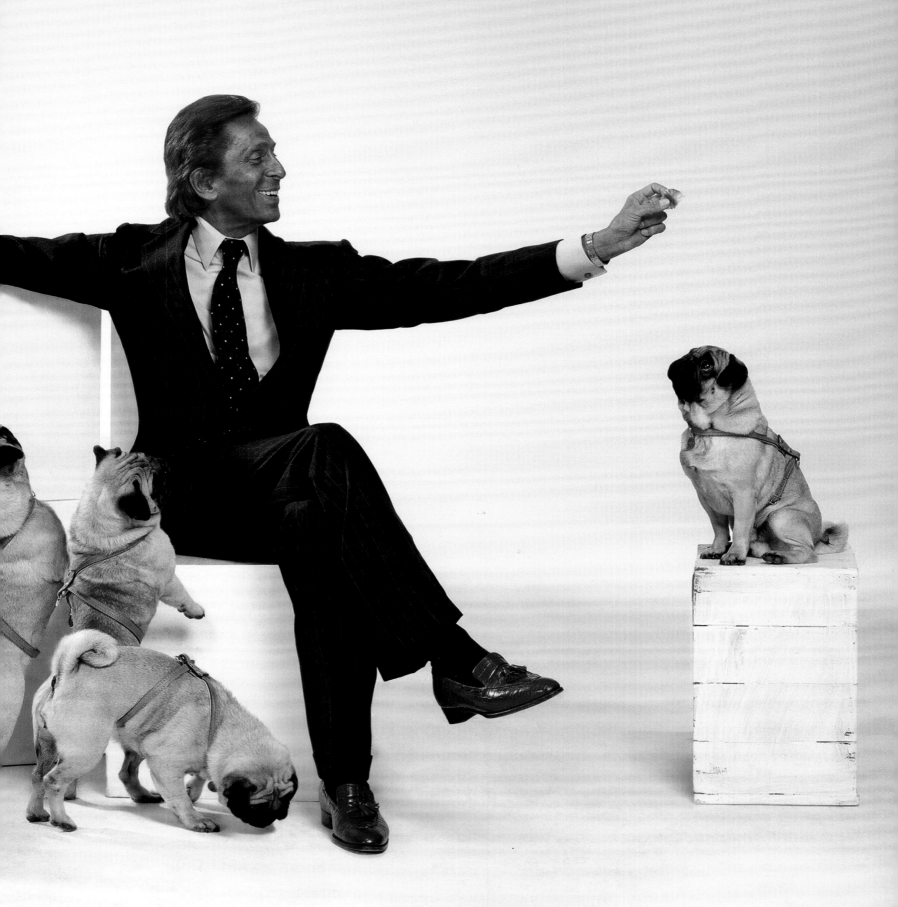

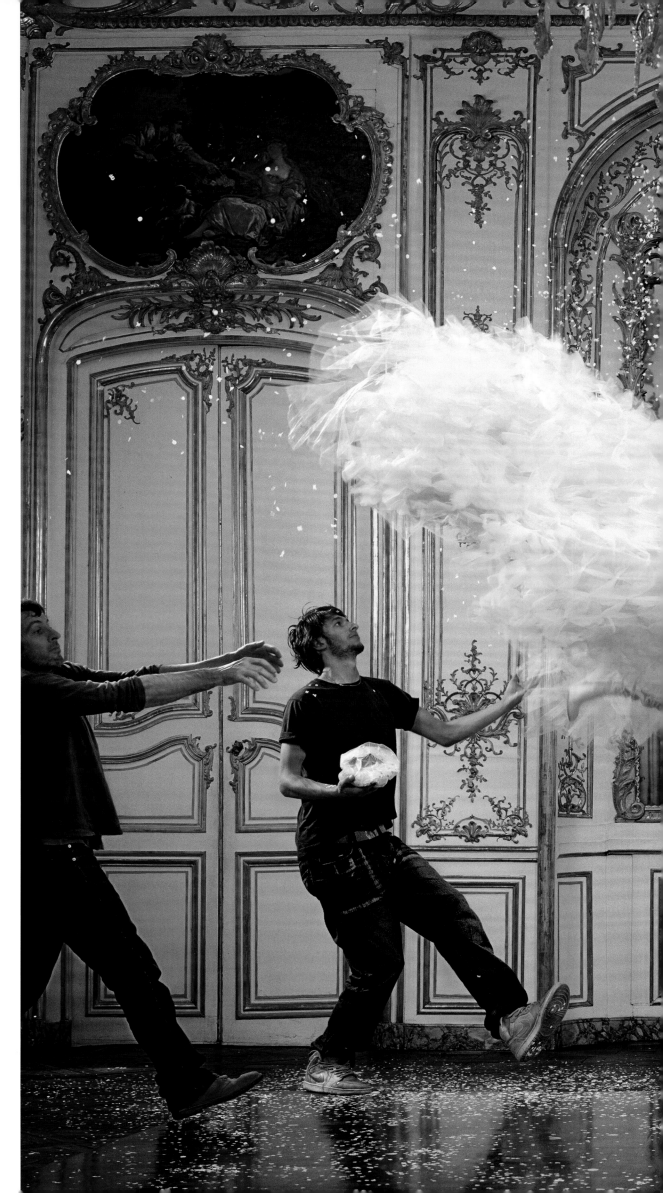

FLYING HIGH

Linda Evangelista, in
Chanel Haute Couture, dances
à deux with Karl Lagerfeld
while photographer Jean-Paul
Goude (second from right)
and Stephen Gan (far right)
get in on the confetti toss.

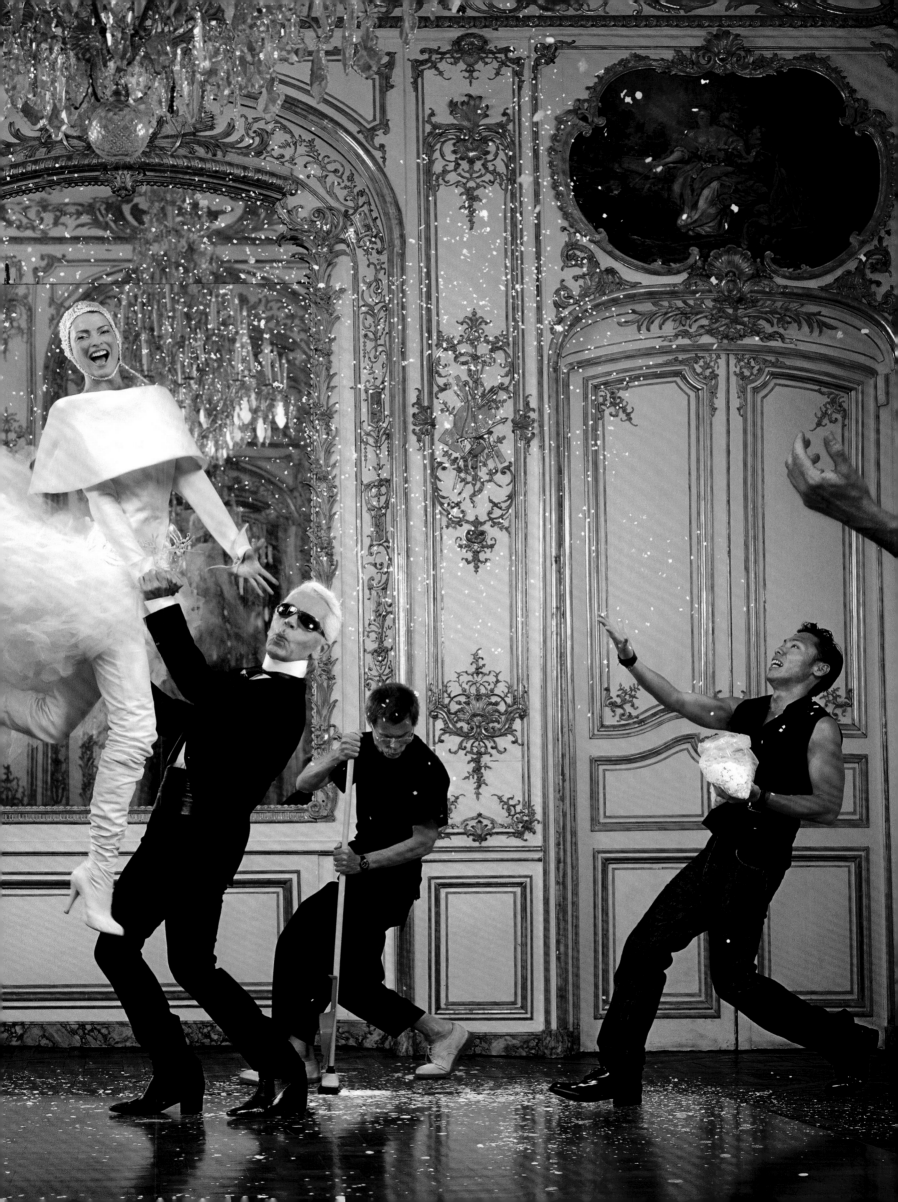

KARL CHATS WITH COCO

What would the two faces of Chanel say to each other if they were to meet today?

BY KARL LAGERFELD

Excerpted from the March issue

COCO CHANEL: I am watching you. The other day I saw you posing on my famous staircase…

KARL LAGERFELD: Your staircase? You sold your business years before you went wherever you are now.

CC: Don't be so down-to-earth. Seen from here, one looks at things differently. I know people say the soul was invented to degrade the body—

KL: Anna de Noailles said that, not "people."

CC: You are just too bookish! When the body is gone, the soul is gone, too. Look at me! It's not true!

KL: The spirit of Chanel was also well-preserved, because your name and the business fell into the right hands. Look what happened to the other names of your day.

CC: Many of them copied me anyway.

KL: Madame Vionnet and Madame Schiaparelli never copied you. You always said you liked to be copied. You said Saint Laurent copied you very well. I am just quoting you.

CC: Now, in your world, you can be considered a genius if you copy well. Ripping off is part of the game in fashion now.

KL: They often call it homage if it's too obvious. You can even show the copies in museums now.

CC: Only Andy Warhol understood all that very well. We've become very friendly up here and often watch *Life on Earth,* our favorite show, on Britain's Sky TV. They show a lot of what is called fashion nowadays, but it's what you hardly ever see people wearing in the streets.

KL: And what do you think about fashion today?

CC: You know me—or you know the way people described me. I am not really interested in other people's work. I am only interested in me, in what I was… a little like you are now.

KL: Coming from you, it's a kind of compliment. I am happy to find out that you are not in hell—where everybody expected you to be sent. They say you were such a bitch.

CC: I was ferocious but not really mean. I was perhaps unnecessary, but irreplaceable.

KL: Sounds like a quote.

CC: I always quote myself!

KL: For sure, you are irreplaceable.

CC: And certainly not by you!

KL: I am not so ambitious!

CC: Some of the things you do under my name are okay.

KL: Thank you.

CC: Don't imagine I am mad for what you are doing at Rue Cambon, but you have to do so many collections now that I cannot be too difficult.

KL: I try to do what I can.

CC: As you said: You are not ambitious.

KL: Are there other designers you like today?

CC: I told you I was never interested in other designers. As people, some seem to be very *nice*… I hate that word… Calvin Klein, Tom Ford, John Galliano—

KL: You see, you even know the names.

CC: I like the work of this boy, Hedi Slimane for Dior Homme, who makes the kind of clothes you wear all the time—and you remember what I said about Dior himself. But John Galliano is a very good dressmaker.

KL: We are called designers now. Some people call us *createurs,* which I think is a terrible word—

CC: —for *dressmakers.* I only made dresses for myself that others were stupid enough to wear. But they looked best on me! Even when I was old!

KL: You had style in your clothes.

CC: My style! I am bored to death (in fact, death, in my case, is not boring) by the way the word *style* is used today! That is the biggest misunderstanding of your times. Mrs. Vreeland put that word on the fashion map. I see now that you even have a magazine called *In Style.* What style? There is not a style for everybody!

Illustrated for the March issue by Karl Lagerfeld

C.C: The streets always looked terrible...

C.C: people have to believe that ideas you had were mine...

C.C: you design Chanel and you dress in Dior...

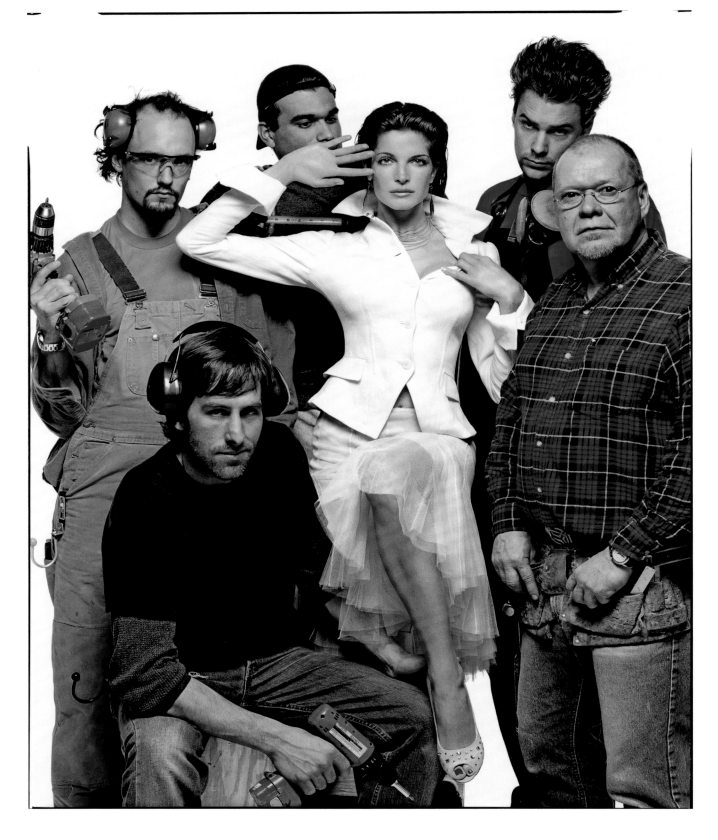

WORKING GIRL

Above: Stephanie Seymour in Ralph Lauren Collection, photographed for the May issue by Inez van Lamsweerde and Vinoodh Matadin, styled by Polly Allen Mellen.

KING OF CURVES

Azzedine Alaïa, diminutive in stature yet outsize in talent, with Elise Crombez in Alaïa, photographed for the May issue by Patrick Demarchelier, styled by Melanie Ward.

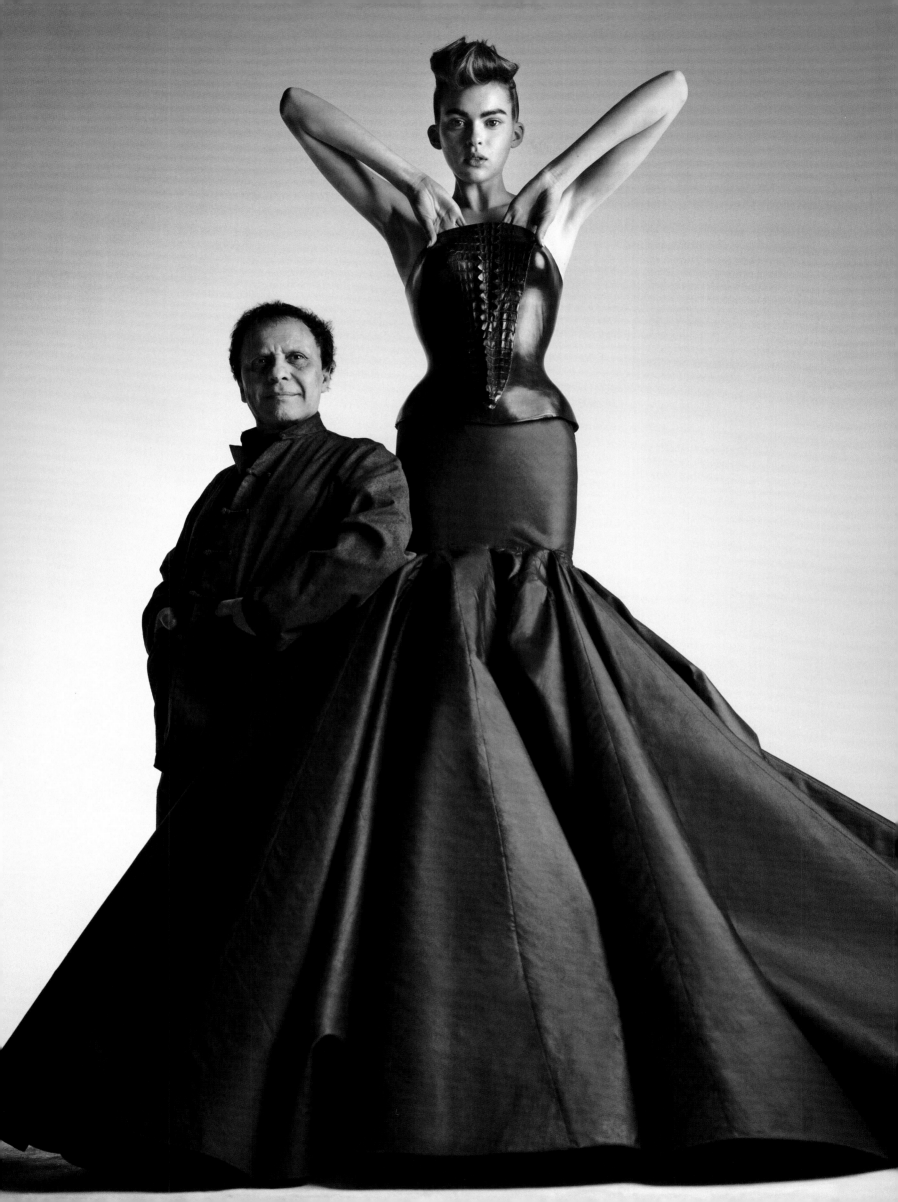

CELEBRATE YOUR BEAUTY

Is there more essential loveliness in the usual face than the so-called classic one?

BY CATHY HORYN
Excerpted from the September issue

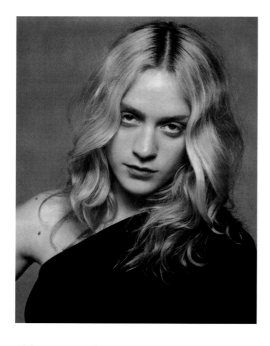

Chloë Sevigny (above) in OMO Norma Kamali and Tilda Swinton in Viktor & Rolf, photographed by Inez van Lamsweerde and Vinoodh Matadin for the September and October issues, respectively, styled by Brana Wolf.

GOOD WRITERS KNOW HOW to make mincemeat of conventional beauty. "Beauty is an *experience,* nothing else," D.H. Lawrence wrote in 1929, arguing that there was more essential beauty in the odd face than the so-called beautiful one. "It is not a fixed pattern or an arrangement of features. It is something *felt,* a glow, or a communicated sense of fineness." The ill-tempered and blackened-toothed Lawrence probably had reason to be defensive. Still, he would never have defended anything so weak-toothed as "Beauty is in the eye of the beholder." The glow he meant was the fire of sex. "And when the glow becomes a pure shine, then we feel the sense of beauty."

But where do we find that *experience* today? And, I may add, has it been altered by the availability of cosmetic surgery, Botox, and even digital imaging, which can erase wrinkles and other distinctions that give a face character? Some women definitely possess a sense of beauty without being beautiful, and the difference is the experience you see in a face—the experience of love, the experience of loss and determination. Clare Boothe Luce once said that the great Garbo only looked human—and therefore beautiful—during her love affair with the actor John Gilbert. Otherwise she was a cold, inarticulate woman "with a chip on her shoulder." By contrast, Diana Vreeland was no beauty at all. Yet her Kabuki makeup and cranelike walk fed the larger-than-life ideal of herself. Many summers ago, on Nantucket, before I thought anything of fashion or beauty, I used to see a woman with a very small, groomed head and immense dark glasses going up Main Street. This was D.D. Ryan, a former editor of *Bazaar.* I had no idea then who she was, and it would be a while before I'd connect this strange sphinx to the woman whose pictures I saw in magazines. But clearly, like Vreeland, she arranged her looks to leave a strong impression.

Nowadays I think of women like Tilda Swinton and Anjelica Huston, whose irregular features make them stand out, as ugly ducklings do, amid a sea of cutely blondes. In fact, Swinton, a fine-boned redhead who can appear very androgynous, suggests that unusual-looking women (and men) are all the more striking when they display a lack of self-consciousness about their beauty. "I'm so lazy. I never particularly wanted to look like anything," she says. "It helps as a performer if your looks can change, but I don't really think about it much."

Swinton modeled this season for Viktor & Rolf, recording a monologue about individuality that she composed for the show. And Huston began her career as a photographer's model, often working for Richard Avedon and her boyfriend at the time, Bob Richardson. Fashion has always harbored a special affection for unconventional beauties, especially in periods of extreme fashion, though it's striking how often you hear these exotic creatures being compared to animals. Nan Kempner says of the '60s model Penelope Tree: "Penelope always looked to me like a large amoeba." Cecil Beaton described his great friend Lady Mendl as "a vaguely plain woman with a marmoset face." Yet, more generously, he notes that she introduced the fashion for pale-blue hair and was one of the earliest devotees of plastic surgery. In her 80s, she acquired a more mystical look.

For me, though, Anjelica Huston is tops. She has that pale milky skin, those wide flaring eyes, and that gorgeous ski-jump nose. Yet even Huston admits that when she was growing up—and even after she had become a successful model—she felt the immense tug of the American beauty ideal: the blue-eyed California blonde. "Oh, God, I wanted to be Barbie from the moment I first started looking at myself in the mirror," says Huston, laughing. She was in a double bind because her mother, a former Balanchine dancer named Enrica Soma Huston, was a classic beauty. "My mother always told me I was beautiful, which all mothers do, and that's every good reason for having them. My mother really loved life. She really had bitten it off. That's so much of what I love about beauty—people who have get-go."

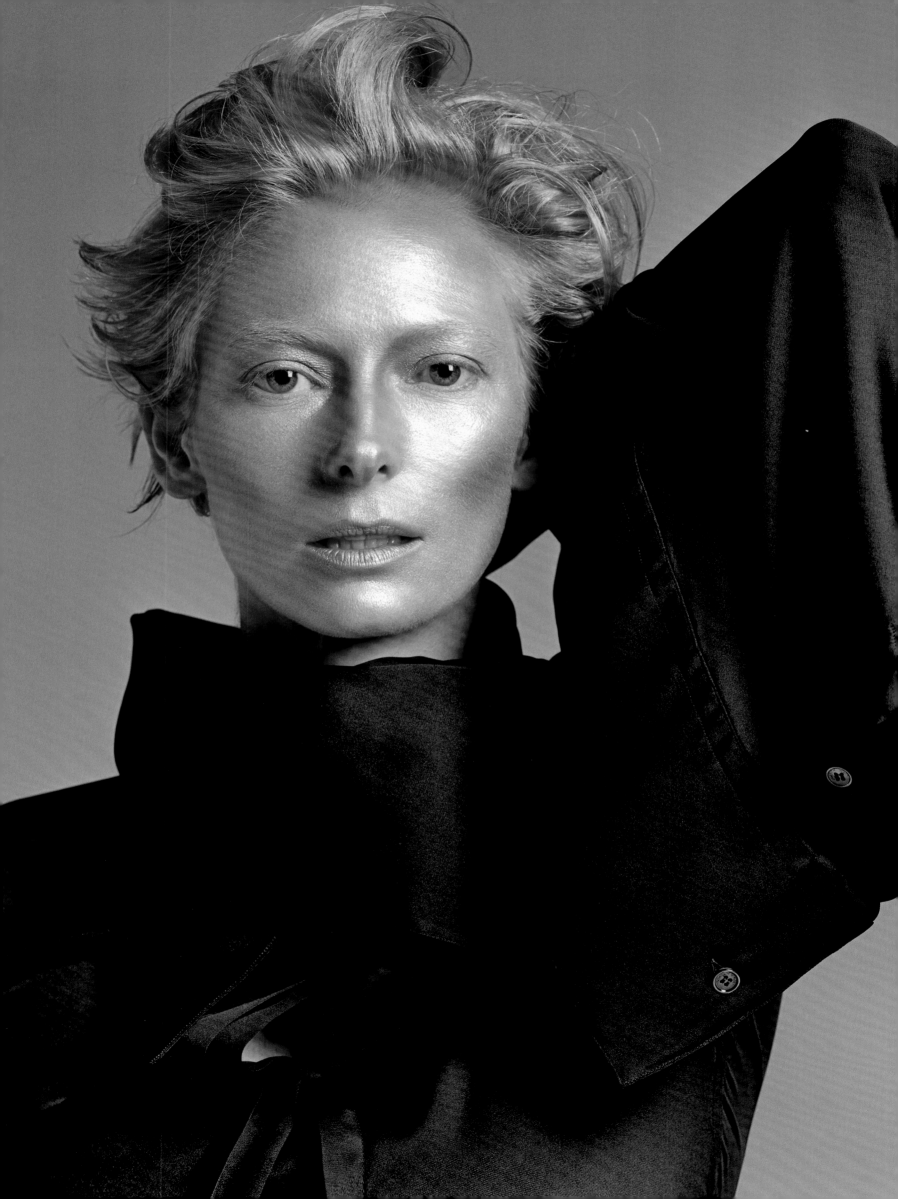

AGE OF INNOCENCE

Natalia Vodianova in
Alexander McQueen (this
page) and Ralph Lauren
Collection, photographed
for the March issue by
Peter Lindbergh, styled
by Jillian Davison.

2004

CHIC OFFERING

Drew Barrymore in Dolce & Gabbana, photographed for the April issue
by Patrick Demarchelier, styled by Katie Mossman.

Harper's
BAZAAR

Fabulous at Every Age

ELECTING FOR ELEGANCE

AT *HARPER'S BAZAAR,* 2004 began with the departure of Tom Ford from Gucci and Yves Saint Laurent and ended with the arrival of Ellen DeGeneres in the White House.

In an exclusive interview Ford gave *Bazaar* less than two weeks before announcing his decision to resign as creative director for both houses, he hinted at what would eventually turn out to be a long sabbatical from ready-to-wear. "I might buy my own company or start one," he said in the January issue, "even though I've always said I wouldn't do that."

While Ford had his bittersweet last seduction, elsewhere designers evoked a sense of bygone glamour. In particular, the Milan spring collections, photographed in languid afternoon light by Glen Luchford for the January issue, had an air of fantasy that was redolent of old Hollywood.

The womanly silhouettes that heralded the spring season provided a welcome respite from a hawkish political climate. While the entire world seemed to be in conflict, the stylish and optimistic were dispatching their communiqués for a brighter future in silk trenches and airy chiffon.

Displaying her own streak of optimism, Bailey rang in the year by instituting the two-cover concept, showing that you can have your editorial cake and eat it too. The visionary idea has become a hallmark of her editorship. While one cover pops at the newsstand, the subscriber version takes a more artful approach.

Artistry reigned supreme in the spring couture collections as well, as shown in the May story "Couture's Flight of Fancy," a collaboration between Patrick Demarchelier and Japanese artist Chiho Aoshima. A member of Takashi Murakami's Kaikai Kiki collective, Aoshima animated a fashion Elysium with zooming fairies, nuzzling woodland creatures, and glittering stardust. Not only did the layout illustrate the enchanted feeling of the collections, it coincided with the *manga* madness sweeping the fashion world in the wake of Murakami's line of bags for Louis Vuitton.

It's impossible to overstate the importance of the cult of the must-have handbag that year. But that's no fluffy phenomenon. It became a major driver for the industry's most treasured labels. And a woman's choices of what to carry—and wear—influence how she's viewed by society at large. In her piece for the September issue, "Nice vs. Ice," Candace Bushnell explored the various messages that a powerful woman's clothes can telegraph. Should the female executive dress to kill or coddle? Bushnell's conclusion: "It doesn't really matter if you're nice or ice, just as long as you always get the job done."

As the presidential election approached, one job that was being discussed by everyone in the country was that of commander in chief. *Bazaar* realized the forward-thinking dream of a woman occupying that post with the help of comedian Ellen DeGeneres in the November issue.

In a moment of self-reference, Peter Lindbergh shot an homage to his classic 1992 Donna Karan ads, this time presaging the campaign of DeGeneres's blondel-gänger, Hillary Clinton, by a full four years. When listing the reasons she thought a woman would make a good president, DeGeneres noted, "It would reinvigorate the pantsuit industry."

Bazaar's strength is predicting the future and making a moment in time magical.

A ROUND OF APPLAUSE

Raquel Zimmermann in Lanvin and, on the following spread,
Alexander McQueen (left) and Yves Saint Laurent Rive Gauche, photographed
for the July issue by David Sims, styled by Melanie Ward.

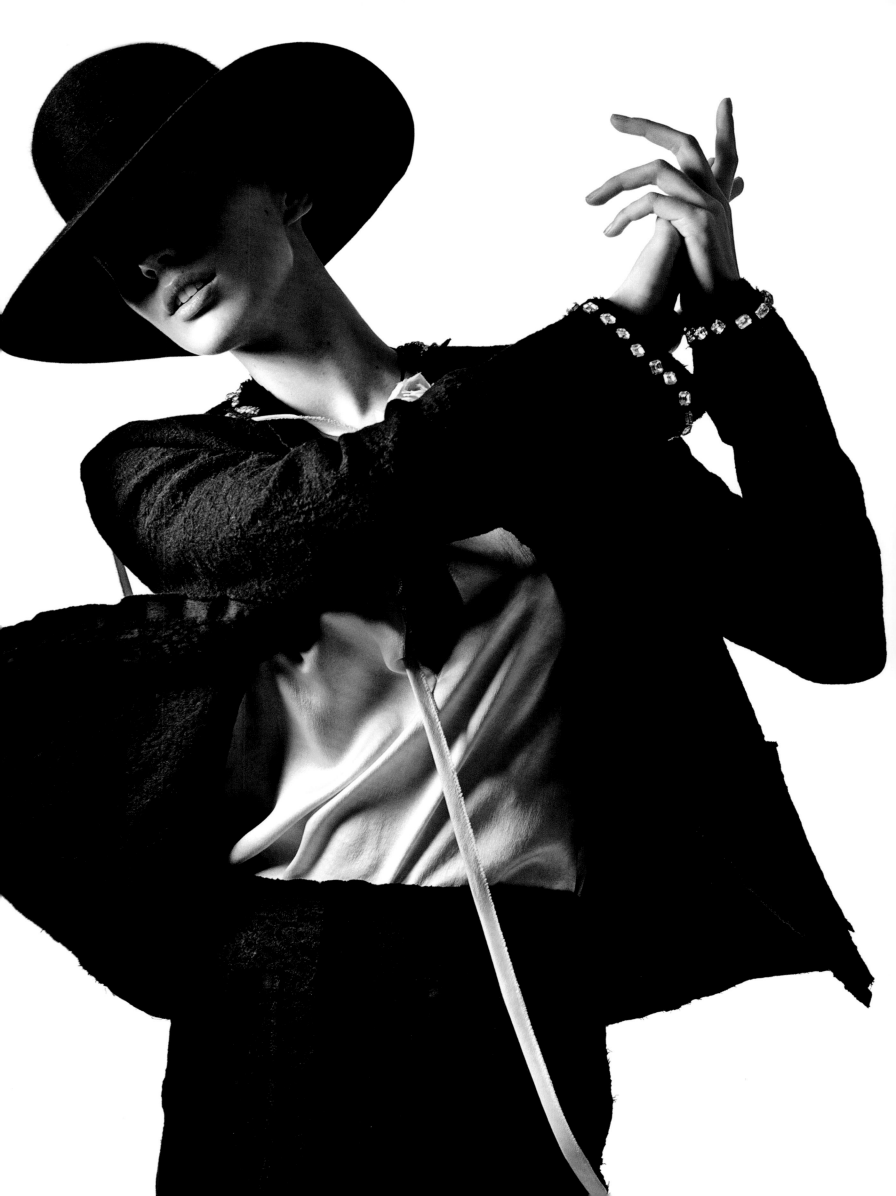

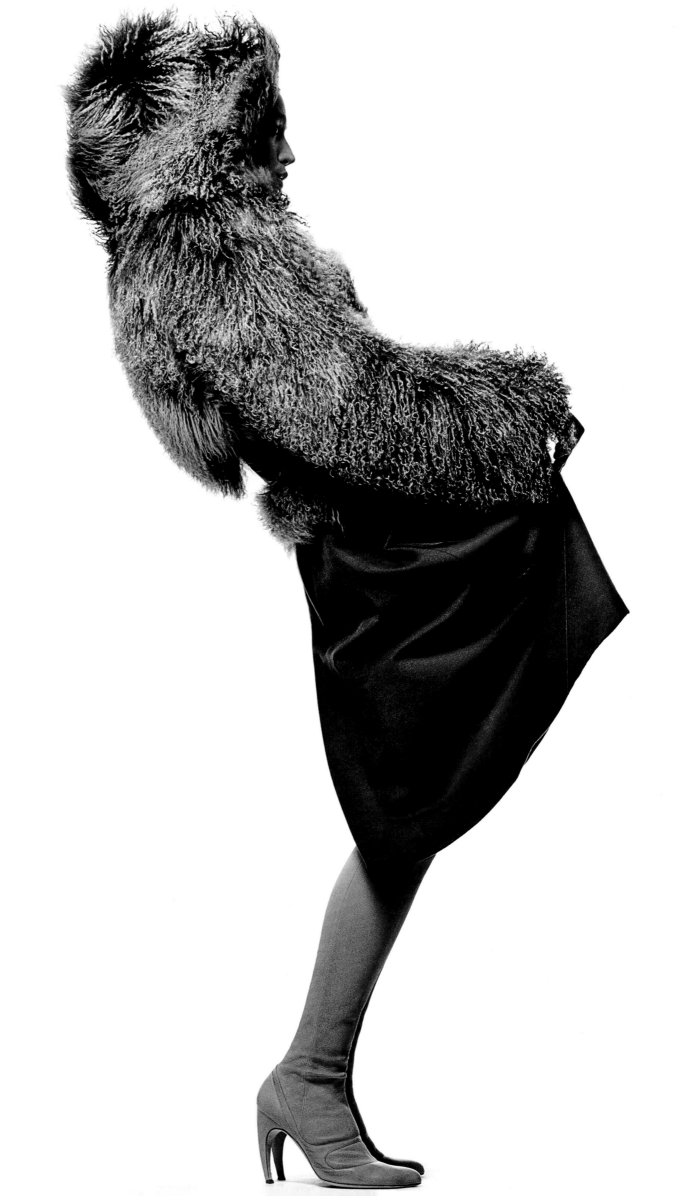

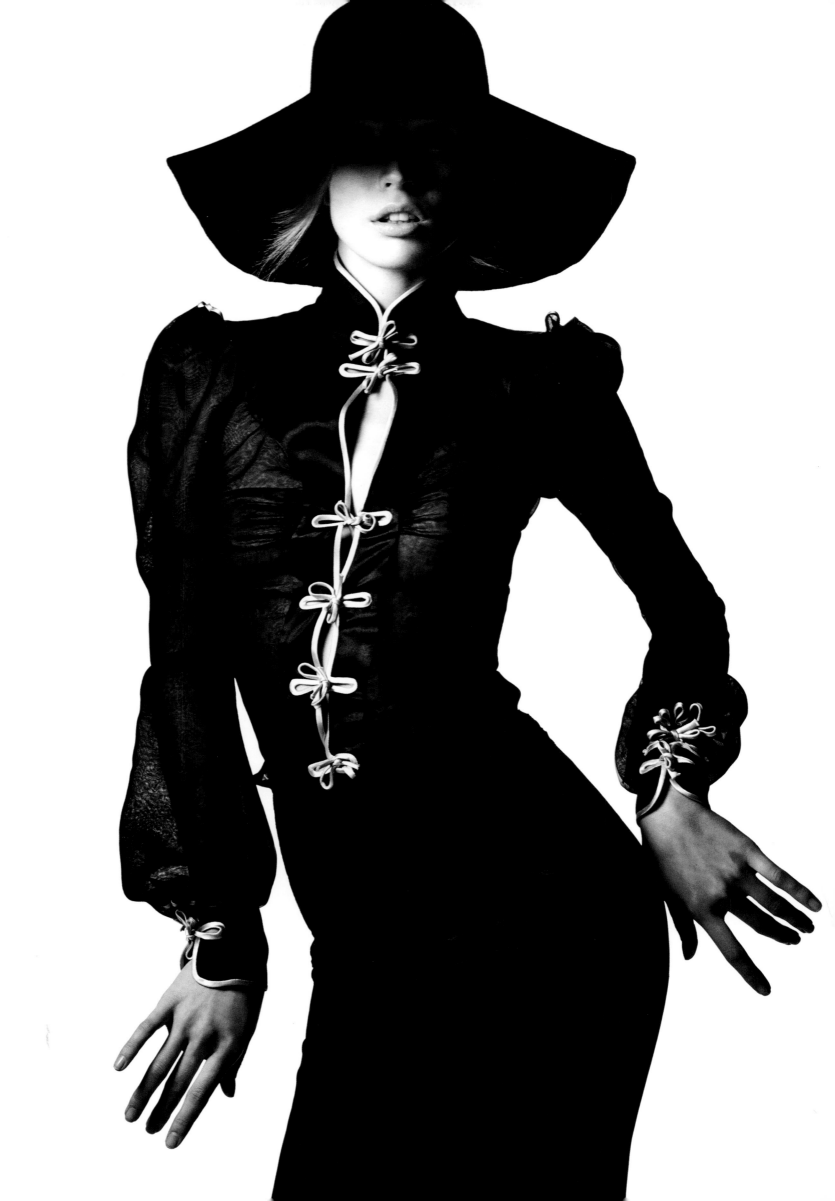

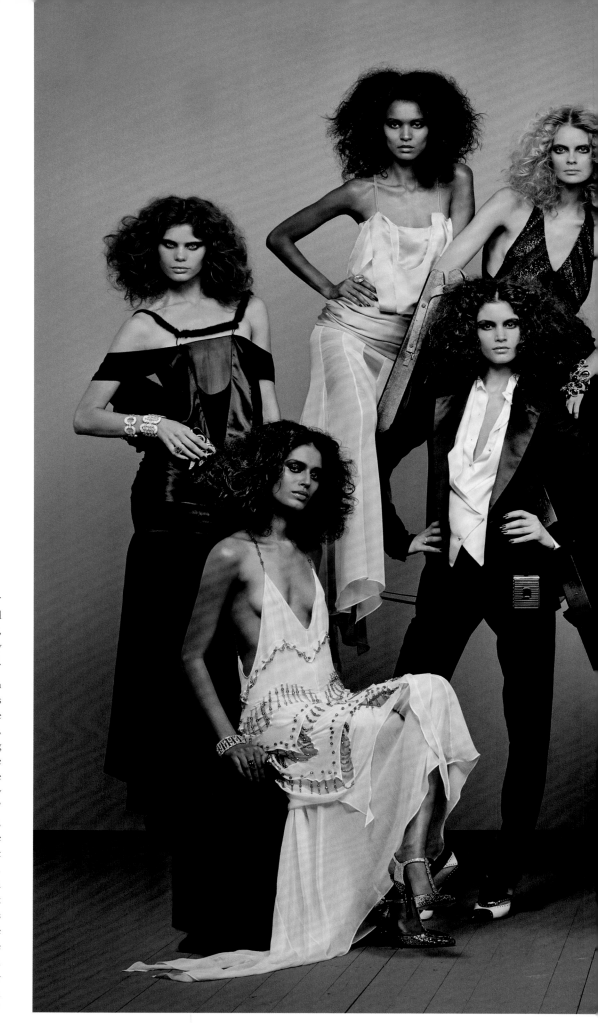

FORD'S FAREWELL

Tom Ford with models in Gucci and Yves Saint Laurent Rive Gauche, photographed for the January issue by Sølve Sundsbø, styled by Brana Wolf.

In an exclusive interview with Phoebe Eaton (which turned out to be his last major magazine profile while he was creative director of the Gucci Group), Ford described his double duty as dressing two characters. "They may both be beautiful and they may both be roughly the same age and they may both have money and they may both be sexually available," he said. "But the Gucci woman is sweeter, more naive. She may be like, 'You're a great guy, let's fuck.' The Saint Laurent woman is more twisted, more perverse. She is going to tie you up and slap you around before she finally lets you have sex with her." In the course of Eaton's interview, which took place just before Ford announced his resignation, the designer also mused about his uncertain future. "I might buy my own company or start one," he predicted, "even though I've always said I wouldn't do that."

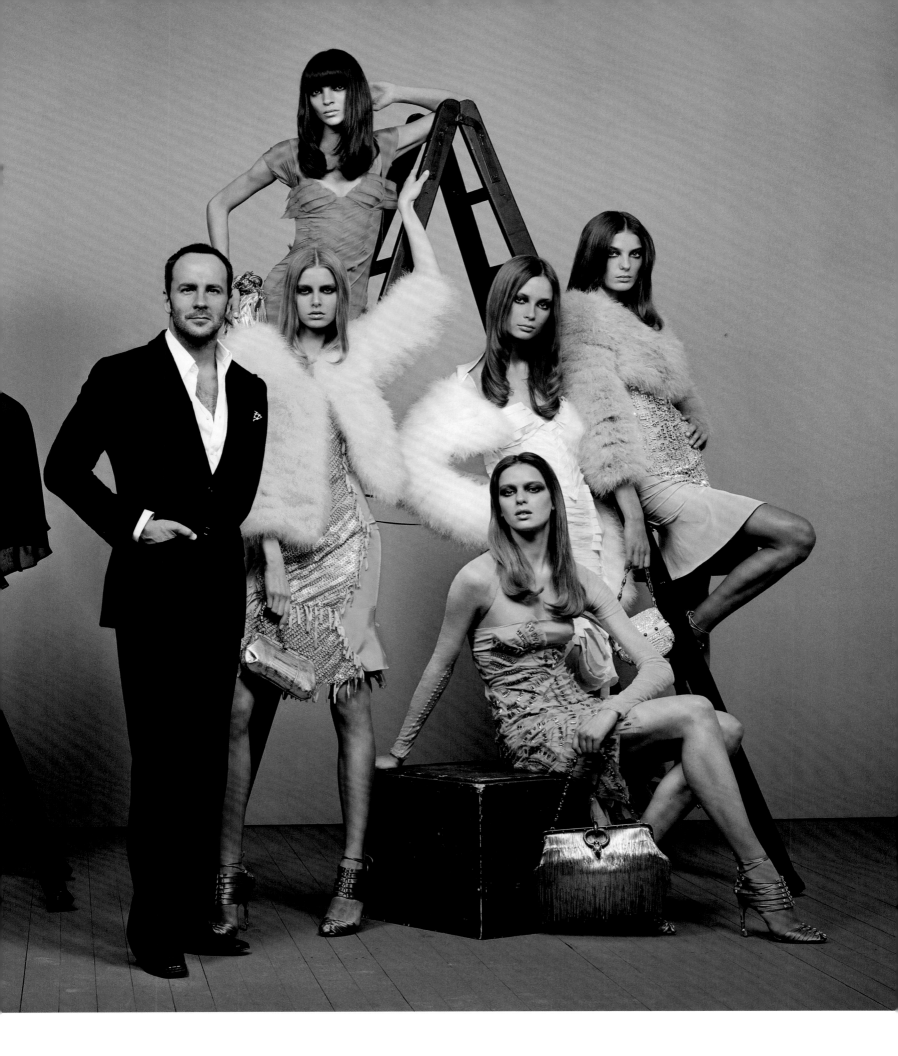

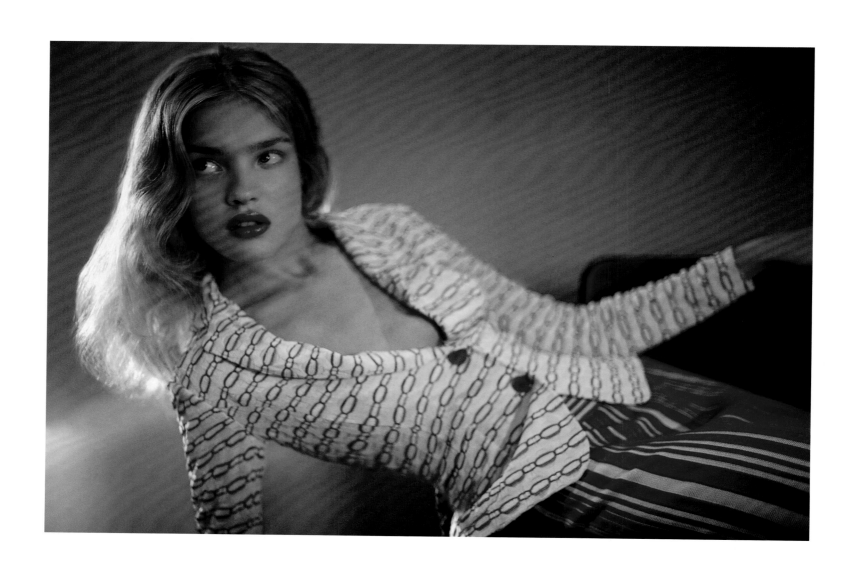

FEMME FATALE

Natalia Vodianova in Missoni (above) and
Fendi, photographed for the January issue by
Glen Luchford, styled by Katie Grand.

Couture's Flight of Fancy

FANTASY FASHION

Gemma Ward in Christian Lacroix Haute Couture and, on the following spreads,
Valentino Haute Couture, Chanel Haute Couture, Atelier Versace, and Gaultier Paris, photographed for
the May issue by Patrick Demarchelier, styled by Brana Wolf. Illustrations by Chiho Aoshima.

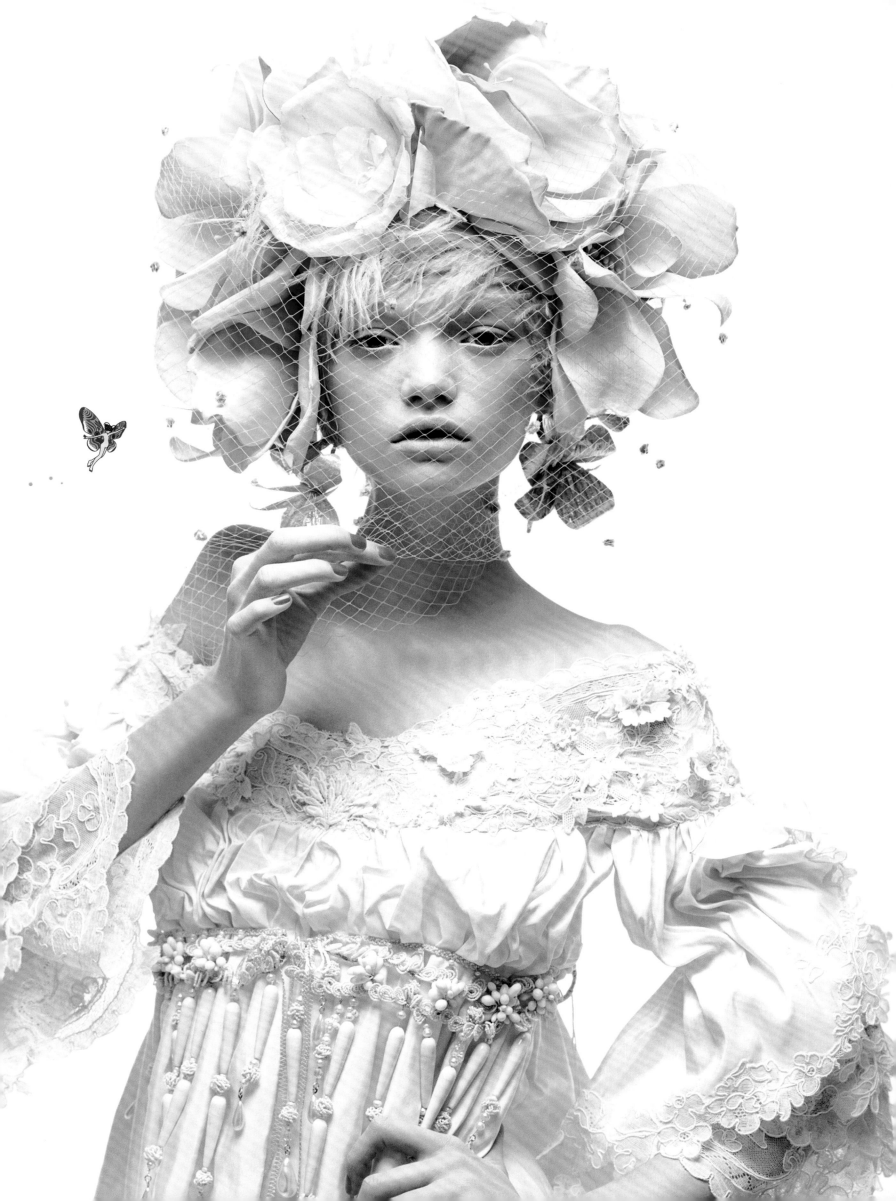

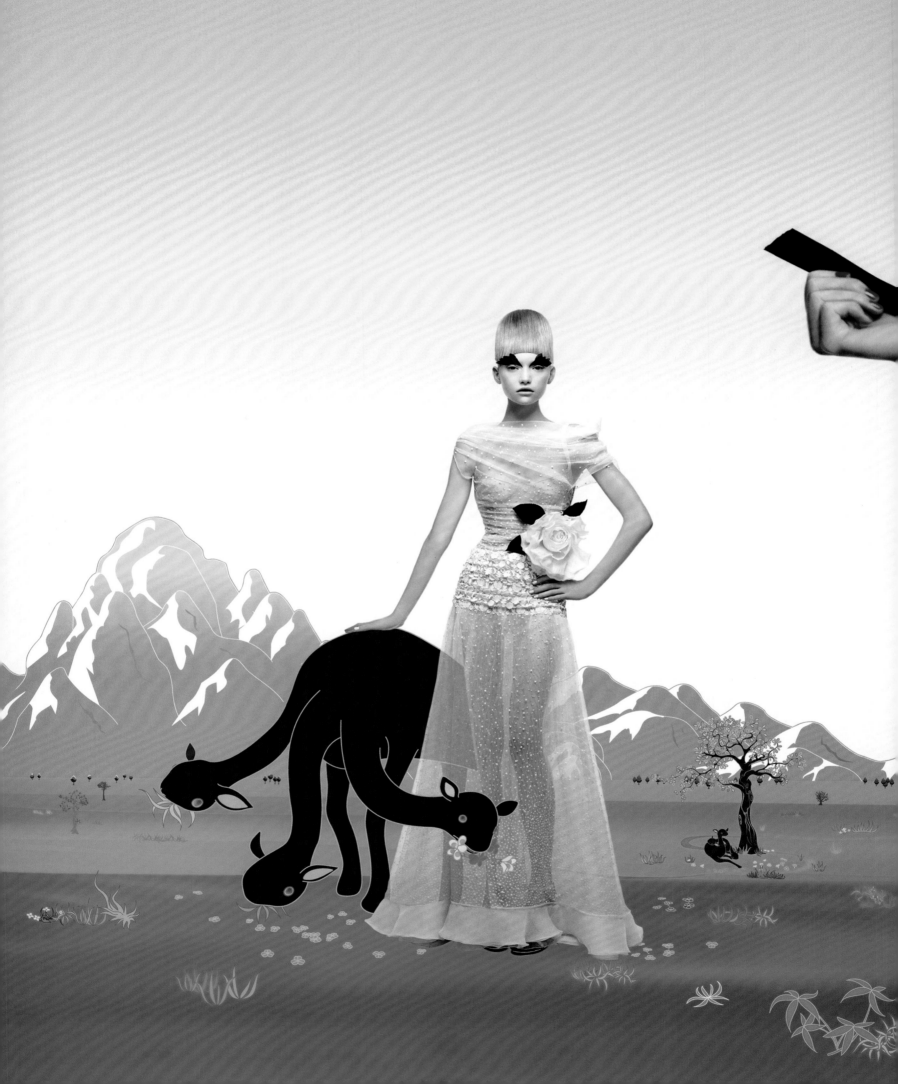

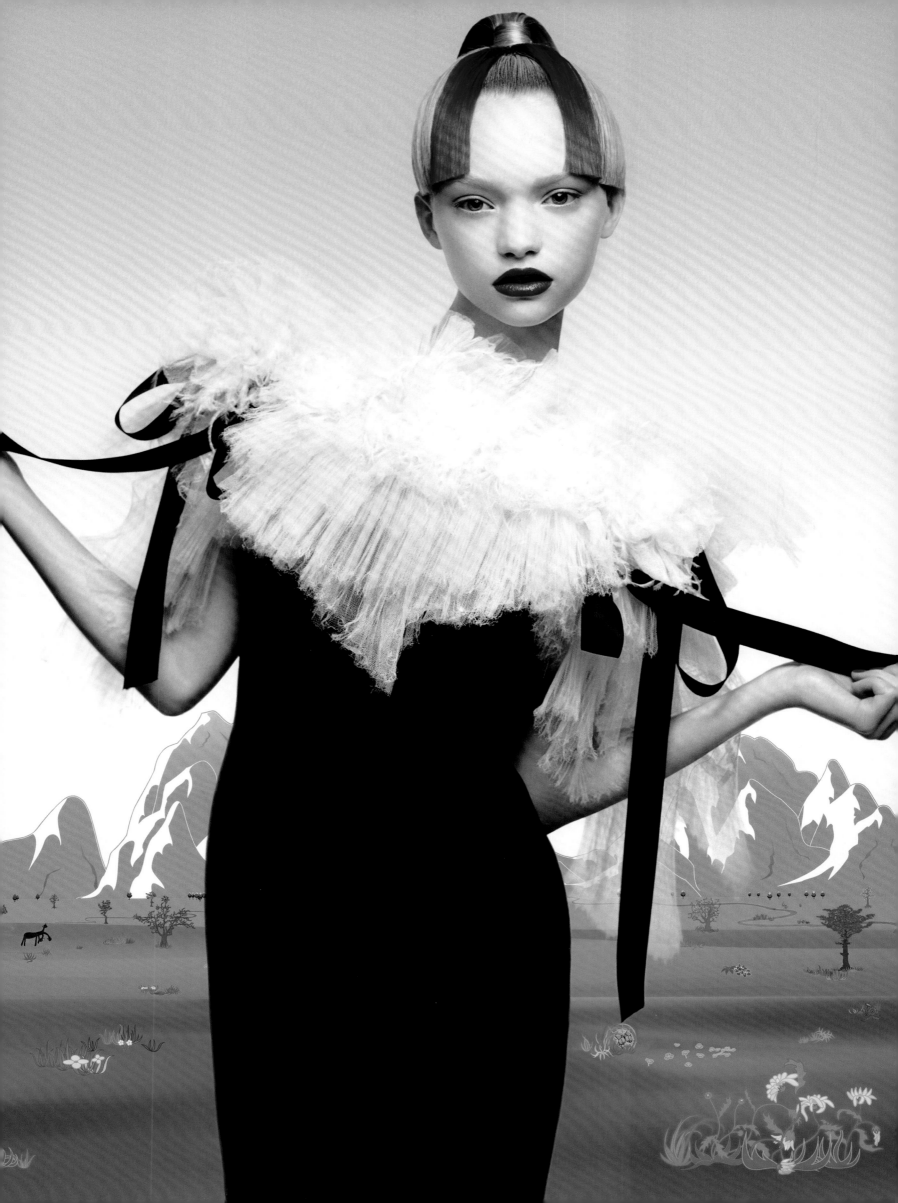

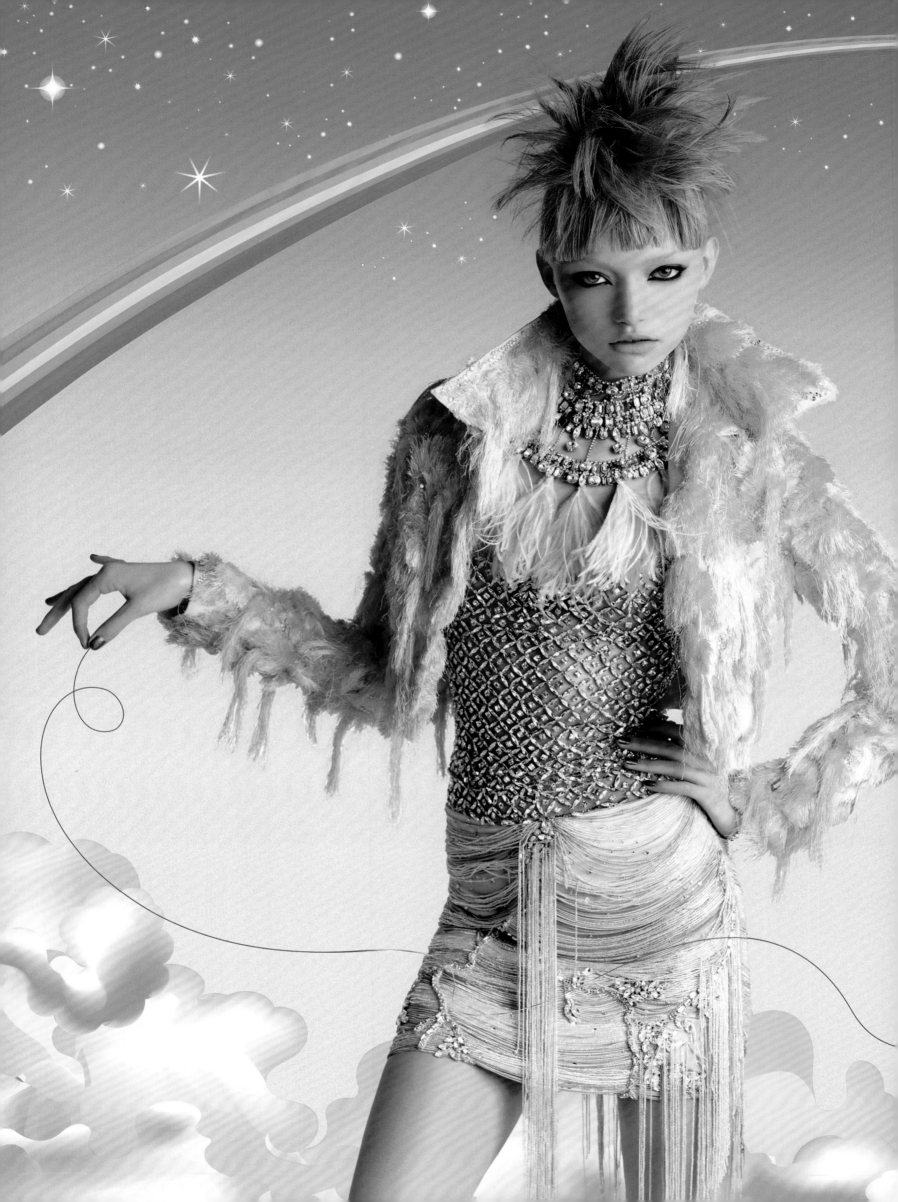

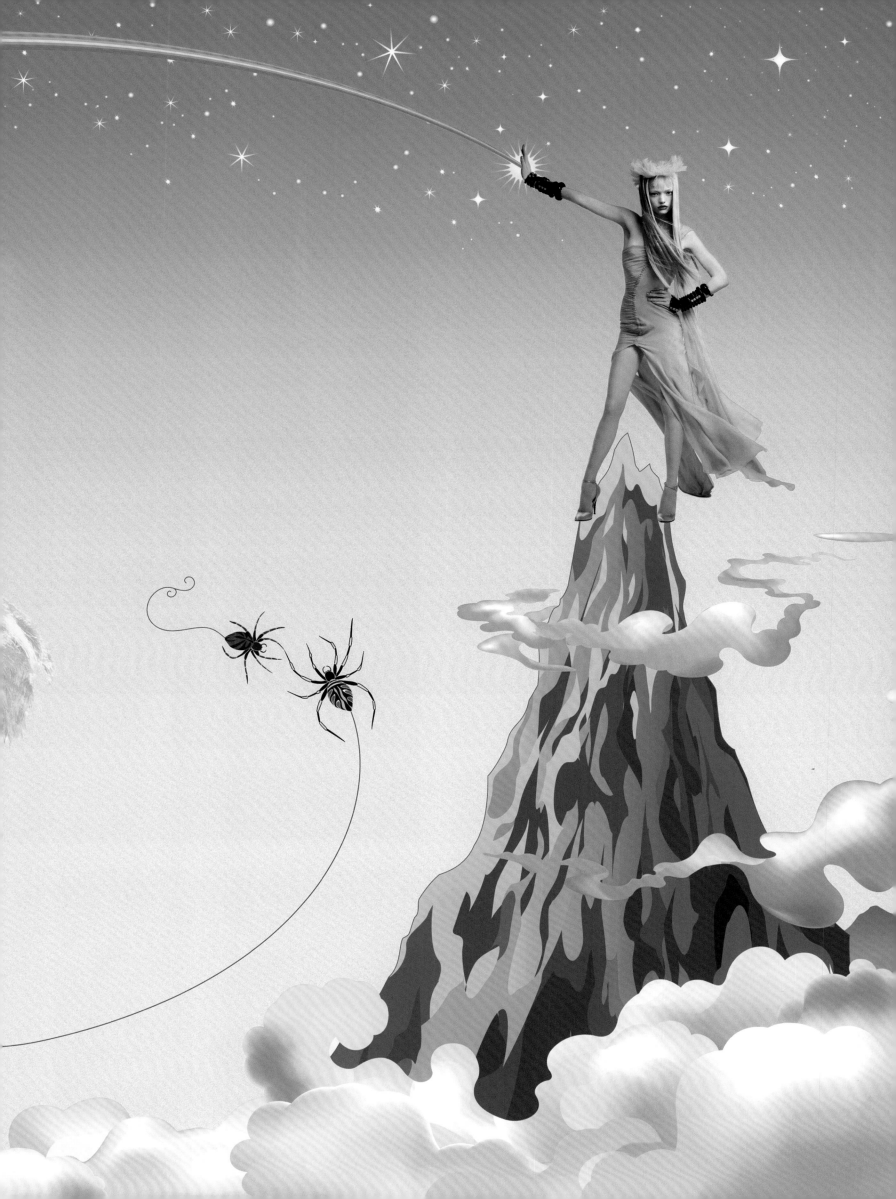

ELLEN TAKES OFFICE

Ellen DeGeneres, here and on the following
spread, photographed for the November issue by
Peter Lindbergh, styled by Andrew Richardson.

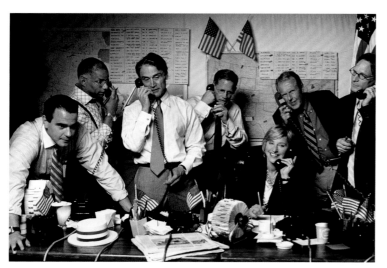

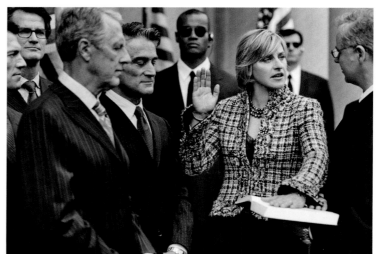

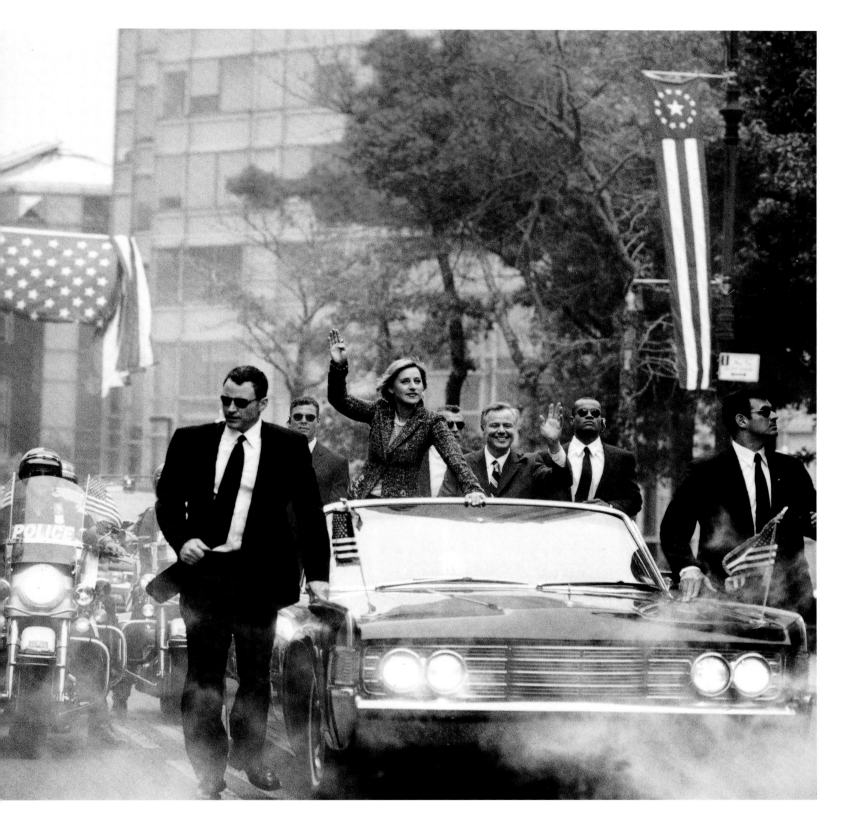

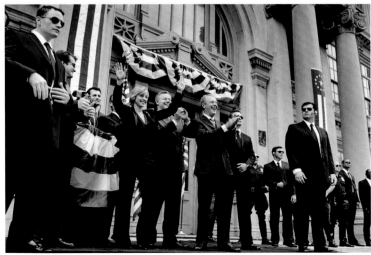

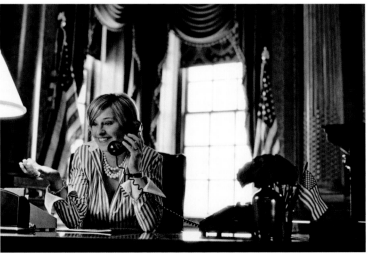

WHY I THINK A WOMAN WOULD MAKE A GOOD PRESIDENT

BY ELLEN DEGENERES

Excerpted from the November issue

IF AMERICA IS A METAPHORICAL "bratty teenager" of a country, then what it needs to get along with the rest of the world is a firm but loving hand to help it mature and grow into its full potential. What America lacks is the guidance and leadership that can be given only by a wise and nurturing woman. And why not? Women have always had to work faster, study longer, and try harder to make it in this man's world. We've had to learn to succeed without threatening, to persuade without demanding, to lead by standing behind. We are natural politicians. The minimum age requirement to run for president is 35. This is the age when a woman is at her intellectual peak, not primed for a midlife crisis. Yet suggesting that a woman could be commander in chief seems, to most people, unrealistic, even funny. Maybe it is.

1 Taxpayers would save a bundle because they wouldn't have to pay a woman president as much—about 27 percent less, in fact [the current gender wage gap in America]. And since women's brains are better than men's at multitasking, she probably wouldn't even need a vice president, just a cell phone and a good personal assistant.

2 Her Cabinet would be cedar-lined.

3 The budget would stay balanced because women actually use those things in your checkbook that record deposits and withdrawals. And they are certainly not afraid to use a coupon.

4 Because women comprise 51 percent of the population, a female president would truly represent the majority.

5 Foreign relations would improve because a woman president would just keep calling back, saying, "We need to talk."

6 It would reinvigorate the pantsuit industry.

7 If she switched her position on an issue, no one could criticize her. Everyone knows it's a woman's prerogative to change her mind.

8 Camp David would be renamed the Camp Denise Spa and Yoga Retreat. I guess that would be if *I* were president.

9 It sure would break up the monotony of Mount Rushmore.

10 Be honest. Wouldn't you love to see a Secret Service agent holding the presidential purse?

11 A female president would probably introduce more soft, muted tones into the White House. Perhaps after some redecorating, it would be called the Eggshell House.

12 Who's better suited to clean up the environment?

13 The antidrug slogan would be "You Kids, Get Off the Grass!"

14 We'd have a president who respects the rights of every individual, since her own rights are still relatively new to her.

15 Her road map to peace could actually work because she wouldn't be afraid to ask for directions.

16 She'd know better than to have a contract with America. [Before the 1994 congressional elections, a group of Republican representatives and candidates for the House released a contract that detailed the actions they would take if their party secured the majority.] She'd get herself a prenup.

17 She would figure out a way to feed the hungry *and* make them eat their vegetables.

18 "Hail to the Chief" would be played an octave higher, or it would be replaced entirely by Destiny's Child's "Bootylicious." Do you think you're ready for that jelly?

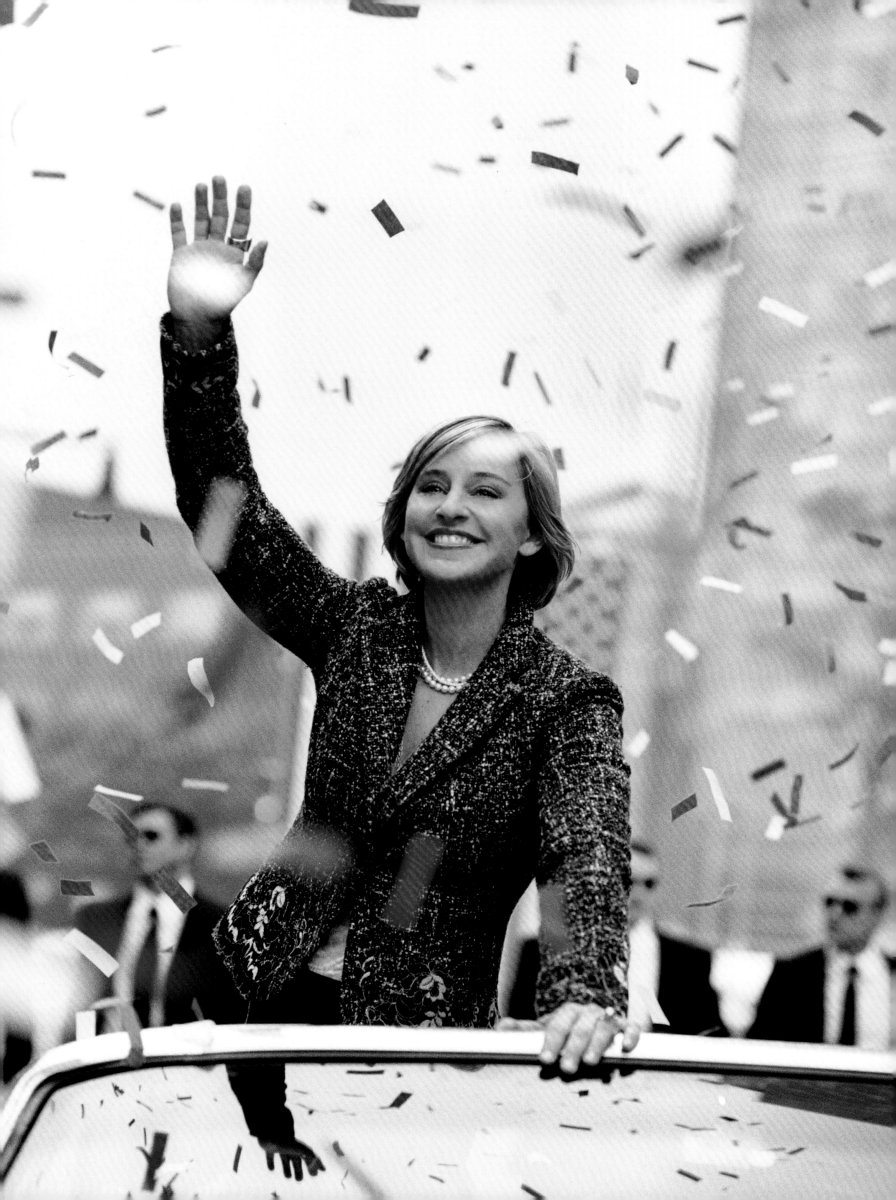

NICE VS. ICE

Which gets you further: acting friendly or frosty?

BY CANDACE BUSHNELL

Excerpted from the September issue

EVER SINCE SMART WOMEN decided to trade in their glasses for contact lenses and began highlighting their mousy brown hair, the world has been gunning for the powerful dame (even if, deep down, she's secretly a softy). Remember Sigourney Weaver in *Working Girl*? Nasty. (Although she did try to appear "nice" by wearing a white hairbow.) Or the ultimate—Glenn Close in *Fatal Attraction*? She, too, tried the white trick in order to appear "nice," but underneath those flowy dresses, she was murderously insane. In the real world, women in positions of authority still tend to make us suspicious. How did they get there? And why them and not us? The real answer—"they rose at 5:00 A.M. every day and worked their darn butts off!"—is not particularly glamorous or appealing, so most people assume an easy answer: They must have terrified their way to the top. But should a girl work it—or underplay her power and position by being sweet and understated?

Appearances can be deceiving—and useful. As Karl Lagerfeld once said, "Apparently, I am very scary. But if you get to know me, you see that I am very nice. Happily, I don't look like I am." Indeed, some of the nicer women in business have figured out that an "ice" look guarantees that other people don't walk all over them, especially high-powered men. Take my friend Monique, a big-deal movie producer. In her personal life, she's always mothering her friends, cooking dinners for them, and lending them money and advice. But in business, she's a different story. She wears only black Armani, and she pulls her blonde hair into a bun so severe that her hairdresser told her that if she didn't stop, her hair was going to start falling out. On the other hand, when Monique walks into a room, you know she's in charge—and it doesn't hurt that she's six feet tall. "I could dress nice," she says, "but the problem is, no one would believe it. Who wants to see a six-foot-tall woman in ruffles? They want ice, and I give it to them."

At the opposite end of the spectrum is Cindi, the president of a major talent agency. If you didn't know who Cindi was, you'd never think she held such a high position of power, a fact she uses to her advantage. She's a tiny, adorable little thing who looks like a child and dresses in flowery fabrics and Peter Pan collars. No one ever suspects that such an innocent-looking creature could possibly be a secret killer, and by the time they figure it out, it's too late.

The point is that both nice and ice are valid options, as long as you don't take it to extremes, in which case the result is either a) everyone hates you, or b) you become a joke. It's one thing to look pleasantly approachable, like Princess Di, but quite another to fashion yourself as a frosted supermarket sheet cake. Remember Barbara Cartland, whose favorite accessory was a fluffy little dog? Or Mary Kay Ash, of Mary Kay cosmetics? Instead of her coming off as sweet and harmless, people always wondered what kind of freakish behavior she was trying to cover up. And, of course, the ultimate, Tammy Faye Bakker. Too much pink, velvet hairbands, inappropriate bows, and light-blue eyeshadow will always backfire. All of this got me thinking the other day about a very nice cosmetics executive I know who suddenly ended up running the whole company. She decided that in order to succeed, she needed to change herself into ice. She lost 15 pounds and began wearing spike heels and tight black skirts with architectural blouses. She also developed a disdainful sneer. The change was so great that no one could accept it, and her formerly adoring colleagues took out the long knives; she was fired within a year. She has now gone back to wearing flower-print dresses.

Conducting your life as the walking embodiment of winsome or wicked is a fascinating strategy. However, studies have shown that the psychologically healthiest and most successful people are able to pull off the what-you-see-is-what-you-get look. Trouble arises when people think they're getting Laura Ingalls and end up with Leona Helmsley.

All names have been changed

BEDAZZLED

Polina Kouklina, here and on the previous spread, photographed for the September issue by Sølve Sundsbø.

2005

THE FRILL OF IT

Renée Zellweger in Balenciaga by Nicolas Ghesquière, photographed for the
June issue by Alexi Lubomirski, styled by Katie Mossman.

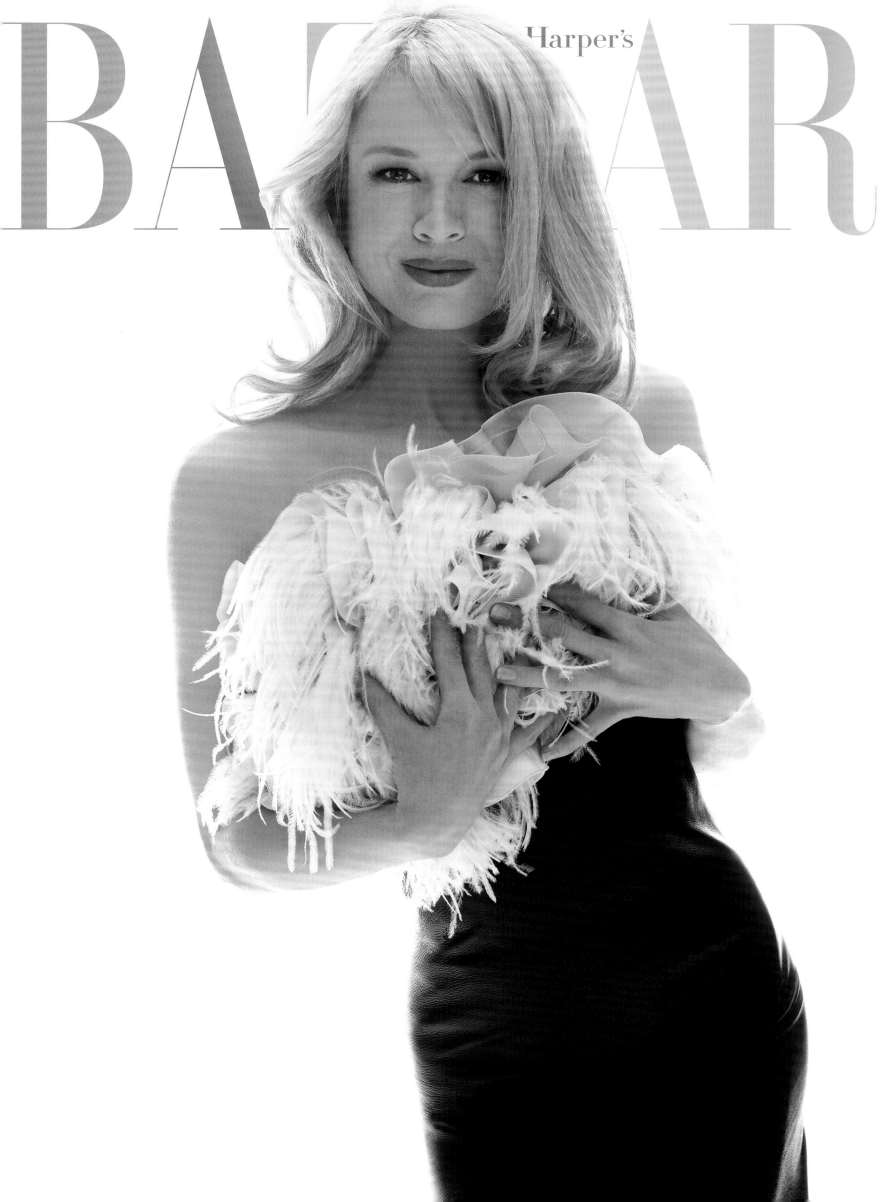

A TRANSFORMATIVE TOUCH

THINK BIG. That could have been the mantra for 2005, when fashion designers became all about volume and relaxed shapes. Silhouettes bloomed into trapezes and bubbles but were made feminine and sexy with pleating, draping, and, of course, skyscraper-high heels and even higher chunky platform wedges.

For Stefano Pilati, who was profiled in the January issue, after he had debuted his first collection at Yves Saint Laurent, that meant referencing Saint Laurent's archives from the late '70s. "Nothing ostentatious," he said, "just pure, simple lines."

In the March issue, Domenico Dolce and Stefano Gabbana masqueraded as Gotham's caped crusaders to battle Naomi Campbell's Catwoman—pure, simple genius. This was also the issue in which Donatella Versace celebrated her shared initials with Diana Vreeland by composing her own "Why Don't You … ?" list.

The coolly bohemian look that was on the rise seemed to inspire a spirit of bonhomie. That idea was fleshed out by Peter Lindbergh in the March issue's epic story "Give Peace a Chance." His extensive cast of groovy hippie insurgents, including Angela Lindvall, Famke Janssen, Liberty Ross, and rocker Scott Weiland, embodied the pacifist leitmotif of the day by harking back to the '60s. In light of 2005's ongoing wars in Afghanistan and Iraq, the plea was as heartfelt as it was when John Lennon wrote it.

The spirit of that era was also defined by a sexual revolution. The iconic images of barely there swimsuits shot by Ralph Gibson in May's "The Season's Sexiest Swimwear" certainly invited a level of rebellion against societal mores.

But the most important trend of the year was in fact weightlessness. And no designer more eloquently defined it than Alber Elbaz, with his airy jewel-toned frocks and flaring silk trench coats. They were the clothes that every chic woman simply ached to wear. Appropriately, Elbaz appeared to walk on water in the September story "An Artist of the Floating World." Alas, even a fashion god has to deal with sartorial realities. Elbaz rushed from our shoot to receive his CFDA best-international-designer award wearing the same soggy shoes from that day. In the interview accompanying our story, the very sage Elbaz said: "When I got the job at Lanvin, it dawned on me that the one thing I had to do there was go back to basics. Does the world need another 600 handbags? I don't think so. The challenge now is to make everything about *design* rather than styling."

The October issue offered a glimpse of another designer in fashion's new pantheon, one whose thoughtful work also goes beyond mere styling: Balenciaga's Nicolas Ghesquière. Lindbergh created a '50s version of Tomorrowland for Hong Kong actress Maggie Cheung, who perfectly suited the narrow space-age silhouette that became a Ghesquière touchstone.

Considering that 2005 marked the middle of Bailey's first decade at *Bazaar*'s helm, perhaps it was only fitting to glance both forward and backward in time.

BEST FOOT FORWARD
Designer Stefano Pilati and model Marina Perez in
Yves Saint Laurent, photographed for the January issue
by Anthony Ward, styled by Melanie Ward.

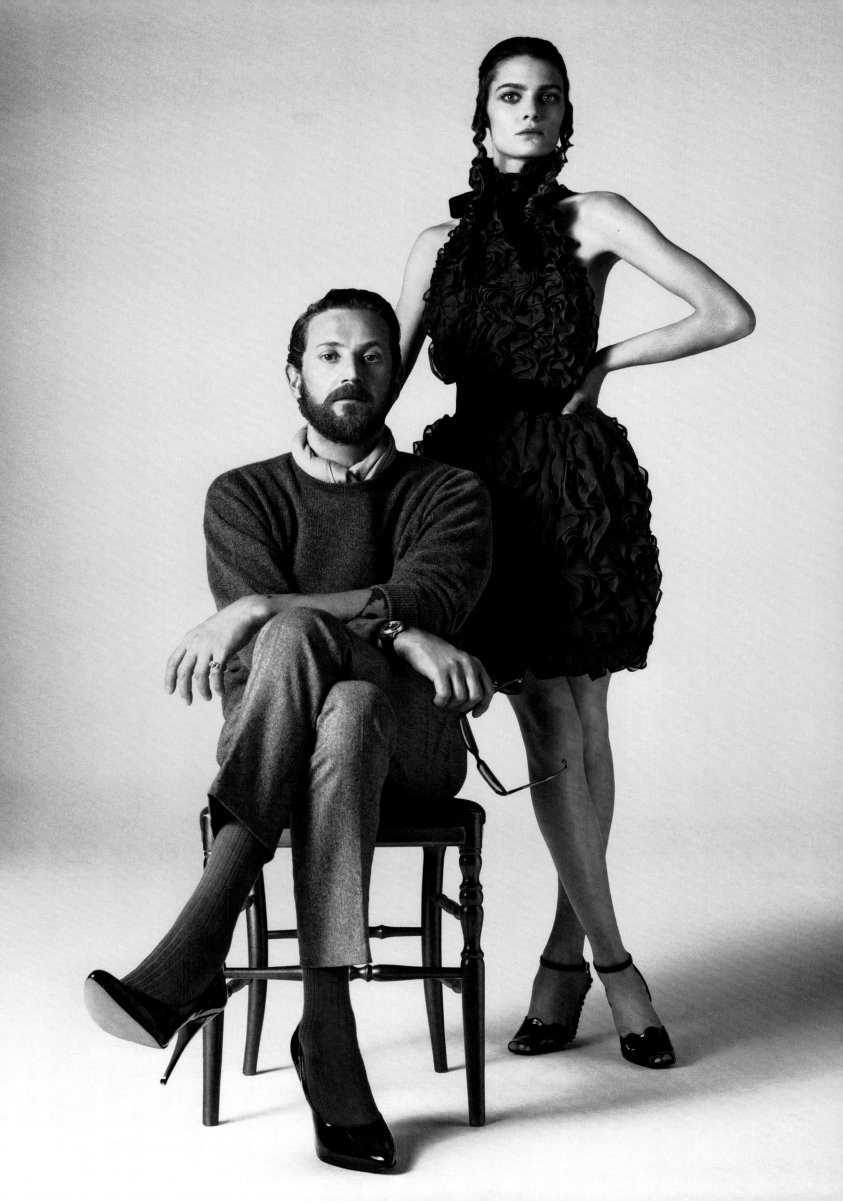

IMPERIAL GRACES

Carmen Kass in a Michael Kors coat, photographed for the September issue by Sølve Sundsbø, styled by Anastasia Barbieri.

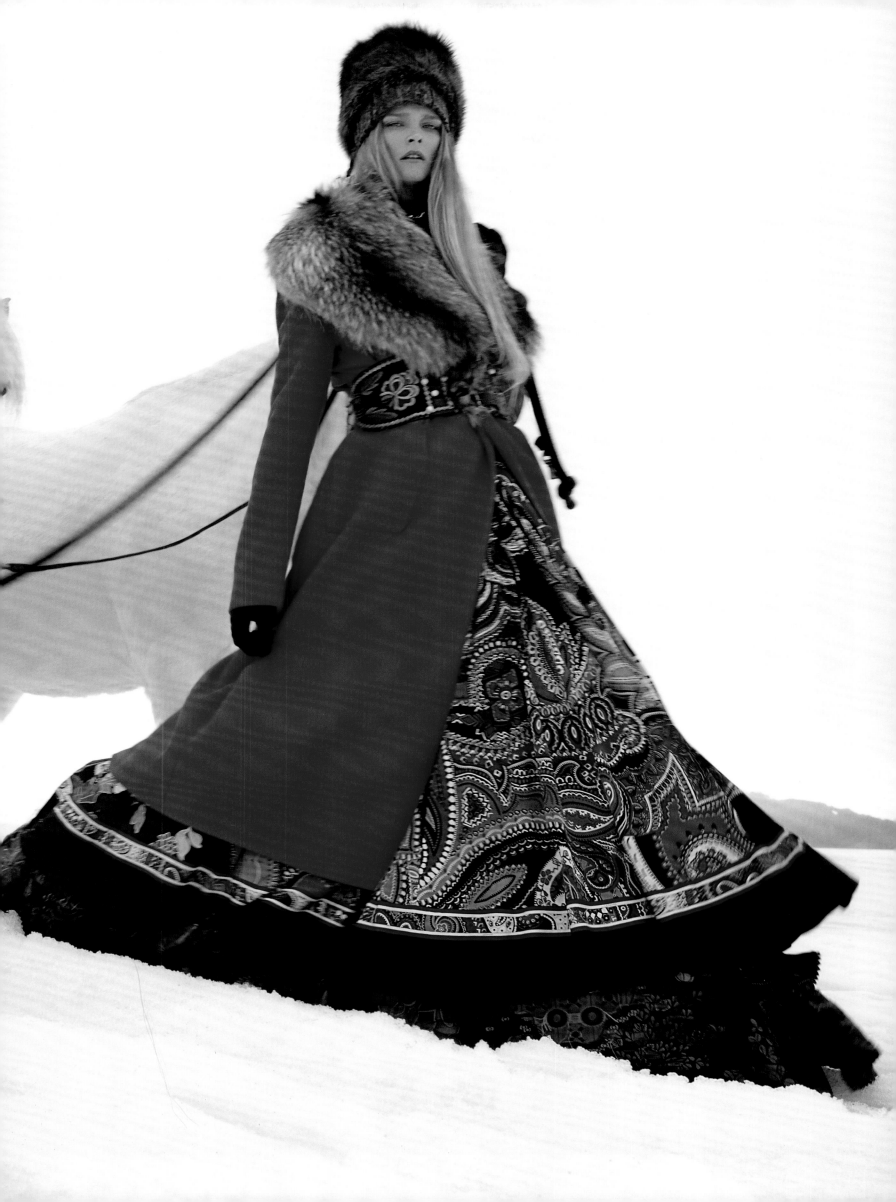

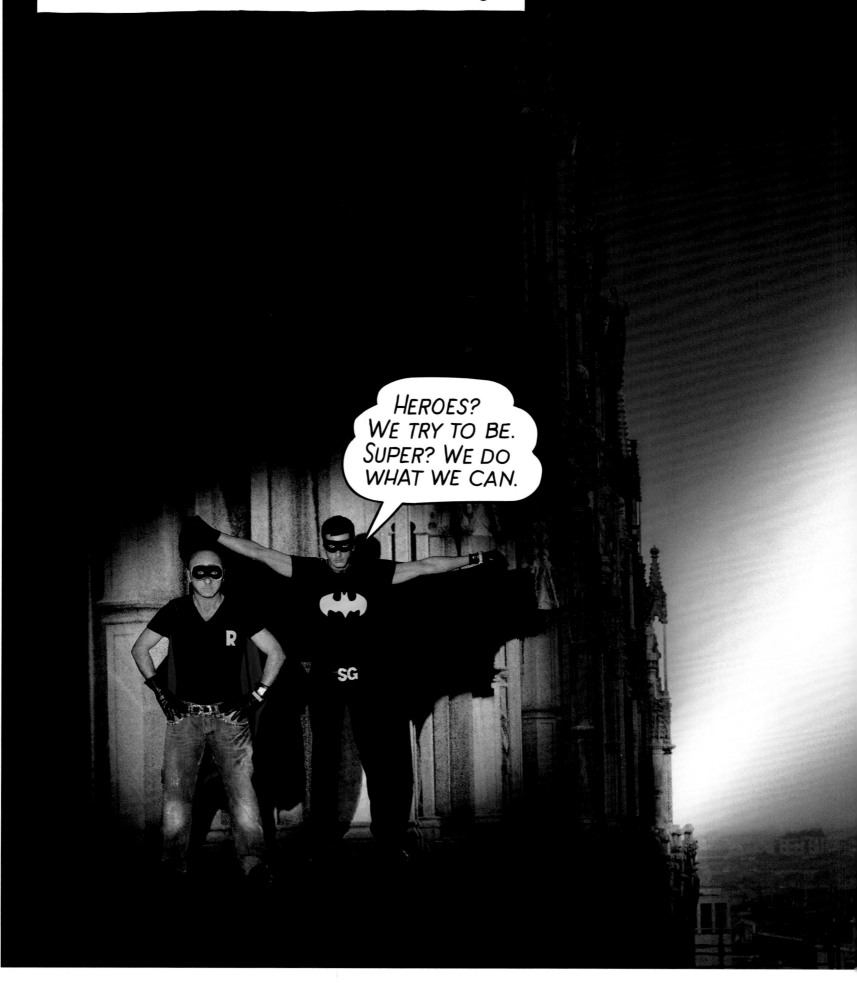

APPROVED
BY THE
COUTURE
CODE
AUTHORITY

FASHION SUPERHEROES®

STARRING

STEFANO GABBANA
AS BATMAN

DOMENICO DOLCE
AS ROBIN

BIANCA BALTI
AS THE DAMSEL IN DISTRESS

AND

NAOMI CAMPBELL
AS CATWOMAN

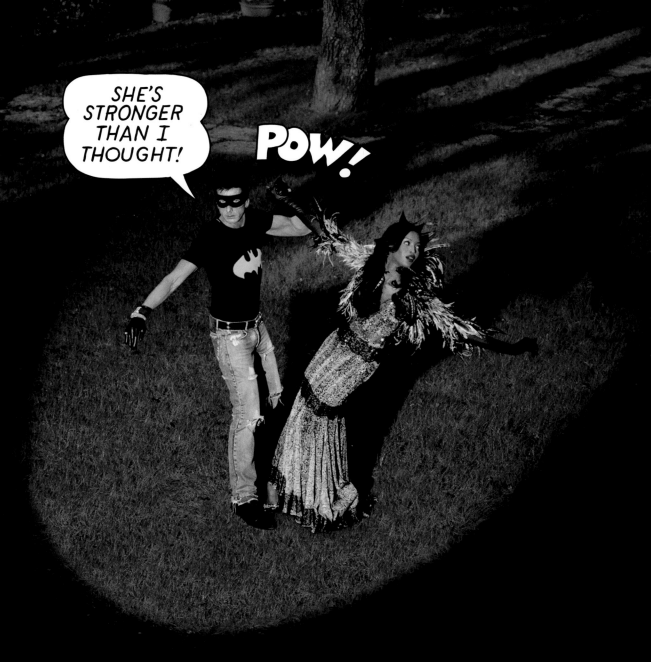

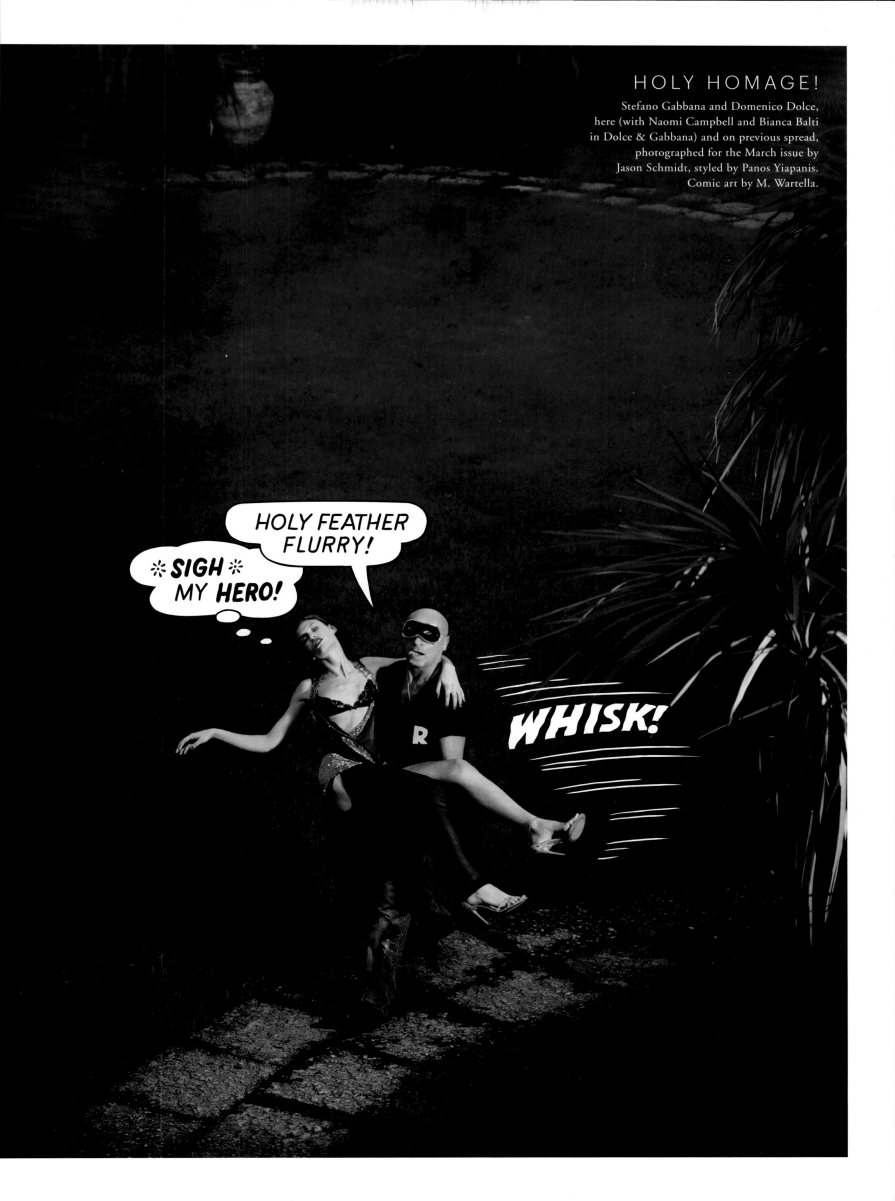

HOLY HOMAGE!
Stefano Gabbana and Domenico Dolce,
here (with Naomi Campbell and Bianca Balti
in Dolce & Gabbana) and on previous spread,
photographed for the March issue by
Jason Schmidt, styled by Panos Yiapanis.
Comic art by M. Wartella.

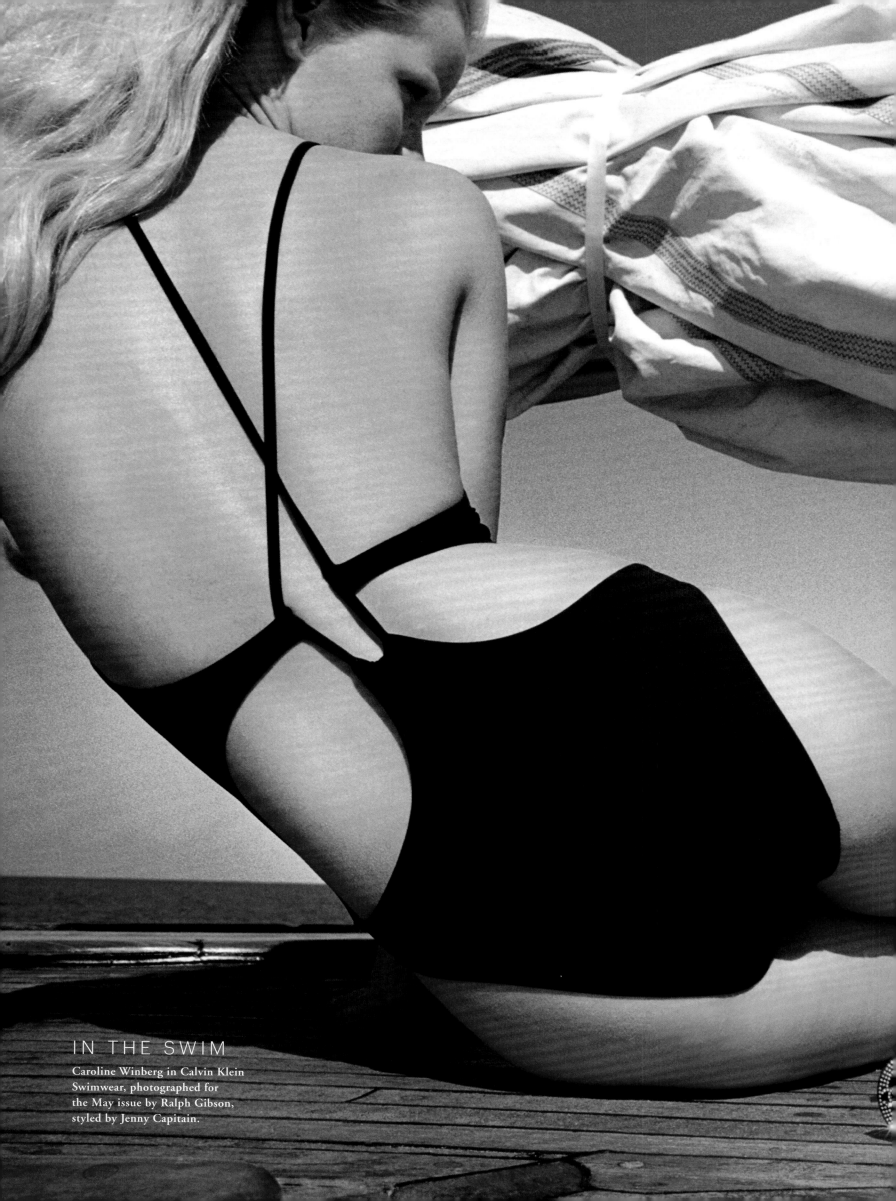

IN THE SWIM

Caroline Winberg in Calvin Klein
Swimwear, photographed for
the May issue by Ralph Gibson,
styled by Jenny Capitain.

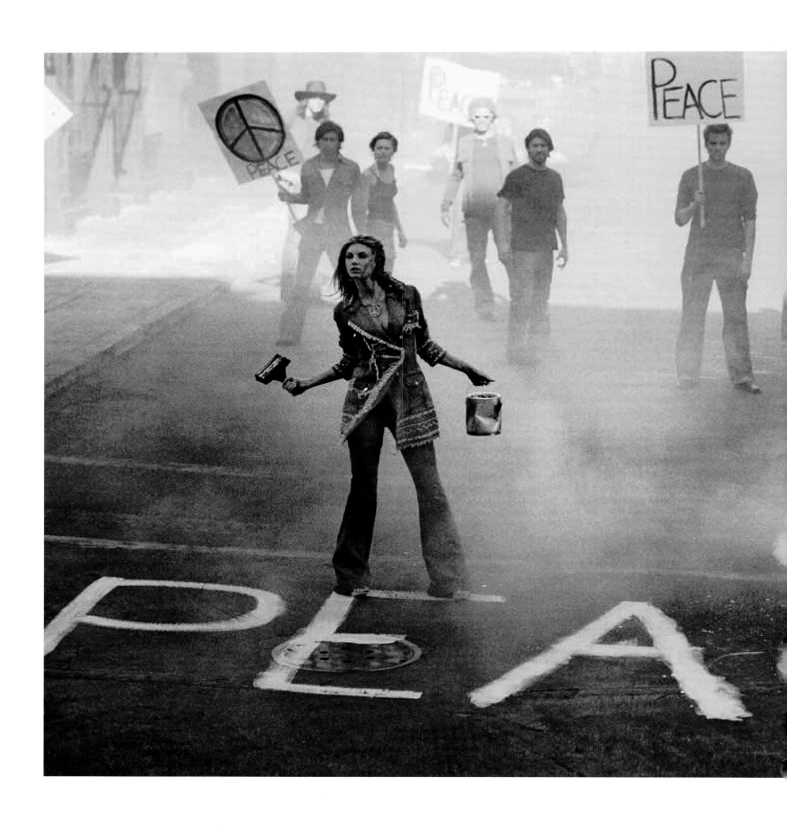

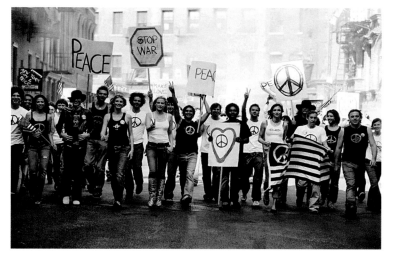

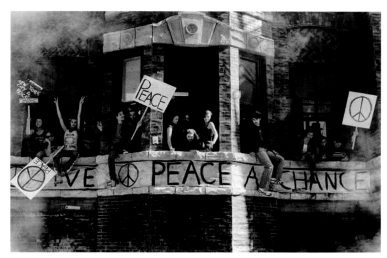

STYLE RALLY

Angela Lindvall in John Galliano (left),
photographed for the March issue by Peter
Lindbergh, styled by Nicoletta Santoro.

WALKING ON WATER

Alber Elbaz, photographed for the September issue by Ben Watts, styled by Jacqui Getty.

Even a fashion god has to get his feet wet sometimes. Elbaz gamely waded out into New York's Central Park Lake for *Bazaar*'s photo session. But drying off after the shoot proved a little more difficult. He rushed from the park to receive his 2005 CFDA Award for best international designer—soggy shoes and all.

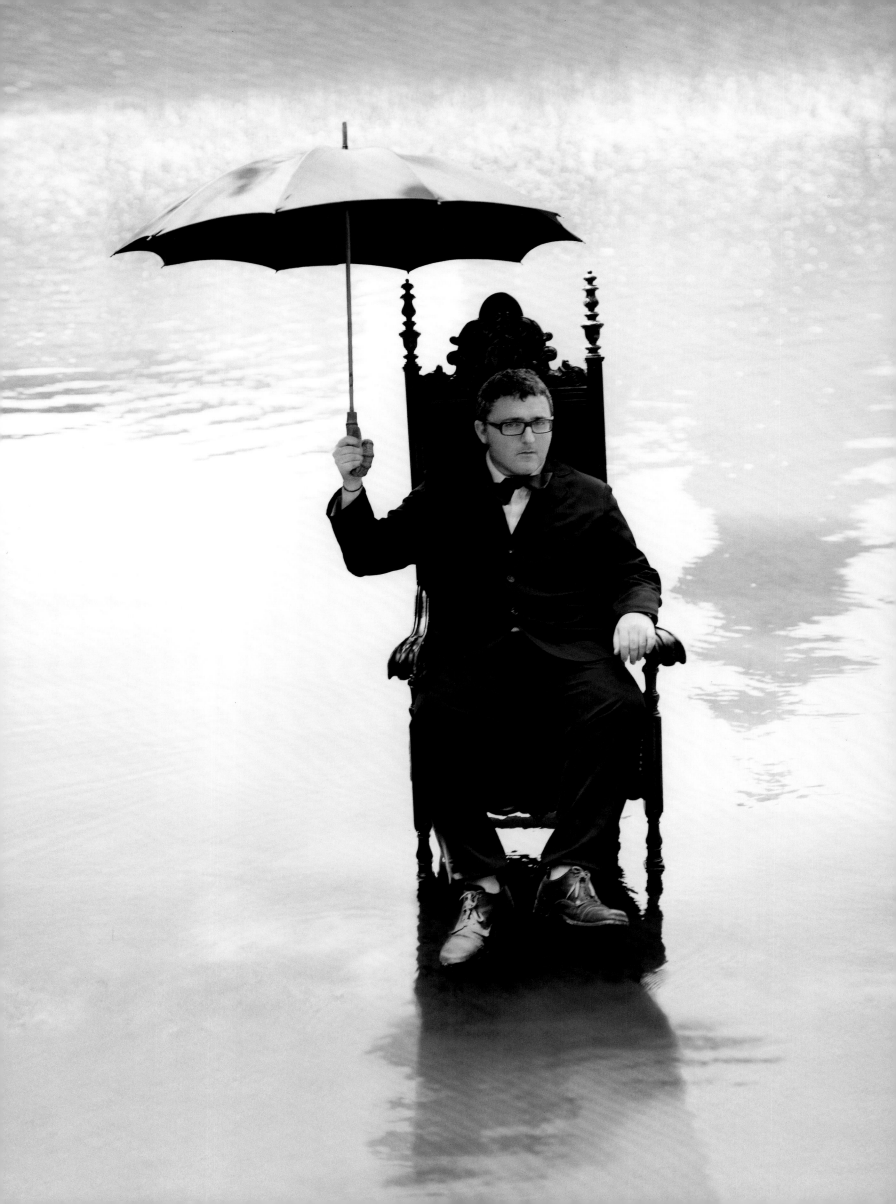

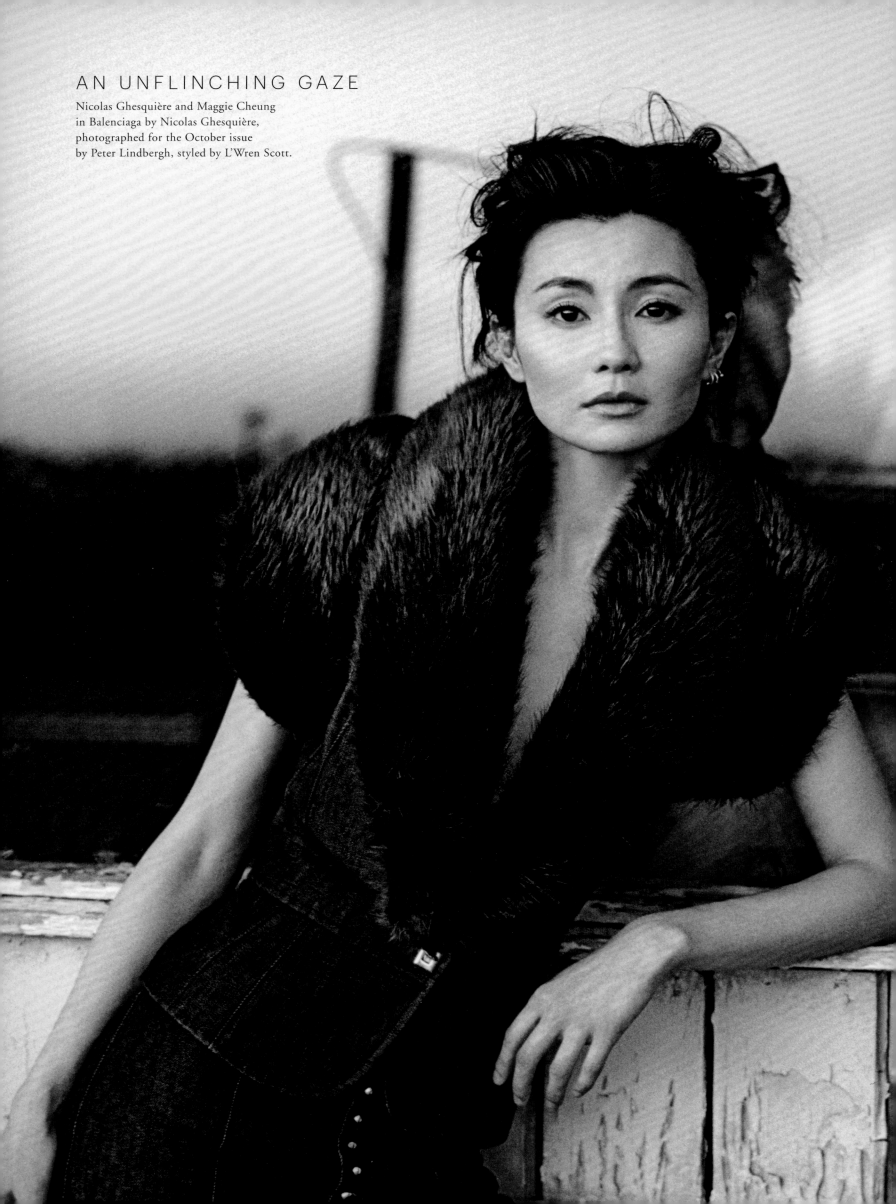

AN UNFLINCHING GAZE

Nicolas Ghesquière and Maggie Cheung
in Balenciaga by Nicolas Ghesquière,
photographed for the October issue
by Peter Lindbergh, styled by L'Wren Scott.

2006

GREEN WITH ENVY

Julianne Moore in Gucci, photographed for the January issue by Peter Lindbergh, styled by Jenny Capitain.
Winner of an ASME Best Celebrity Cover award.

Harper's

BAZAAR

JULIANNE
MOORE

635
NEW
LOOKS
FOR EVERY AGE

BEAUTY
SECRETS
FAST, EASY IDEAS

SEASON'S
MUST-HAVES

Fashion
Best of What's New

ASTONISH ME!

THIS CREDO OF LEGENDARY *Bazaar* art director Alexey Brodovitch remains a mantra today. Bailey rose to the challenge by welcoming 2006 with a striking cover of Julianne Moore that flouted conventional cover wisdom with the actress's smile partially obscured by her hair and her dressed in the color green—a hue thought to be newsstand poison. The final creative flourish was the dégradé coloration of the cover line, conceived by Gan. But the gamble paid off with a coveted award.

Calculated risk is Madonna's forte. The March cover's balletic triptych, shot by Sølve Sundsbø, displayed the pop icon's athleticism and artistry. Inside, the then-47-year-old star shared the wisdom she would impart to her 19-year-old self: "Don't do it if you don't really mean it."

Patti Smith embodied that sentiment in her reflection on "The Return of the Tie." She is famous for wearing a skinny black version in the Robert Mapplethorpe photo on her album *Horses,* but she revealed that her affair with the androgynous accessory began in childhood.

In July, Mario Sorrenti lensed "The News from Paris," a preview of the darkly romantic drama on tap for fall. And the witty Rita Wilson wondered what her closet would be like with an injection of French style.

To astonish, you may need a jolt. The August cover featured a nude, pregnant Britney Spears. The piece was slated for later, but when Spears gave a controversial prime-time television interview, then showed up to her *Bazaar* shoot with newly dyed brown hair, Bailey broke the story early. The response? Hundreds of millions of media impressions.

The issue also featured two rising stars: model Doutzen Kroes and photographer Daniel Jackson. Along with ace stylist Katie Grand, they made a triumphant triumvirate. The next month saw yet another notable debut: photographer Camilla Akrans, who brought a graphic crispness to the pages. In September, influential lensman Peter Lindbergh shot Mariacarla Boscono in a setting of industrial toughness that played against the season's abundant curves.

Bazaar also loves to show a new side of the story. For September's profile of Martha Stewart, she is provocatively posed with a man's hand reaching into her YSL smoking. In the text, penned by Susan Orlean, Stewart called her legal troubles "the interruption."

Her statement had the flip, headstrong air of Holly Golightly. On the November cover, *Bazaar* paid homage to Audrey Hepburn, featuring the original Givenchy LBD from *Breakfast at Tiffany's.* Natalie Portman wore it to publicize the auctioning of the dress for charity. *Bazaar* further contributed by selling a limited-edition Kenneth Jay Lane reproduction of Holly's pearl necklace. More than $900,000 was raised for the City of Joy Aid charity. It was the perfect way to usher in the holidays. As was Lindbergh's December story "The Future of Fashion," in which Liya Kebede made spirits bright on the moon. Astonishing, indeed.

GOTHIC REVIVAL

Gemma Ward in Dior by John Galliano (opposite), Balenciaga by Nicolas Ghesquière (next spread, left), and Yves Saint Laurent (right), photographed for the July issue by Mario Sorrenti, styled by Melanie Ward. Winner of a Lucie Award for Fashion Layout of the Year. *Following spread:* Doutzen Kroes in Yves Saint Laurent and Alexander McQueen (left) and Lily Donaldson in Dior by John Galliano, photographed for the April issue by Sorrenti, styled by Ward.

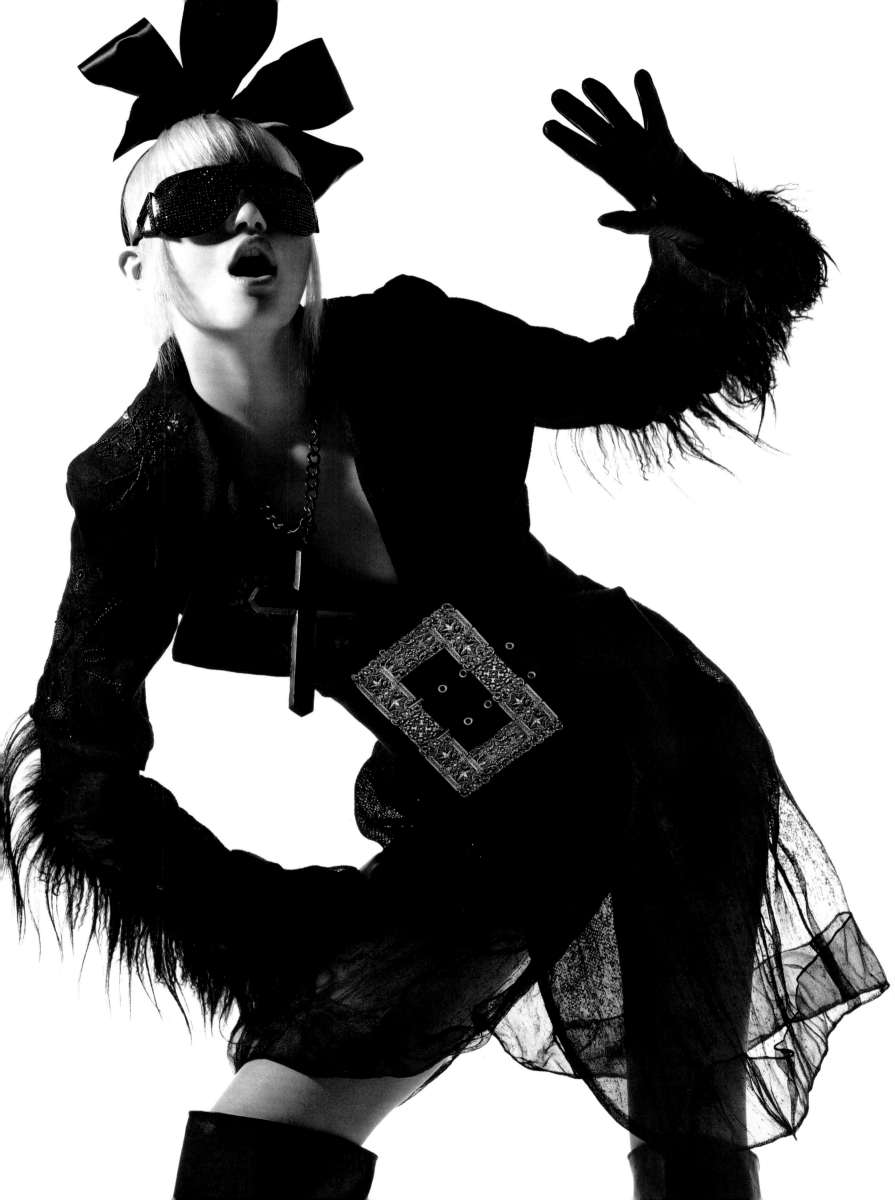

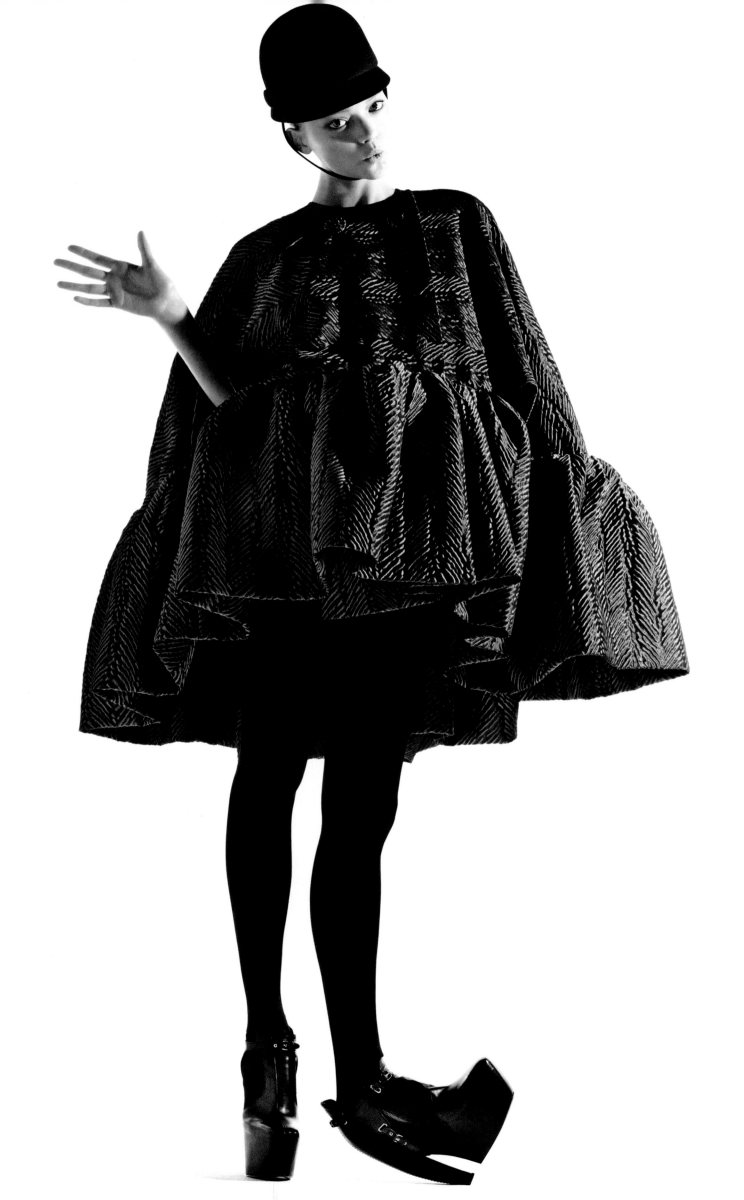

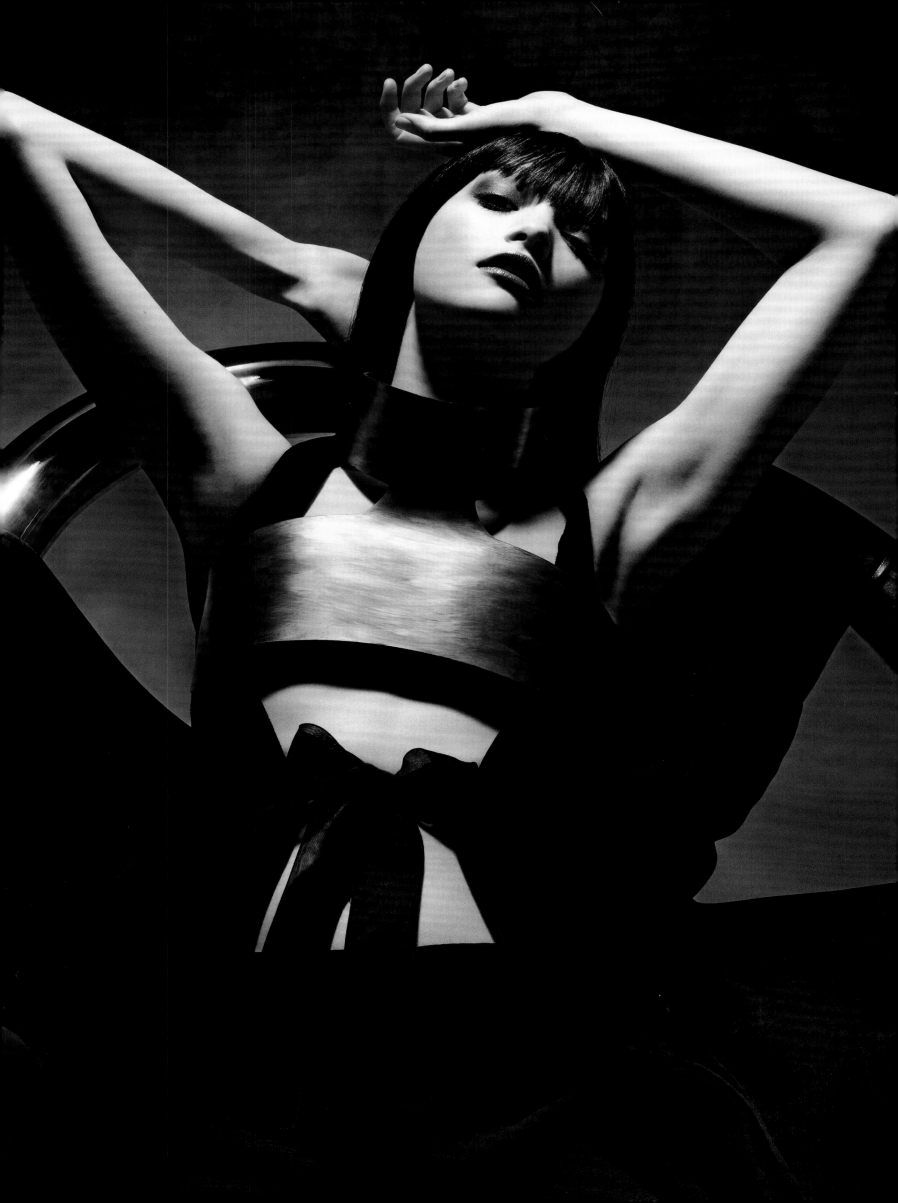

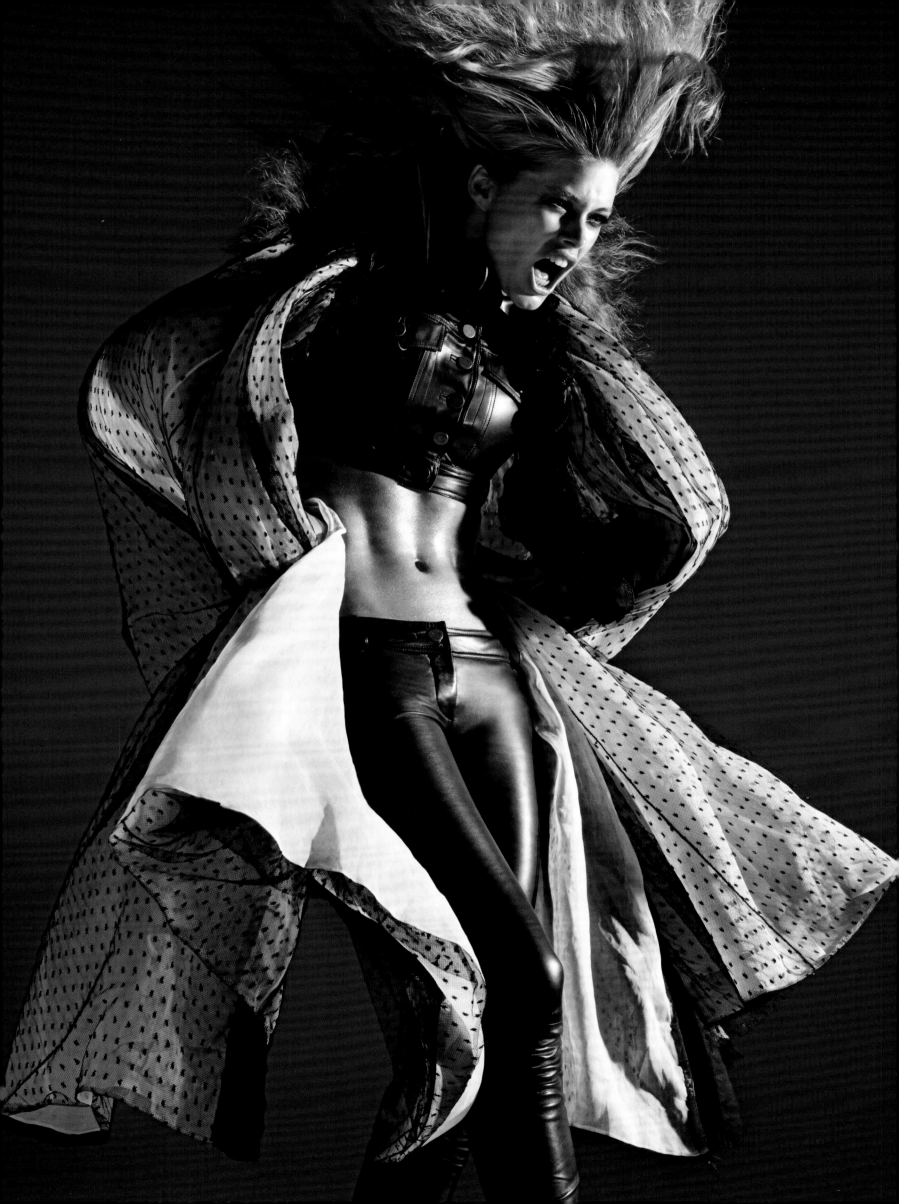

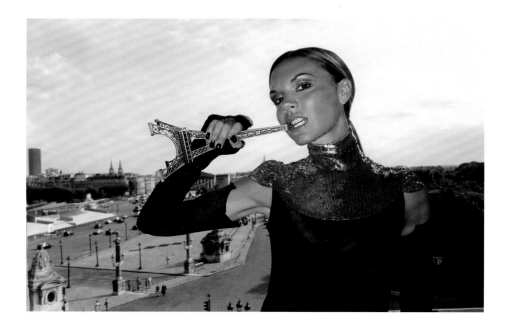

STEALING FRENCH STYLE

Living in Paris while husband Tom Hanks filmed The Da Vinci Code, *Rita Wilson decided to immerse herself in the ways of French style. Her verdict? It's* très difficile *to be* très jolie.

BY RITA WILSON
Excerpted from the May issue

LADYLIKE LUXE

Above: Victoria Beckham in Chanel Haute Couture, photographed for the November issue by Terry Richardson, styled by Andrew Richardson. *Opposite page:* Natalie Portman in Hubert de Givenchy and a Kenneth Jay Lane necklace, photographed for the November issue by Peter Lindbergh, styled by Jenny Capitain.

PARIS. AN ENTIRE SUMMER. I couldn't wait. I would live life as a local. I would go to the markets for fresh cheese, sip cafés au lait in the Marais, Rollerblade around the Rue de Rivoli on Thursday nights. Within a few days I would be unmistakably French. But what would I wear? Would my style translate? Would I ever look as cool as Jane Birkin? Oh, wait—she's English. But she does have an Hermès bag named after her.

What is French style anyway? I thought I was going to see berets, striped tees, sleek capri pants, ballet slippers, and scarves tied more ways than a first date's tongue. Instead, I saw prairie skirts, tank tops, flip-flops, tousled ponytails, and bronze skin. And this was on the *French* women. Where was I—Paris or Malibu? Didn't I just see Cameron Diaz wearing that exact prairie skirt in *Us Weekly,* or was that *Hello!*? Or *OK!*? (I just like typing magazine titles with exclamation points!) I didn't want prairie skirts and Birkenstocks; I wanted pencil skirts and pumps. But where were they? I had to investigate further.

In an attempt to assimilate I spent the first few weeks putting my hair in a French twist—and having it fall down the second I walked away from the mirror. I also practiced keeping my mouth in that perpetual "ooh" position in case I needed to exclaim *"Ooh là là!"* over perfect croissants. (The "ooh" mouth also works for looking bored. It's an all-around useful mouth position.)

As I discovered, French women can look so chic wearing the least amount of stuff. Even when they're dressed, they look stripped. So I removed my bracelets, necklaces, dangling earrings, studded belt, and oversize purse. But I didn't feel chic; I felt naked—which is what most French women are in Saint-Tropez, and which I will never be in public.

I asked [my friend Tom Ford] what he thought French style was. "It's not about what the French woman is wearing," he said, gazing deeply into my eyes (oh, all right, that's a lie, but a woman can dream). "It's in how she stands or tosses her hair or ties her scarf. You can see the years of women wearing Louis heels in her attitude. The 19th century is carried within her. French women strike poses. It's more about the pose than the clothes." Note to self: Practice posing. (What happened next I would like to forget. I was in high heels, a velvet beret, my new spangly blouse, with a belt tied around my neck, standing in front of the mirror ... posing. I was also not wearing pants. What happens in Paris stays in Paris.)

But then, there she was, shopping for flowers. She had a perfectly lithe body, a pout worthy of Bardot, and she was wearing—*mais oui*—a pencil skirt and pumps. On cobblestones. She may have been from Beirut for all I know, but at that moment she was the epitome of French chic. And I, with my prairie skirt and ponytail, was at the end of the day a hopeless American.

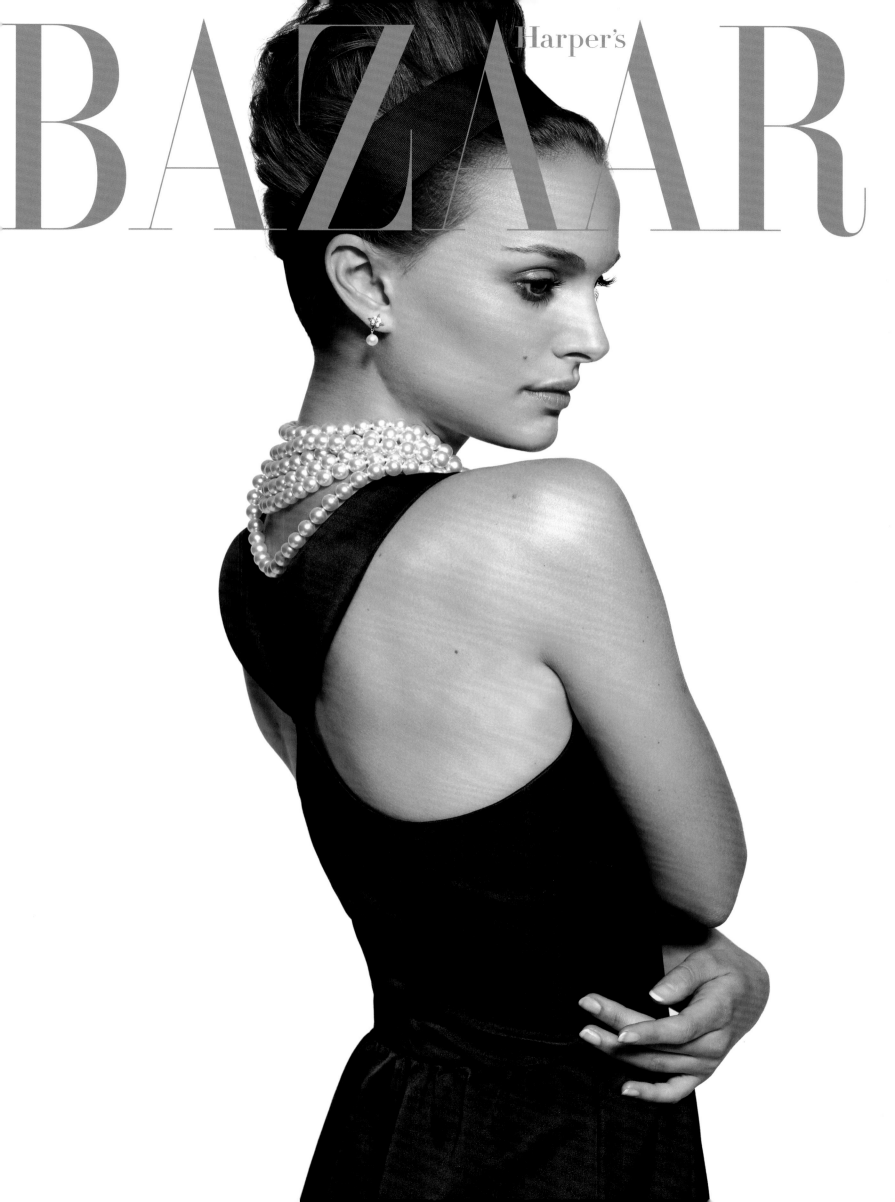

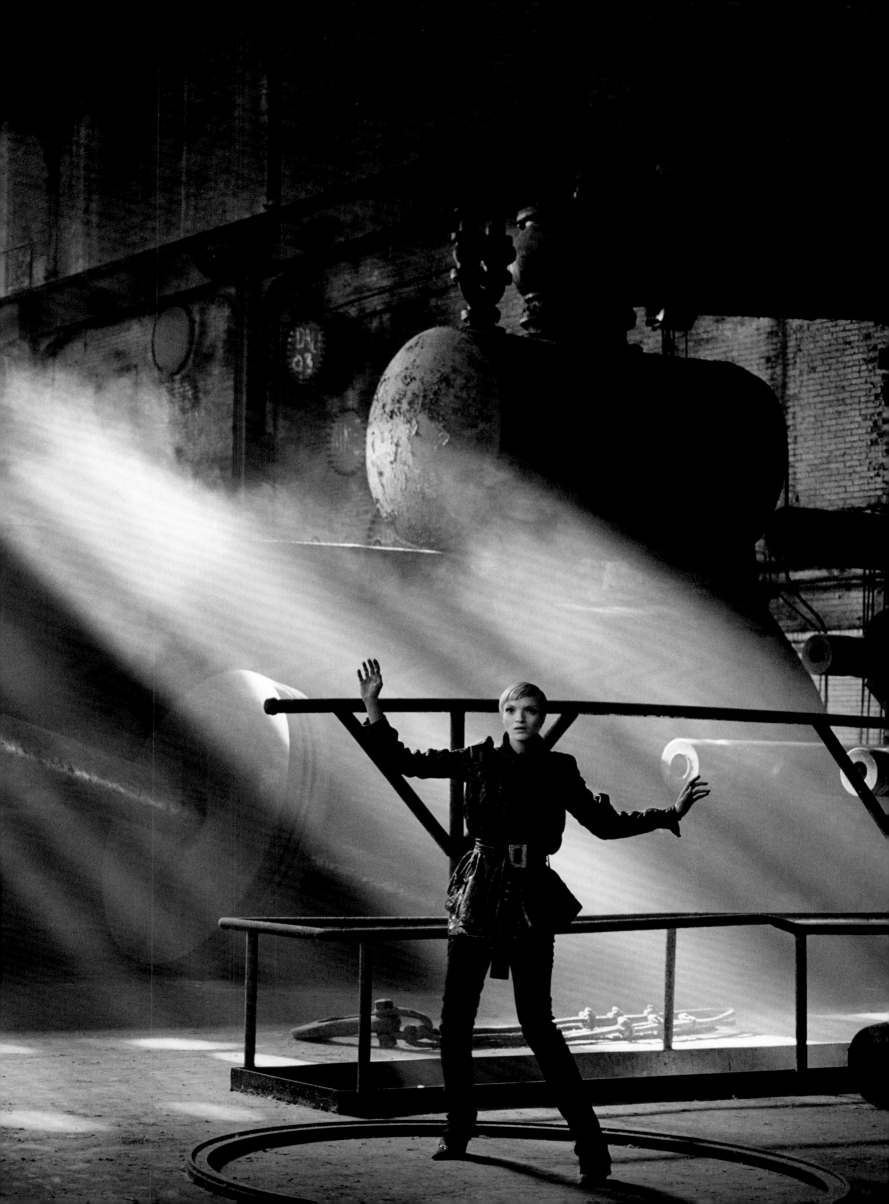

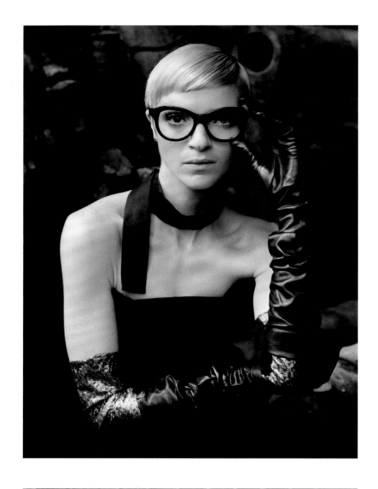

PATTI SMITH ON THE RETURN OF THE TIE

For the legendary singer, a tie has never represented a uniform; rather, it symbolizes freedom

BY PATTI SMITH
Excerpted from the March issue

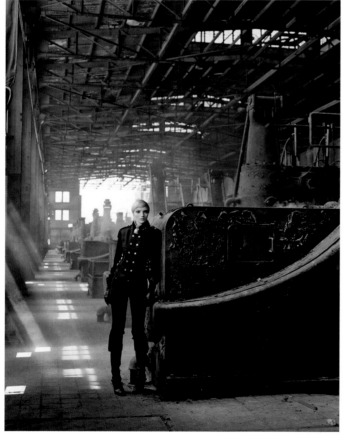

I WAS TRUE TO THE SHIRT AND TIE through the '60s and '70s. My models were the likes of Alan Price and Eric Burdon of the Animals, who rose from the British lower class to the arena of rock 'n' roll in white shirts, black ties, and bad skin. I clocked Frank Sinatra's loose, sultry look. The radiant Jeanne Moreau in *Jules et Jim.* When I lived at the Chelsea Hotel, I often strolled with William Burroughs. William in a cashmere overcoat, striped shirt, and hand-painted tie and me in a motorcycle jacket and black ribbon. A gentleman bum and a disheveled wild boy.

For my 23rd birthday Robert Mapplethorpe made me a tie rack adorned with an image of the Virgin Mary. When I recorded my first album, *Horses,* Robert shot the photograph for the cover. I couldn't decide on which tie to wear that morning, so I grabbed French satin ribbon and fashioned my own. I let it hang loose to give off that Frank Sinatra irreverence. As if to say, "Yeah, I got my tie, but I'll wear it my way."

In the '80s my husband, the late Fred "Sonic" Smith, always chose a tie that reflected the task at hand. When we traveled through the Amazon, a khaki shirt with a brown wool tie gave him the air of a correspondent for *National Geographic.* An understated tie on the golf course saluted the gentleman amateur. When he played sax, he added a loosened black dinner tie as redefined by John Coltrane. When he played electric guitar, he often chose the racetrack/Abstract Expressionist look—dark shirt, darker tie. He valued the tie as a symbol of order meant to be reinvented.

For me the tie still holds. When I dress for the stage, there is little fuss involved. A black jacket, black pegged pants, a white shirt, and—whether a length of satin, a black mourning ribbon, a leather bola, or a classic four-in-hand—always a tie.

FACTORY GIRL

Mariacarla Boscono in Alessandro Dell'Acqua (opposite) and, on the previous spread, Dior by John Galliano, photographed for the September issue by Peter Lindbergh, styled by Panos Yiapanis.

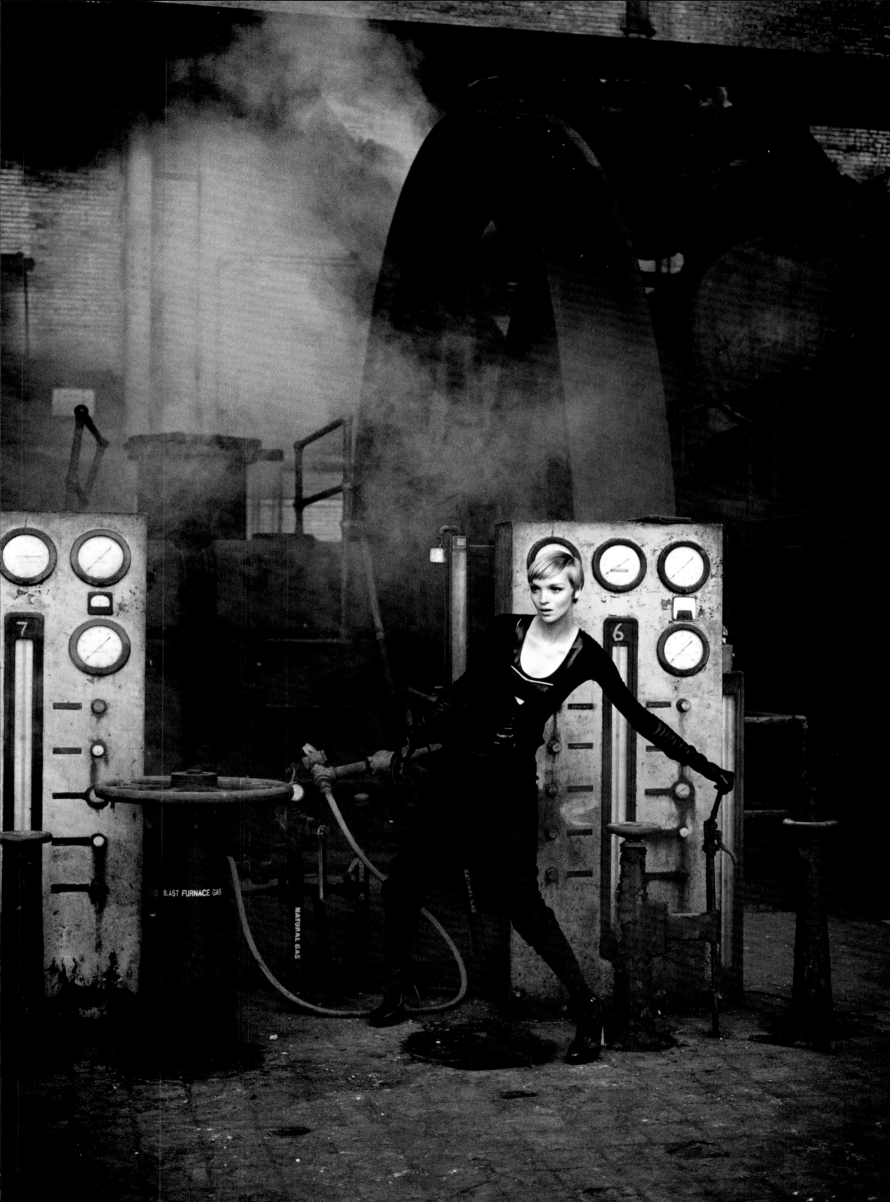

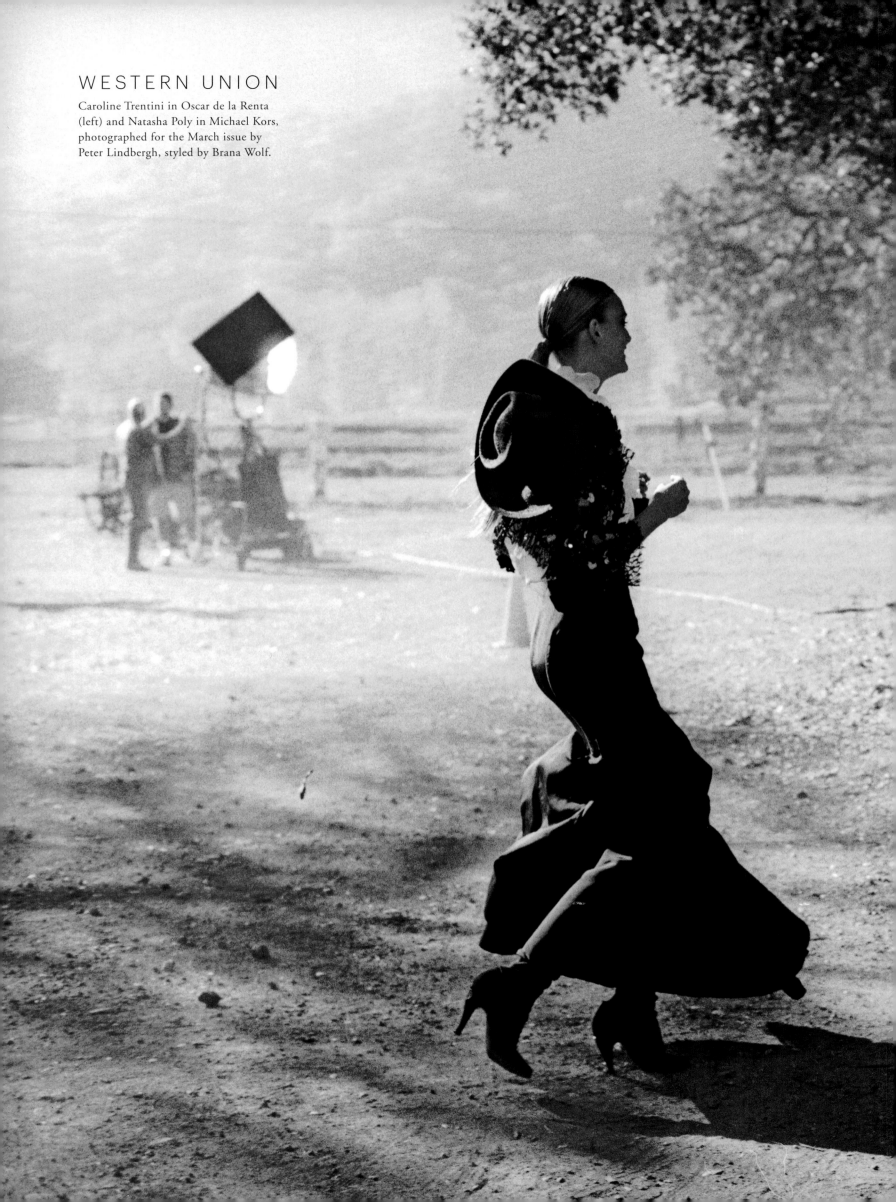

WESTERN UNION

Caroline Trentini in Oscar de la Renta
(left) and Natasha Poly in Michael Kors,
photographed for the March issue by
Peter Lindbergh, styled by Brana Wolf.

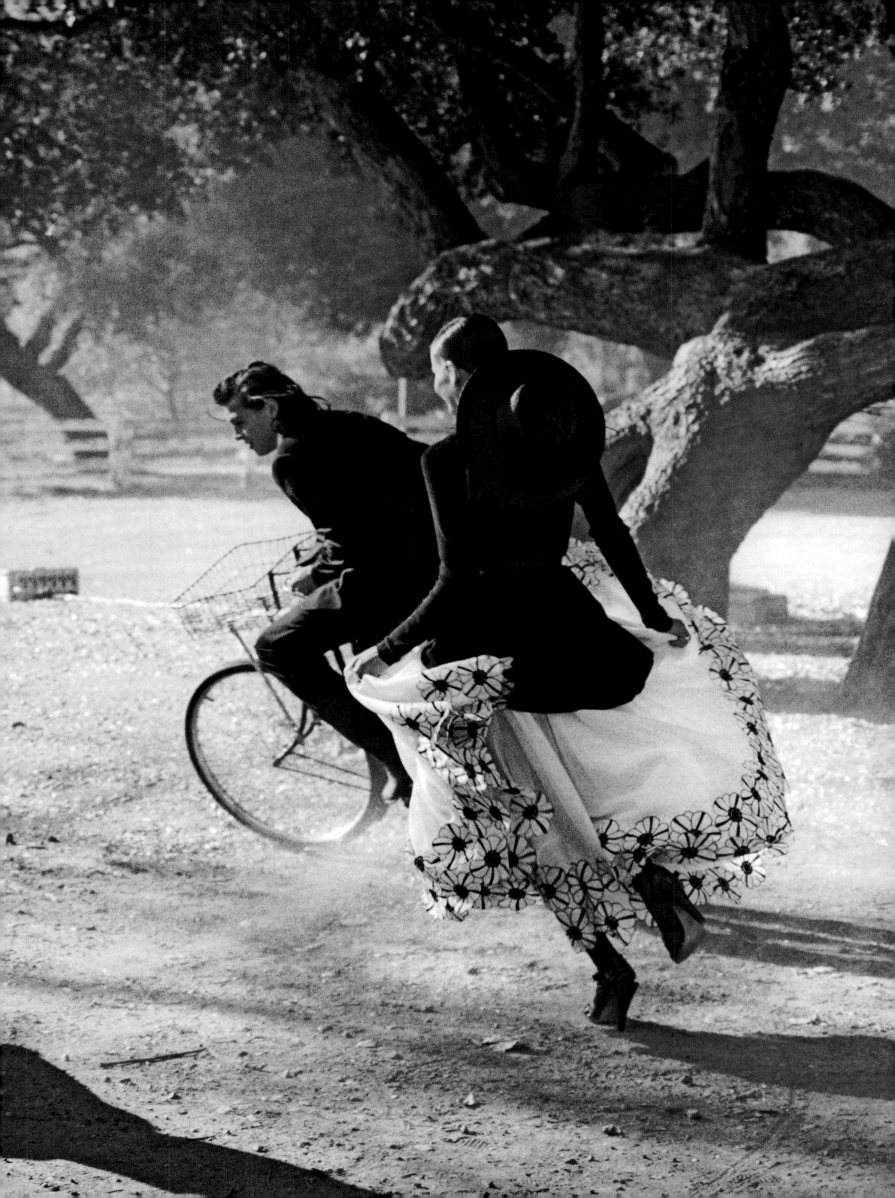

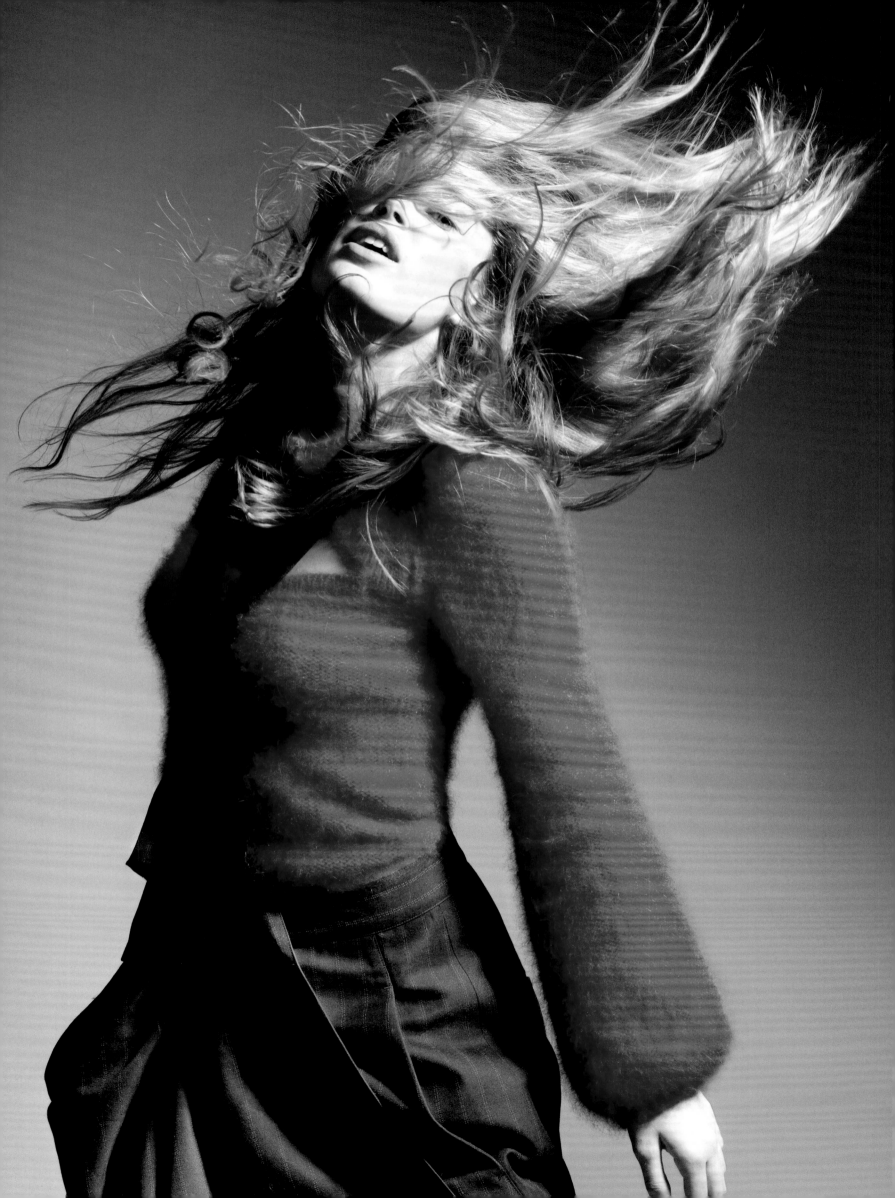

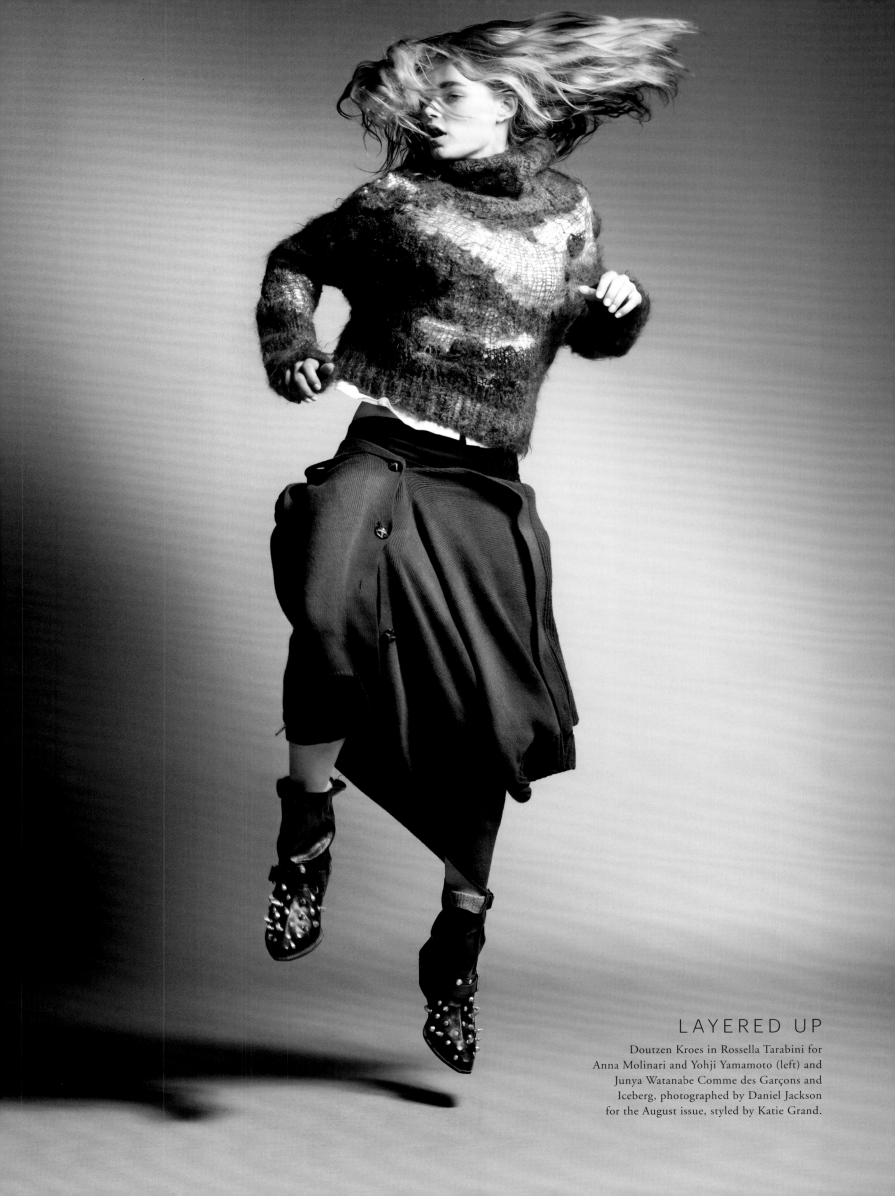

LAYERED UP

Doutzen Kroes in Rossella Tarabini for
Anna Molinari and Yohji Yamamoto (left) and
Junya Watanabe Comme des Garçons and
Iceberg, photographed by Daniel Jackson
for the August issue, styled by Katie Grand.

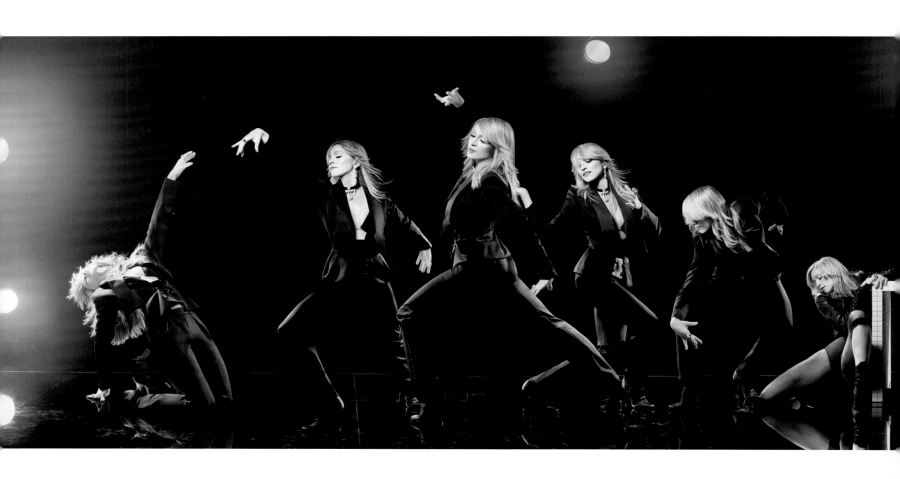

DANCE FEVER

Madonna, photographed for the March issue
by Sølve Sundsbø, styled by Arianne Phillips.

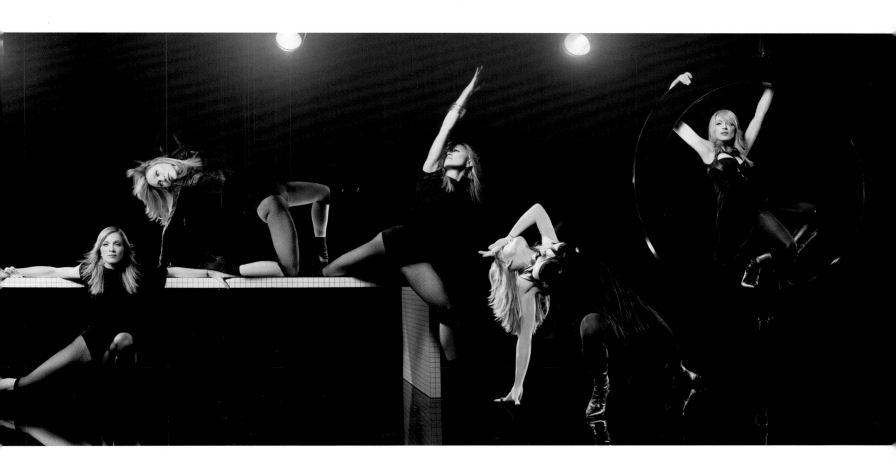

GOLDEN GODDESS

Donna Karan, photographed for the
October issue by François Dischinger,
styled by Mary Alice Stephenson.

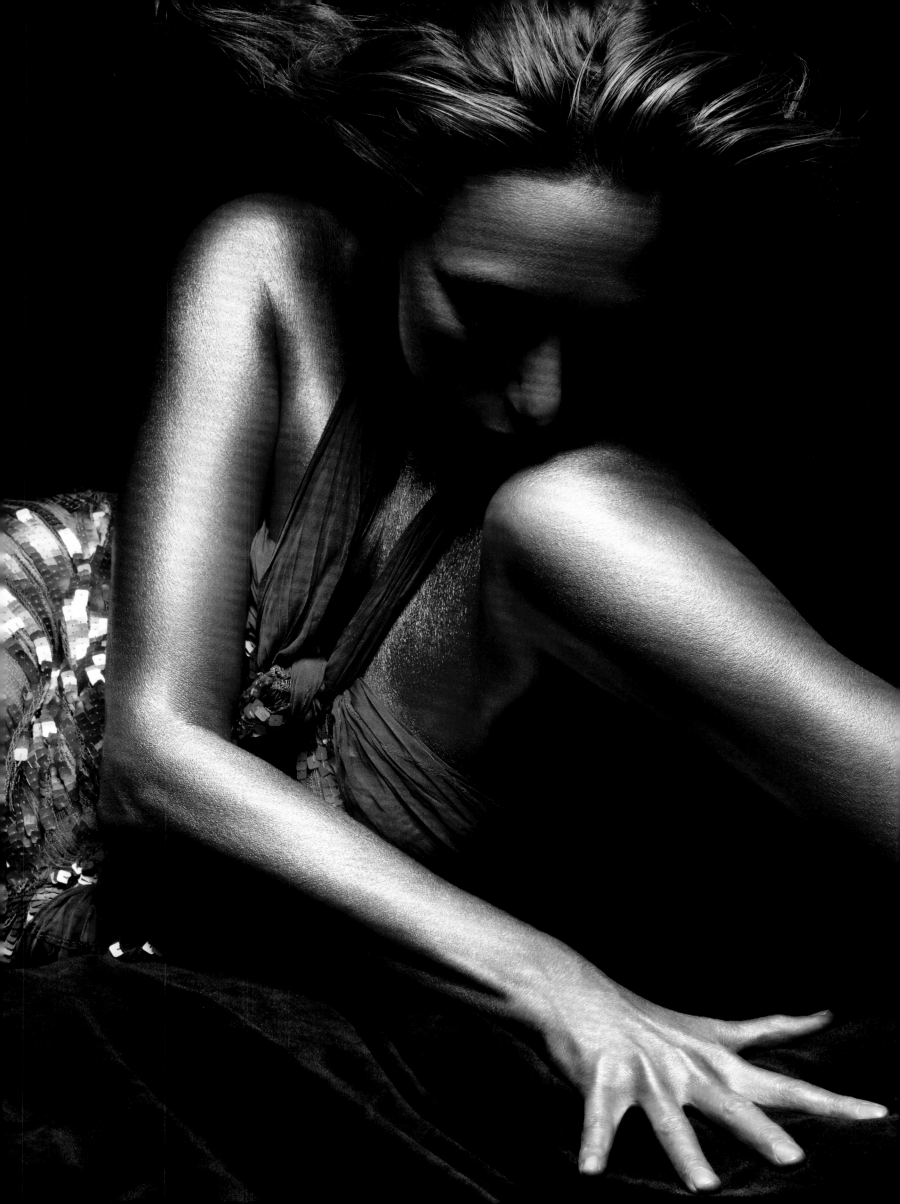

THE SEDUCTIVE SIDE OF MARTHA

Despite her mega-successful career and her iconic status as America's favorite domestic diva, few really know the woman behind the brand

BY SUSAN ORLEAN
Excerpted from the September issue

Martha Stewart in Chado Ralph Rucci (above) and Yves Saint Laurent, photographed for the September issue by François Dischinger, styled by Ann Caruso.

MARTHA IS TALL (five foot nine), square-shouldered, with heavy blond bangs, a direct gaze, and beautiful skin. Her breezy good looks—especially her midlength, layered, casual-but-sophisticated honey hair—are almost unchanged from that day in 1982 when she was photographed for the cover of her first book, *Entertaining,* and immediately became the person who defined and painstakingly refined American homemaking style. She loves fashion—more exactly, she loves gorgeous fabric and expert tailoring, and, true to her passion for utility and a certain exquisite practicality, she especially loves gorgeous, well-made clothes that are very wearable. Her own style—the elaborate lace-and-piqué confection on the cover of *Entertaining* aside—is unfussy, untrendy, slightly countrified, elegant in its plainness. She wears Ralph Rucci, Hermès, Jil Sander, and Ralph Lauren—or old denim work shirts and khakis when she's in the garden.

For nearly 25 years, she has looked like a woman who is getting ready to have friends over for lunch but just might take a horseback ride or plant a few daylilies before they show up. She is warm and funny—someone you would want to invite you over for lunch. Considering she has a million things going on, a great deal of power, and an overscheduled life, she is surprisingly personable and attentive. We have met several times over the years, but always in passing, yet when she sees me on this particular day, she remembers exactly where we were the last time we saw each other. She mentions that it was just before I married my husband—something I had actually forgotten. ("You don't remember that?" she teases me. "Well, how is it going?") The five months she spent in prison starting in 2004, after misleading investigators during the course of an insider-trading probe, seems to have bruised her only lightly; there is no hardness in her face and no flinching when she talks about what she refers to as "the interruption." "I have a short memory for painful things," she says, poking at her salad. "I honestly don't remember exactly what I was prosecuted for." She glances up, her expression steady and serious. "Look, I'm not sick. I'm not dead. I had two friends—young friends, as a matter of fact—who died while I was on trial. So I would say there are more important things to worry about than what happened to me."

Martha is now 65 years old, divorced from her college sweetheart since 1990, the mother of one. (Her daughter, Alexis, is 40.) She has a boyfriend ("a *man* friend," she says, chuckling at the awkwardness of the phrase) who lives out of town, so she sees him only once a month or so, which is less often than she wishes but all that their schedules permit. (His name is Charles Simonyi. He lives in Seattle, is a software tycoon, and is training to fly into outer space on a manned rocket, making him quite possibly as driven and industrious and multitalented as Martha is.) She is living in Bedford, New York, having recently decided to sell Turkey Hill, her home in Connecticut for more than 30 years, because, as she says, the gardens at Turkey Hill were mature and the house was done—in other words, there was nothing left for her to do with it to be creative. At a time when she could certainly retire from business and devote herself to mastering Sudoku, she is instead launching new ventures (a new magazine, housing developments, photography and furniture lines) and continuing to oversee the restoration of her company's image with the public, which was buffeted by her legal conviction but has rebounded and even improved. Her purposefulness doesn't seem maniacal; she just seems like someone who has lots and lots of good ideas and the resolve to bring them to life.

The café is now emptying. She has to leave too—to get to her next appointment, to write a column, to finish designing aprons for an issue of her magazine, to pack for a trip to Paris, where she is going to attend the couture shows and see Charles and probably pick up a few thousand or so new ideas. Did she ever imagine the life she has now? She shrugs. "I don't know how to answer that. I just do what I do." She smiles. "I have a knack for what's needed," she says. "For what's useful. That's it. It's just a knack."

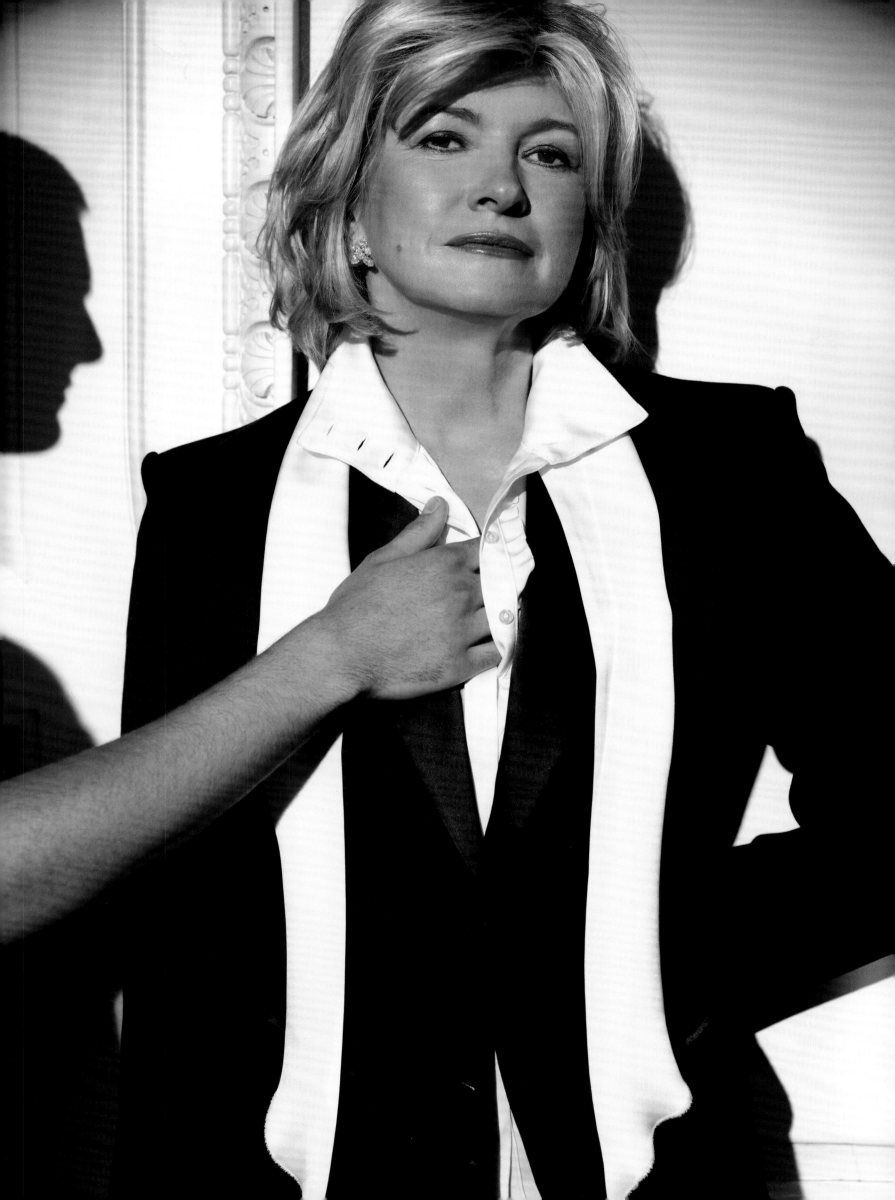

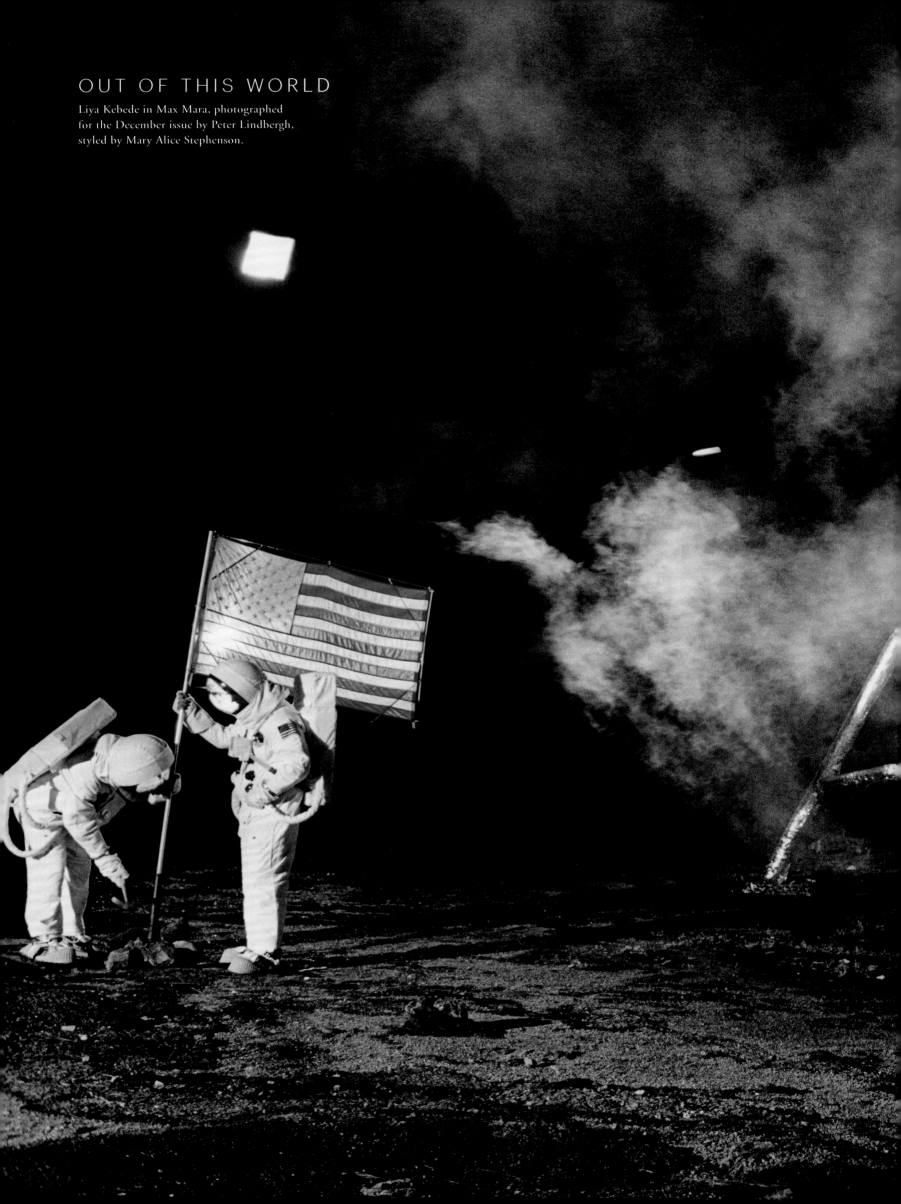

OUT OF THIS WORLD

Liya Kebede in Max Mara, photographed
for the December issue by Peter Lindbergh,
styled by Mary Alice Stephenson.

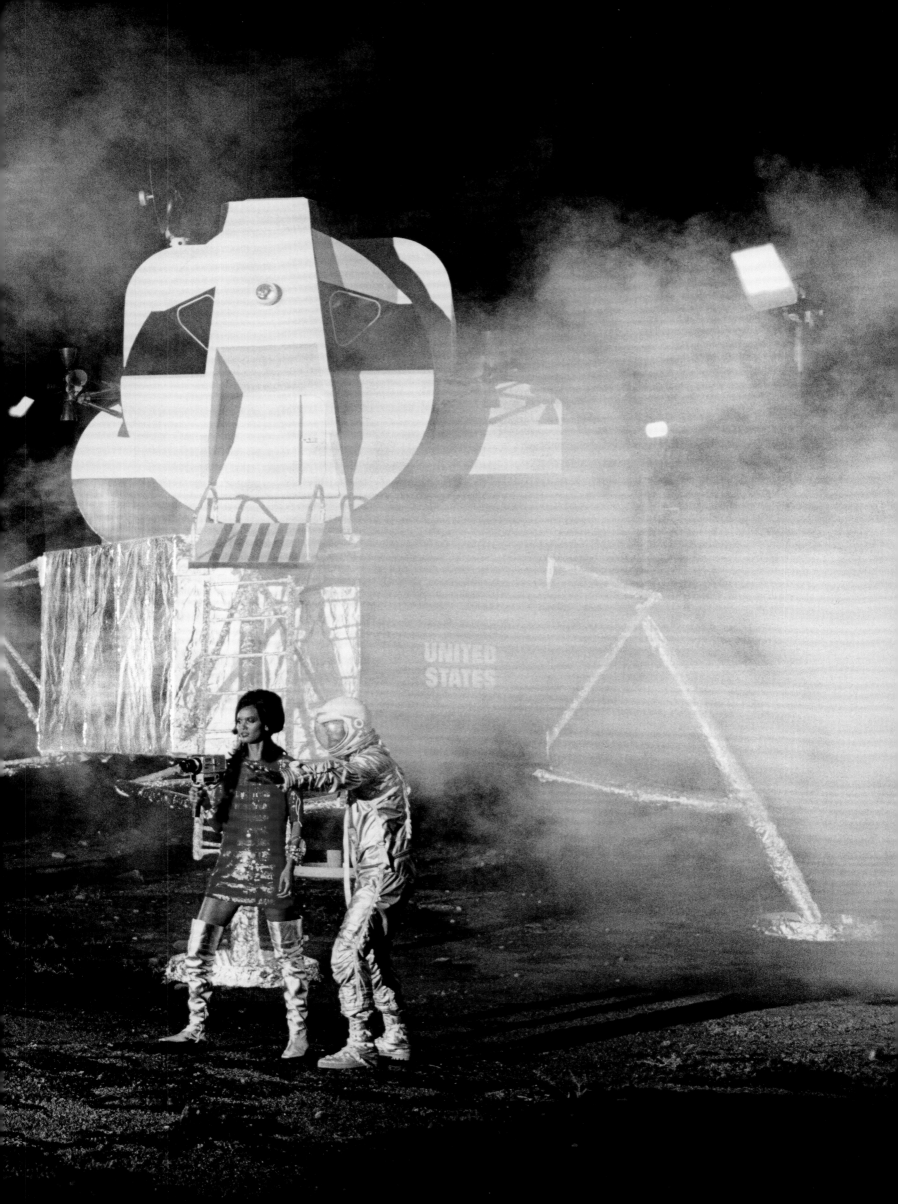

2007

SWEEPING VISION

Drew Barrymore in Carolina Herrera, photographed for the February issue by Peter Lindbergh, styled by Mary Alice Stephenson. Winner of an ASME Best Fashion Cover award.

140 YEARS AND COUNTING

BAZAAR WROTE THE BOOK on being fabulous at every age, so it's only logical that its 140th anniversary called for a yearlong party.

The February cover painted the town with Peter Lindbergh's photograph of Drew Barrymore saluting Manhattan's skyline. In March, *Bazaar* hailed Hollywood by featuring Katie Holmes in her first interview since marrying Tom Cruise. Holmes openly counted her blessings about her charmed life. Of her husband, she enthused, "He's the biggest movie star ever." In the same issue, one of fashion's biggest stars, Donatella Versace, posed and was interviewed for the first time ever with her daughter, Allegra.

Further cause for celebration: William Klein's first fashion shoot in more than 30 years, featuring top designers and the people who support and inspire them. Marc Jacobs was thronged by fabulous friends like Pharrell Williams, Lee Radziwill, Katie Grand, and Camille Miceli, while Alber Elbaz hired a bus and brought everyone from the president of Lanvin to the cleaning lady.

To mark John Galliano's 10th anniversary at Christian Dior, he was shot astride a white steed and flanked by models in looks from each of his 20 couture collections. The painterly neoclassical images by Simon Procter nodded to the designer's theatrical style.

Our pictures grab headlines, sometimes shaping history. Witness Judith Giuliani puckering up with her husband in March. *CNN* questioned whether the image—and its appearance on the front page of the *New York Post*—could mark the downfall of Rudy's presidential bid.

Bazaar covers the news but also creates the news. That was clear when features/special projects director Laura Brown suggested the magazine take *The Simpsons* to Paris in honor of its characters' feature-film debut. With help from Linda Evangelista, Jean Paul Gaultier, Karl Lagerfeld, Alber Elbaz, and others, *Bazaar* and the Simpsons will always have Paris. (After the story appeared, Marc Jacobs had his *Simpson*-ized likeness tattooed on his arm. Talk about a lasting impression.)

The only thing the magazine loves more than a wink is spreading goodwill. In September, it reconciled a feud between Lagerfeld and Courtney Love that began when Love wore a knockoff Chanel dress. Lagerfeld shot her as a reclining nude on Coco Chanel's couch. The headline declared, "I'd Rather Go Naked Than Wear Fake Chanel."

The tabloids had also been going mad over the number of starlets in rehab centers. In Lindbergh's "They Tried to Make Me Go to Rehab," Chloë Sevigny sent up the schadenfreude of a voyeuristic nation.

A stint in rehab for Marc Jacobs led to a total makeover. In September, for Jean-Paul Goude's images for the story "Marc on Top," Jacobs revealed his postrecovery transformation, balancing on a Louis Vuitton trunk in a tutu while hoisting Naomi Campbell on a pulley.

For November, the actual anniversary, the magazine devoted the entire issue to celebrating. Lagerfeld gifted us with an epic ode to eveningwear, shot at Versailles. To further commemorate the occasion, 29 of fashion's most influential designers sent their congratulations in the form of customized *Bazaar* covers. Each was included in the issue, then auctioned for charity at an anniversary event. It was a glamorous end to a momentous year, and the greatest gift of all was a private performance by Stevie Wonder. It just goes to show that when *Bazaar* throws a party, everyone is best dressed.

A FRESH LOOK

Jennifer Aniston, photographed for the September issue by Alexi Lubomirski, styled by Jenny Capitain.

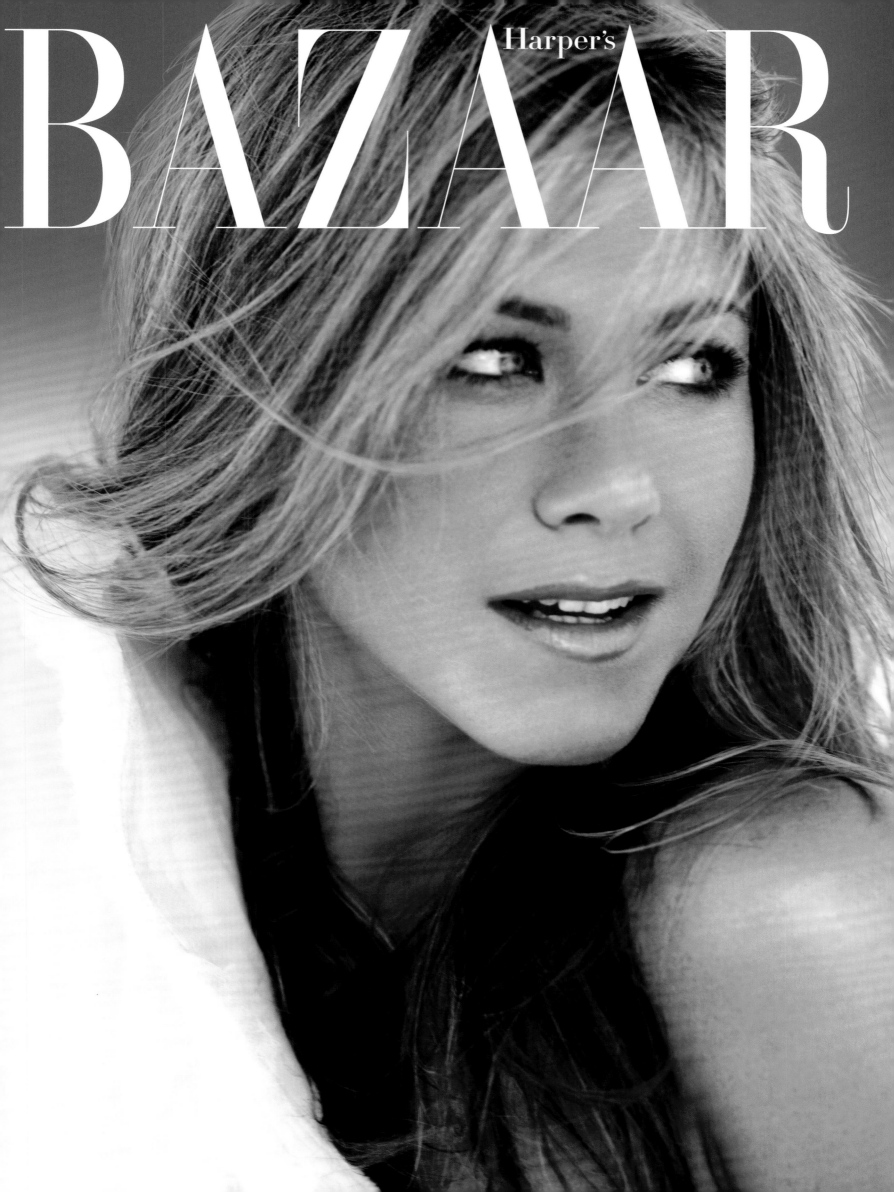

Harper's
BAZAAR

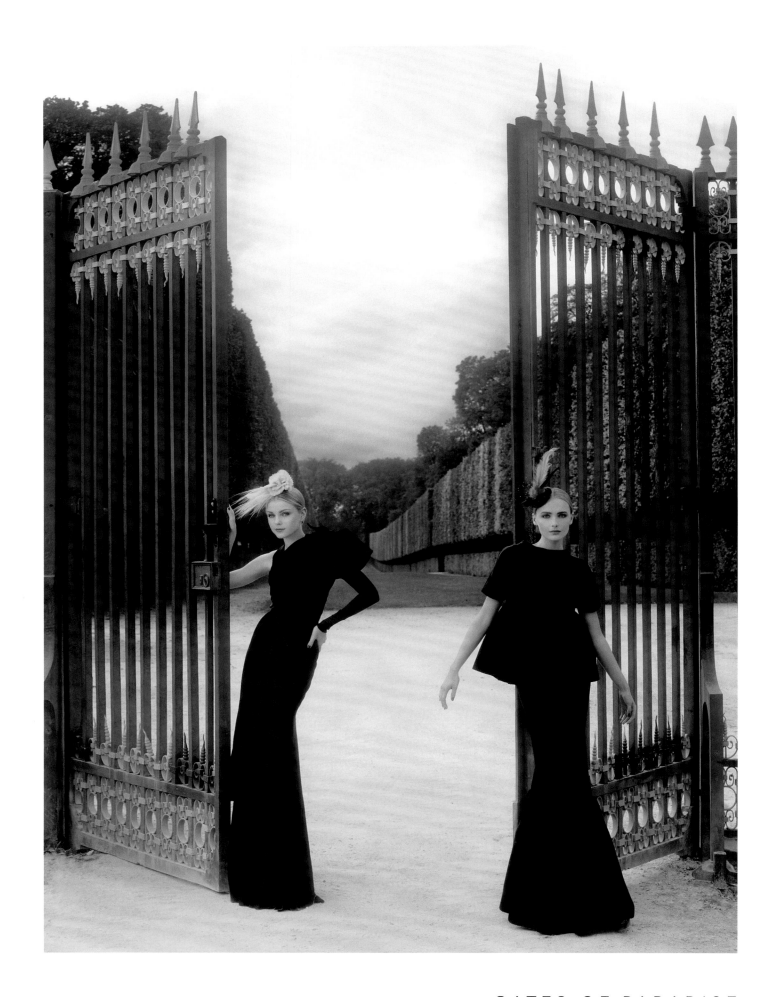

GATES OF PARADISE

Jessica Stam in Givenchy Haute Couture (above left) and Snejana Onopka in
Chanel Haute Couture (above right) and Oscar de la Renta (opposite),
photographed for the November issue by Karl Lagerfeld, styled by Brana Wolf.

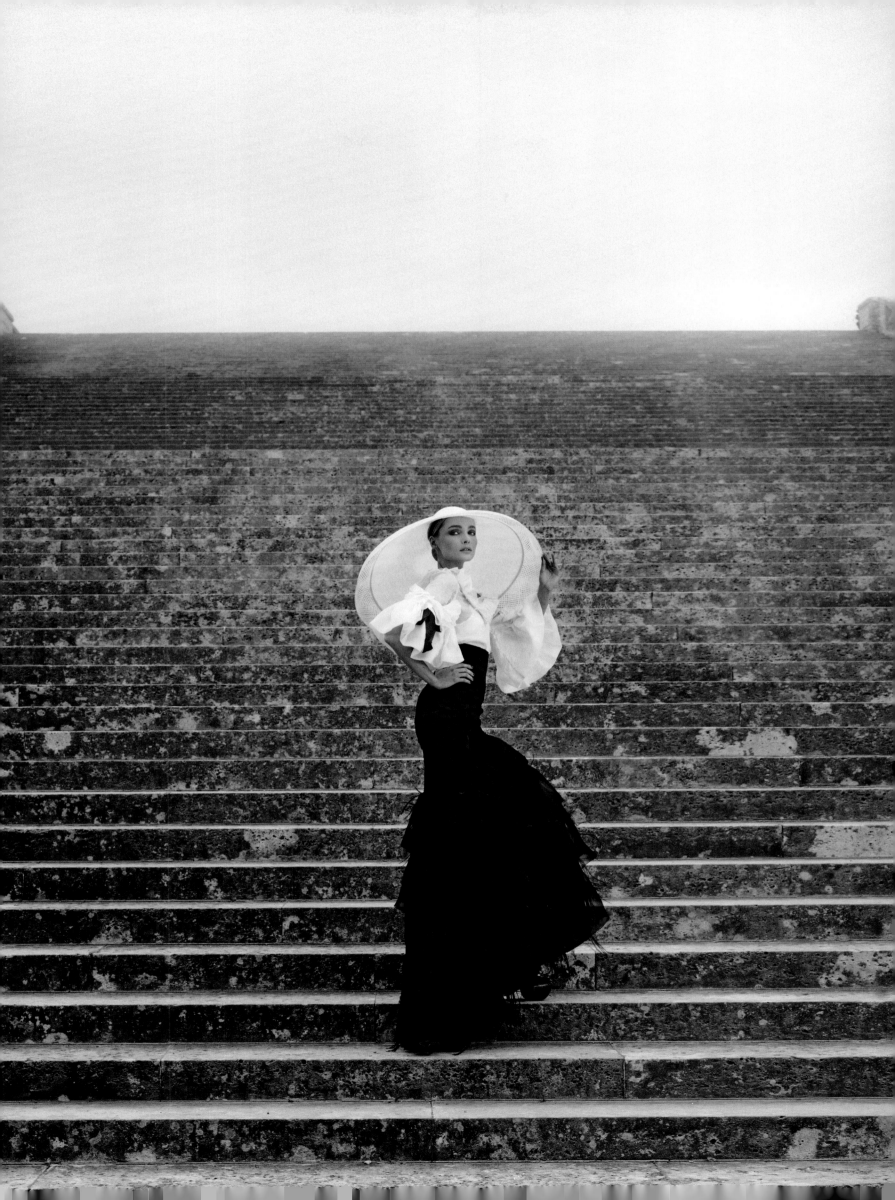

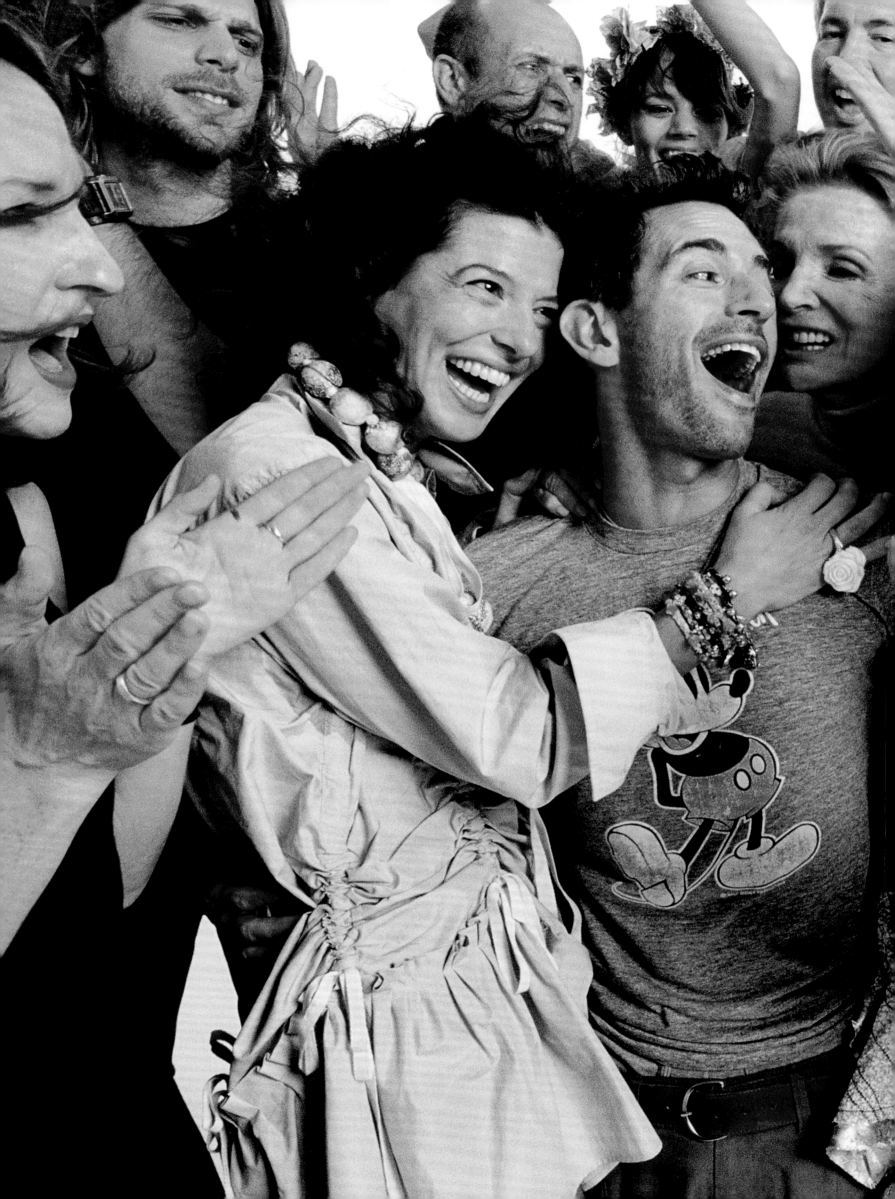

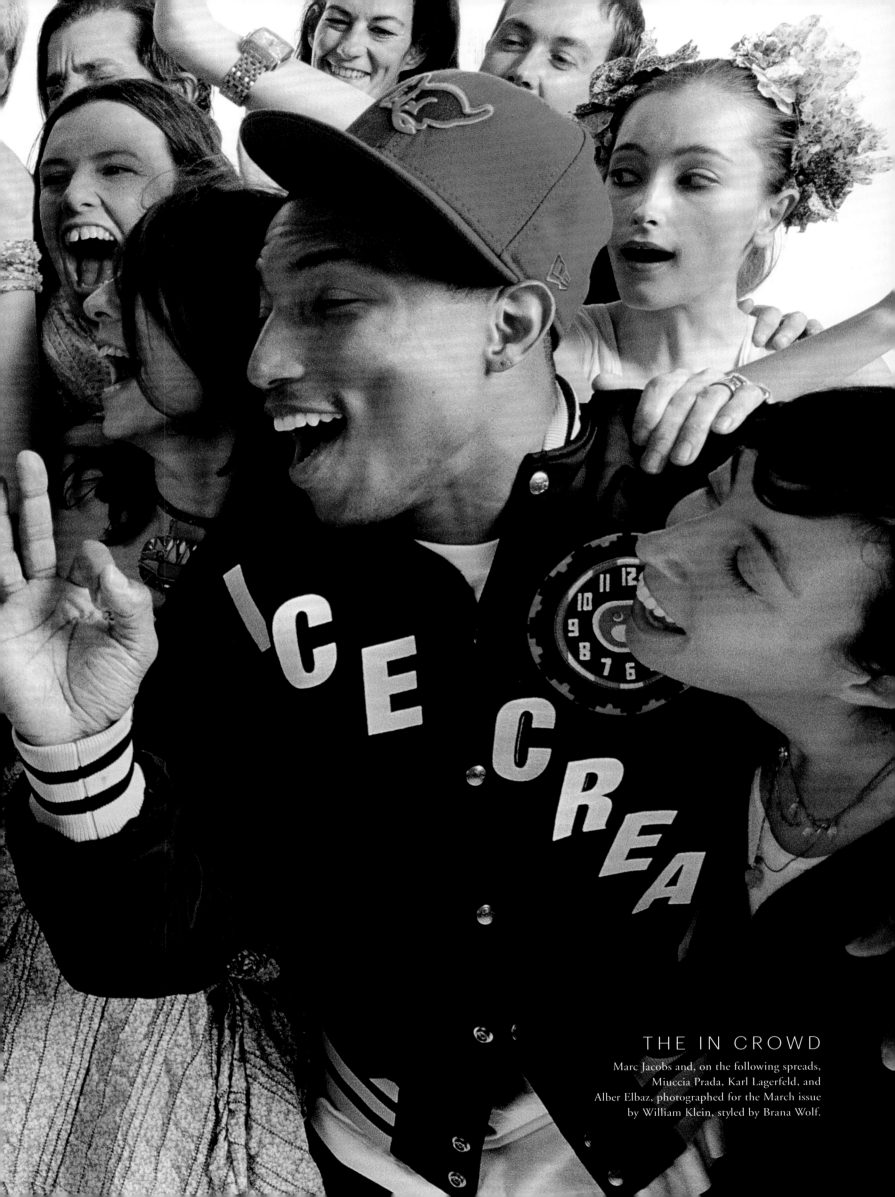

THE IN CROWD

Marc Jacobs and, on the following spreads,
Miuccia Prada, Karl Lagerfeld, and
Alber Elbaz, photographed for the March issue
by William Klein, styled by Brana Wolf.

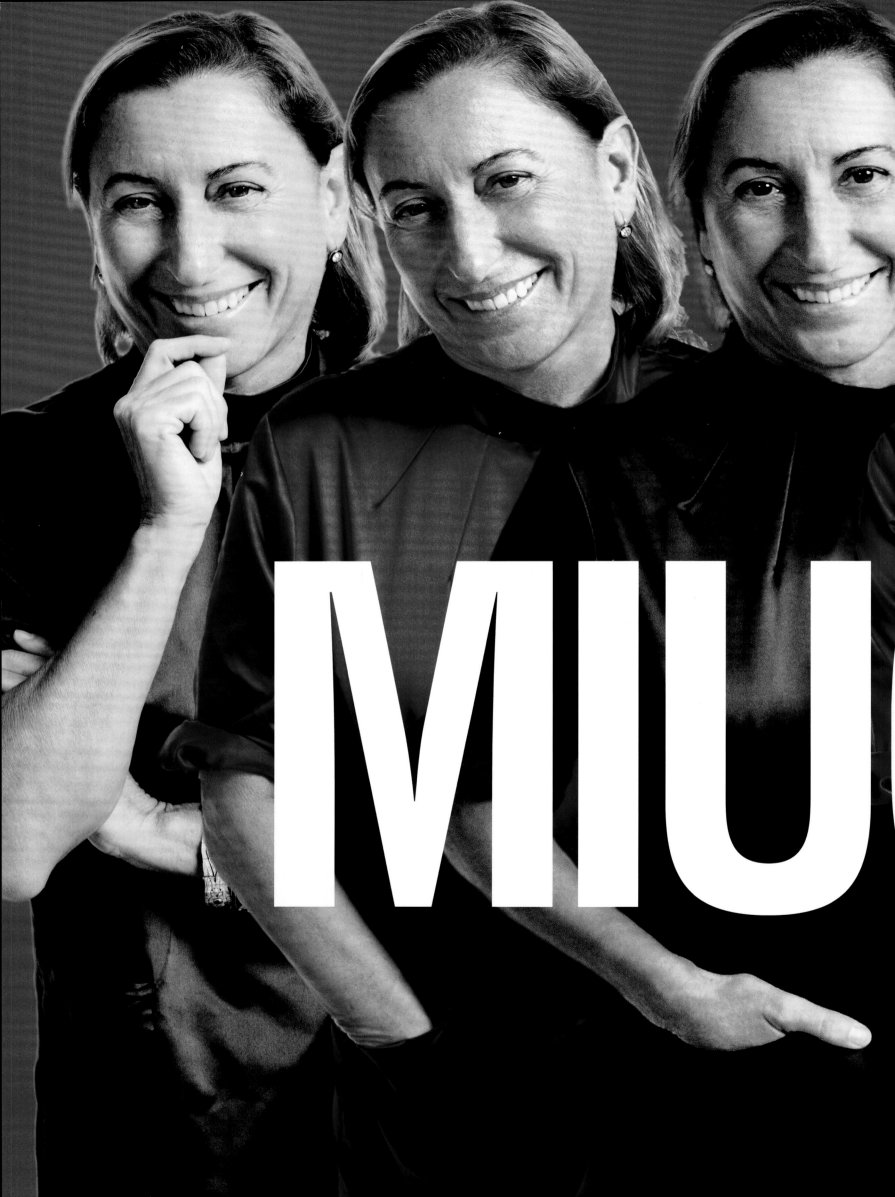

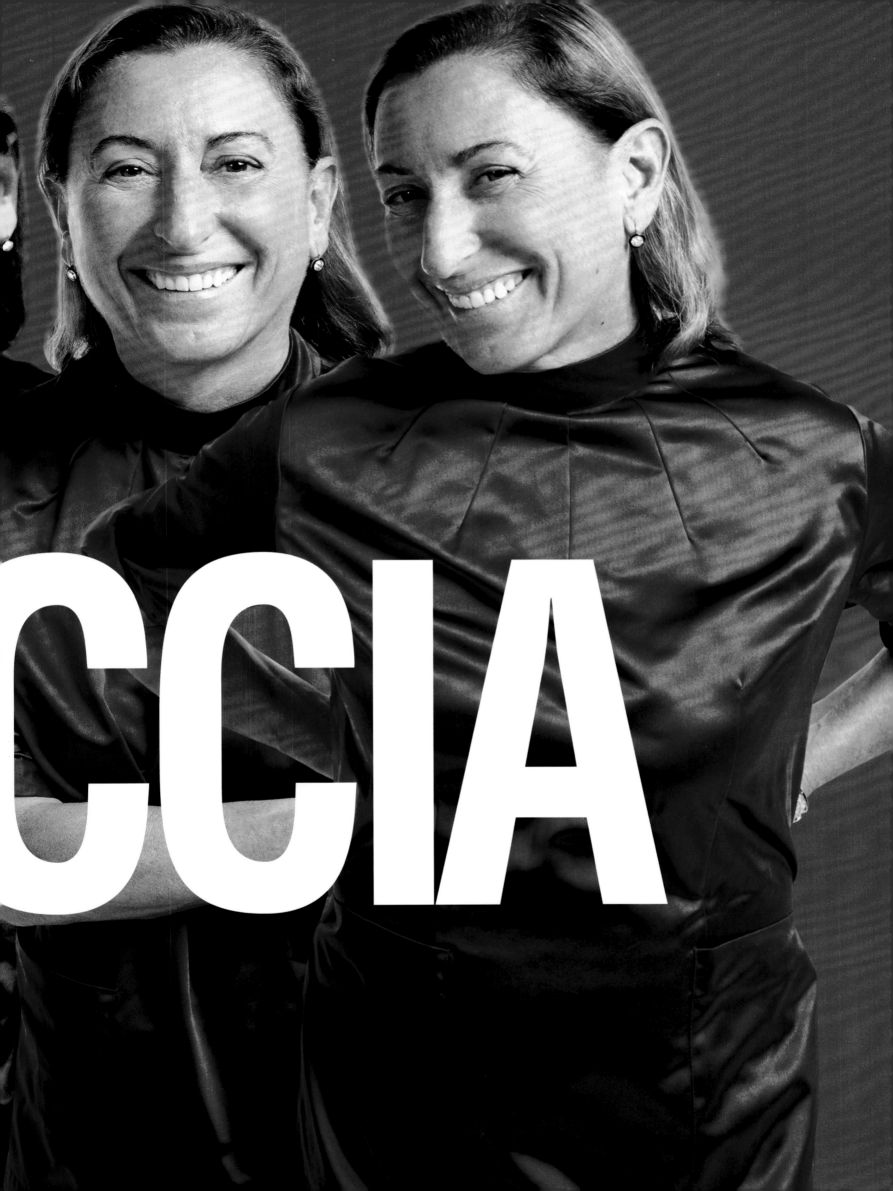

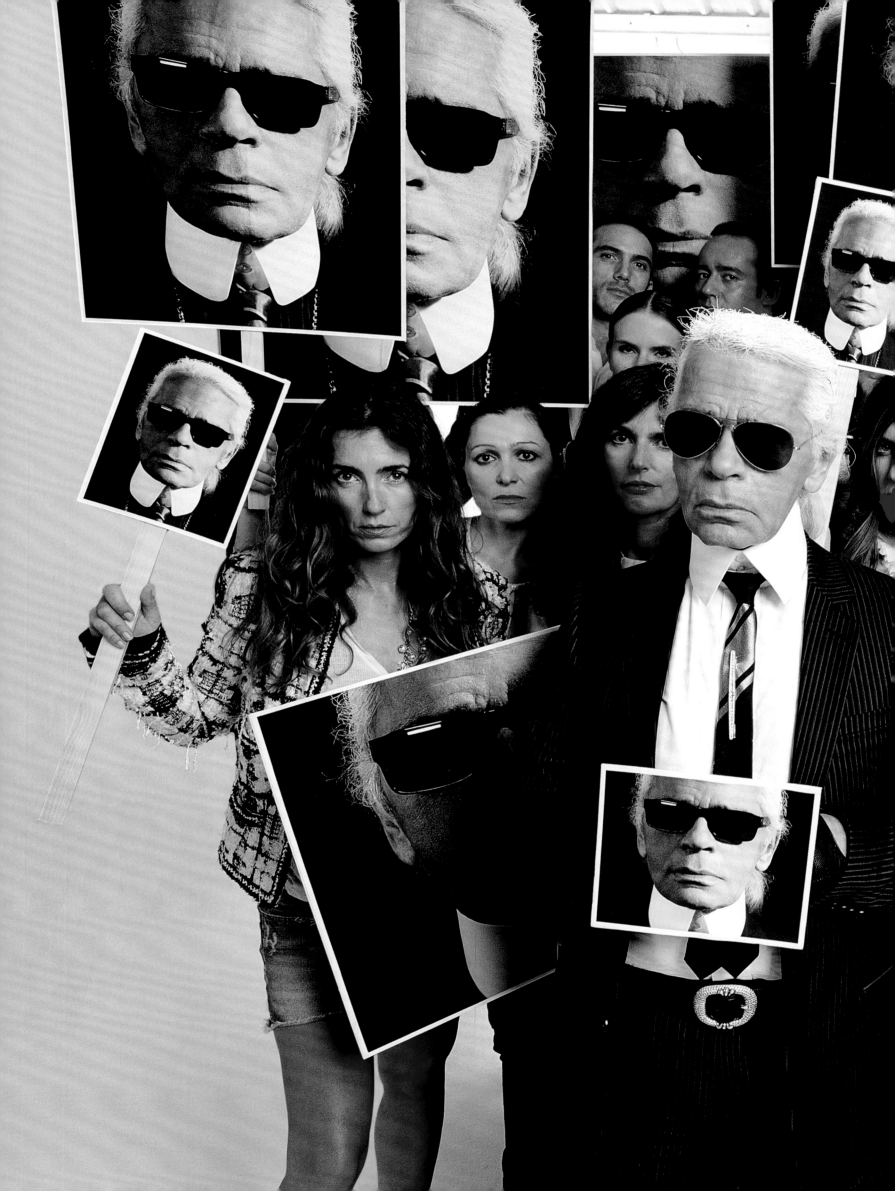

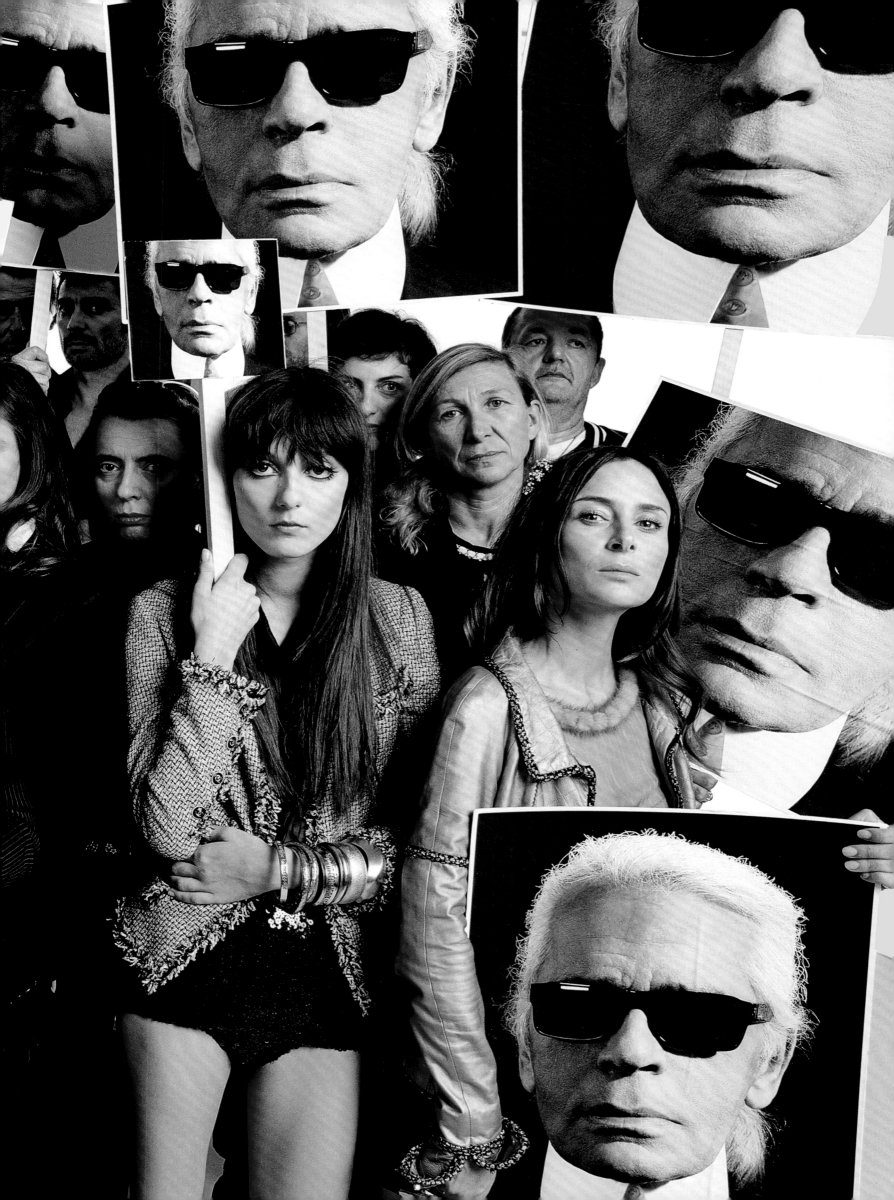

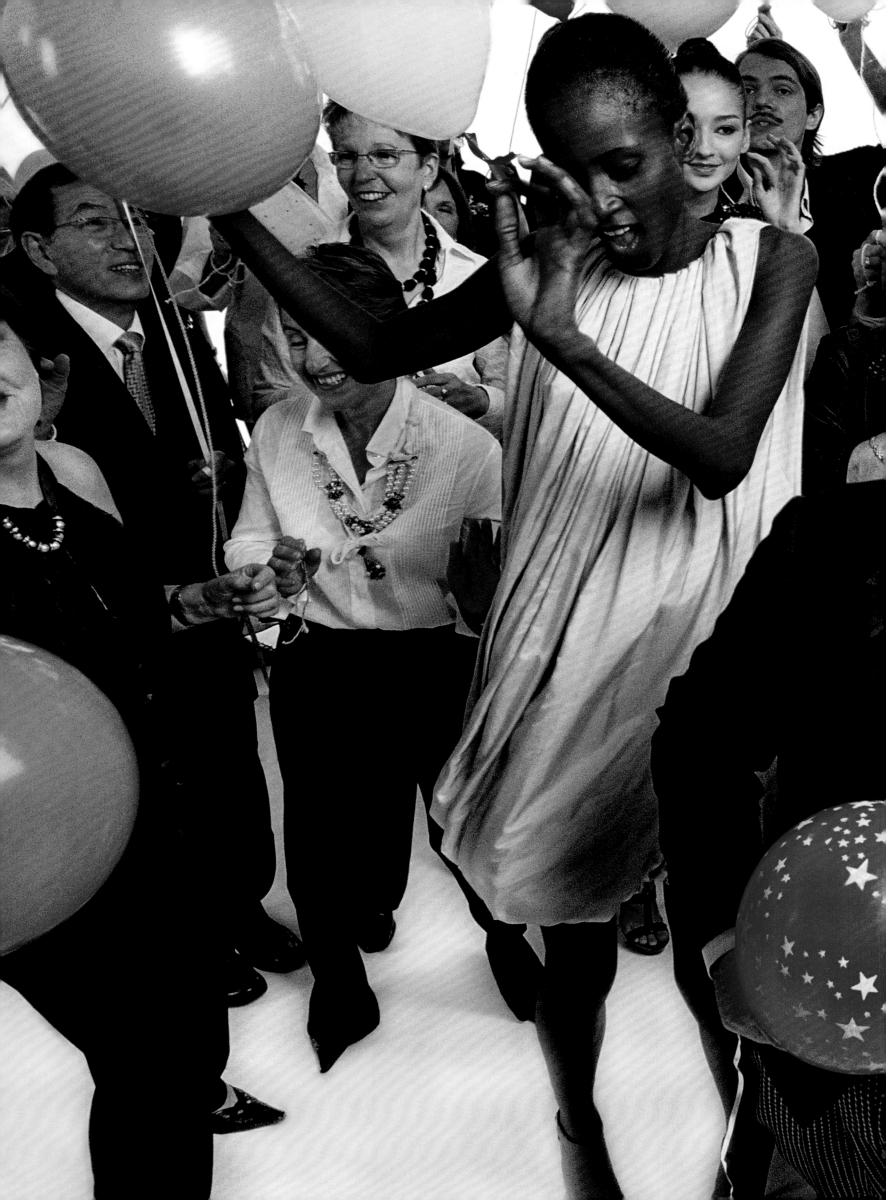

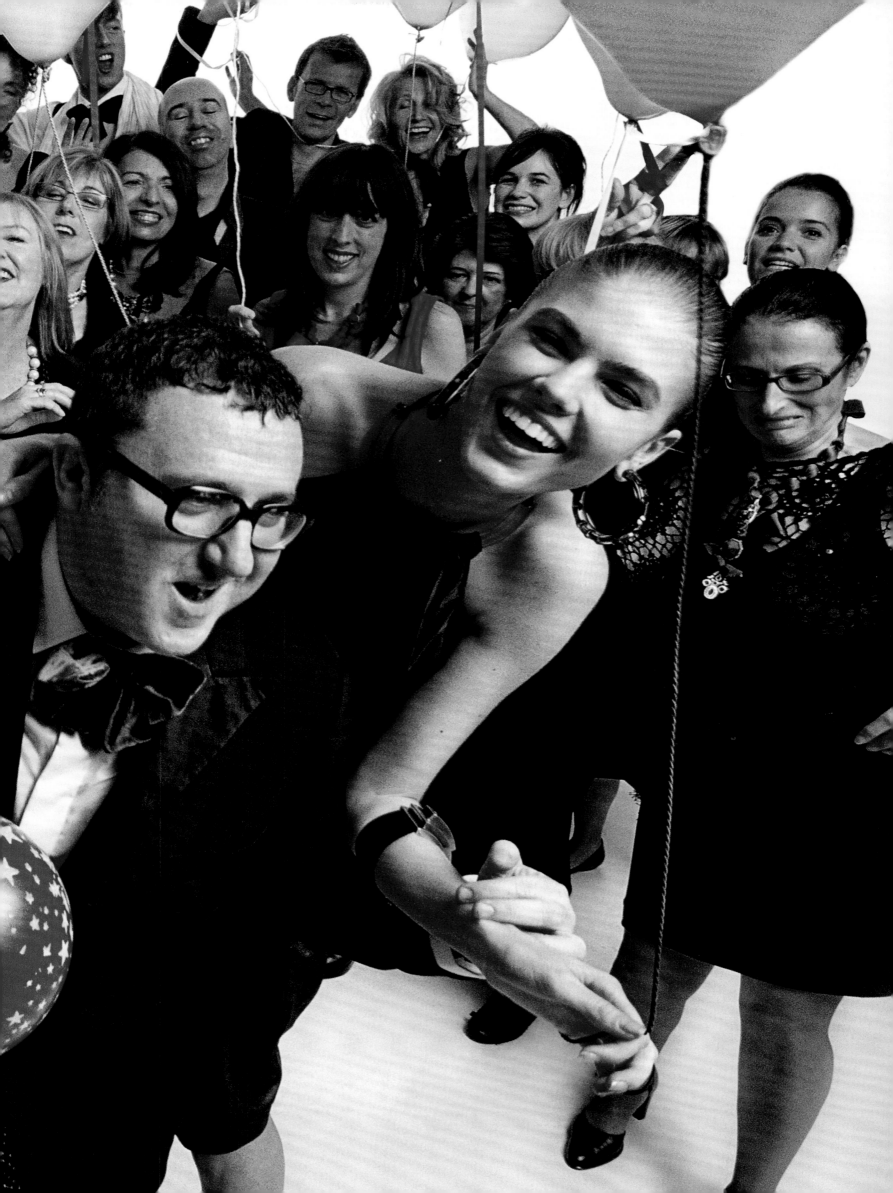

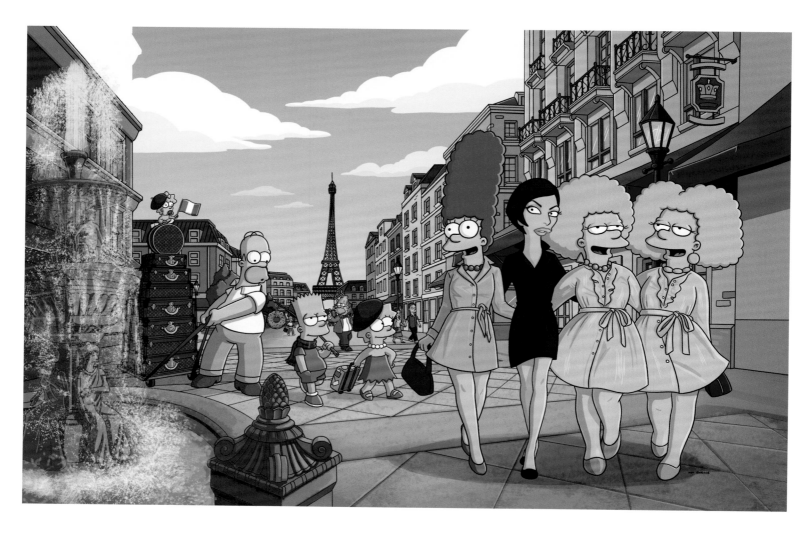

THE SIMPSONS
GO TO PARIS

Illustrated for the August issue by Julius Preite. Winner of a *Folio* Ozzie Award for Best Use of Illustration.

Bazaar took the Simpsons to Paris in honor of their feature-film debut. With help from Linda Evangelista (in Gap, above), the family sat front row at Louis Vuitton (Marc Jacobs so loved his cartoon self, he had it tattooed on his arm); Marge took a night stroll in tartan with Jean Paul Gaultier, had her blue beehive relaxed into silky Donatella Versace tresses, and was fitted by Karl Lagerfeld; and Lisa swapped her add-a-bead necklace for Lanvin pearls.

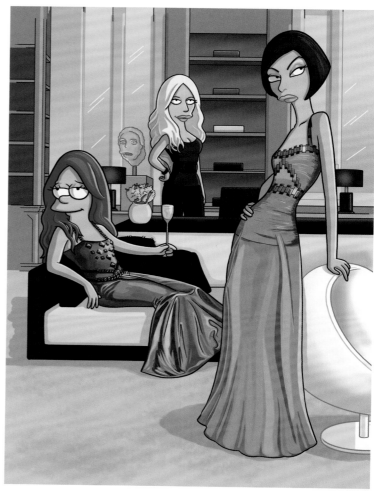

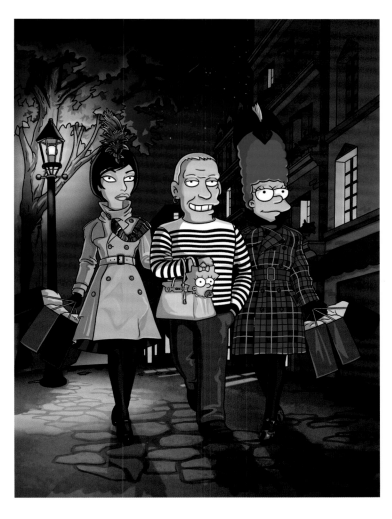

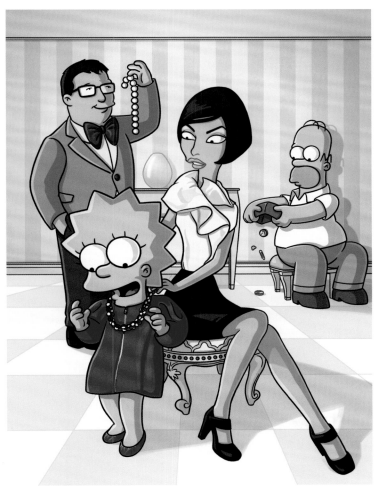

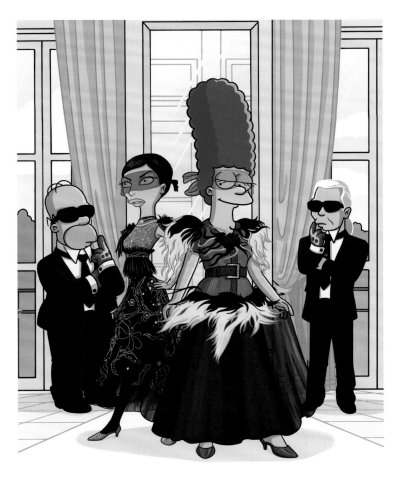

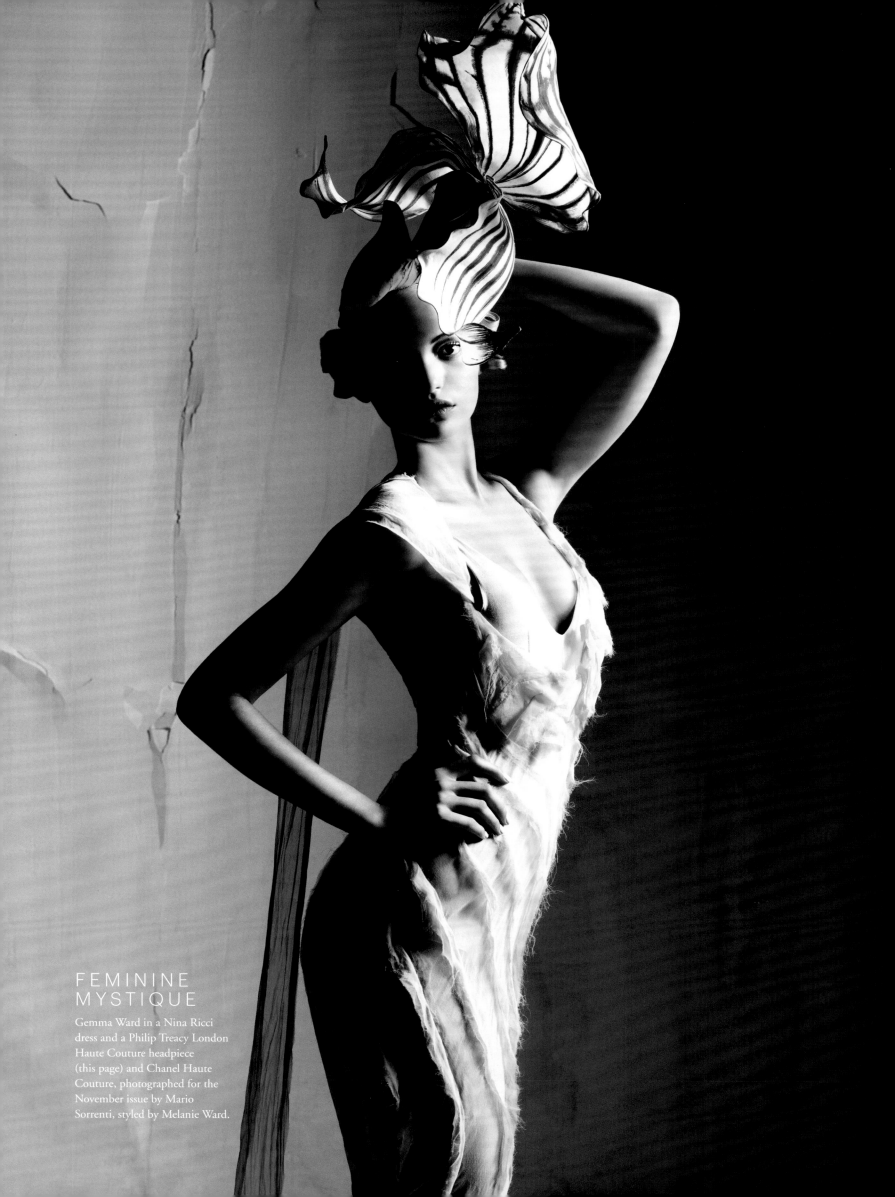

FEMININE
MYSTIQUE

Gemma Ward in a Nina Ricci
dress and a Philip Treacy London
Haute Couture headpiece
(this page) and Chanel Haute
Couture, photographed for the
November issue by Mario
Sorrenti, styled by Melanie Ward.

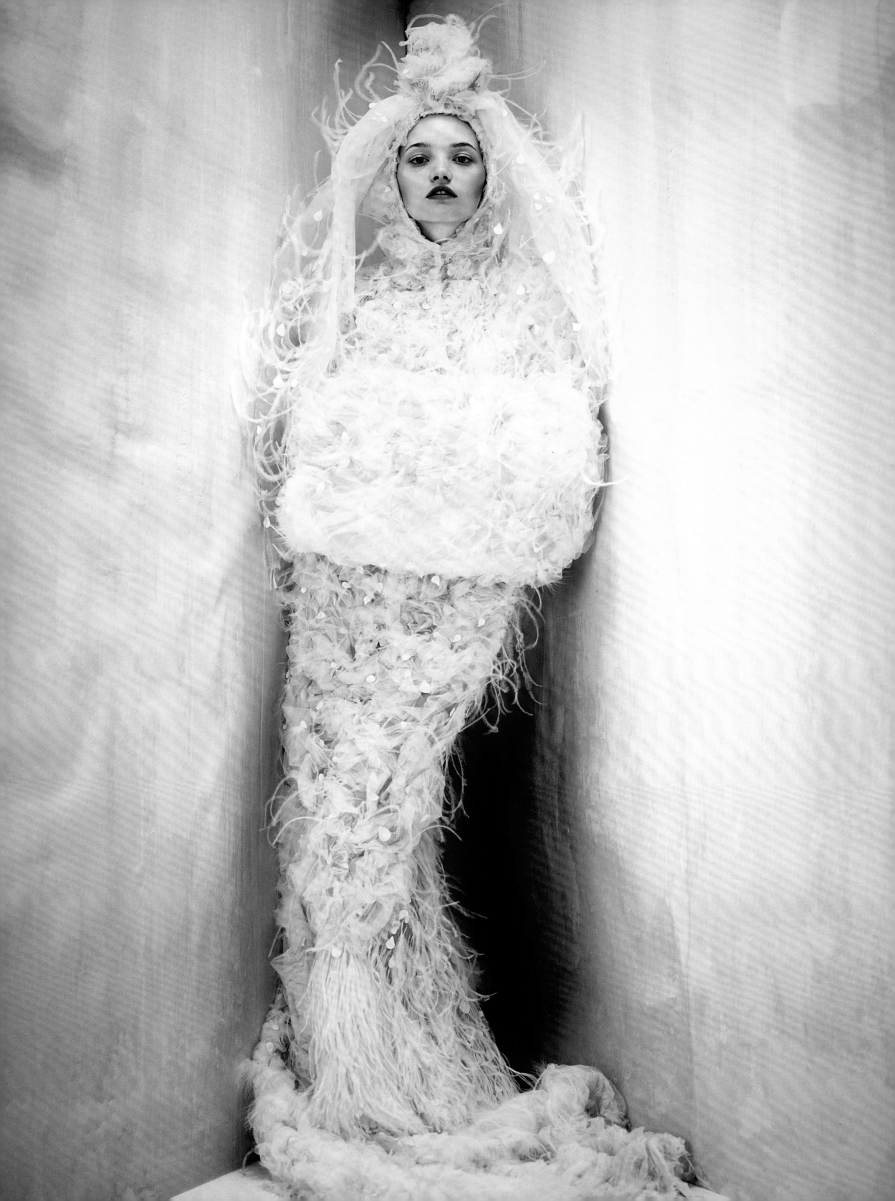

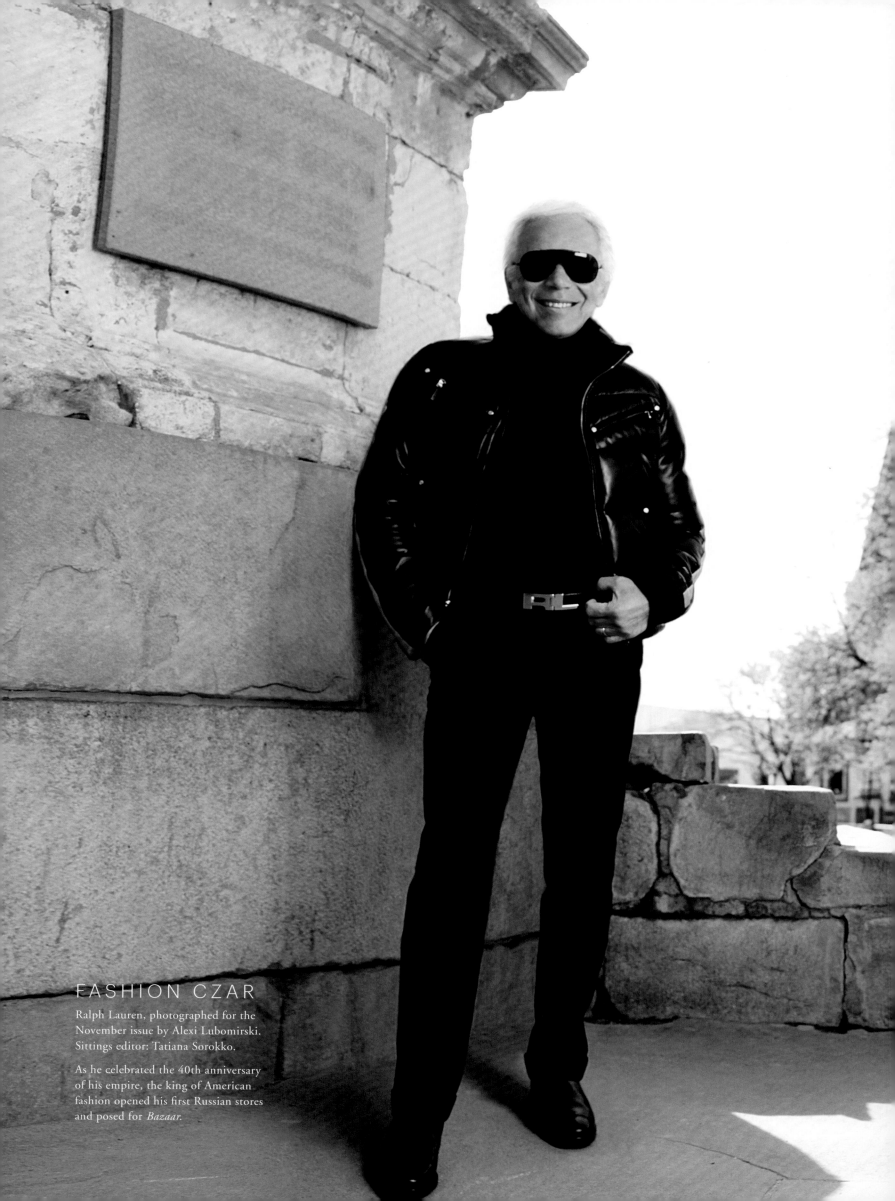

FASHION CZAR

Ralph Lauren, photographed for the
November issue by Alexi Lubomirski.
Sittings editor: Tatiana Sorokko.

As he celebrated the 40th anniversary
of his empire, the king of American
fashion opened his first Russian stores
and posed for *Bazaar*.

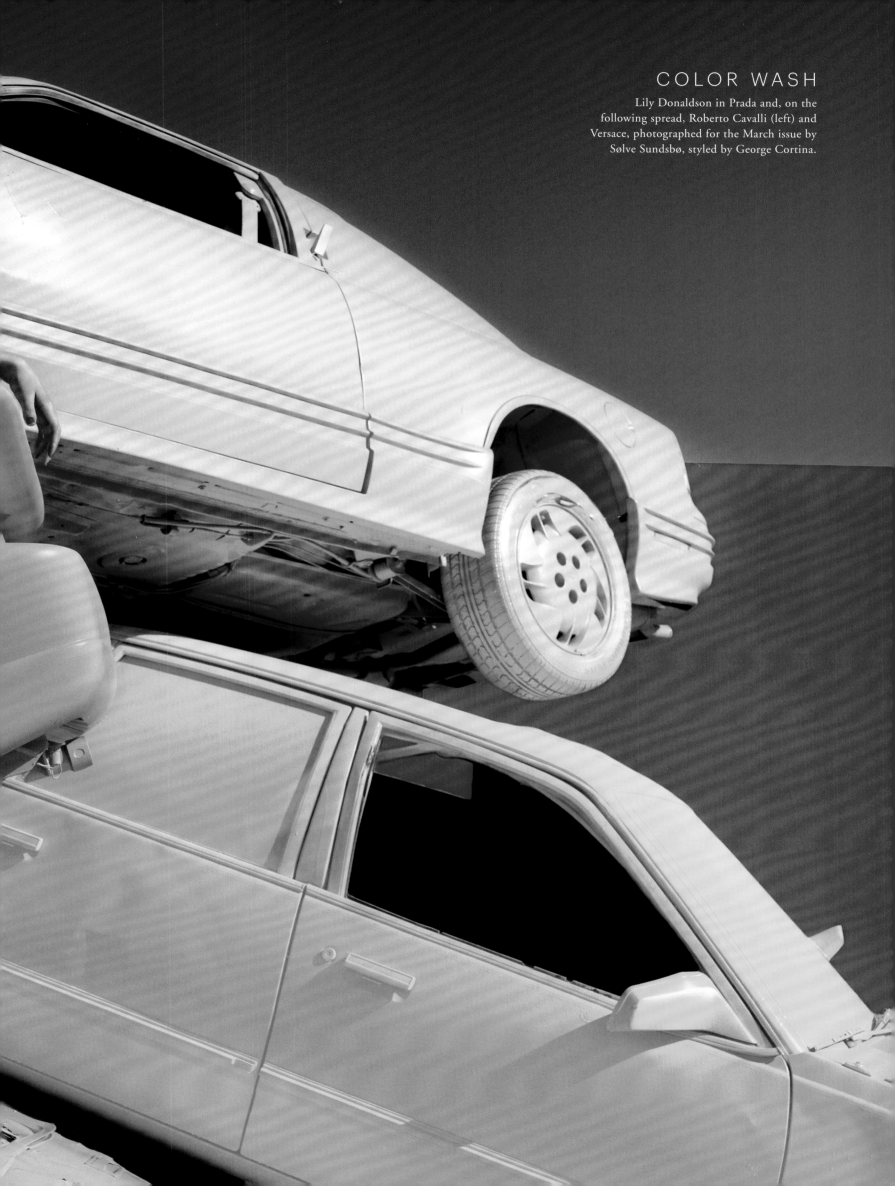

COLOR WASH
Lily Donaldson in Prada and, on the
following spread, Roberto Cavalli (left) and
Versace, photographed for the March issue by
Sølve Sundsbø, styled by George Cortina.

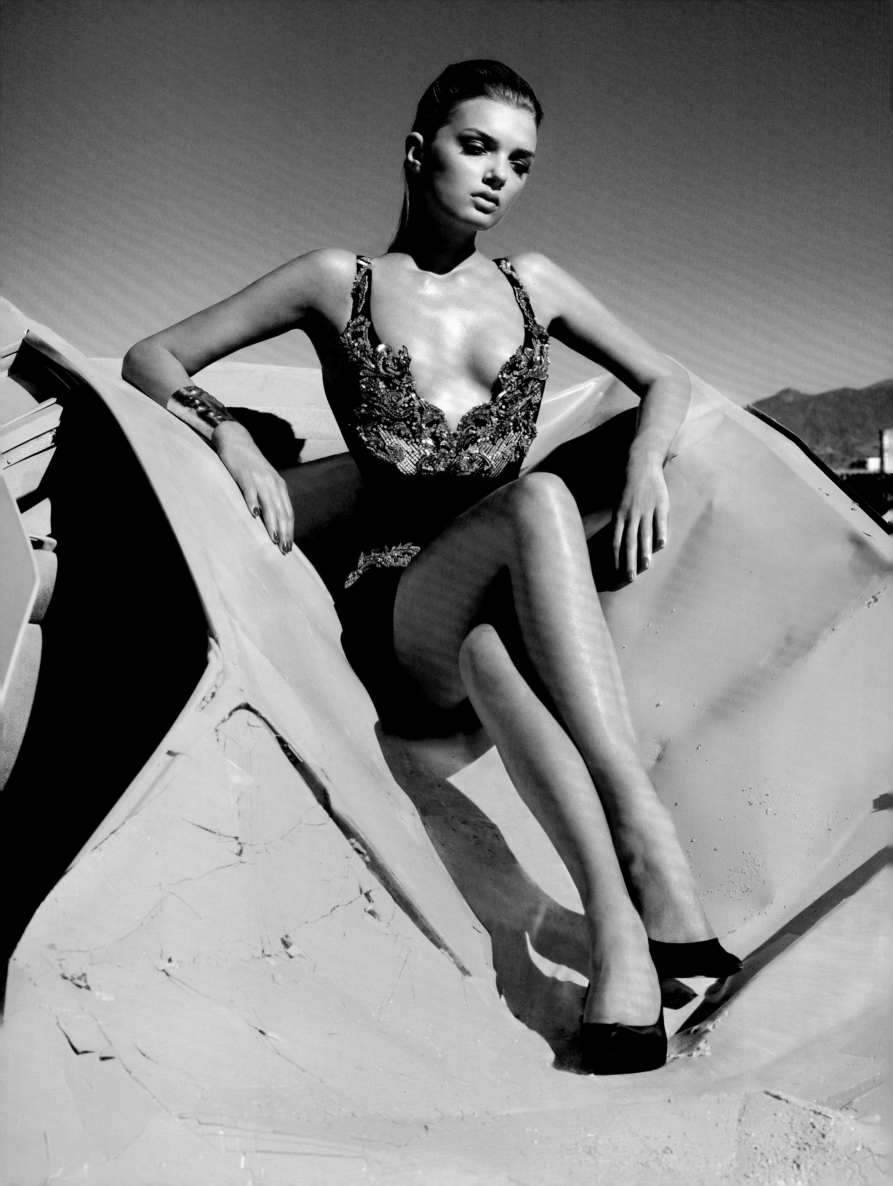

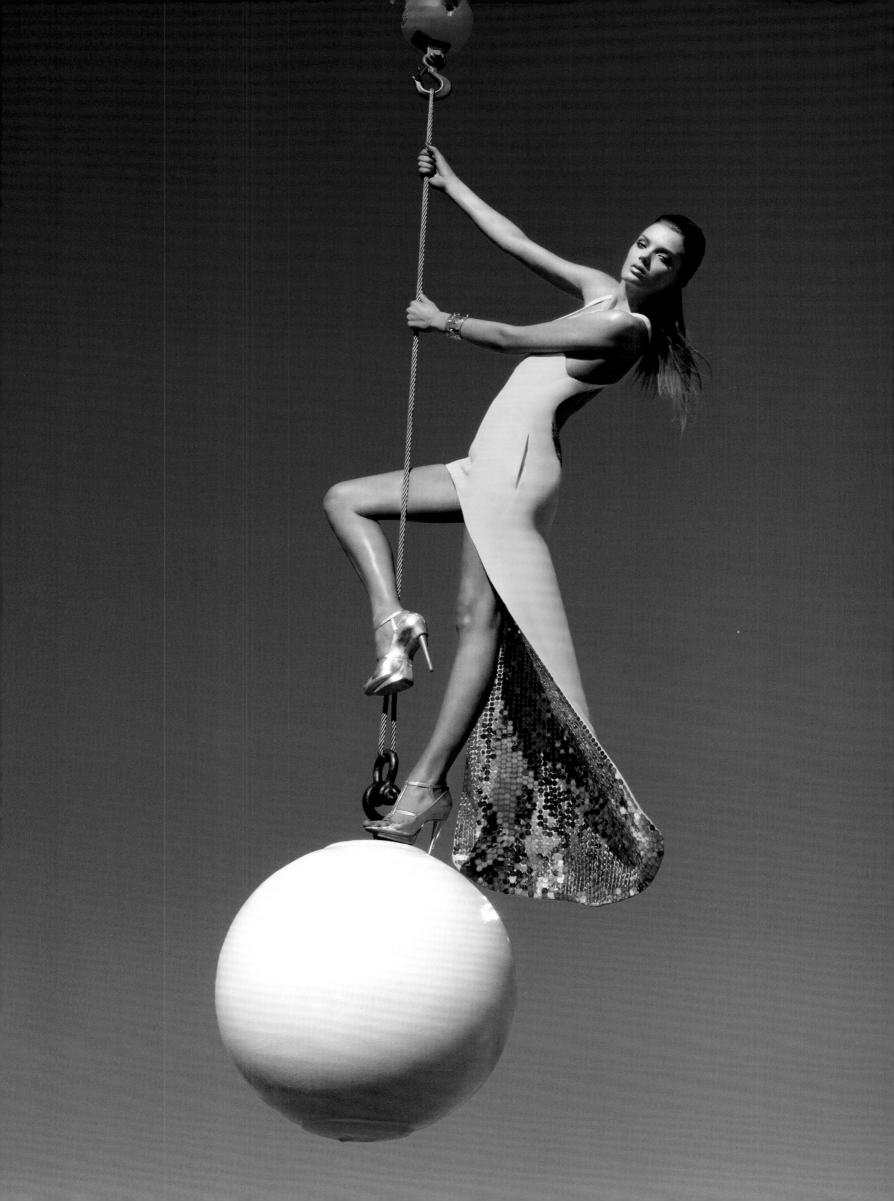

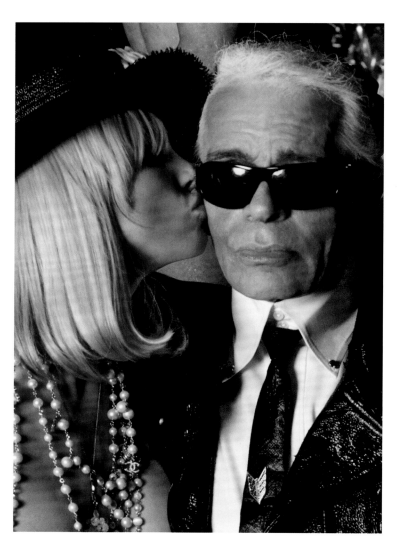

I'D RATHER GO NAKED...

Courtney Love in Chanel, photographed for the September issue by Karl Lagerfeld, styled by Panos Yiapanis.

The headline said it all: "I'd Rather Go Naked Than Wear Fake Chanel." Love drew Lagerfeld's scorn when she appeared in public wearing knockoff Chanel couture (above left). But all was forgiven when *Bazaar* played peacemaker and brought the two together. Lagerfeld shot Love as a reclining nude (save for strand upon strand of pearls, Chanel flats, and a camellia-festooned hat) on Coco Chanel's Rue Cambon couch, and she also donned the real thing (above right).

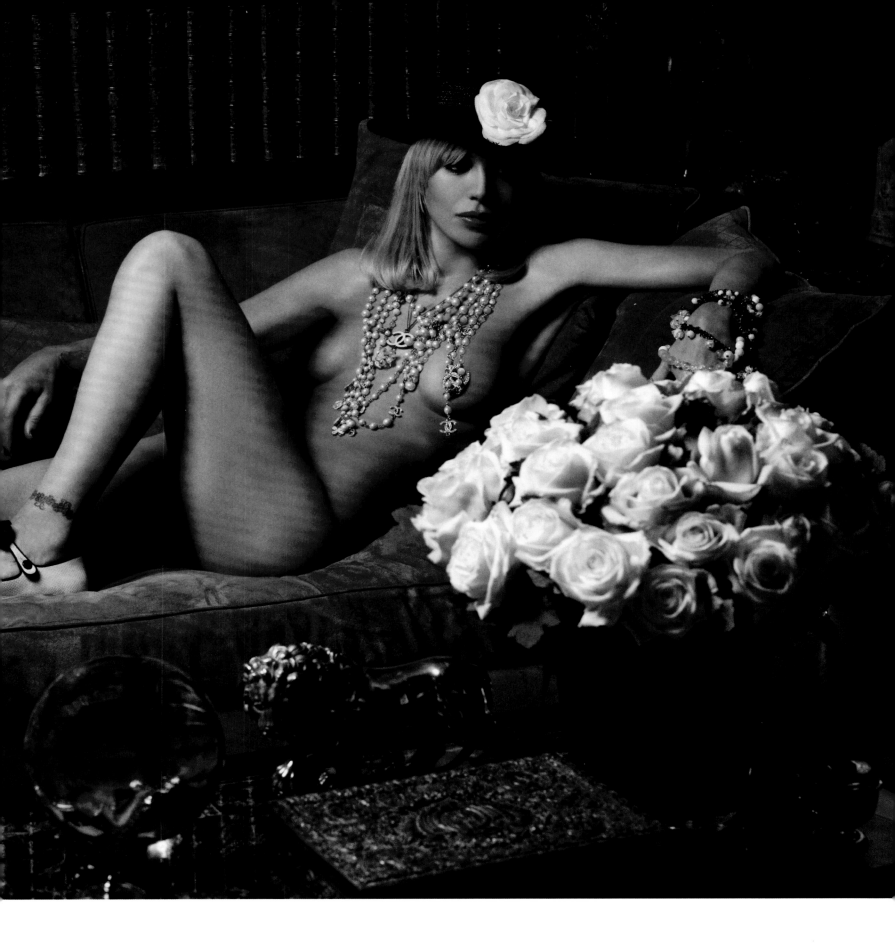

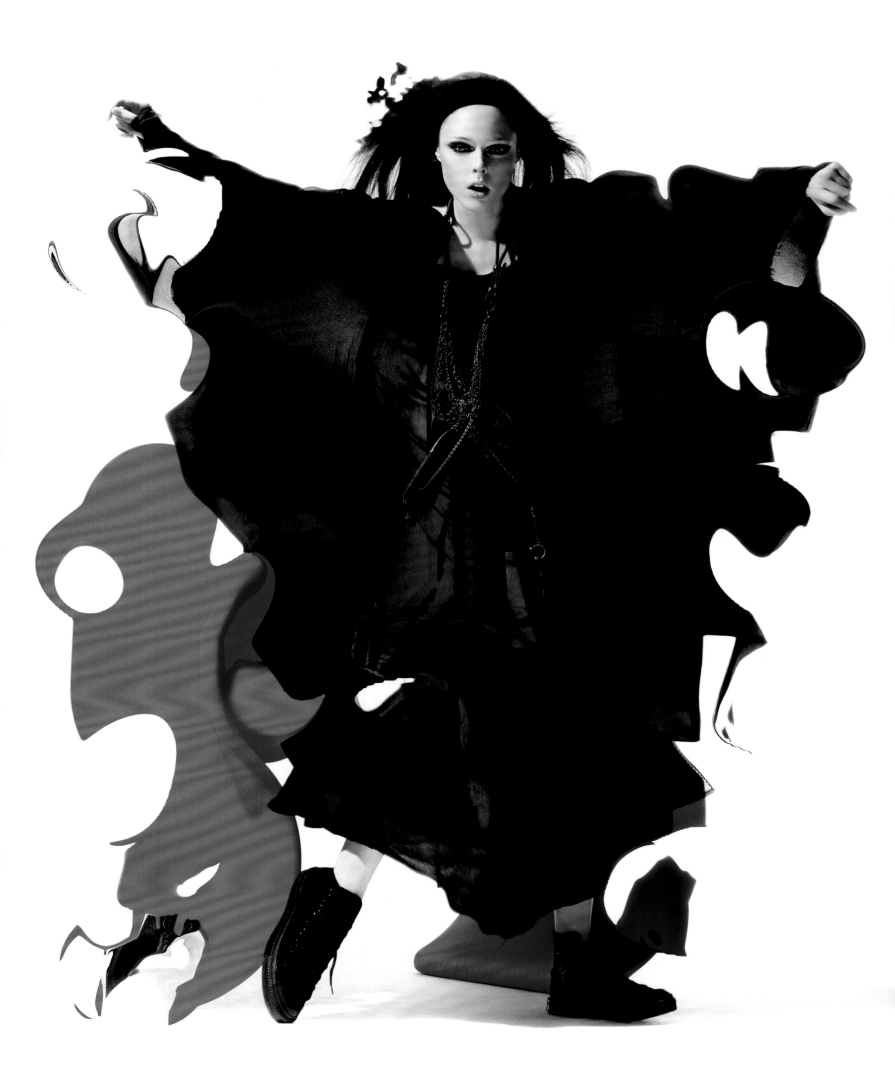

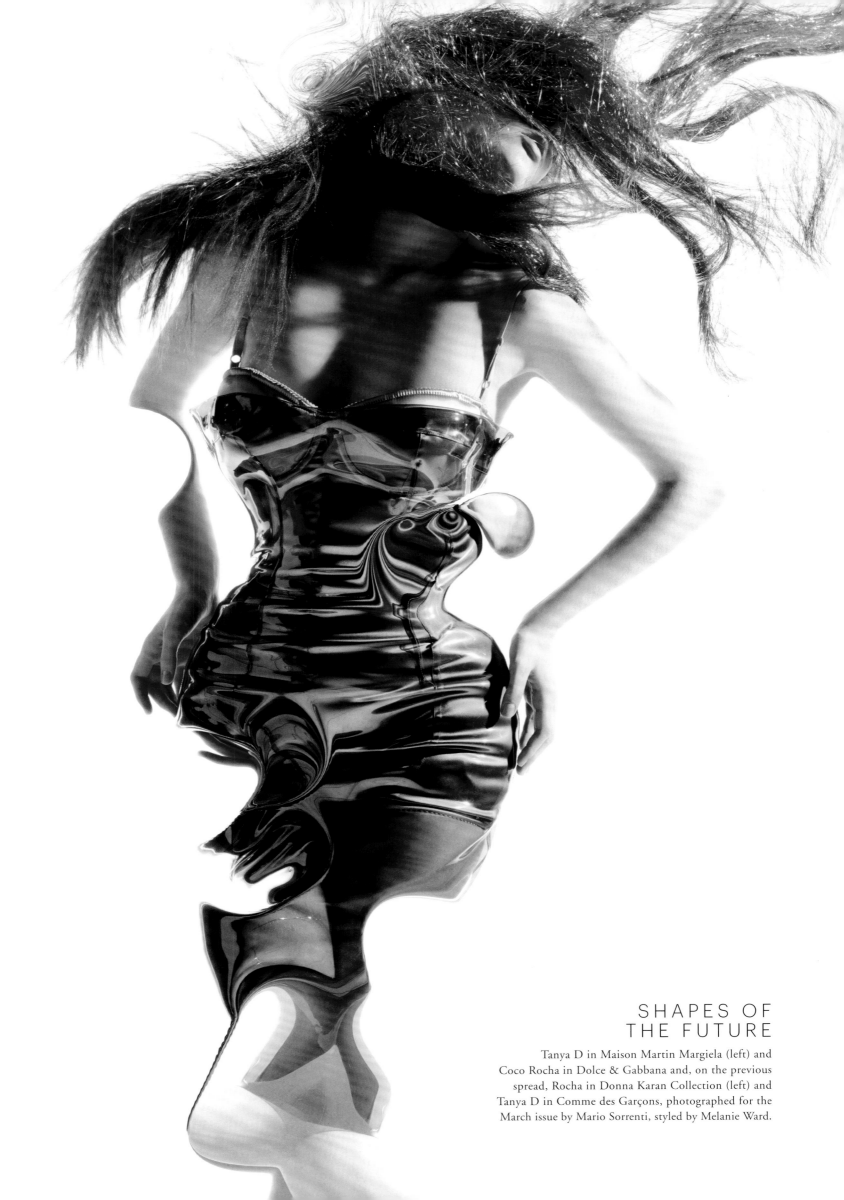

SHAPES OF
THE FUTURE

Tanya D in Maison Martin Margiela (left) and
Coco Rocha in Dolce & Gabbana and, on the previous
spread, Rocha in Donna Karan Collection (left) and
Tanya D in Comme des Garçons, photographed for the
March issue by Mario Sorrenti, styled by Melanie Ward.

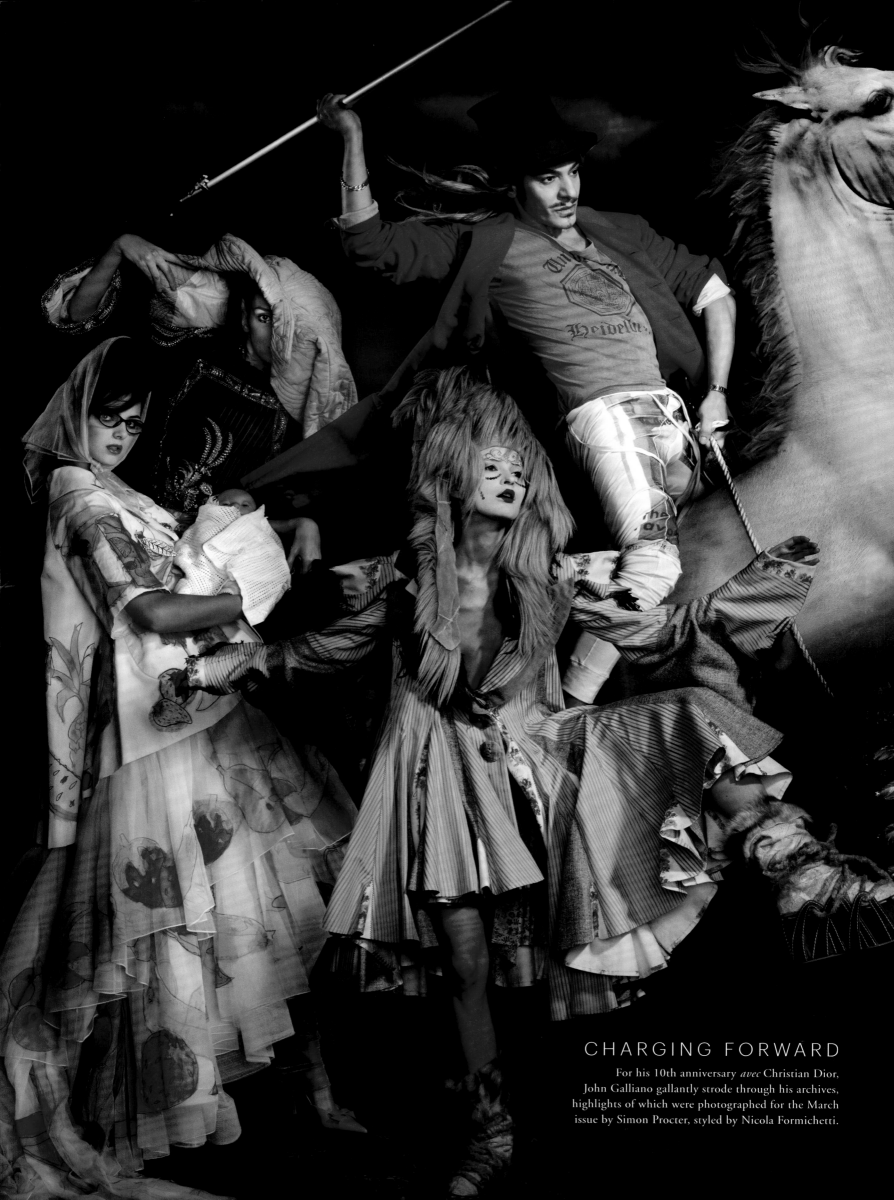

CHARGING FORWARD

For his 10th anniversary *avec* Christian Dior,
John Galliano gallantly strode through his archives,
highlights of which were photographed for the March
issue by Simon Procter, styled by Nicola Formichetti.

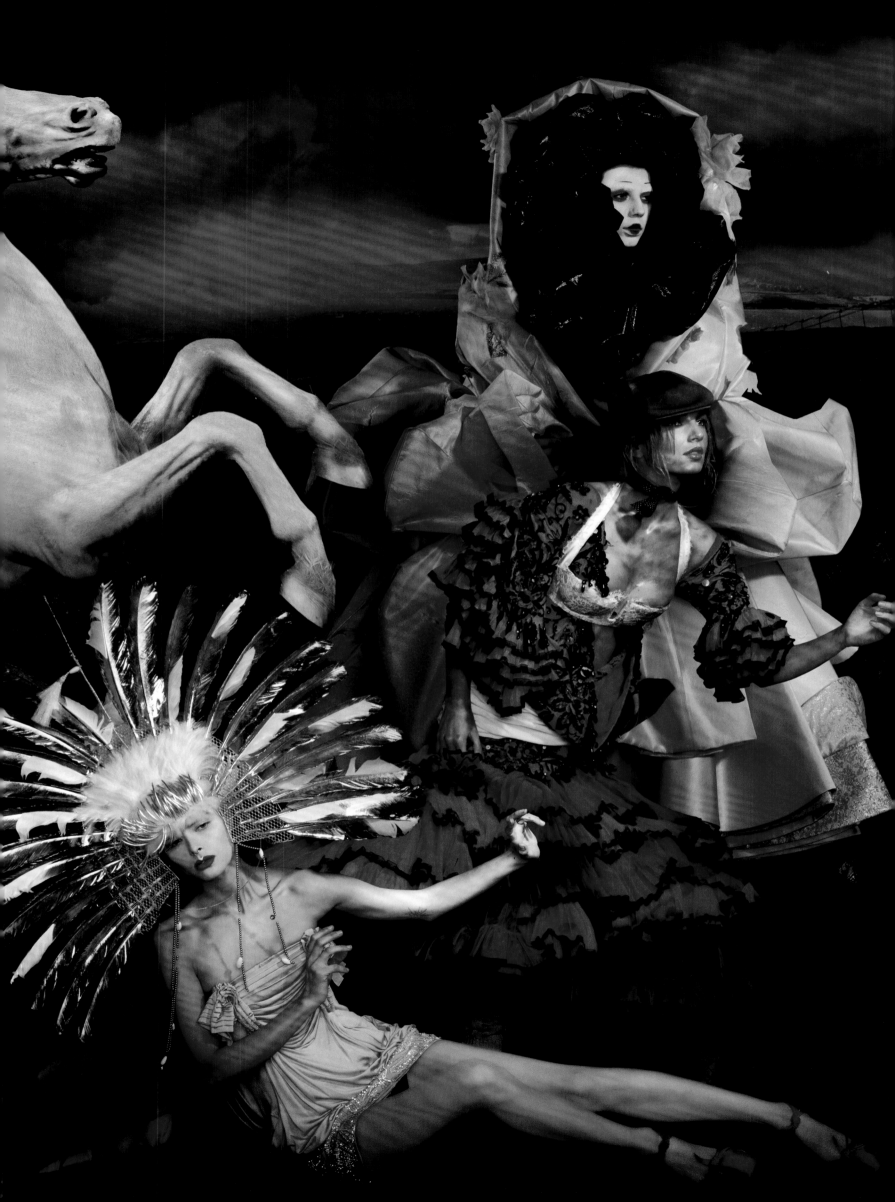

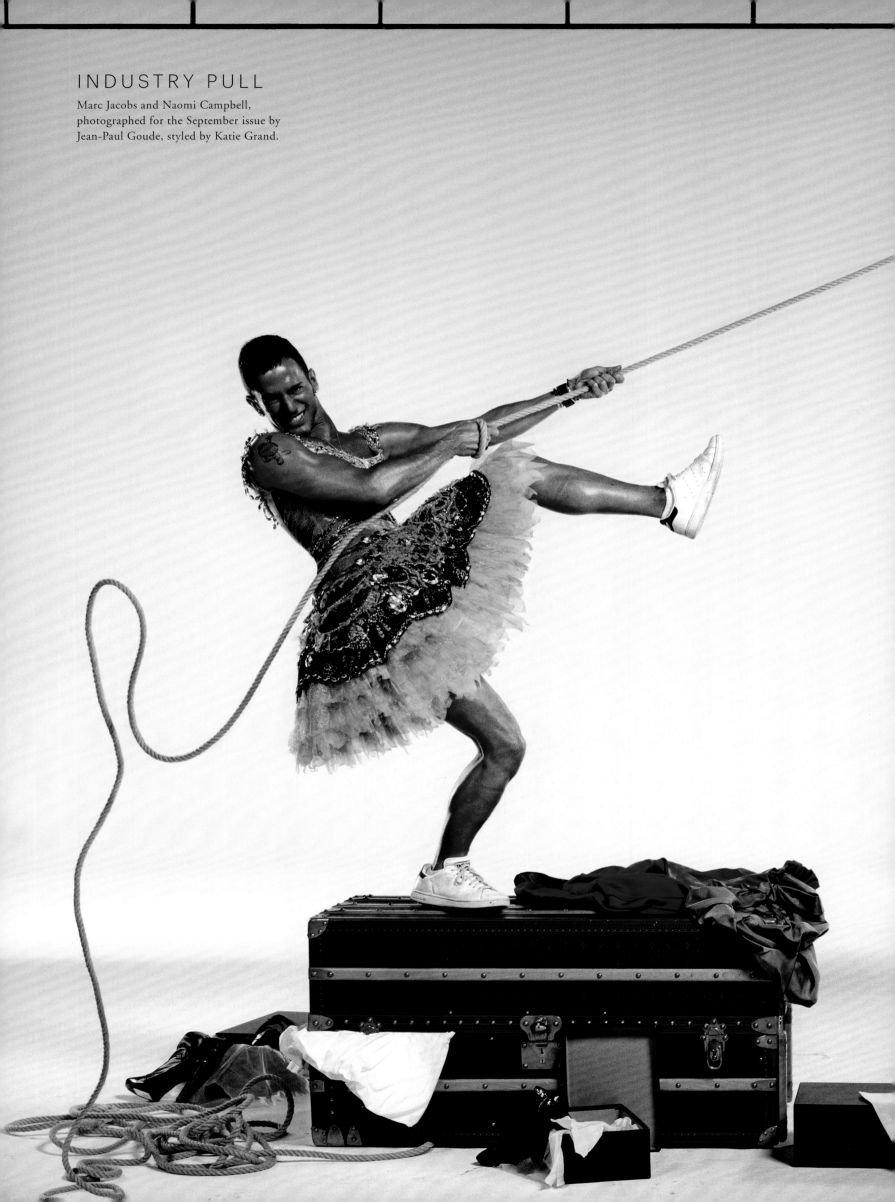

INDUSTRY PULL

Marc Jacobs and Naomi Campbell,
photographed for the September issue by
Jean-Paul Goude, styled by Katie Grand.

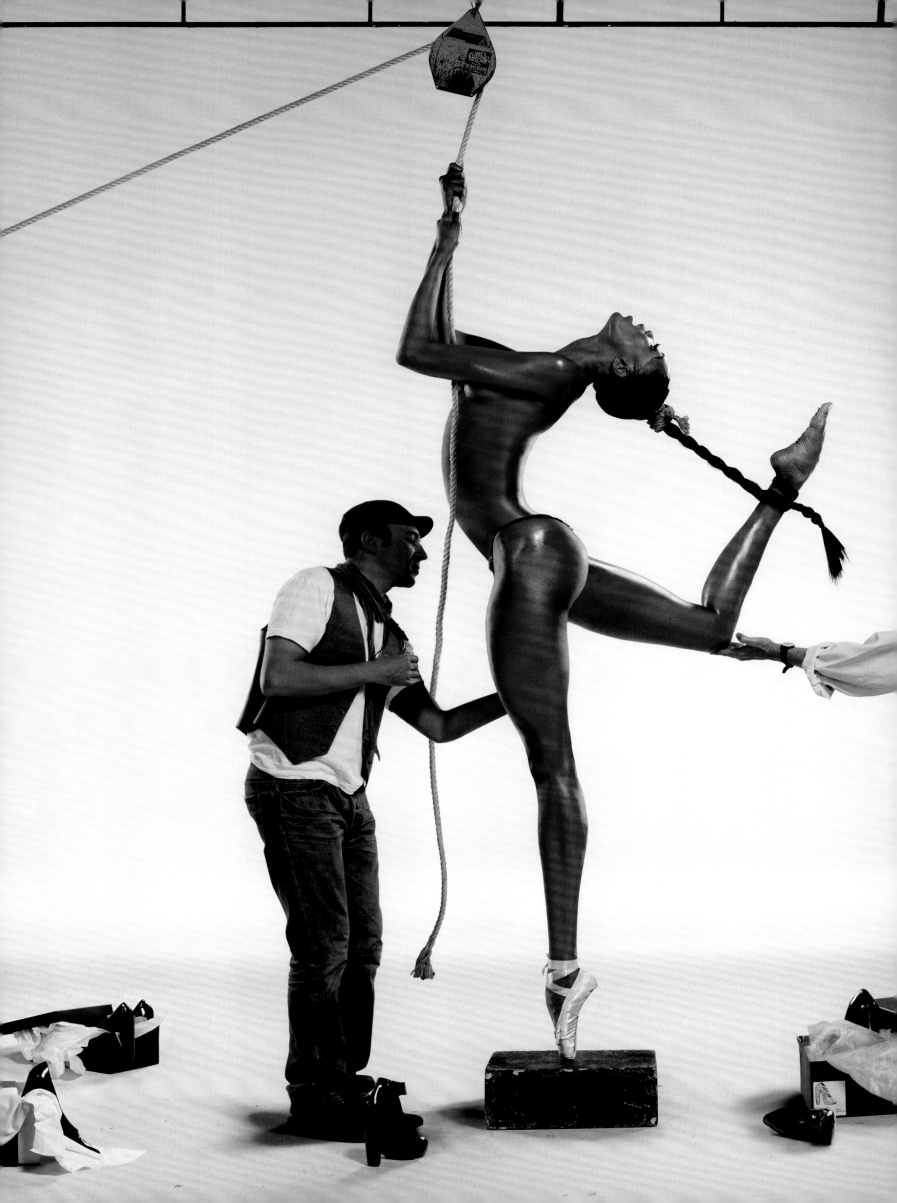

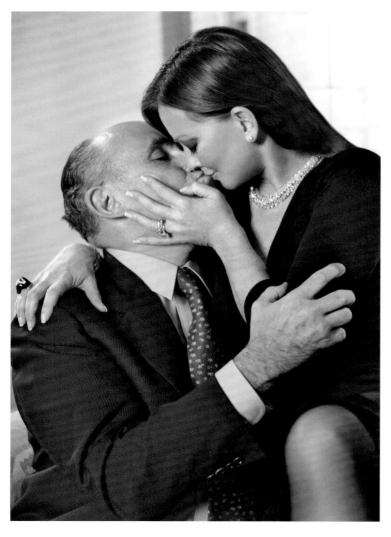

MAKING NEWS

Above left: Sarah Ferguson in Ralph Lauren Collection, photographed for the March issue by François Dischinger, styled by Ann Caruso. The Duchess of York with a riding crop let the British tabloids know she was no one to be trifled with.

Judith and Rudy Giuliani, photographed for the March issue by Martyn Thompson, styled by Ann Caruso. *Bazaar* pictures always grab headlines and get people talking. CNN pundits questioned whether the magazine's image of the Giulianis kissing—and the fact that it appeared on the front page of the *New York Post*—might seal the fate of his presidential candidacy.

THE GETAWAY

Nicole Richie in Carolina Herrera and Michael Kors and Paris Hilton in Michael Kors, photographed for the June issue by Peter Lindbergh, styled by Jenny Capitain.

They survived the fickle moods of fashion, fame, and even each other. United for *Bazaar,* the duo took on the law for a cheeky jewel-heist-inspired shoot. The timing couldn't have been more fortuitous; Hilton landed in jail days after the magazine hit the stands.

BOLD GEOMETRY

Angela Lindvall in Miu Miu and, on the
following spread, Dior by John Galliano (left)
and Lanvin, photographed for the September
issue by Camilla Akrans, styled by Brana Wolf.

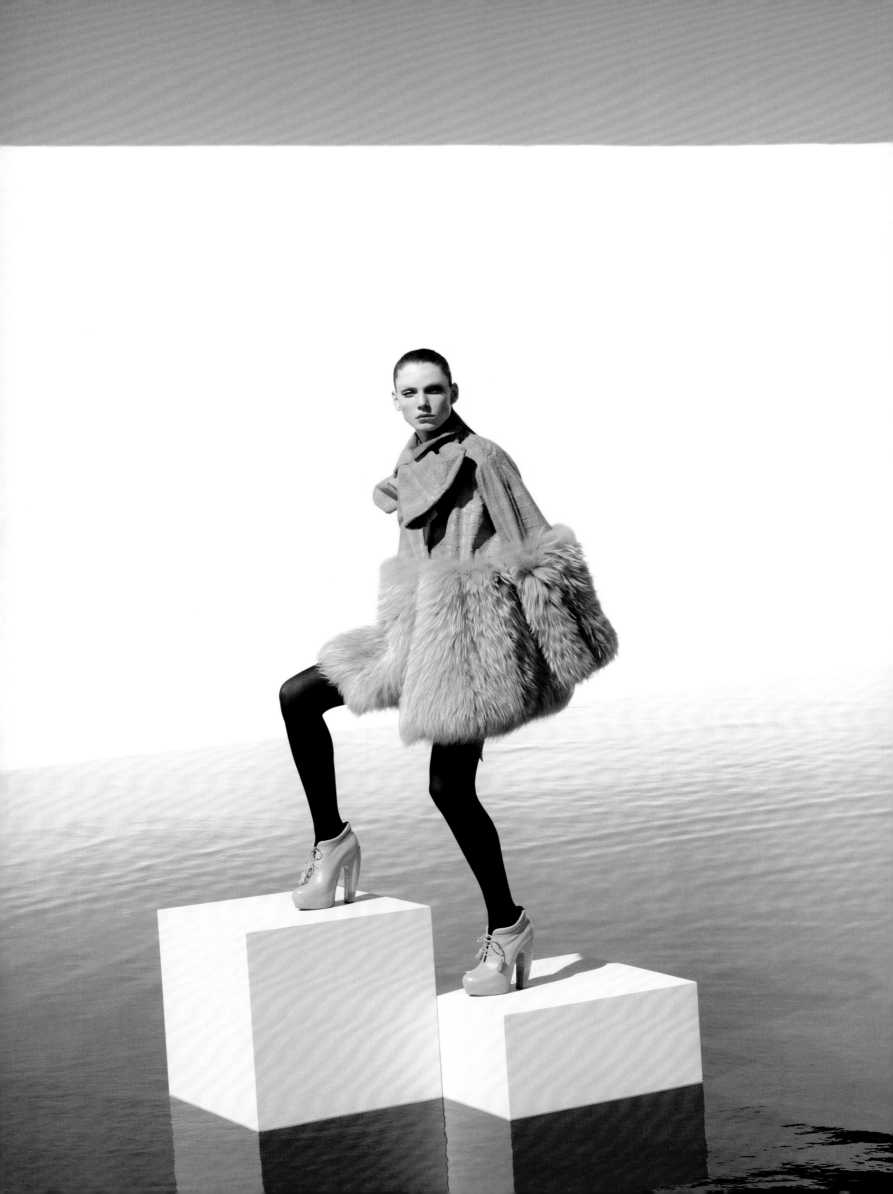

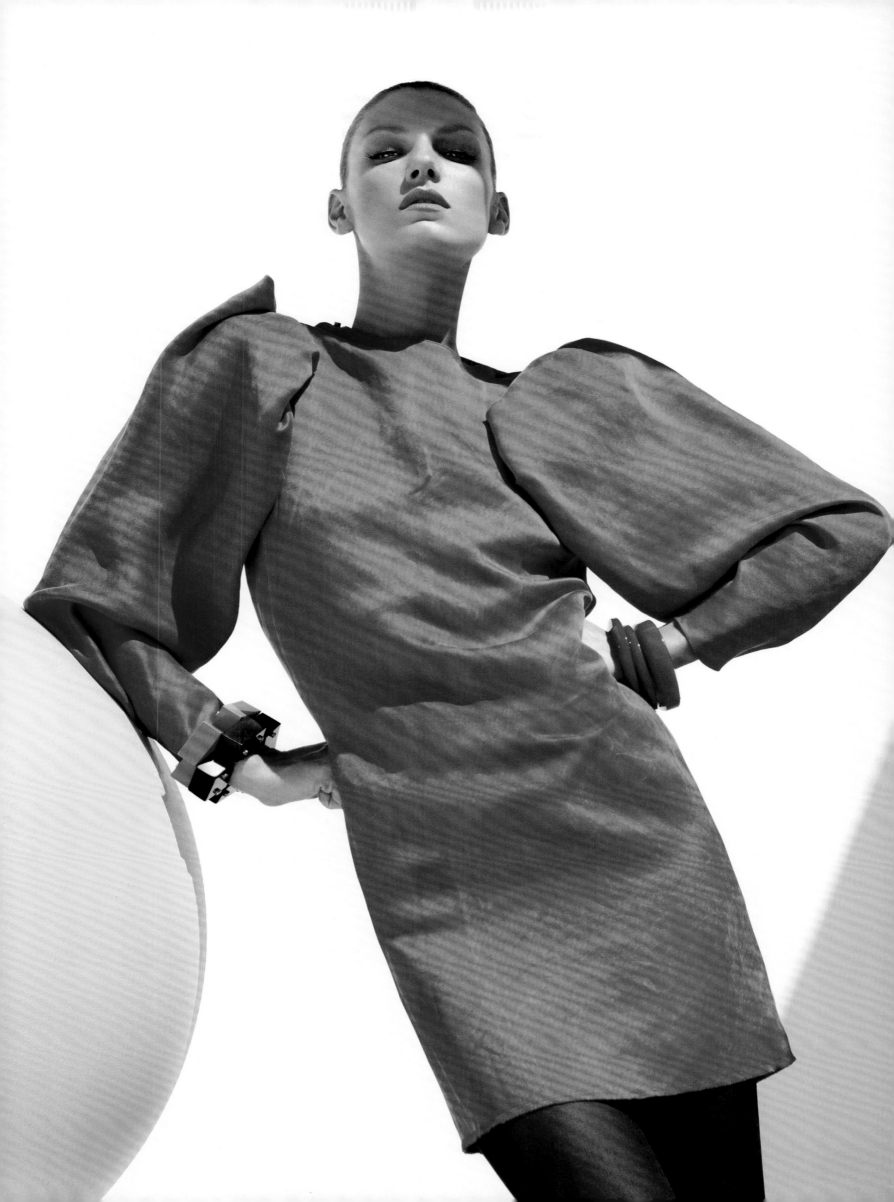

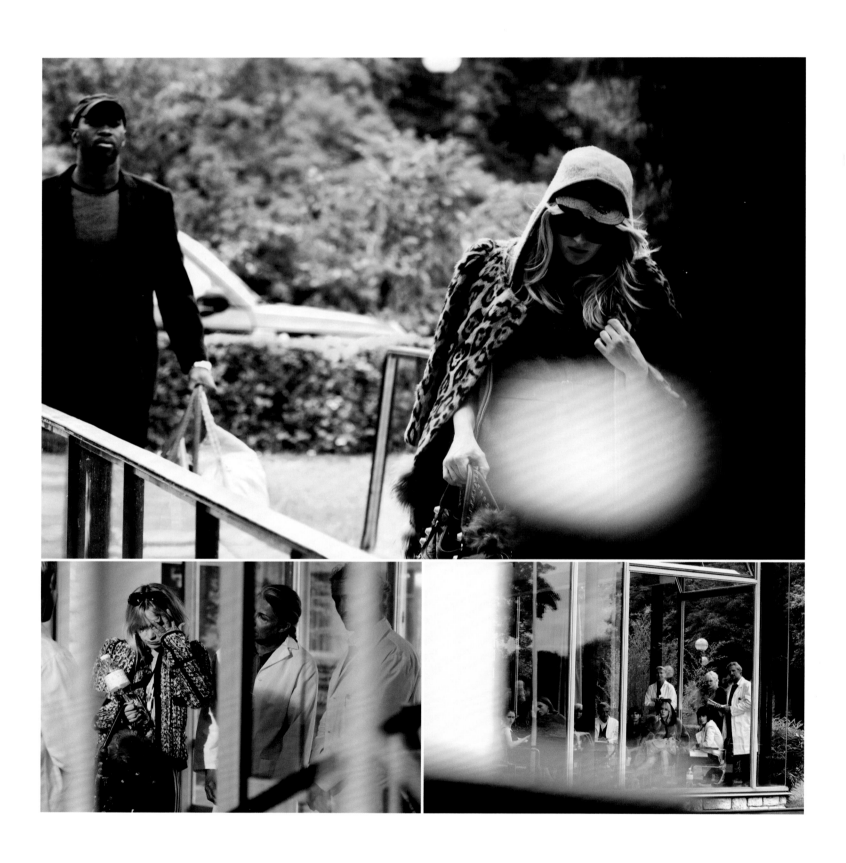

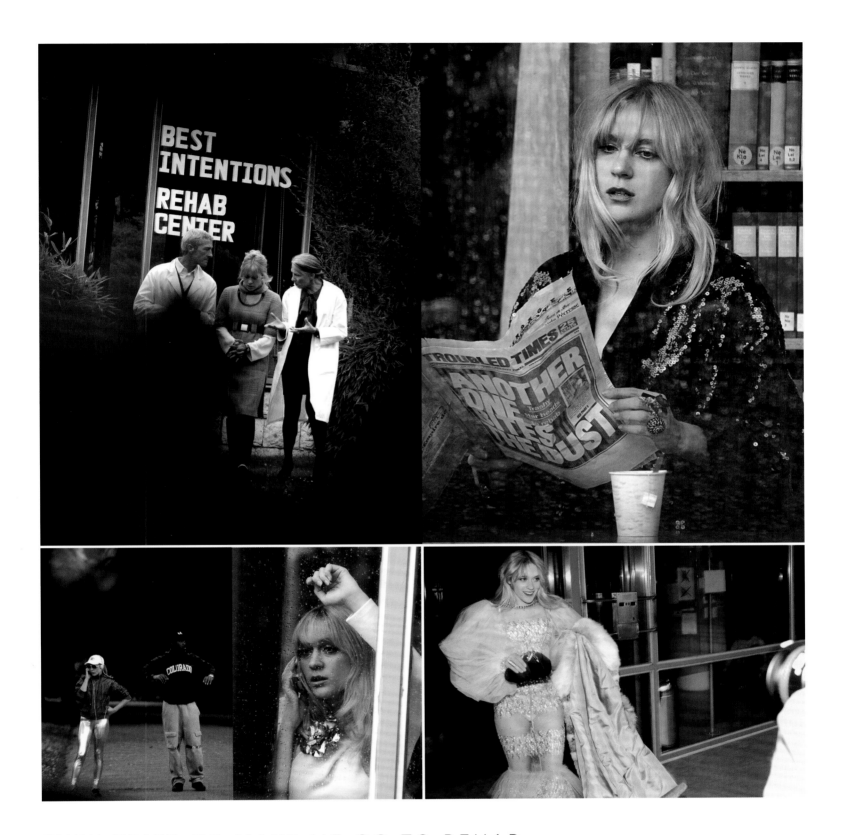

THEY TRIED TO MAKE ME GO TO REHAB

Chloë Sevigny, photographed for the September issue by
Peter Lindbergh, styled by Mary Alice Stephenson.

Borrowing from the Amy Winehouse song—and the trials and tribulations of a host
of young celebrities—Lindbergh played paparazzo, shooting Sevigny with a telephoto lens
for "They Tried to Make Me Go to Rehab." Sevigny checked in, checked out, and was
kept in check by the staff. But for this fictional starlet, the party never stopped.

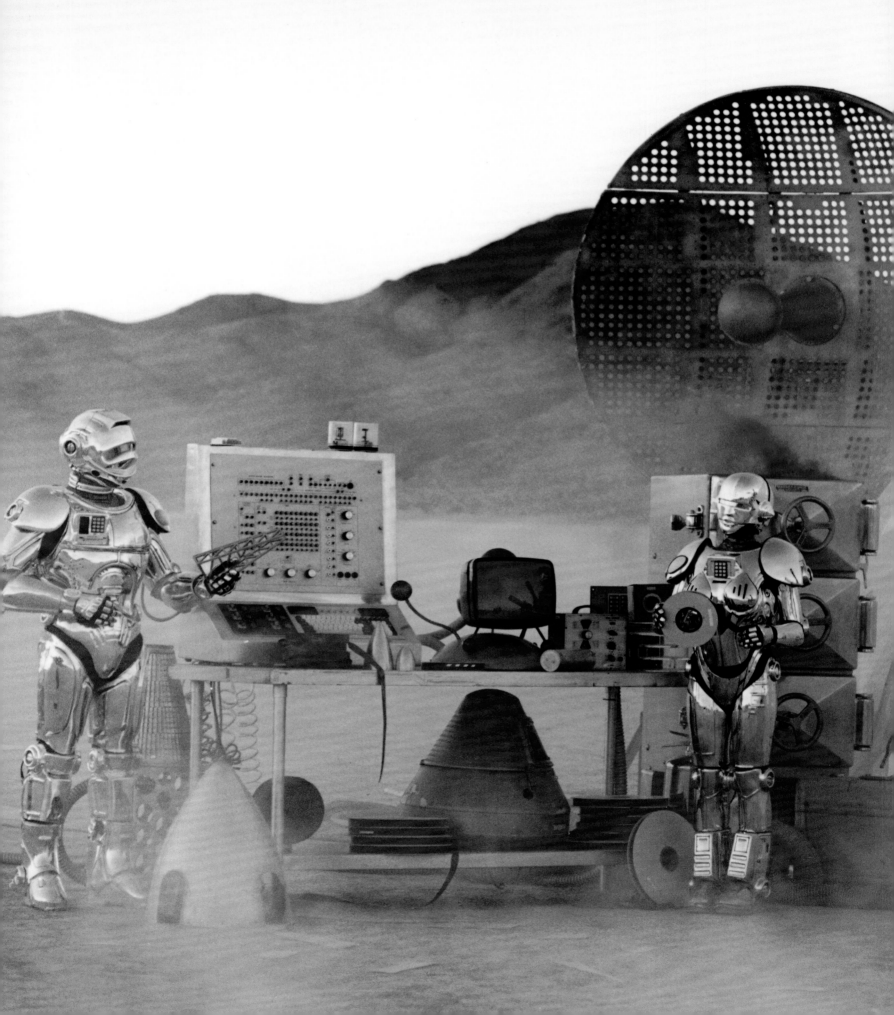

METALLIC MOMENT

Magdalena Frackowiak in Dolce & Gabbana and, on the following spread, Chloé (left) and Anna Molinari, photographed for the March issue by Peter Lindbergh, styled by Brana Wolf. Winner of a Lucie Award for Fashion Layout of the Year.

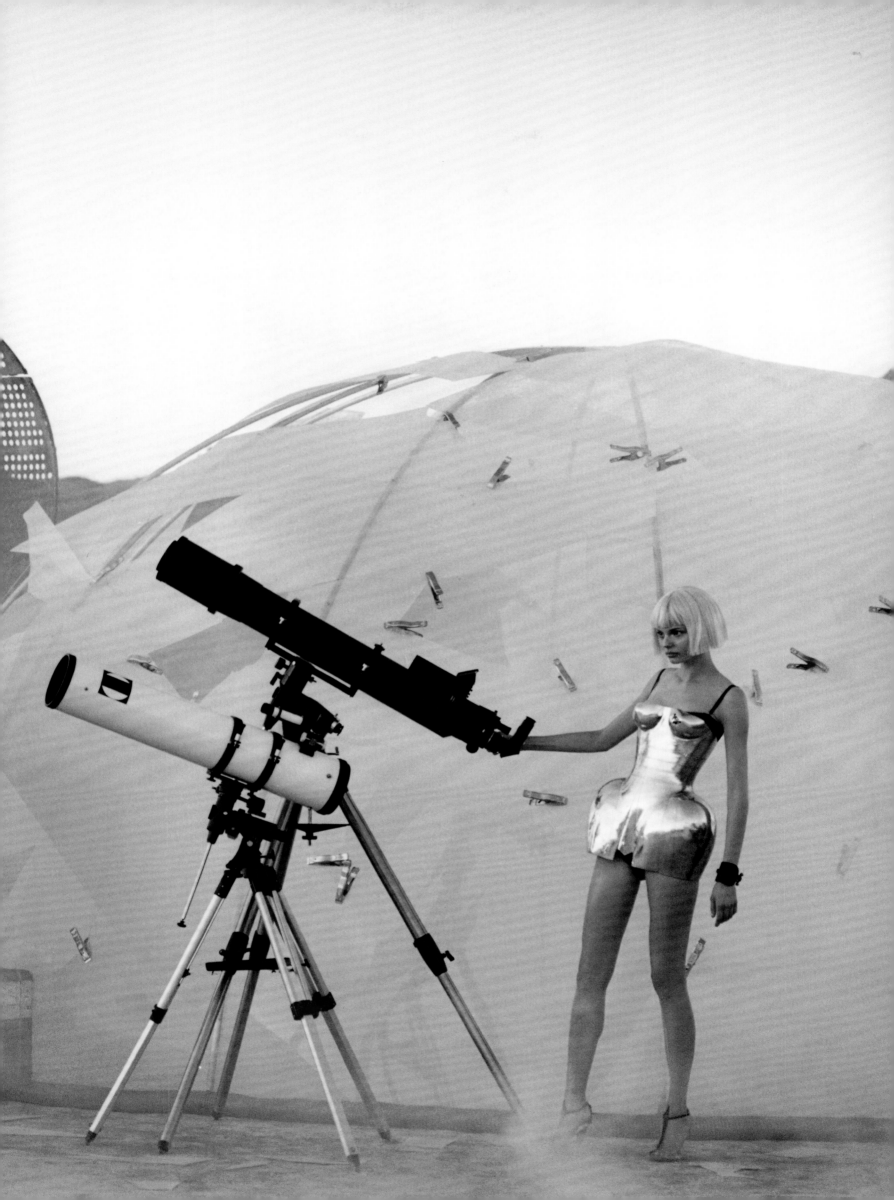

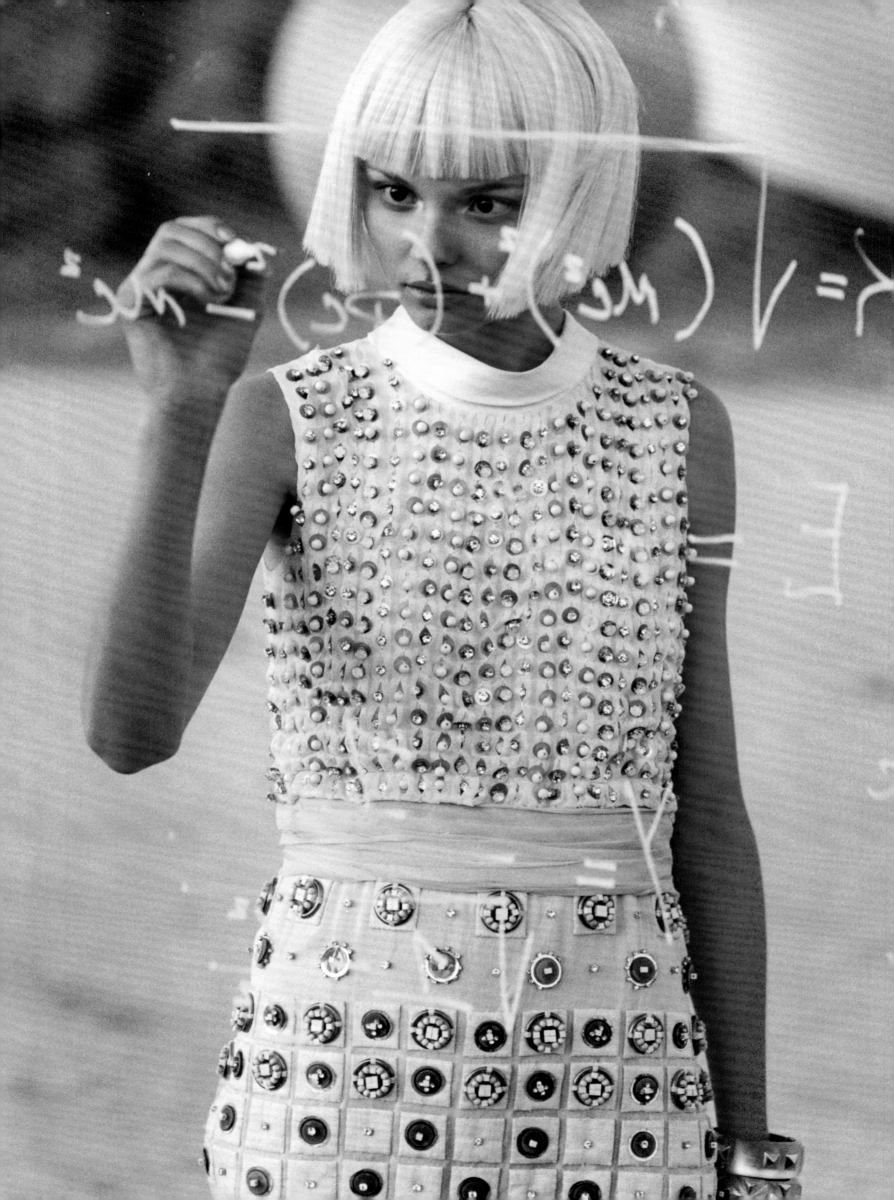

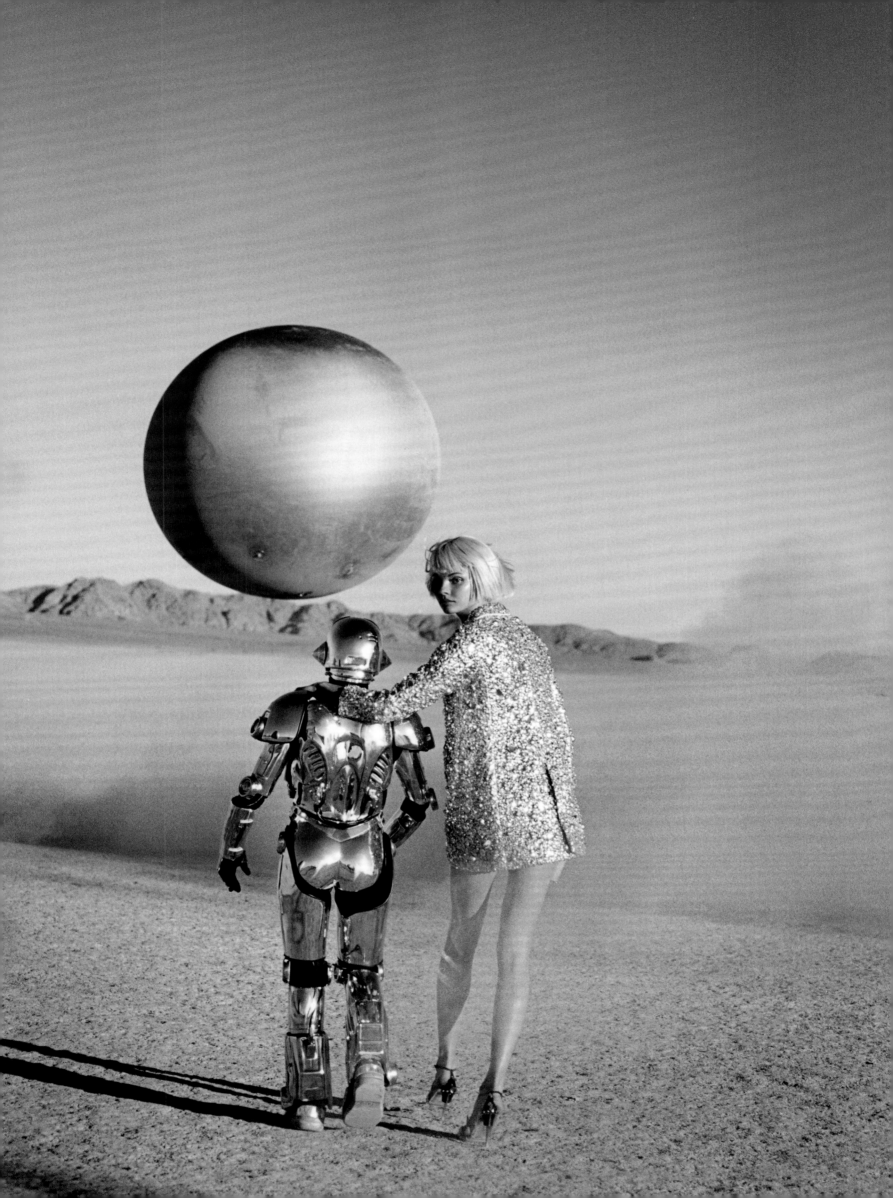

2008

DEVONSHIRE DARLING

Stella Tennant in Valentino Haute Couture, photographed for the October issue
by Karl Lagerfeld, styled by Amanda Harlech.

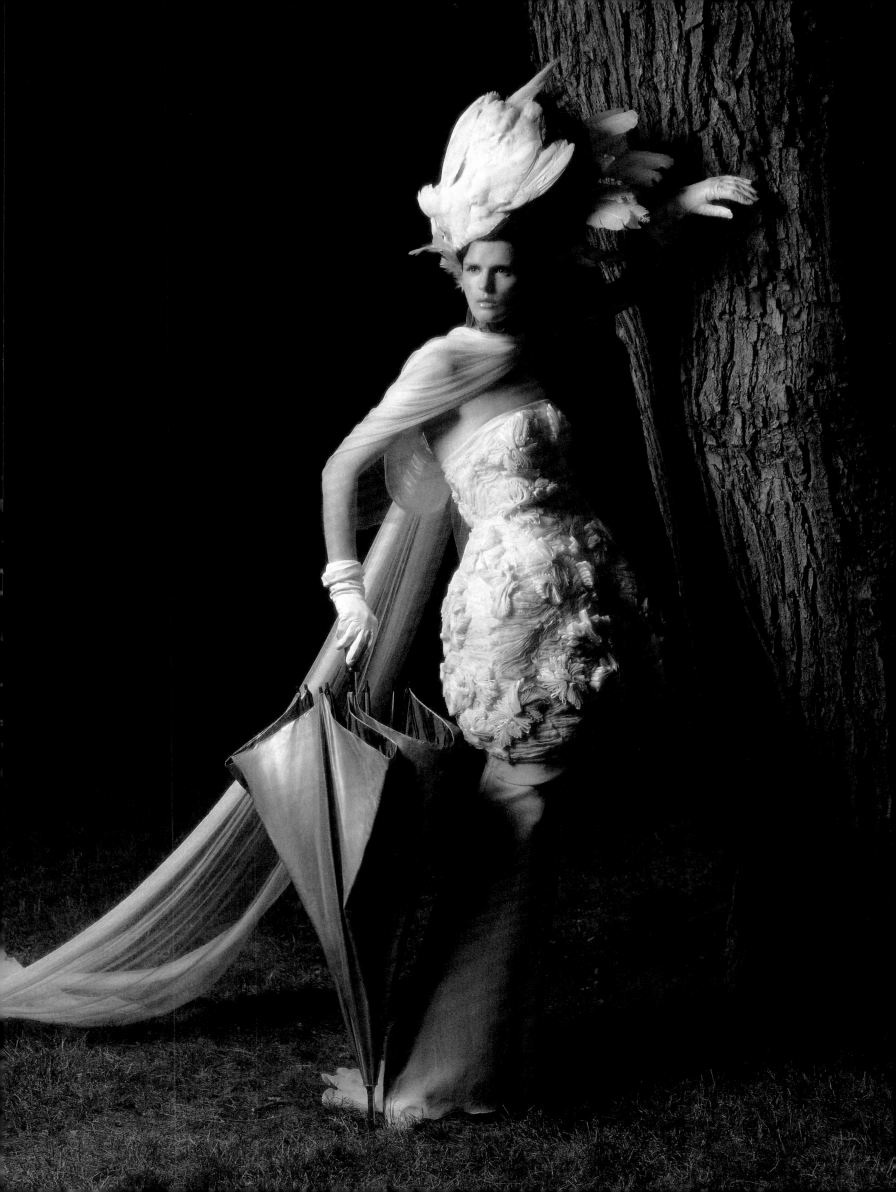

CHIC YOU CAN BELIEVE IN

FROM THE BEGINNING, 2008 was rich with possibility. Change was in the air. In February, *Bazaar* "met" the presidential front-runners in Peter Lindbergh's "The Politics of Fashion." Cardboard cutouts of the contenders joined model Nadja Auermann on the campaign trail. The story posed a question: In politics, is what you see ever what you get?

While the political powers were setting the world right, the super-powerful were squiring designer-clad damsel in distress Lindsay Lohan through the streets of Los Angeles in March's "I Need a Hero." Though playful, the story acknowledged Lohan's real-life issues.

A different sort of winged warrior populated Jean-Paul Goude's "Fairy Tales," in the season's most ethereal gowns. The resulting photographs turned childhood fantasy into fashion reality.

Accessories took center stage in Gan's idea for a March collaboration between photographer Richard Burbridge and fashion's favorite whimsical surrealist illustrator, Ruben Toledo.

In March, *Bazaar* turned its irreverent eye to Marc Jacobs and his notoriously tardy fashion shows. Complete with a ticking clock, Lindbergh's portfolio "On Your Marc, Get Set … Wait!" starred Marc Jacobs's president, Robert Duffy, and friends like Cindy Sherman and Kim Gordon. The upshot? Sometimes great fashion is worth waiting for. Jacobs took the gentle ribbing with his trademark good nature. His shows have started on time ever since.

Bazaar toyed with time again in May, transporting Julianne Moore to seminal moments in art history. In "Portrait of a Lady," Moore stepped in for the flame-haired muses of artists John Currin and Richard Prince, among others, illustrating both the eternal allure of the work and the artistry of the season's fashion.

For September's cover story, Tyra Banks played soon-to-be first lady Michelle Obama with a Barack Obama lookalike who snuggled with her as they wore matching Harvard sweatshirts. It gave America a preview of how good the new White House could look.

With the election right around the corner, the economy weighed heavily on everyone's minds. And by September, the recession was in full force. *Bazaar* tackled the subject with stories that focused on investment dressing.

It was also the perfect time to escape, so *Bazaar* invited some of its favorite designers to indulge in flights of fancy. For a Halloween masquerade, Karl Lagerfeld traded chez Chanel for *Run's House* and dressed as a rapper, and Donatella Versace played the fabled young royal beauty from *The Princess and the Pea.* And in "The Magic of Fashion," *Harry Potter* actress Emma Watson cast a wondrous spell over British designer Alexander McQueen.

The phenomenally popular young wizardry series had many fans that year, including First Lady Laura Bush, who was profiled by Nancy Collins on the eve of her departure from the White House. The lifelong literary advocate was photographed curling up with *Harry Potter and the Chamber of Secrets*—and her black cat, Willie—in the Lincoln Bedroom.

That story, and indeed the year, ended with the election of Obama and the beginning of a new era.

PORTRAITS OF A LADY

Julianne Moore in Armani Privé and, on the following spread,
Louis Vuitton (left) and Bottega Veneta, photographed for
the May issue by Peter Lindbergh, styled by Jenny Capitain.

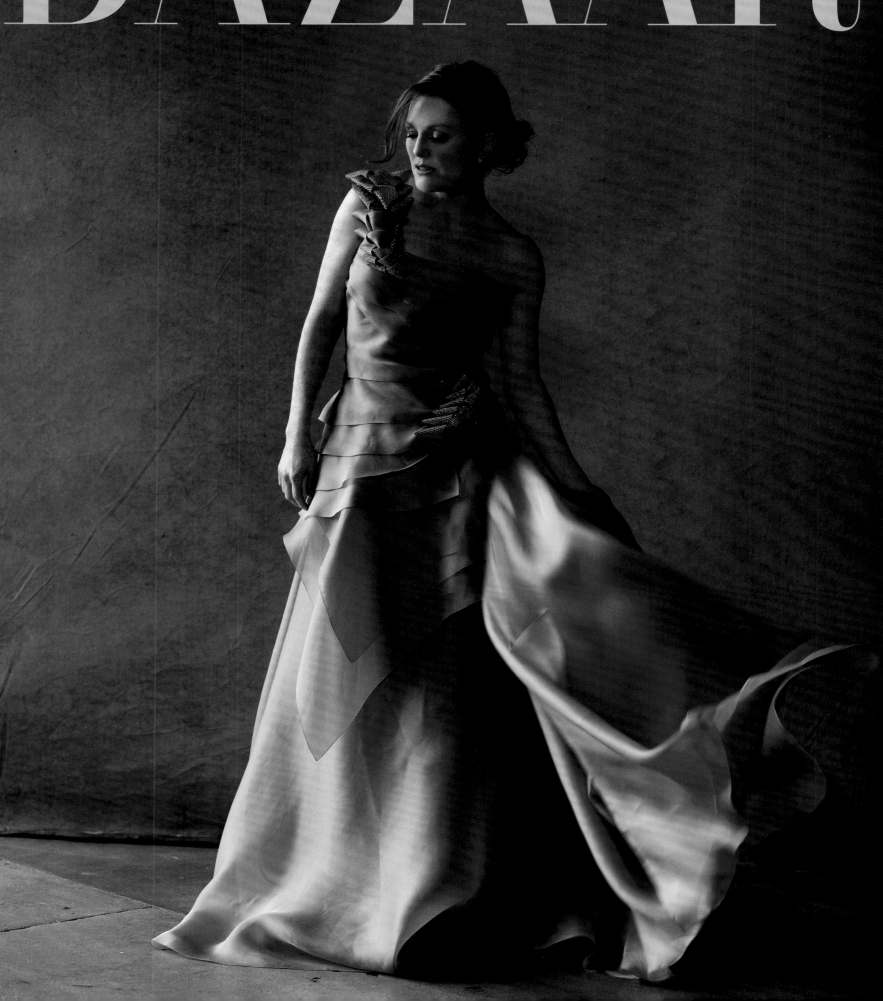

Harper's
BAZAAR

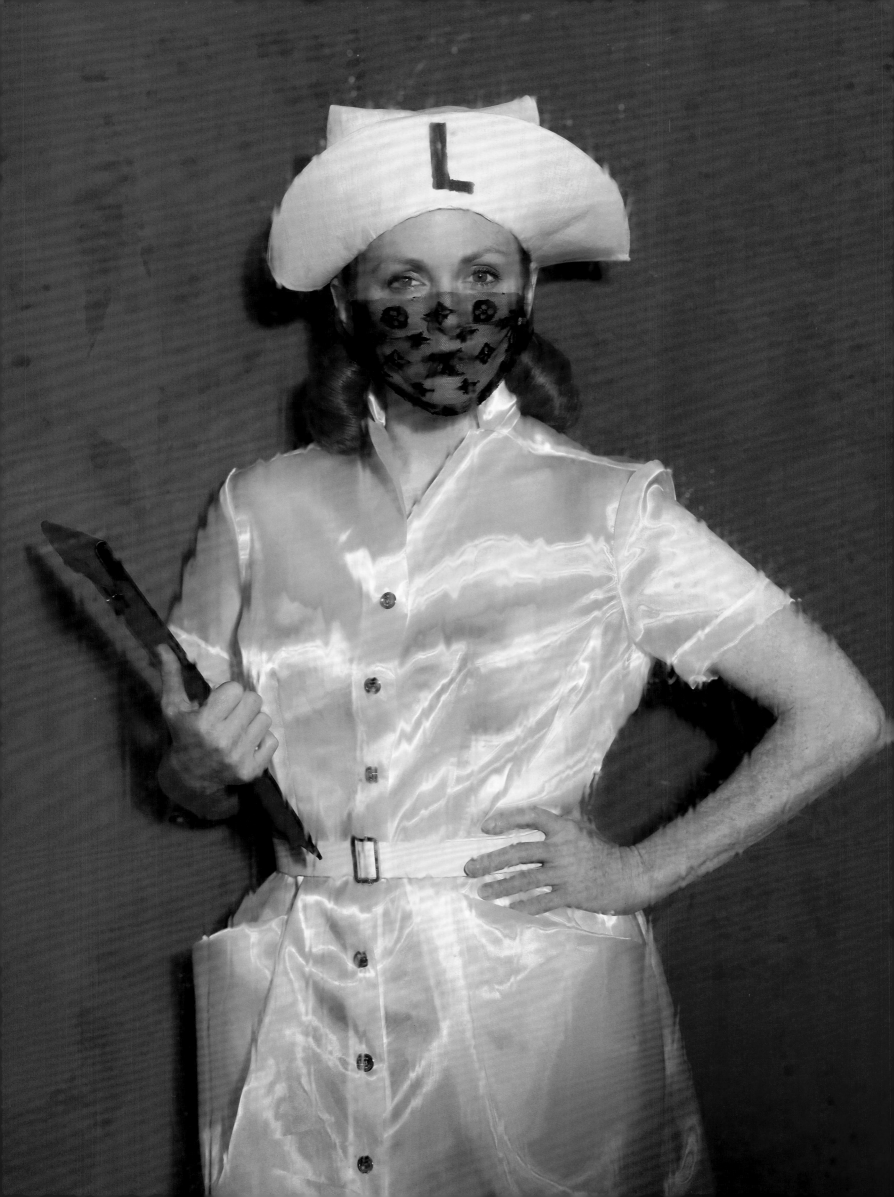

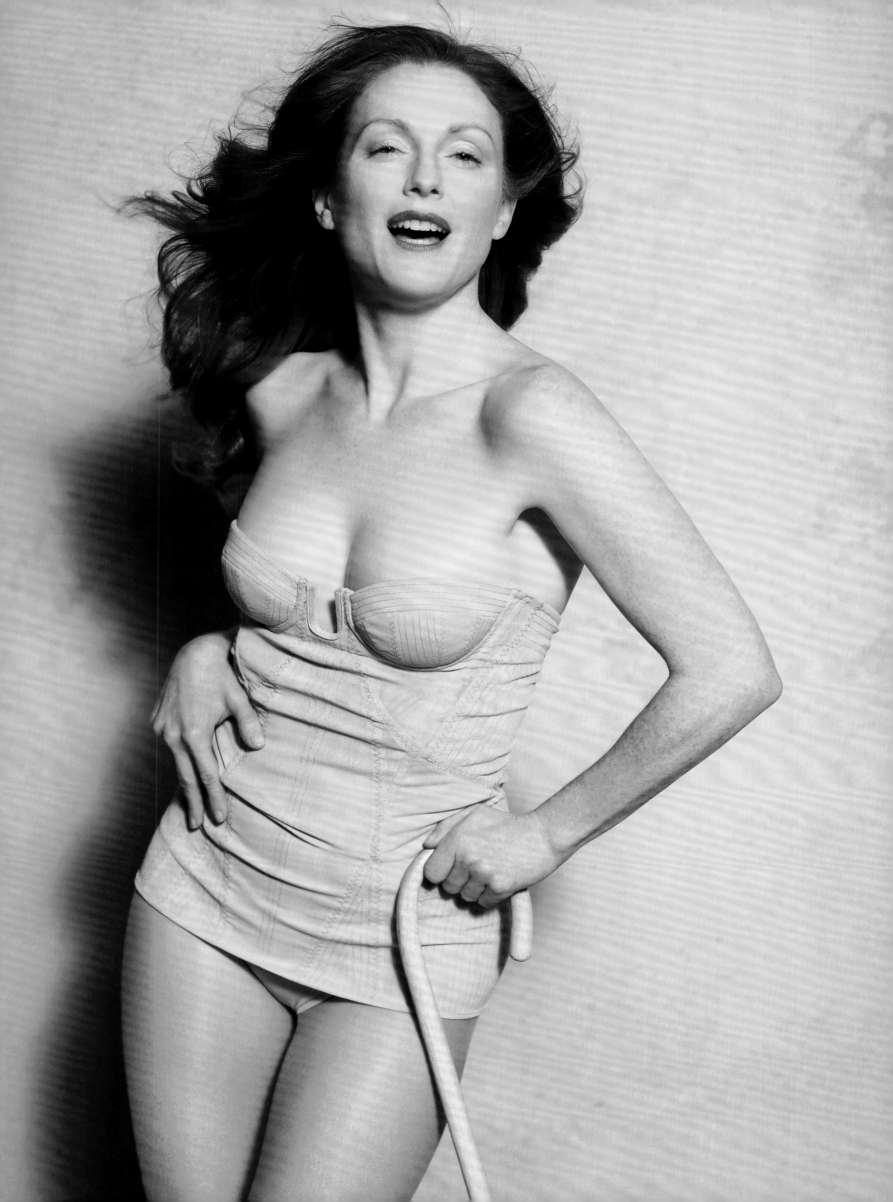

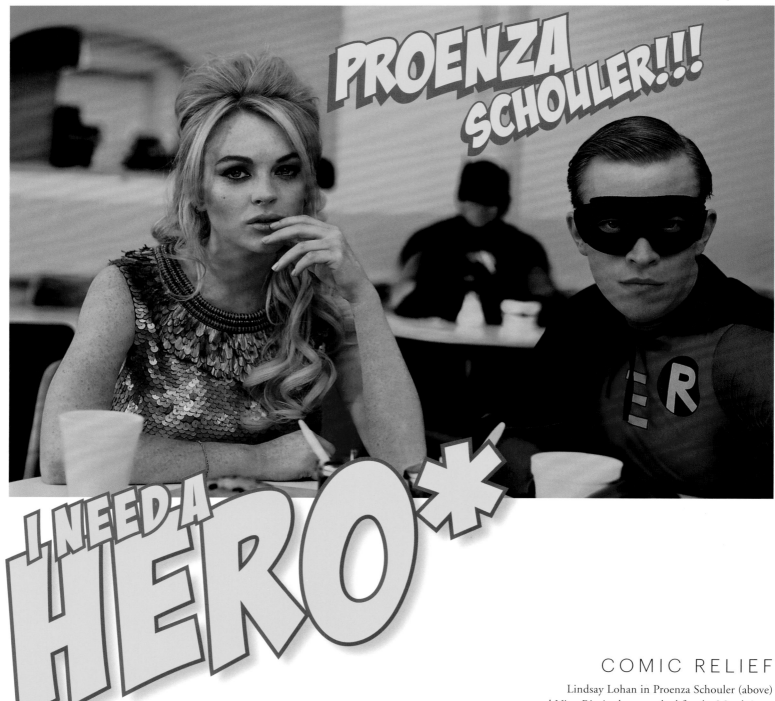

PROENZA SCHOULER!!!

I NEED A HERO*

COMIC RELIEF

Lindsay Lohan in Proenza Schouler (above)
and Nina Ricci, photographed for the March issue
by Peter Lindbergh, styled by Brana Wolf.

✳ These are not real superheroes—although
don't we wish they were? BATMAN & ROBIN
are TM DC Comics. All Rights Reserved.

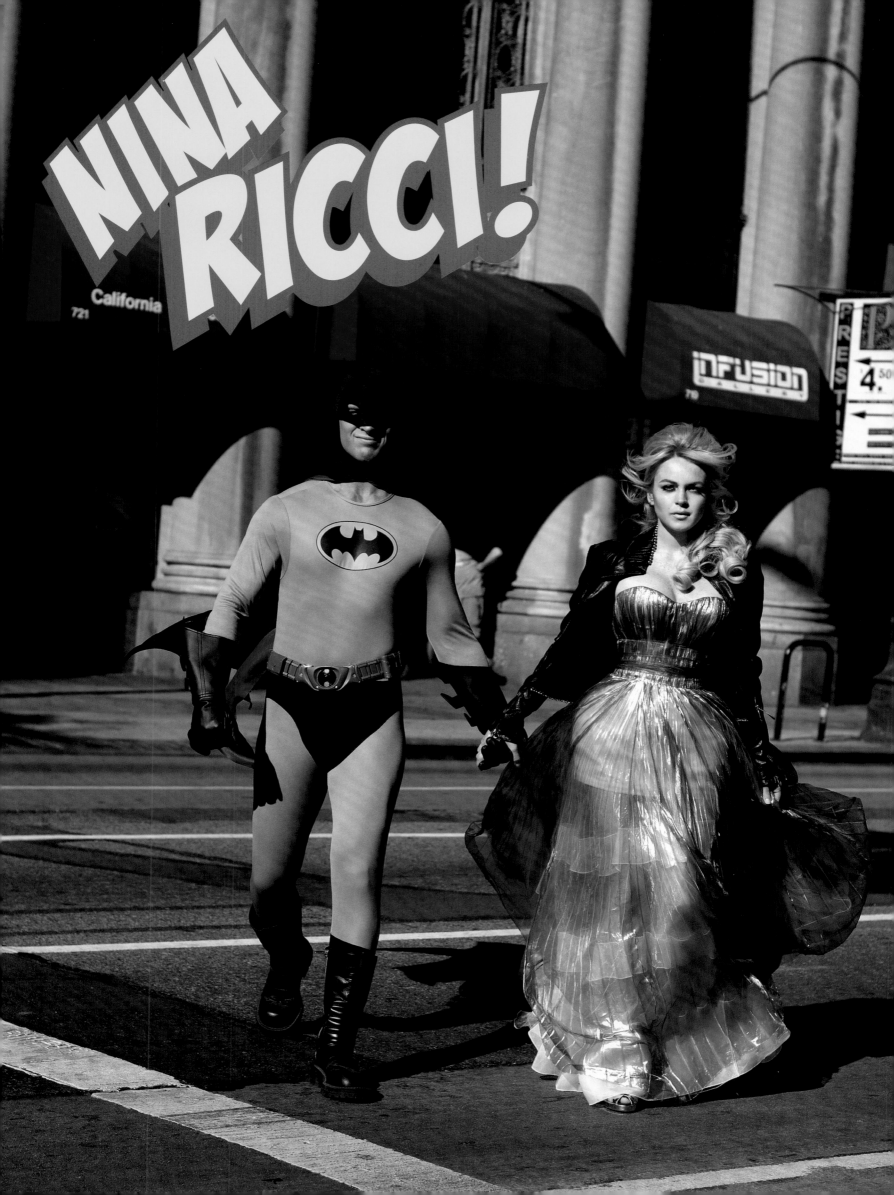

THE POLITICS OF FASHION

What matters more in the 2008 presidential election, style or substance?

BY ARIANNA HUFFINGTON

Excerpted from the October 2007 issue

EVER SINCE JFK TOOK the country by storm, with Jackie and her glamorous Oleg Cassini–designed wardrobe by his side, personal style has been an important component of a candidate's appeal. But the celebritization of politics has reached new heights. With Election Day 2008 still more than a year away, we've already had breathless stories about Obama in a bathing suit and endless mentions of first female speaker Nancy Pelosi's Armani-filled wardrobe and love of Tahitian pearls. And Mitt Romney has been the object of a veritable media man crush, with Chris Matthews gushing about "the perfect chin, the perfect hair" and the *Politico*'s Roger Simon swooning over Romney's "chiseled-out-of-granite features" and "shoulders you could land a 737 on." Who says metrosexuality is only for liberals?

For the record, Obama looks buff, Romney *is* leading-man handsome, and Pelosi gets high marks for elegance. Are these things relevant to what kinds of leaders these people are? Of course not. Do we care how our leaders look? Of course we do. Style shouldn't trump substance—but it is a factor.

To a point. Because, despite the undeniable ascendance of gossip-magazine politics, the American people still have a schizophrenic attitude toward the subject. On the one hand, we want our politicians to look good: attractive, fashionable, well dressed, and perfectly groomed. But we definitely don't want to think of their spending any time or money—or even any thought—on achieving the proper look. We want the steak but don't want to hear about the slaughterhouse.

As is the case in society at large, women in Washington tend to receive more attention for their fashion choices than do their male counterparts, although this could change as the *Queer Eye/Extreme Makeover* mentality becomes further entrenched. Senator Clinton's evolving styles (including her Oscar de la Renta pantsuits, which she pays for herself) have gotten almost as much ink as her evolving political positions. In February, Donatella Versace advised her to tap into her femininity, and she clearly listened. Her coral jacket and the cleavage-revealing top she wore on the Senate floor in mid-July drew the attention of the *Washington Post* and many others in the media, while her talk about the cost of higher education went virtually unnoticed.

Secretary of State Condoleezza Rice has, of course, famously found herself raked across the fashion coals on more than one occasion. Remember the torrent of bad press she received for spending "thousands of dollars" on Ferragamo shoes? Of course, that might have had something to do with her Manhattan shopping spree occurring while people in New Orleans were still dying in the aftermath of Hurricane Katrina.

As for me, here are my style requirements for a possible president: Don't go hat in hand to big-money donors (who always want something in return), don't be afraid to wear your heart on your sleeve, and, for goodness' sake, when someone asks for a show of hands of those who don't believe in evolution, keep your arm by your side.

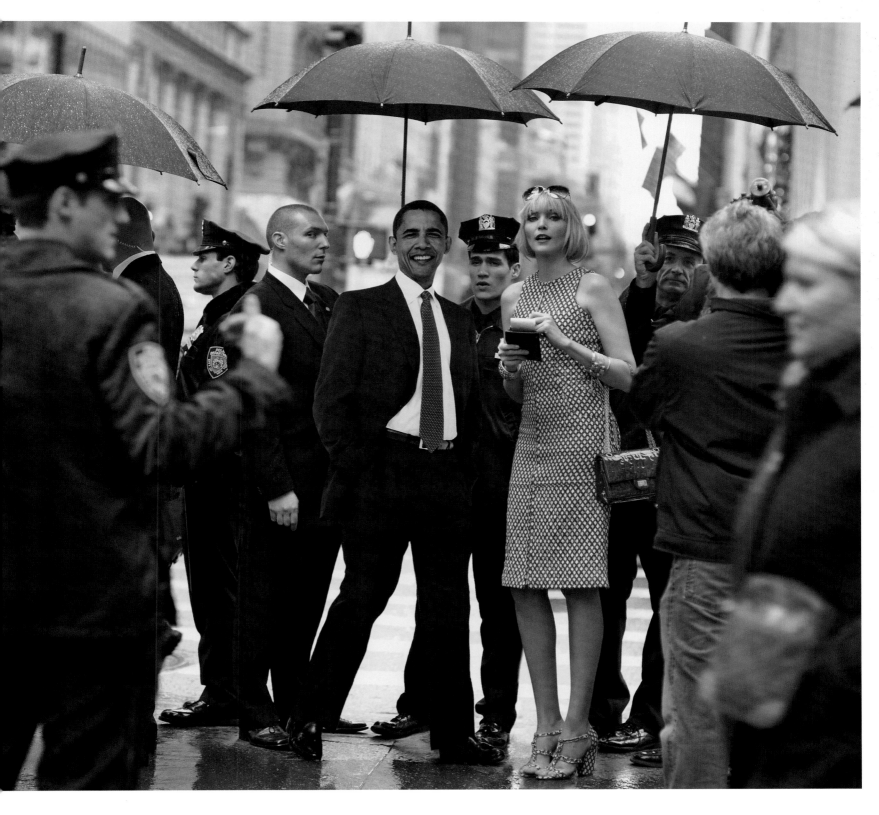

CREATIVE CAPITOL

Nadja Auermann in Chanel (above), photographed for the February issue by Peter Lindbergh, styled by Mary Alice Stephenson.

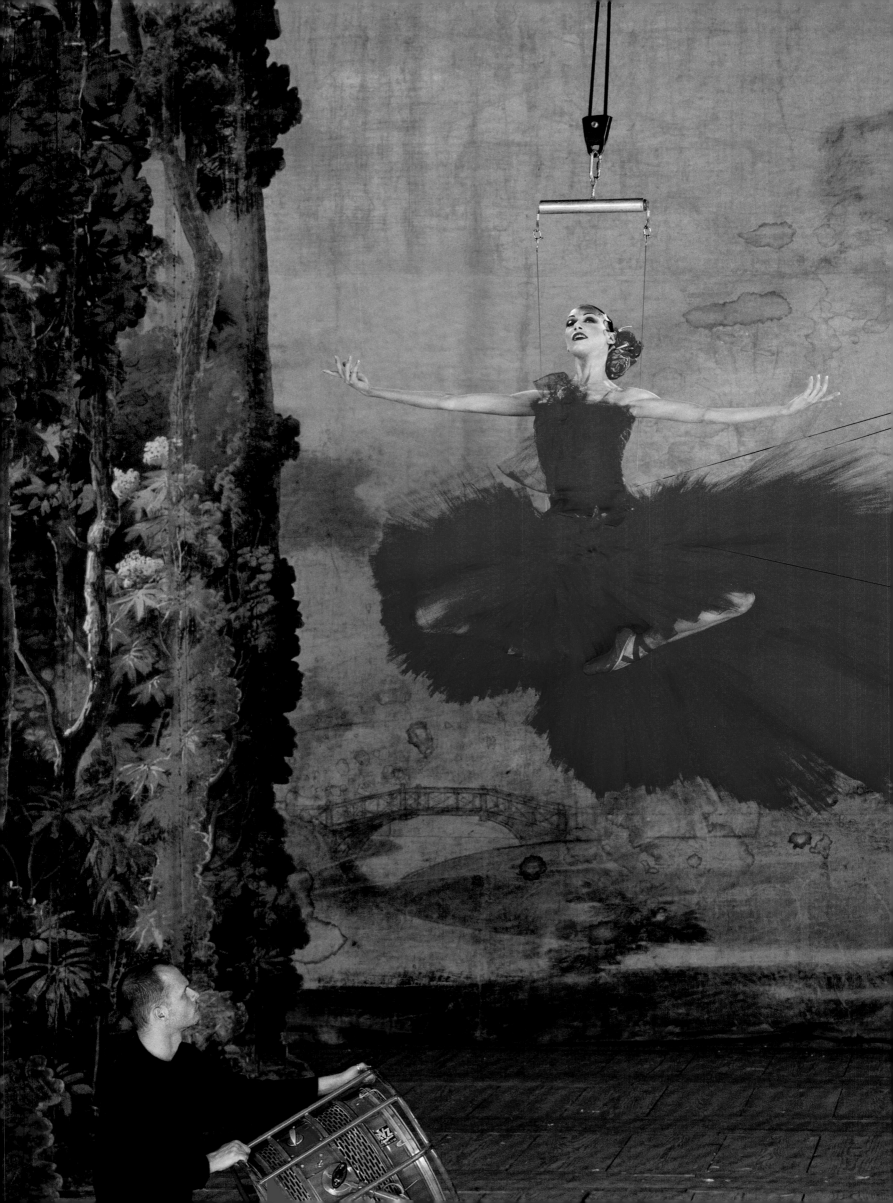

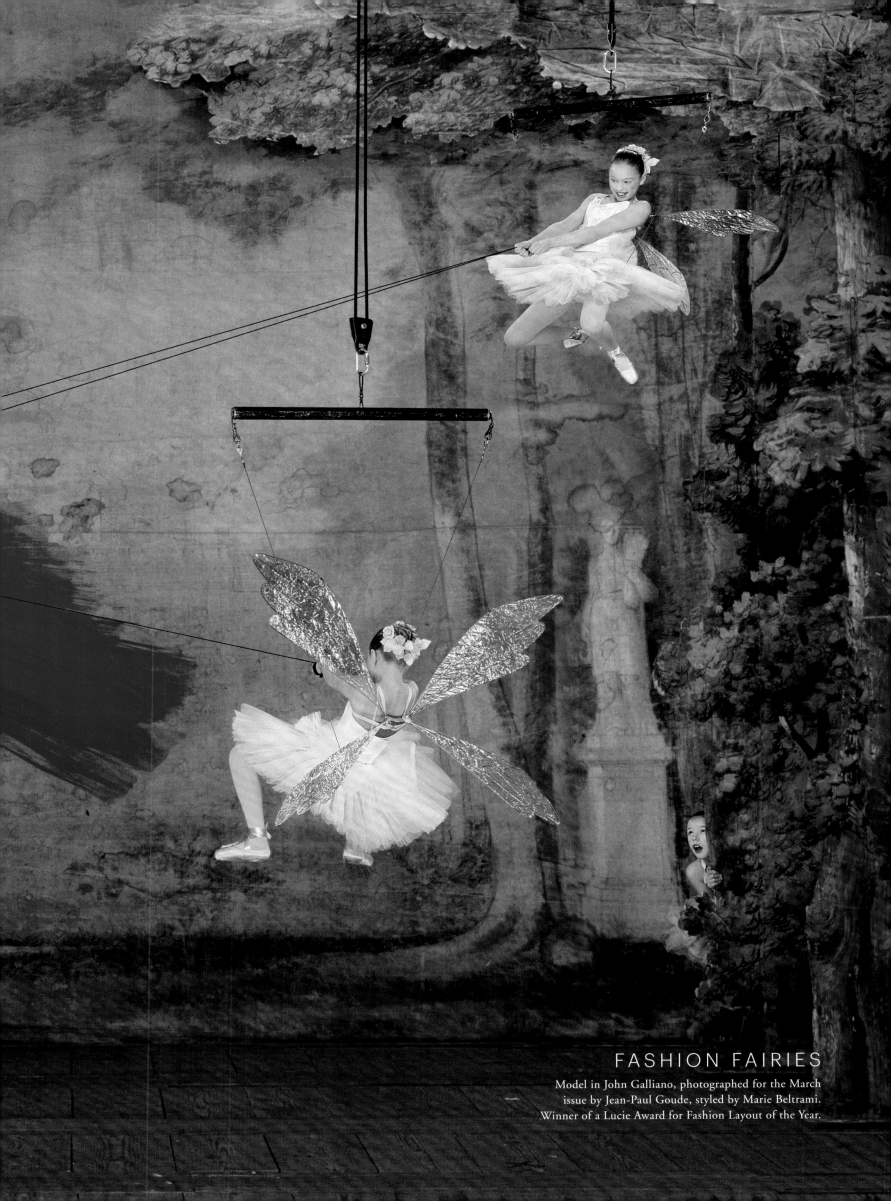

FASHION FAIRIES

Model in John Galliano, photographed for the March
issue by Jean-Paul Goude, styled by Marie Beltrami.
Winner of a Lucie Award for Fashion Layout of the Year.

ON YOUR MARC, GET SET...WAIT!

Photographed for the March issue by Peter Lindbergh, styled by Jenny Capitain.

Complete with a ticking clock, the portfolio "On Your Marc, Get Set … Wait!" was a parody of Marc Jacobs's notoriously two-hour-late runway-show start. It starred Helena Christensen, Marc Jacobs PR director Kate Waters, company president Robert Duffy, key staffers from KCD, Marc mates like Cindy Sherman and Kim Gordon—and the designer himself. The season after this story appeared, Jacobs commenced his show promptly.

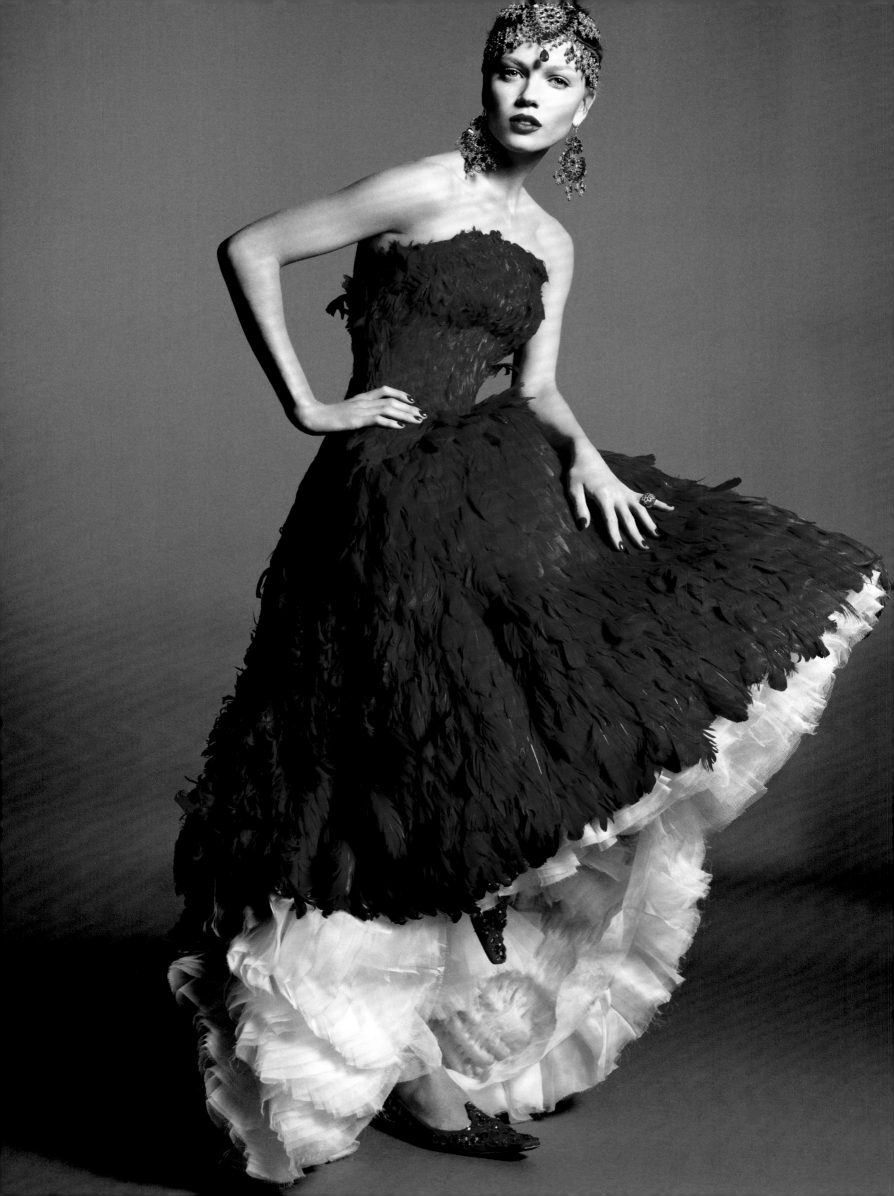

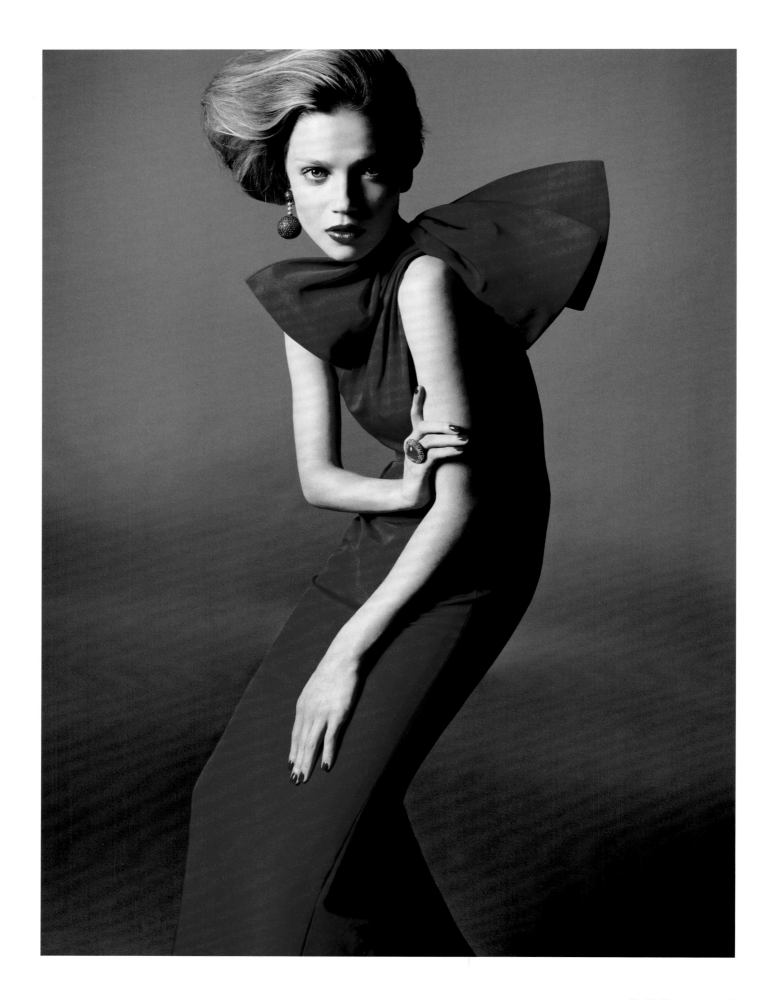

RED-HOT

Masha Novoselova in Carolina Herrera (above), H. Stern (opposite),
and Alexander McQueen (previous spread), photographed for the
September issue by Richard Burbridge, styled by Mary Alice Stephenson.

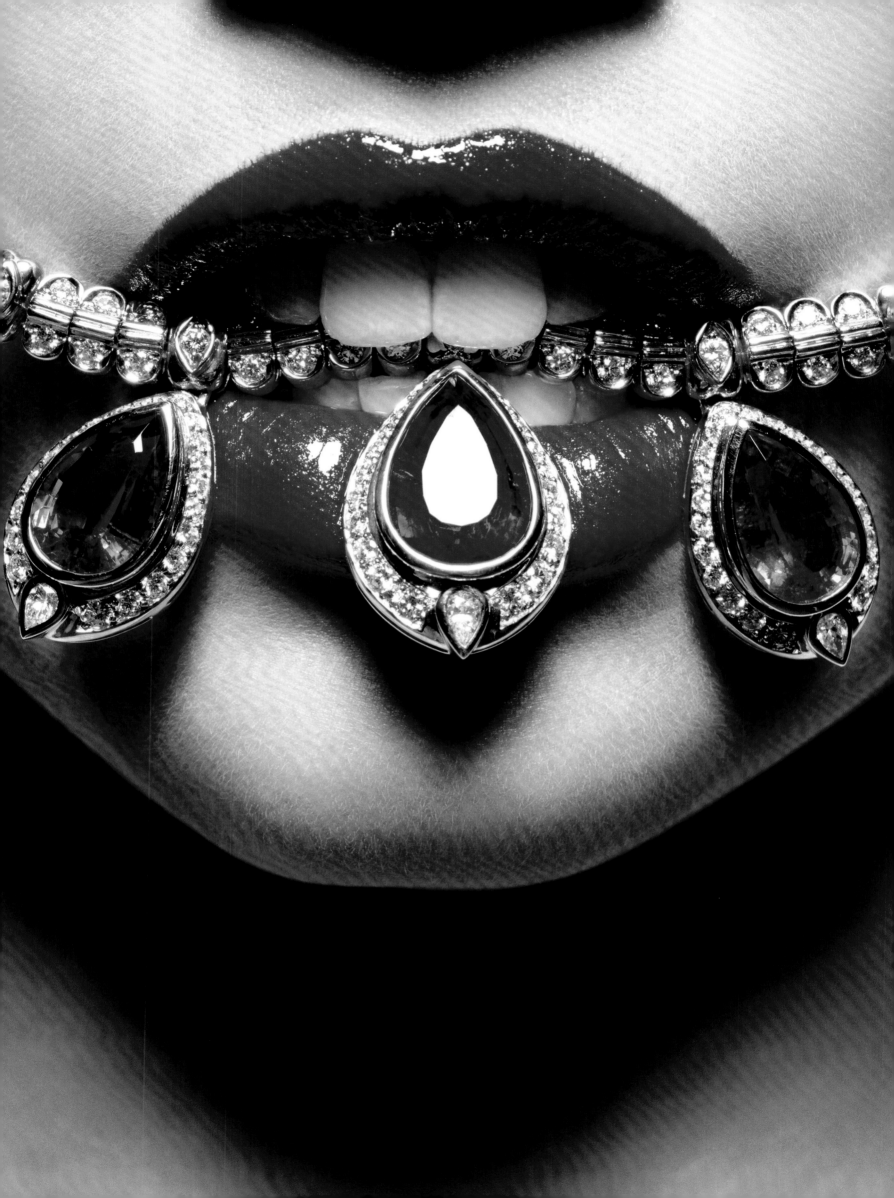

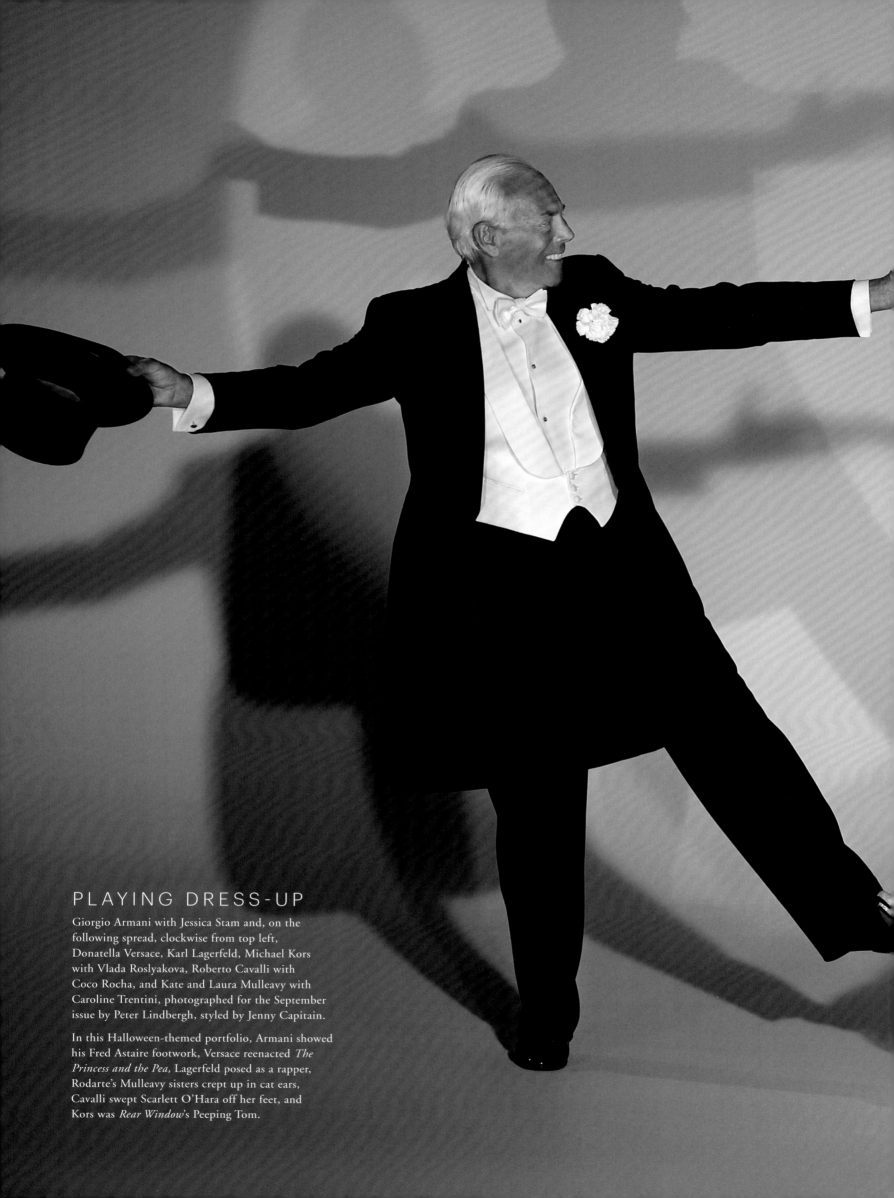

PLAYING DRESS-UP

Giorgio Armani with Jessica Stam and, on the following spread, clockwise from top left, Donatella Versace, Karl Lagerfeld, Michael Kors with Vlada Roslyakova, Roberto Cavalli with Coco Rocha, and Kate and Laura Mulleavy with Caroline Trentini, photographed for the September issue by Peter Lindbergh, styled by Jenny Capitain.

In this Halloween-themed portfolio, Armani showed his Fred Astaire footwork, Versace reenacted *The Princess and the Pea,* Lagerfeld posed as a rapper, Rodarte's Mulleavy sisters crept up in cat ears, Cavalli swept Scarlett O'Hara off her feet, and Kors was *Rear Window*'s Peeping Tom.

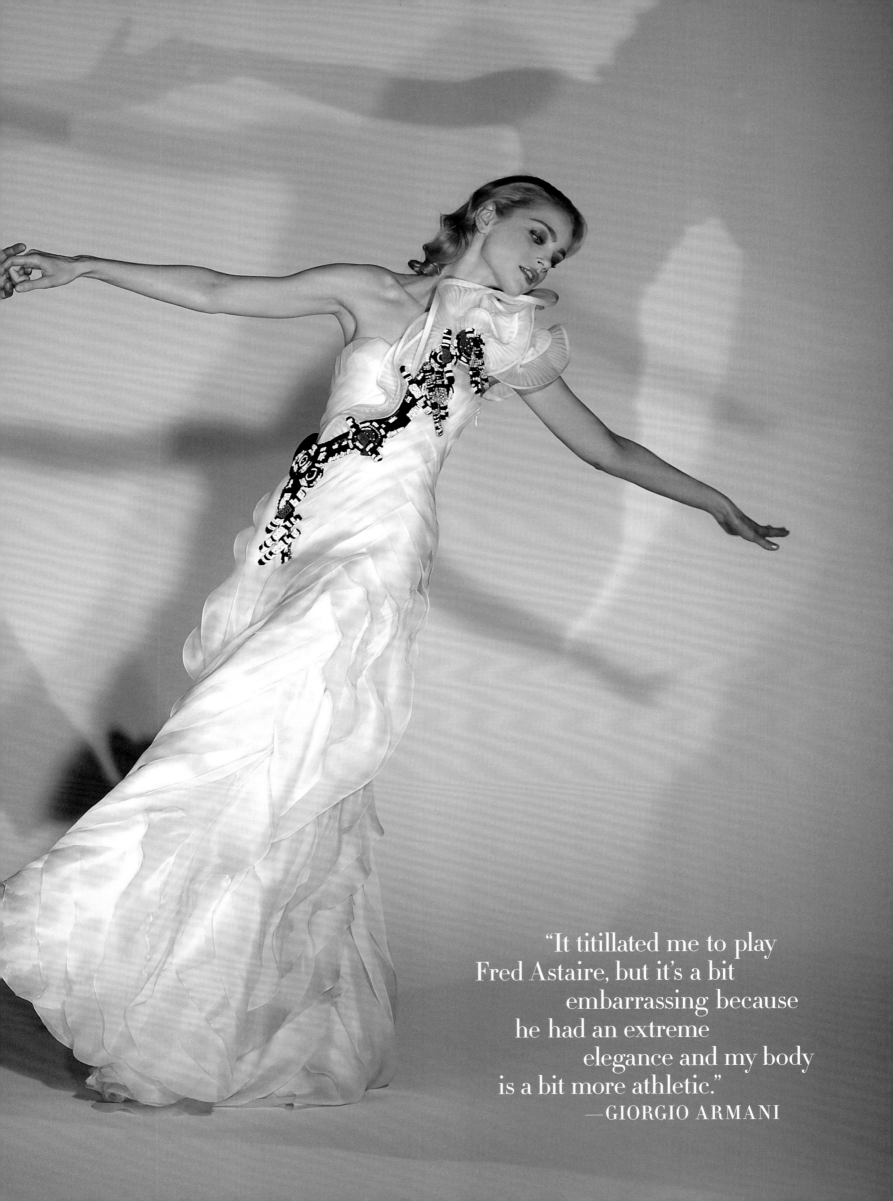

"It titillated me to play
Fred Astaire, but it's a bit
embarrassing because
he had an extreme
elegance and my body
is a bit more athletic."
—GIORGIO ARMANI

"Occasionally it is nice
to wake up as a princess."
—DONATELLA VERSACE

"Believe it or not, I *love* rap!"
—KARL LAGERFELD

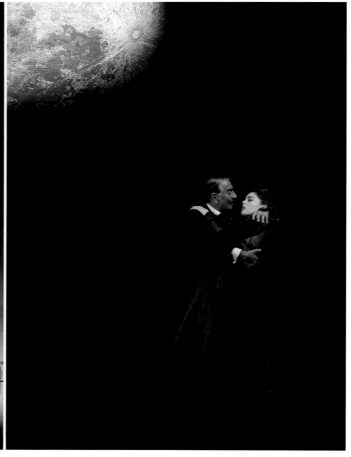

"On Halloween, people think we are dressed
up as *The Breakfast Club*. But we're not."
—LAURA AND KATE MULLEAVY

"To go with the wind means freedom,
which, by the way, is the name of my boat."
—ROBERTO CAVALLI

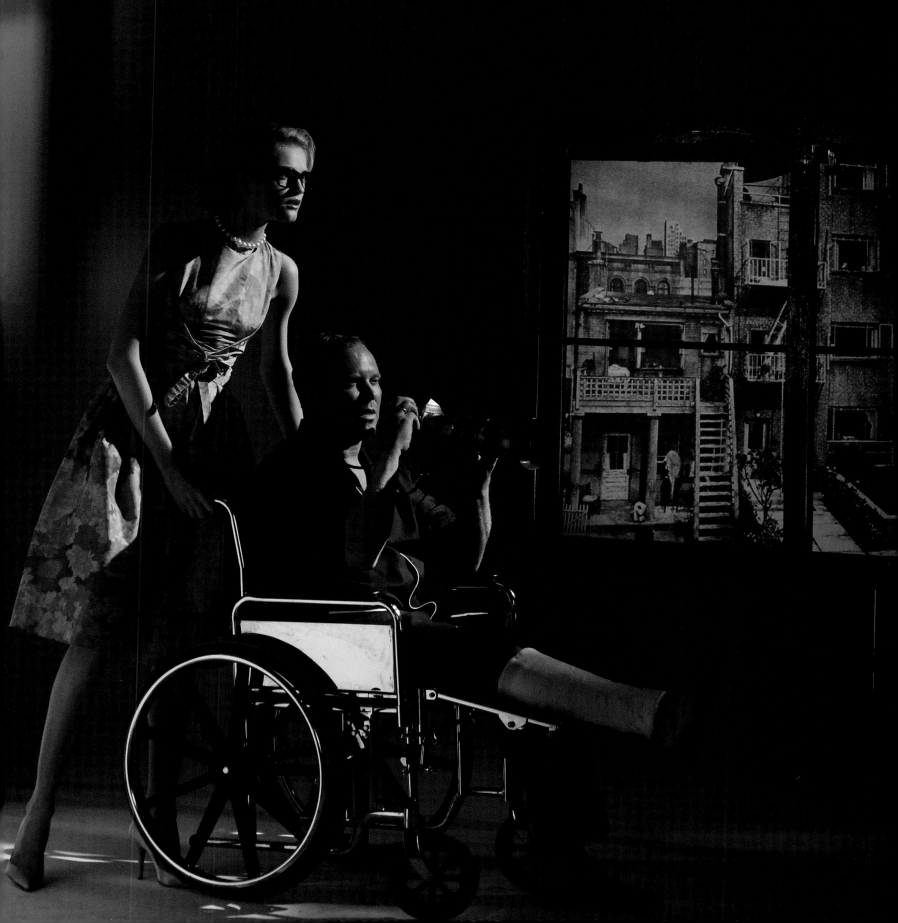

"Grace Kelly plays a fashion editor at *Bazaar* with a wardrobe that most editors today would kill for."
—MICHAEL KORS

SPELL-CASTING STYLE

Right: Emma Watson in Alexander McQueen, photographed for the October issue by Simon Procter, styled by Daniela Agnelli.

Laura Bush in Oscar de la Renta, photographed for the October issue by Douglas Friedman, styled by Ann Caruso.

Bazaar gave props twice to one of the decade's biggest cultural phenomenon: Harry Potter. First, Watson, who literally grew up on film, was schooled in fashion by Britain's top designers. (See Alexander McQueen's likeness in the crystal ball.) Then first lady and literary advocate Bush took a moment to investigate *The Chamber of Secrets* while posing in the Lincoln Bedroom with her black cat.

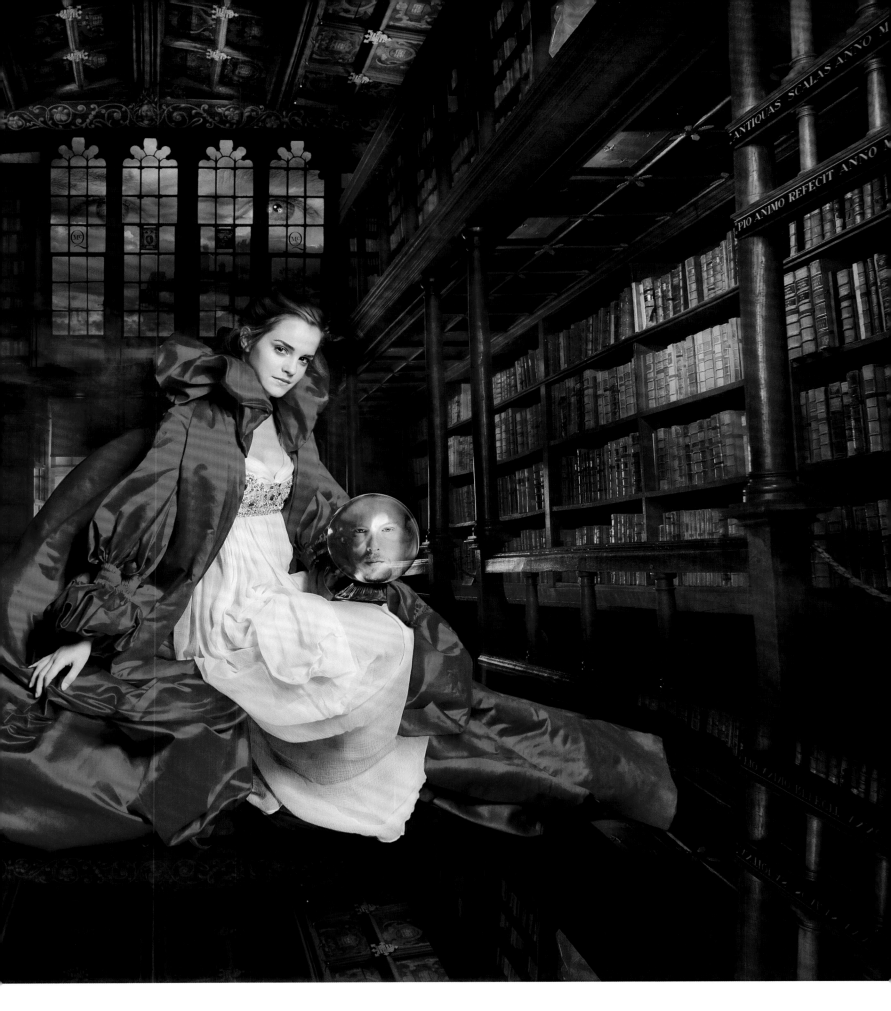

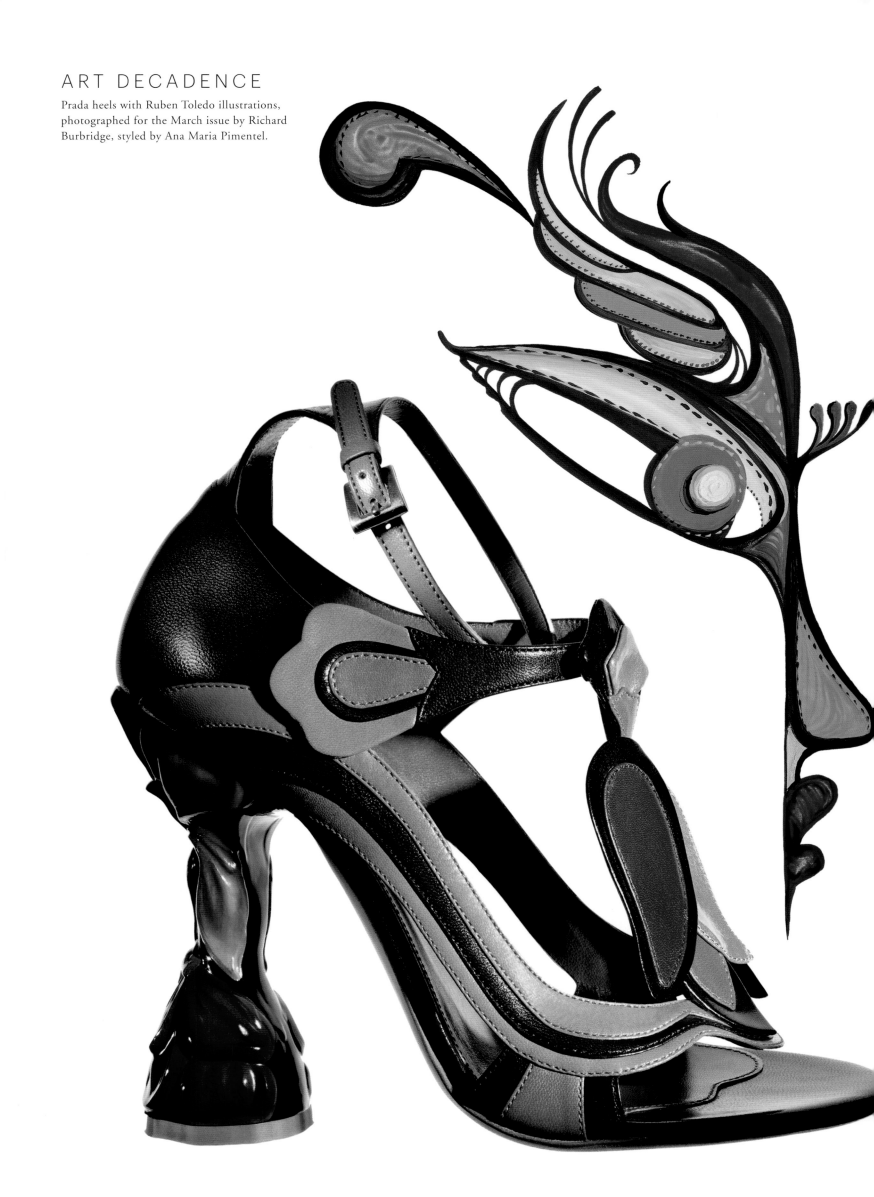

ART DECADENCE
Prada heels with Ruben Toledo illustrations,
photographed for the March issue by Richard
Burbridge, styled by Ana Maria Pimentel.

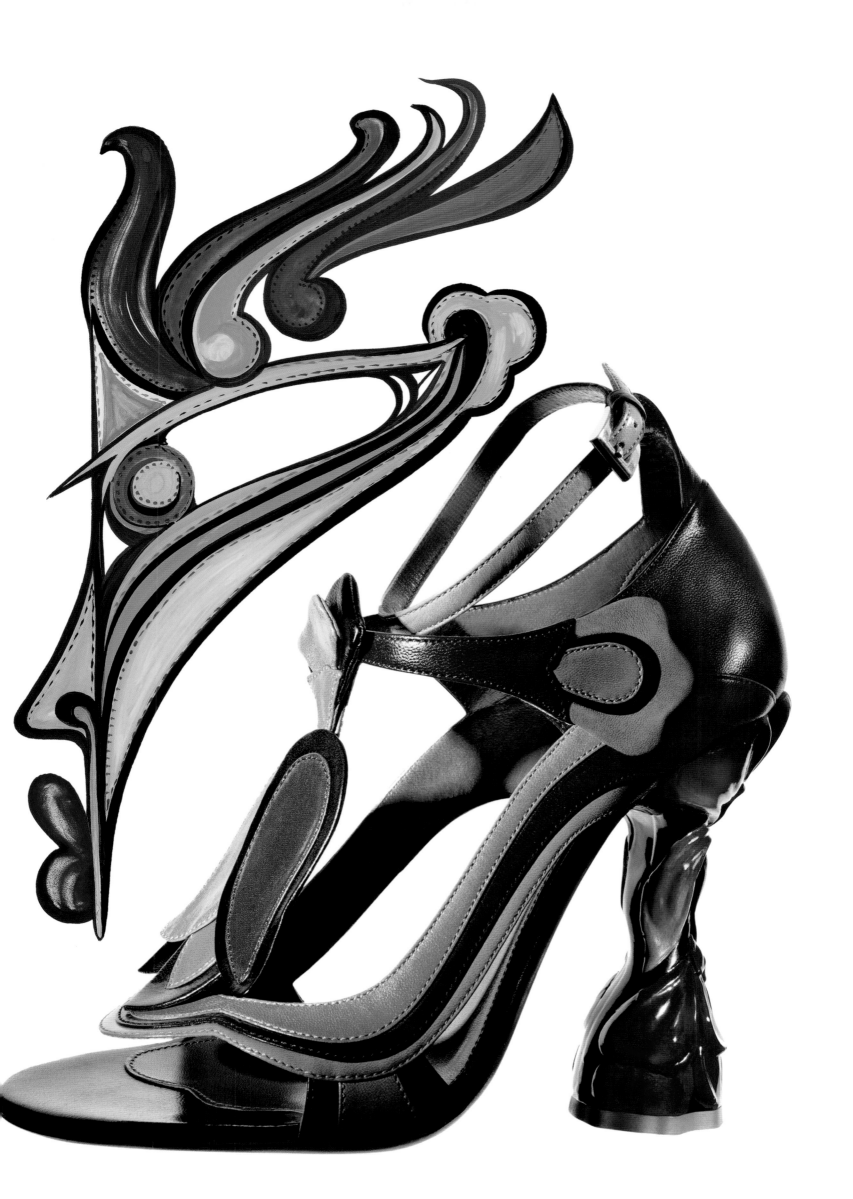

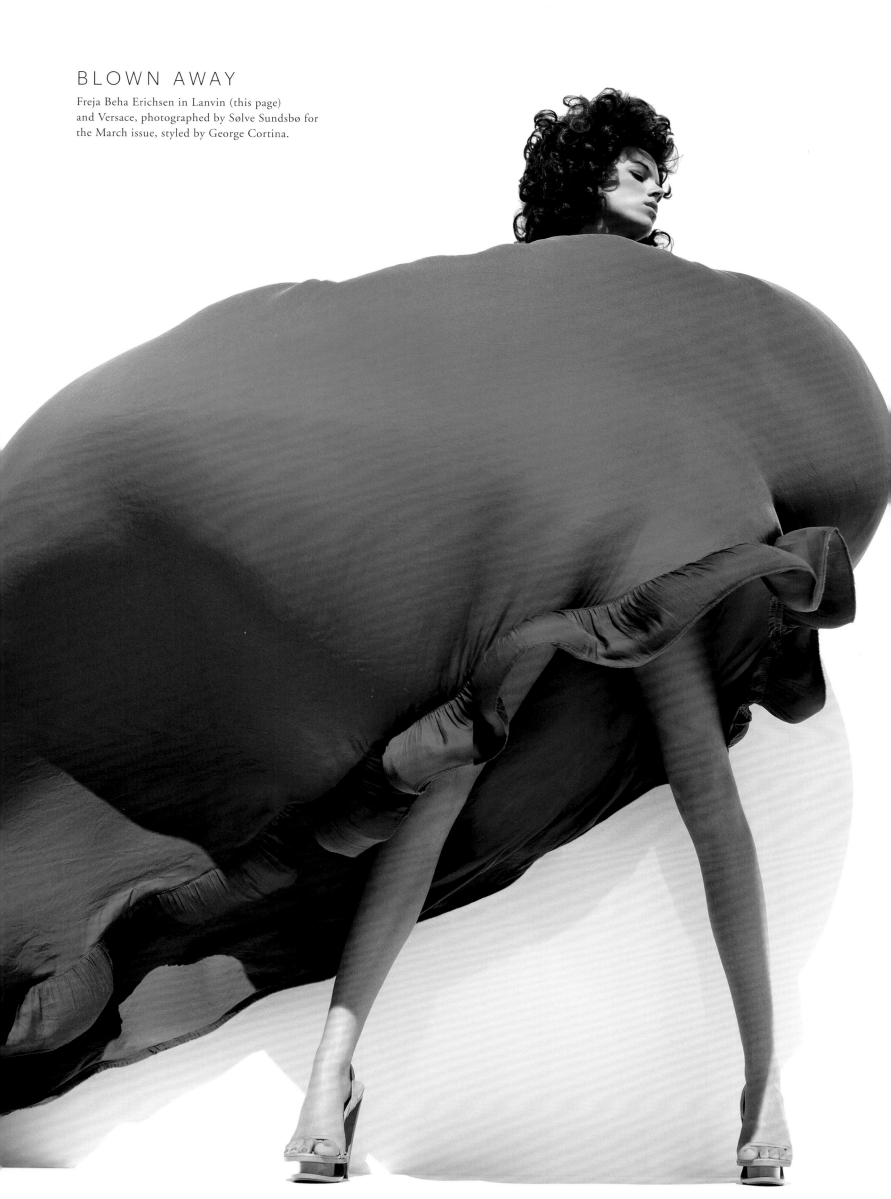

BLOWN AWAY

Freja Beha Erichsen in Lanvin (this page)
and Versace, photographed by Sølve Sundsbø for
the March issue, styled by George Cortina.

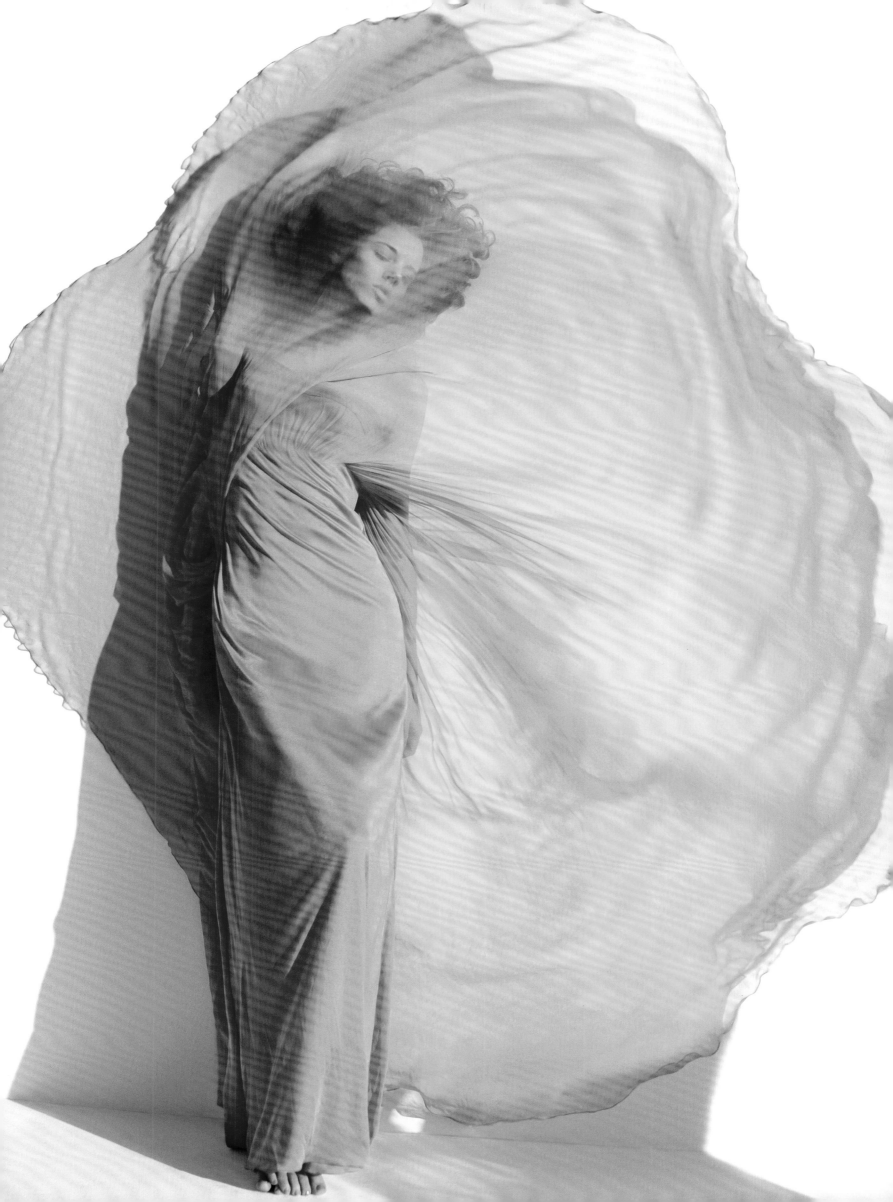

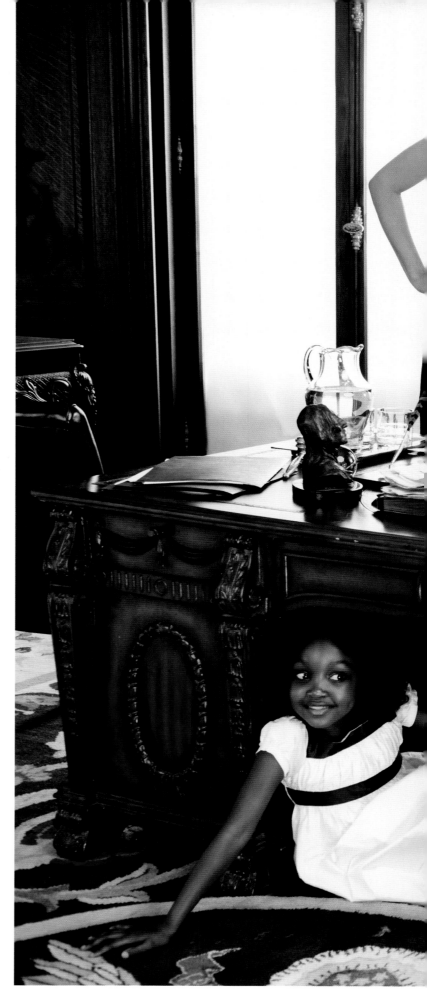

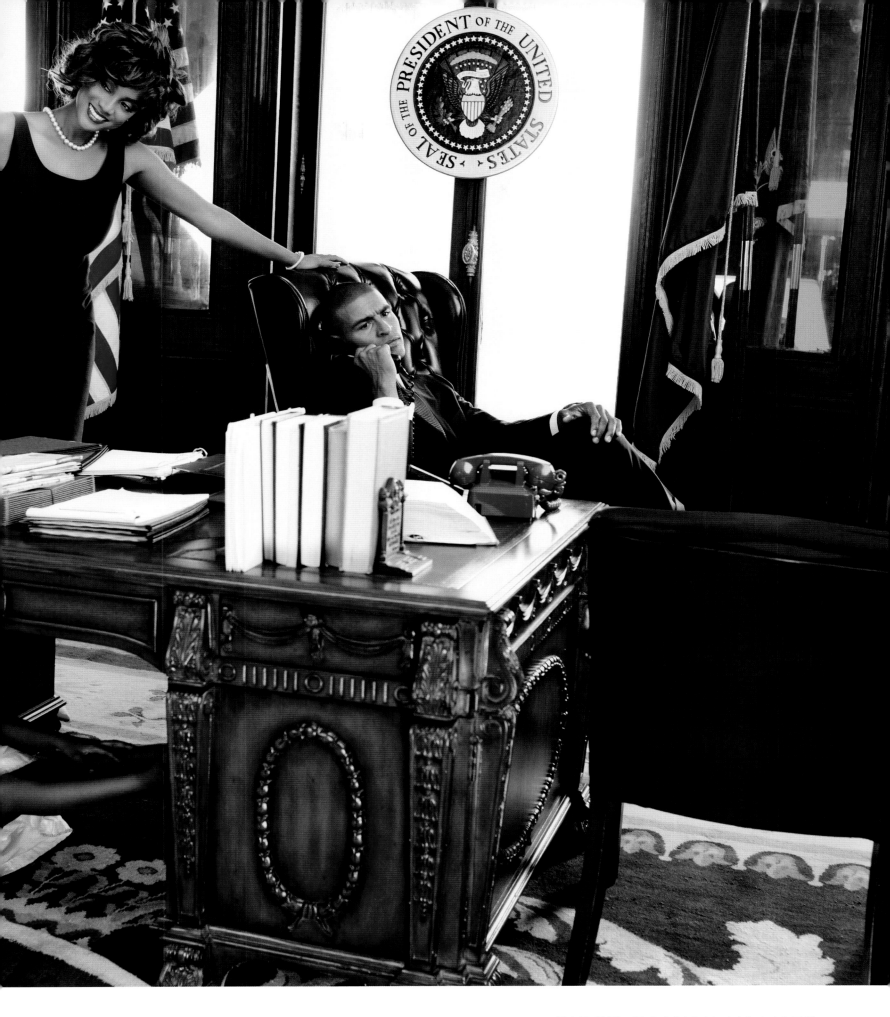

FIRST-FAMILY VALUES

Tyra Banks in Banana Republic (above) and Tommy Hilfiger, photographed
for the September issue by Alexi Lubomirski, styled by Jenny Capitain.

Banks played the first lady with a mix of elegance and attitude. One picture recalled
the famous photo of JFK Jr. playing under his father's desk in the Oval Office, and Banks
and a Fauxbama model went so far as to snuggle up in matching Harvard sweatshirts.

2009

Kristen Stewart, in Alexander McQueen, and Robert Pattinson, photographed for the December issue by Mark Seliger, styled by Katie Mossman. Winner of an ASME Magazine Cover of the Year award.

STYLE SAVES
THE DAY

AS BARACK OBAMA'S INAUGURATION neared, America was feeling optimistic, even as most economists maintained there was little cause to do so.

In January, Marc Jacobs, celebrating the late artist and designer Stephen Sprouse, was photographed by Terry Richardson. Jacobs's provocative pose made headlines, but there was an unmistakable nod to the 1980s, the last time the country had endured so lengthy a recession. "I'm not pretending to cure the nation's economy," said Jacobs, "but we do what we do, and if people enjoy it, even better."

And what could have been more uplifting than the March cover, featuring Sarah Jessica Parker racing across the Brooklyn Bridge wearing an organza cloud of a Chanel gown?

The light touch continued with a wink to Easter in Peter Lindbergh's story "Street Chic," which paired model Catherine McNeil in spring's urban looks with a six-foot-tall bunny.

Pulling rabbits out of hats is something *Bazaar* is accustomed to doing. Take the speediest turnaround ever: For the September issue, Agyness Deyn was featured in a tribute to Michael Jackson and his immeasurable fashion influence. After Jackson's unexpected death, Bailey and her team pulled together a photo shoot with Richardson in a matter of days, just before the issue was put to bed. (As a follow-up, October's cover story was an exclusive interview with Janet Jackson, her first after her brother's death.)

Bazaar recognized more colorful cultural icons with a shoot in honor of the 40th anniversary of beloved children's show *Sesame Street*. It made even Oscar the Grouch, pictured with Oscar de la Renta, smile.

September also illuminated the 1940s influence in the fall collections with Lindbergh's Harlem-renaissance-flavored portfolio, "Fashion…and All That Jazz," and Karl Lagerfeld's homage to Venice in the age of Peggy Guggenheim. The latter was a confluence of art and fashion history that Lagerfeld brought to life in both his latest resort collection and the story.

Fashion is full of references, but sometimes you have to strip them—and everything else—away. Lindbergh did just that in "Supermodels Supernatural," shooting favorites like Cindy Crawford and Claudia Schiffer unretouched and 100 percent makeup free. The images, which received more than six million page views in one day on harpersbazaar.com, showed that reality has its own beauty.

One supermodel in that issue looked as if she had superpowers, courtesy of Jean-Paul Goude. The result: In "Wild Things," Naomi Campbell kept pace with a cheetah. Seeing is believing.

The fantasy carried over to October, when Tim Burton guest-edited a fashion story ahead of his retrospective at New York's Museum of Modern Art. Working with photographer Tim Walker and stylist Jacob K, Burton conjured up the dark magic of the season, just in time for Halloween. *Bazaar* ended the year with more otherworldly pursuits by photographing *Twilight* stars Kristen Stewart and Robert Pattinson for the December cover. It was one of the rare occasions they'd been shot together. Inside, the interview alluded to their real-life romance, but as we said before, seeing is believing.

DREAM CHASER
Sarah Jessica Parker in Chanel, photographed for the March issue by Peter Lindbergh, styled by Mary Alice Stephenson. Winner of an ASME Best Fashion & Beauty Cover award.

WILD THINGS

Naomi Campbell in Blumarine and,
on the following spreads, Dior Haute
Couture, photographed for the September
issue by Jean-Paul Goude, styled by
Alex Aikiu. Winner of a *Folio* Ozzie
Award for Best Use of Photography.

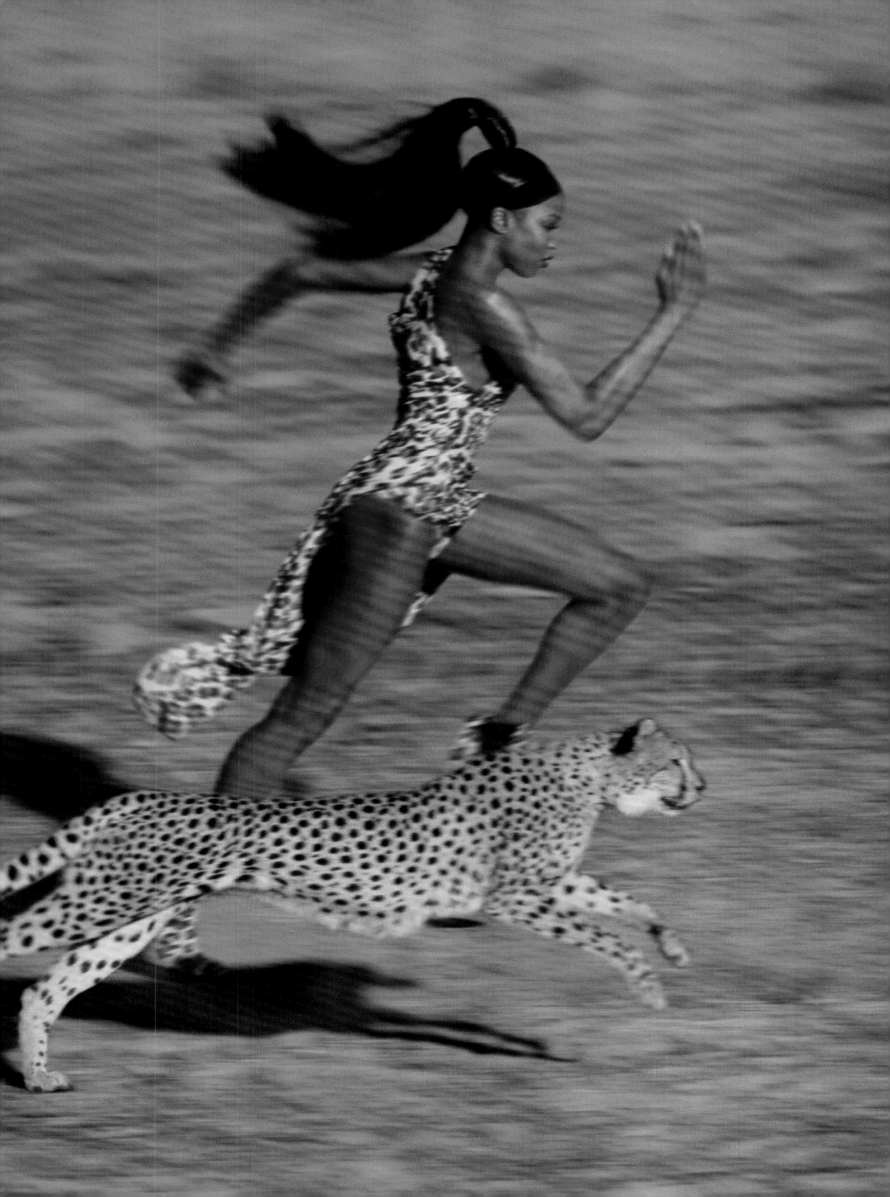

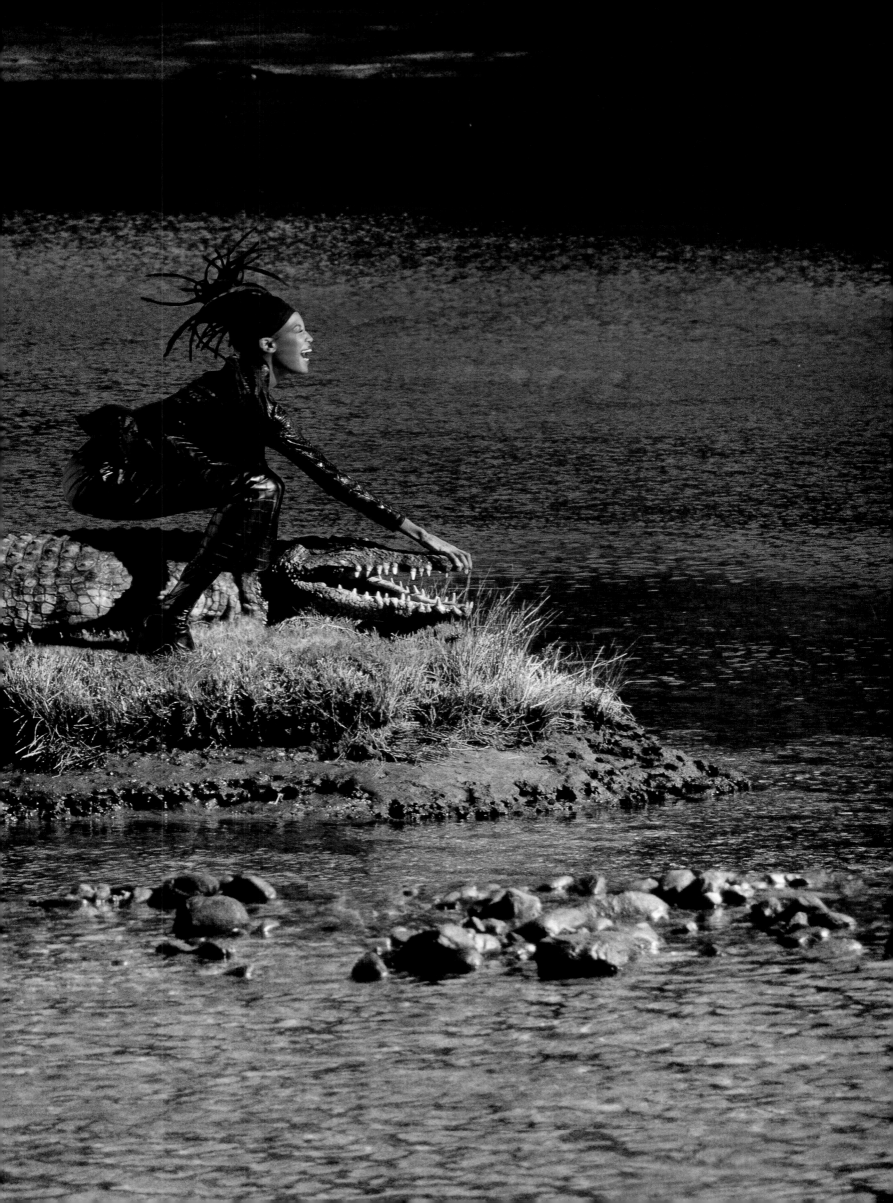

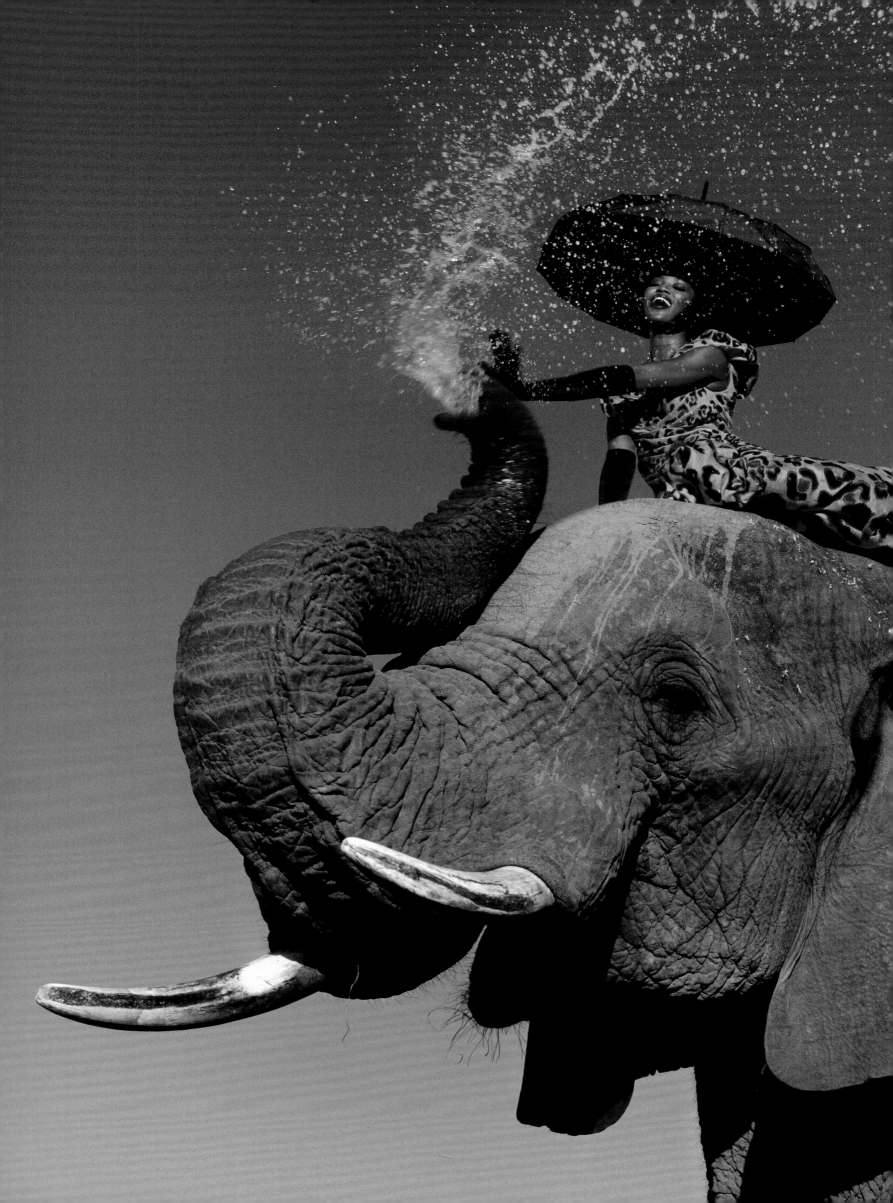

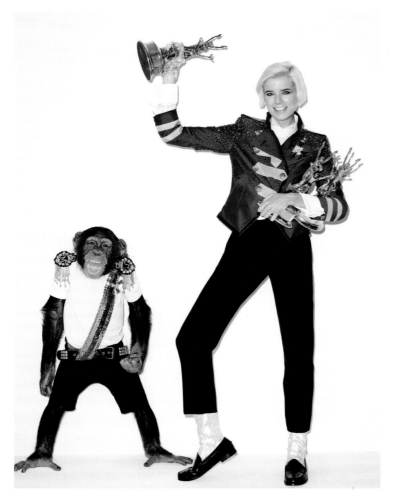

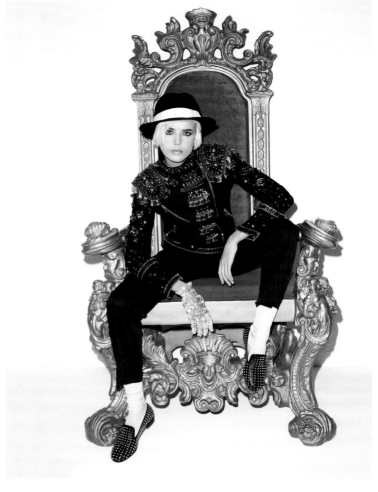

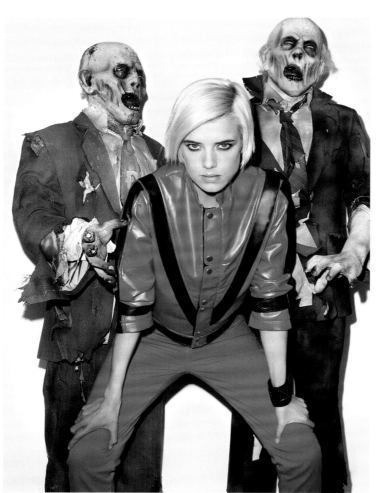

THRILLER

Agyness Deyn in Rag & Bone (above left), Moschino (above right), Yves Saint Laurent (right), and Stella McCartney (opposite), photographed for the September issue by Terry Richardson, styled by Brana Wolf. Winner of a Lucie Award for Fashion Layout of the Year.

SOUL SISTER

Janet Jackson in a Moschino coat and a Ryan Wilde
hat (above) and Bottega Veneta, photographed for the
October issue by Tom Munro, styled by Patti Wilson.

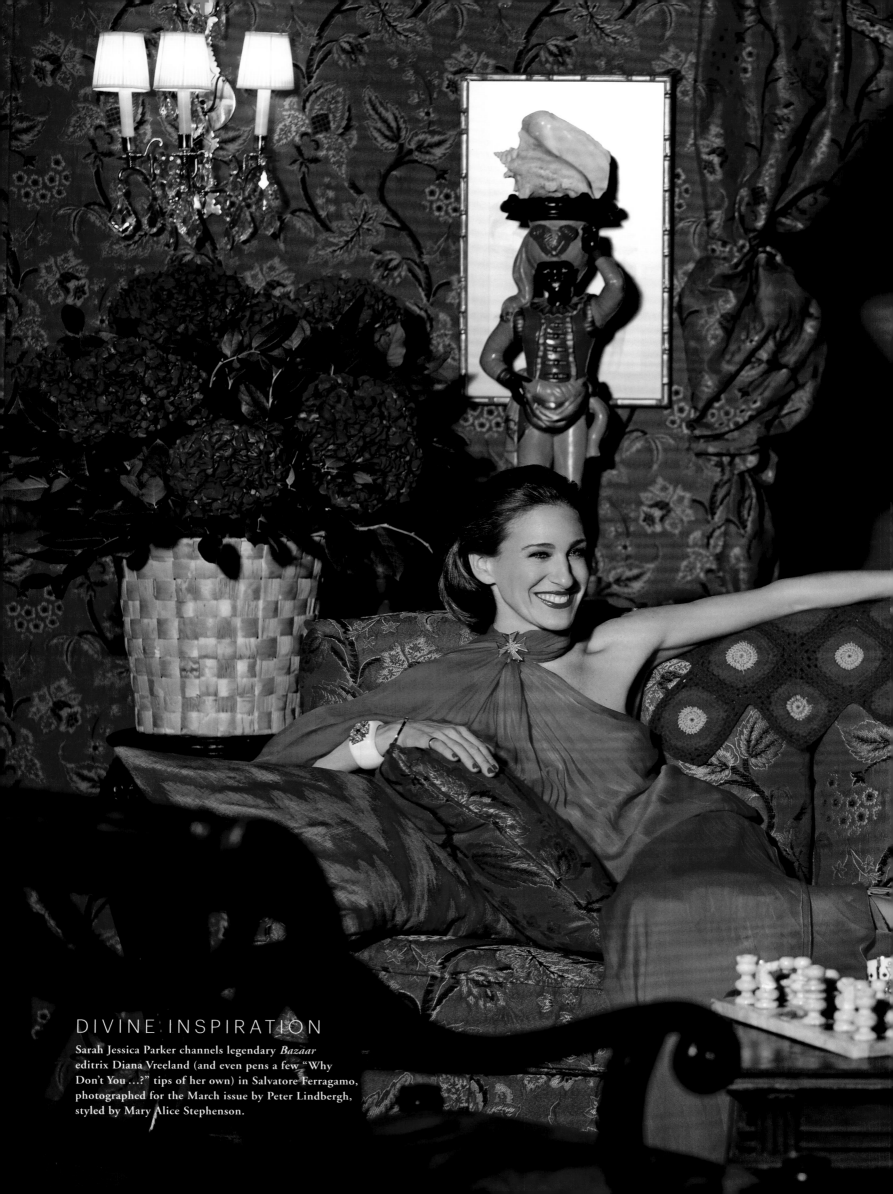

DIVINE INSPIRATION

Sarah Jessica Parker channels legendary *Bazaar* editrix Diana Vreeland (and even pens a few "Why Don't You …?" tips of her own) in Salvatore Ferragamo, photographed for the March issue by Peter Lindbergh, styled by Mary Alice Stephenson.

WHY DON'T YOU...?

- Try, for every 20 e-mails you send, to write a letter, an old-fashioned letter, and post it.

- Walk more. It simply feels great.

- Use your local library. So few people do anymore.

- Get eight hours of sleep, though I never do.

- Keep a bucket filled with candy. Cheap, good candy. It will scratch the itch.

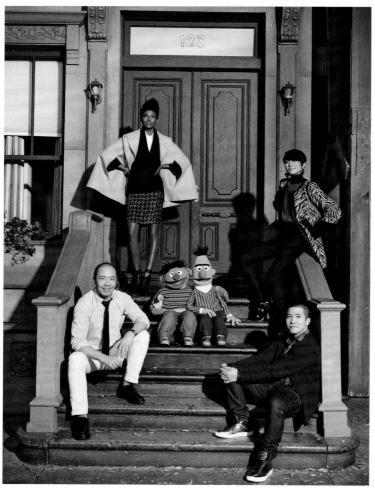

FROM SEVENTH AVENUE TO SESAME STREET

Designers Diane von Furstenberg, Carolina Herrera, Thakoon Panichgul, Derek Lam, and Oscar de la Renta, with models Sessilee Lopez and Tao Okamoto in their designs, photographed for the September issue by Jason Schmidt, styled by Mary Alice Stephenson.

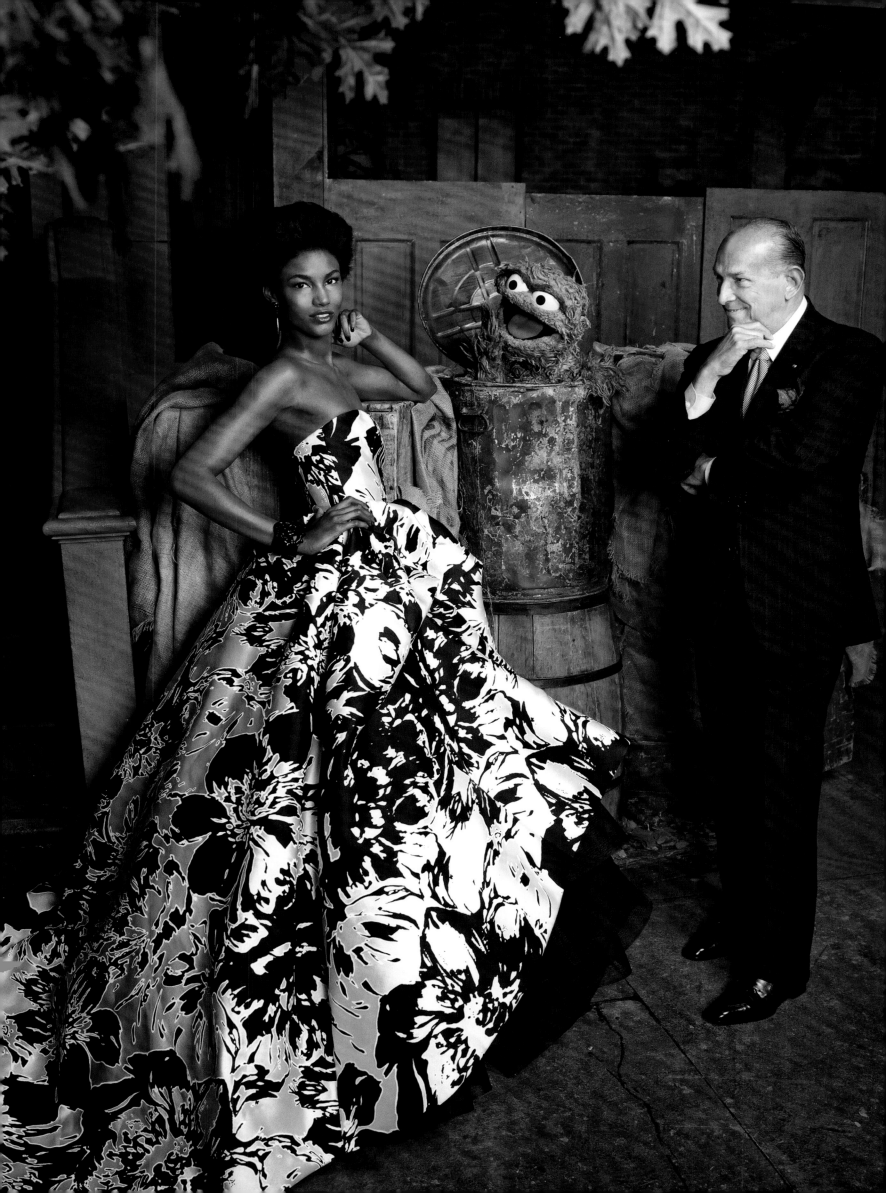

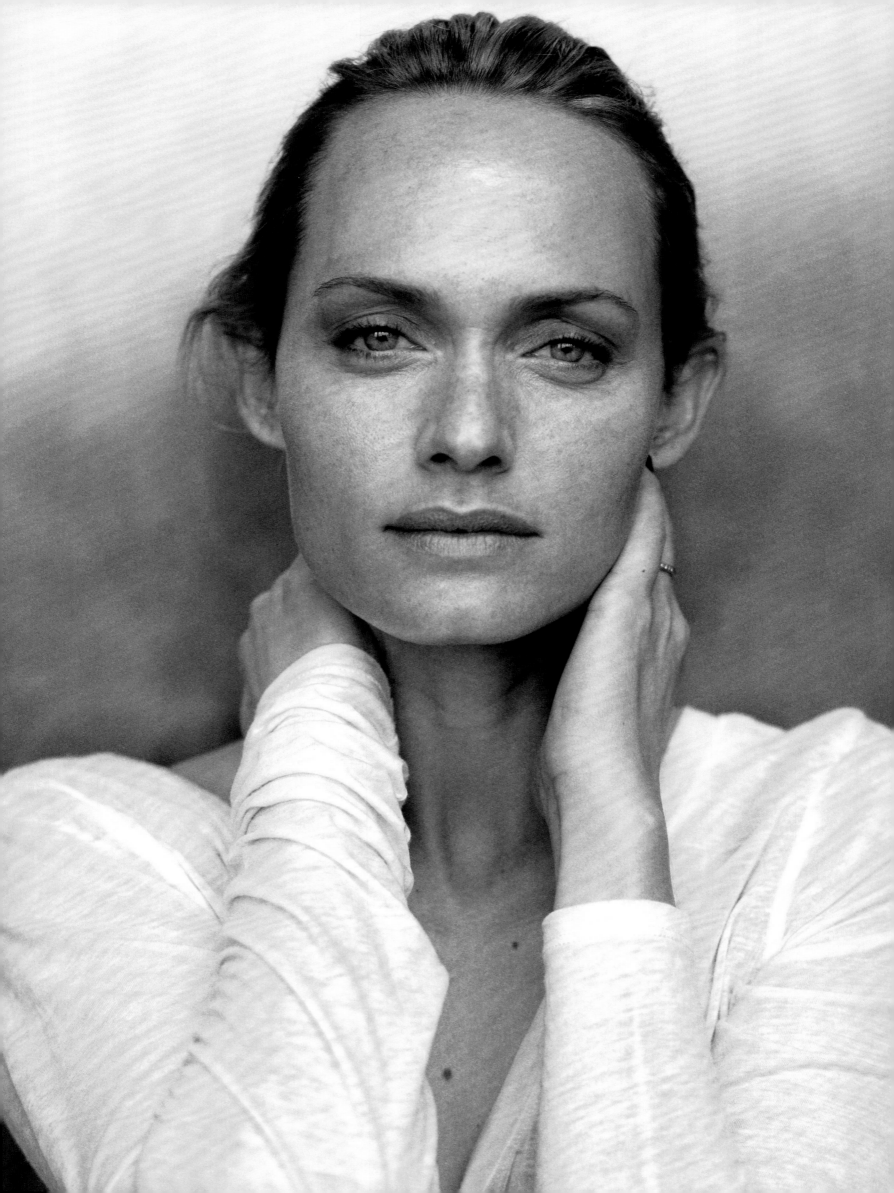

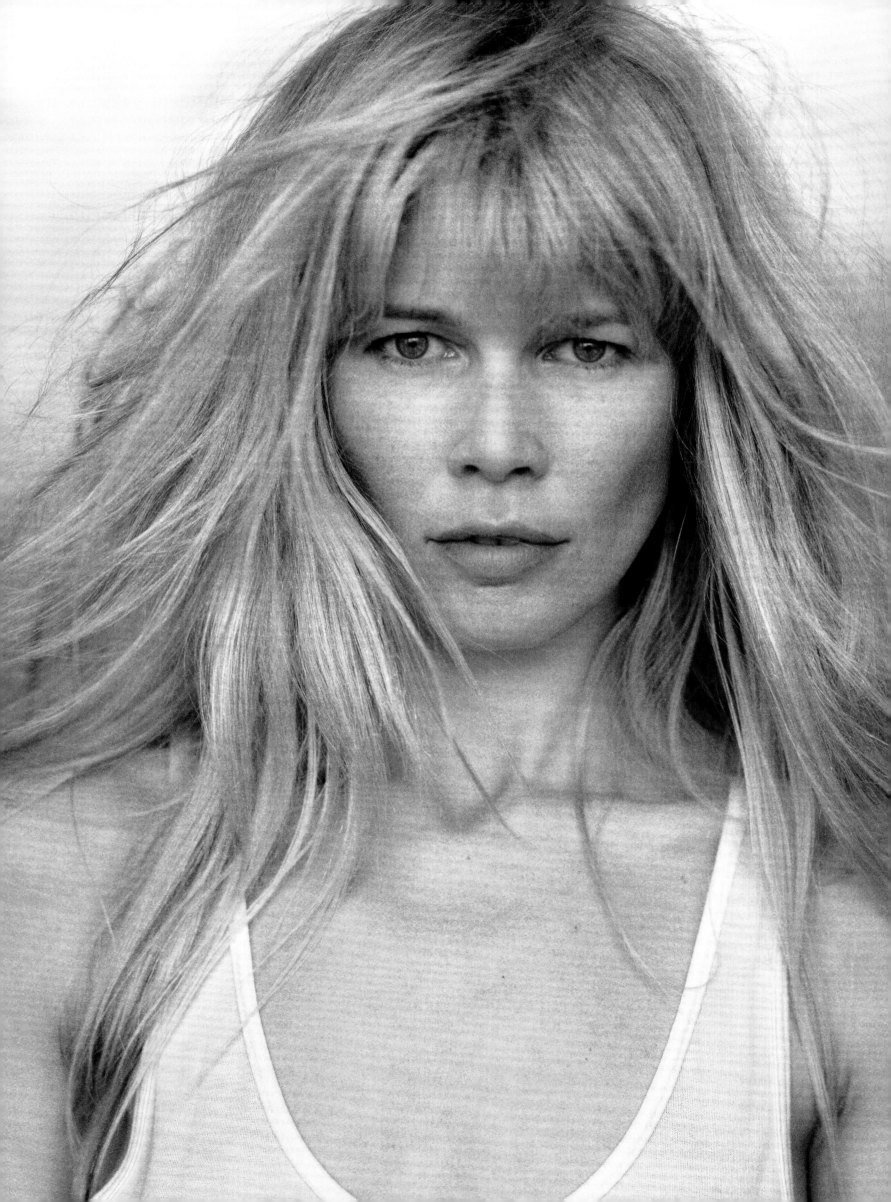

SUPERMODELS
SUPERNATURAL

Models, here and on the previous spread, photographed for the September issue by Peter Lindbergh, styled by Brana Wolf.

Photographing some of his favorite subjects of all time, now in their 30s and 40s, Peter Lindbergh revealed their clean, makeup-free faces. Not only did the models, including Shalom Harlow, Nadja Auermann, Kristen McMenamy, Cindy Crawford, Amber Valletta, and Claudia Schiffer, all look sensational, they also caused a sensation.

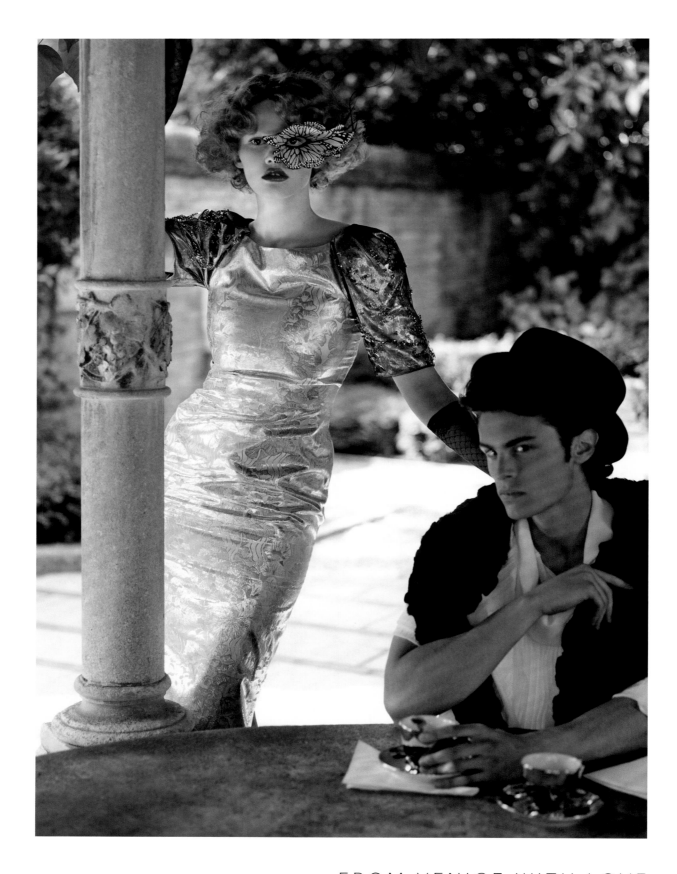

FROM VENICE WITH LOVE

Lara Stone, with Baptiste Giabiconi, in Alberta Ferretti (above), Chanel, Number (N)ine, and Marni, and, on the following spread, Lanvin (left) and Valentino, photographed for the September issue by Karl Lagerfeld, styled by Amanda Harlech and Felipe Mendes.

Lagerfeld was inspired by the Venice of eccentric fashion icon and art collector Peggy Guggenheim. He even used a pair of Guggenheim's own sculptural glasses, which he donated to the Peggy Guggenheim Collection after the shoot wrapped.

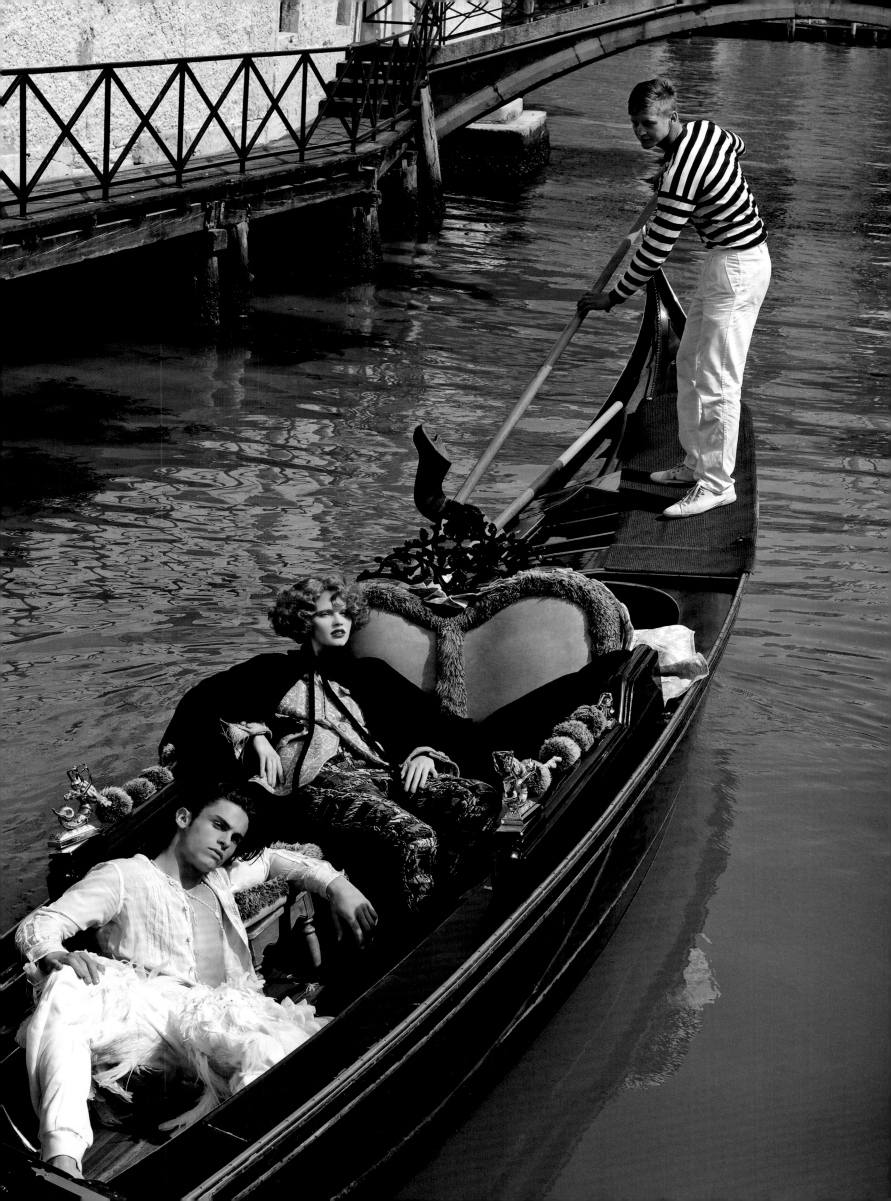

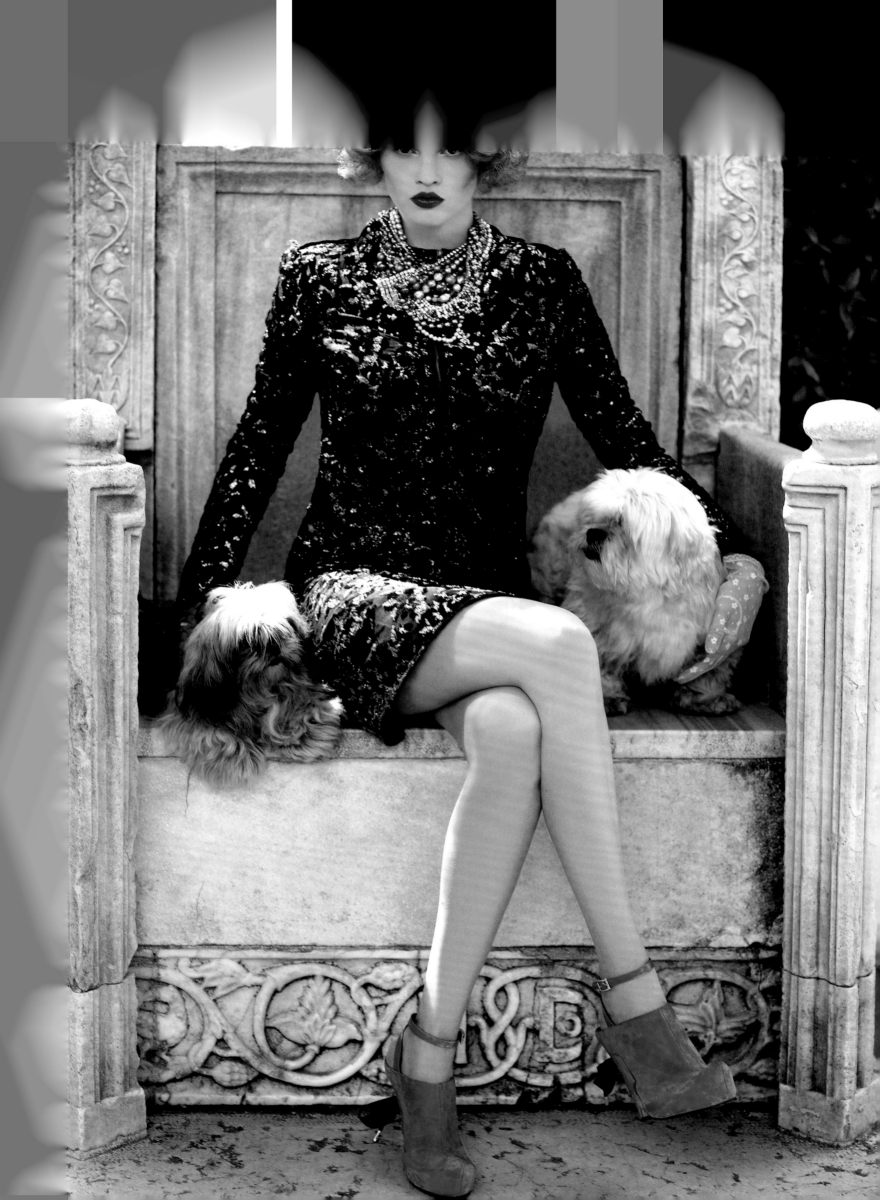

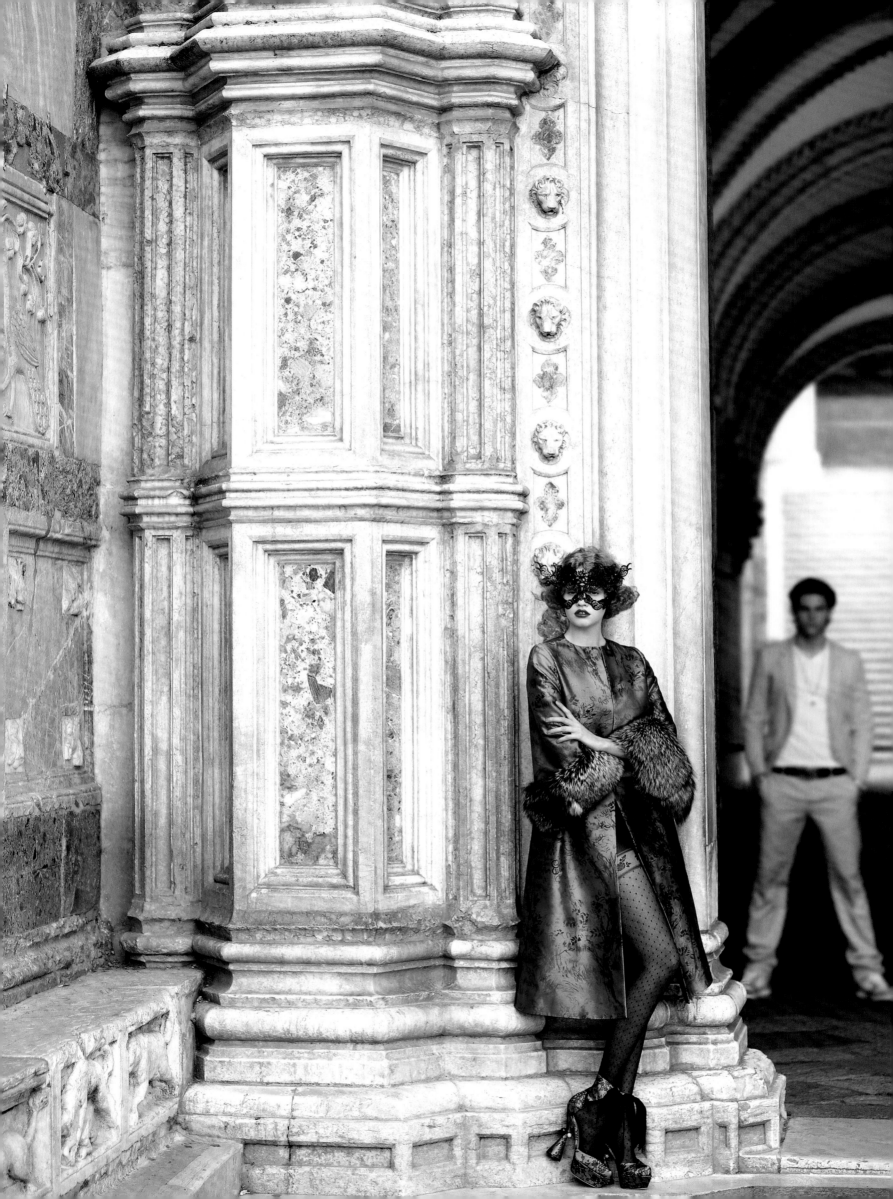

Marc Jacobs with a Louis Vuitton
bag, photographed for the January
issue by Terry Richardson, styled
by Mary Alice Stephenson.

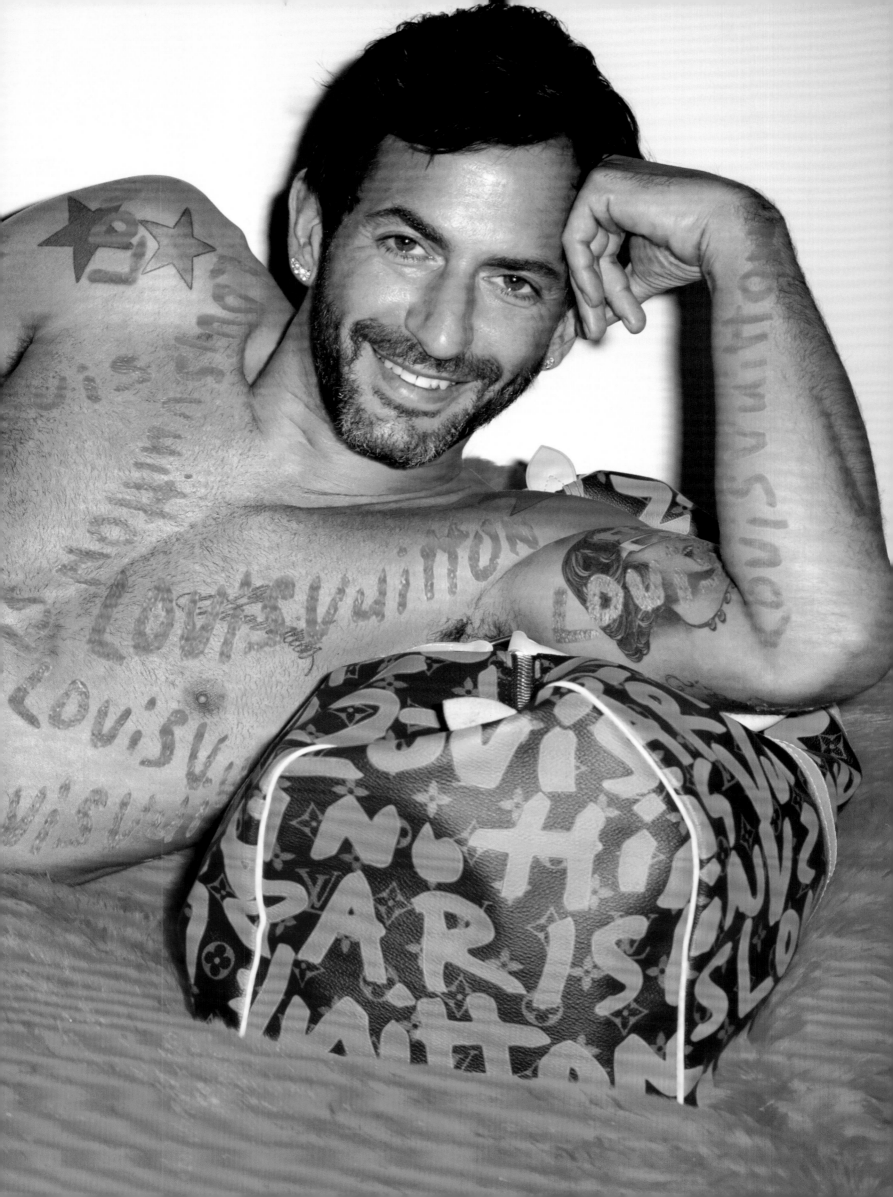

FASHION...AND ALL THAT

jazz

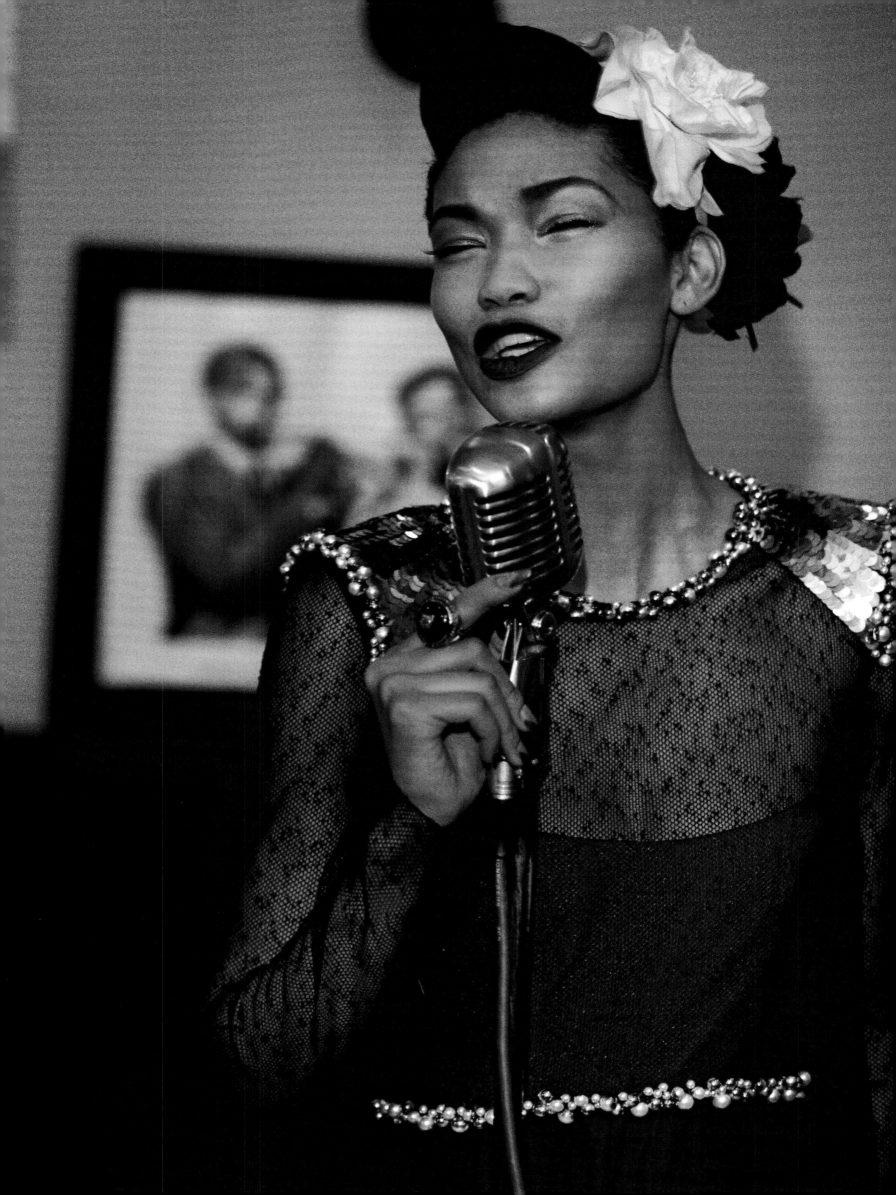

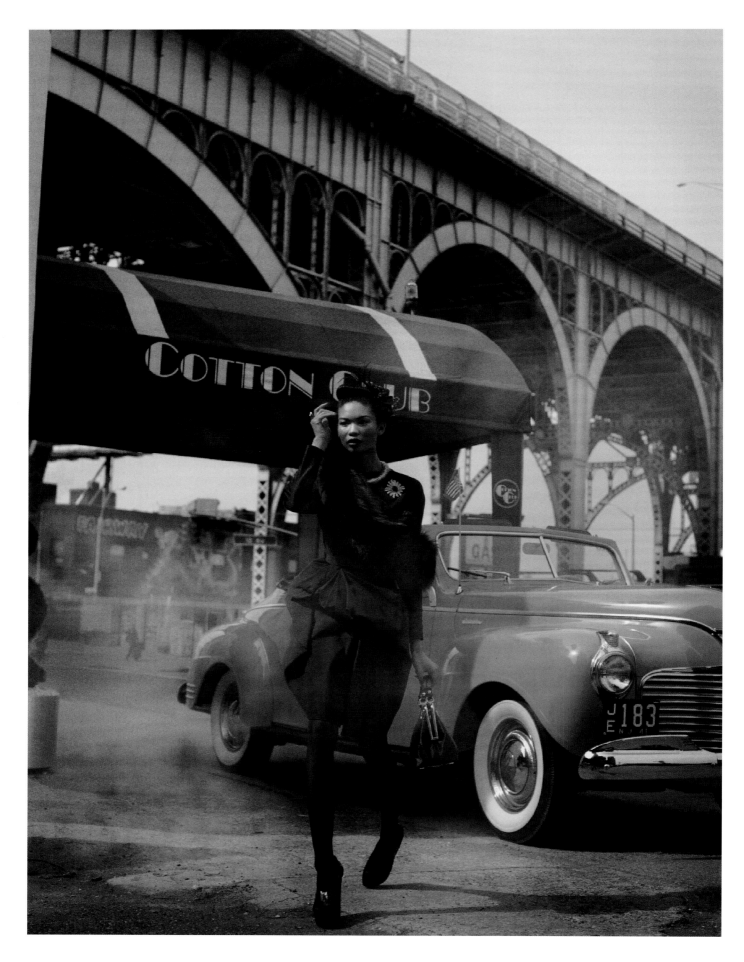

HARLEM ON MY MIND

Chanel Iman in Lanvin (above), Dior (opposite), and Chanel (on the previous spread, featuring the story's original typography, conceived by *Bazaar*'s design director, Elizabeth Hummer), photographed for the September issue by Peter Lindbergh, styled by Brana Wolf. Winner of a Lucie Award for Fashion Layout of the Year.

GRAPHIC
ELEMENTS

Sigrid Agren in Vera Wang (this page)
and Dries Van Noten, photographed
for the March issue by Tom Munro,
styled by Brana Wolf.

GRAPHIC

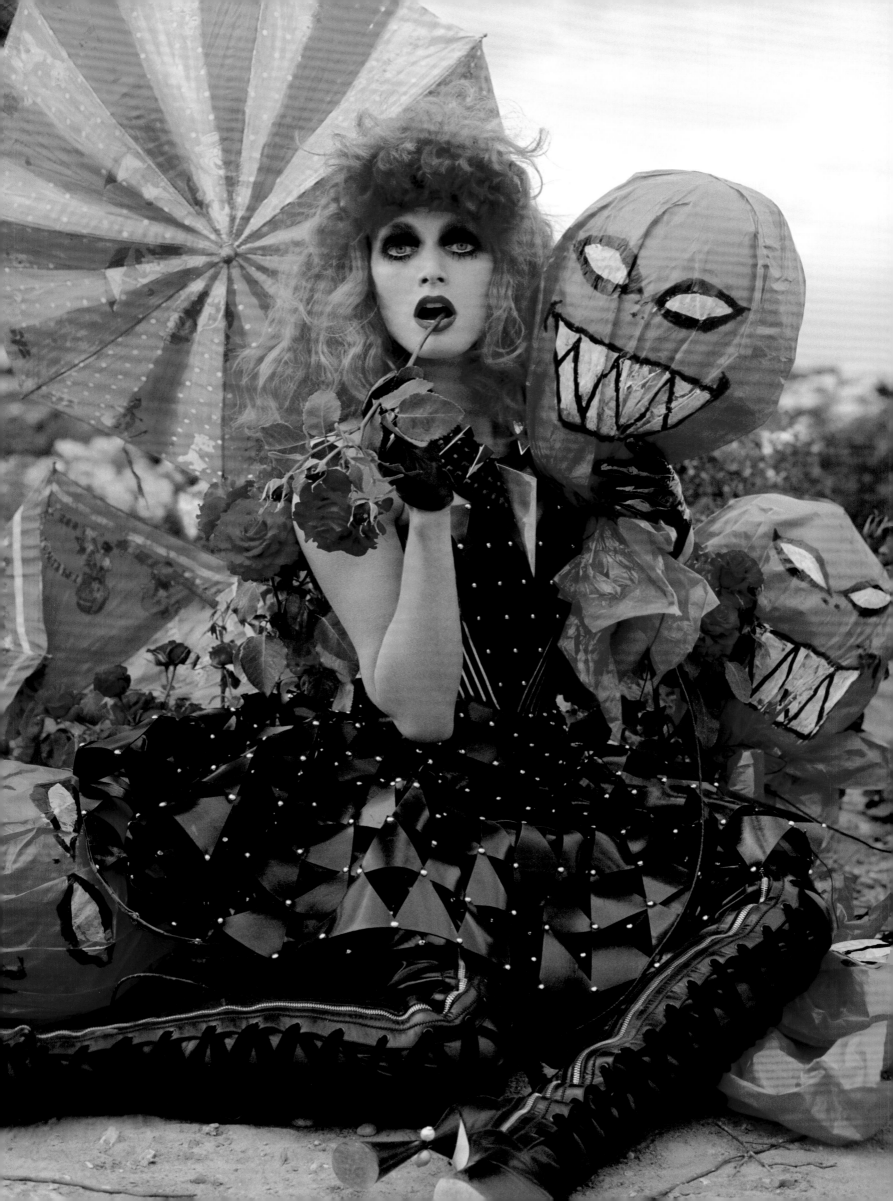

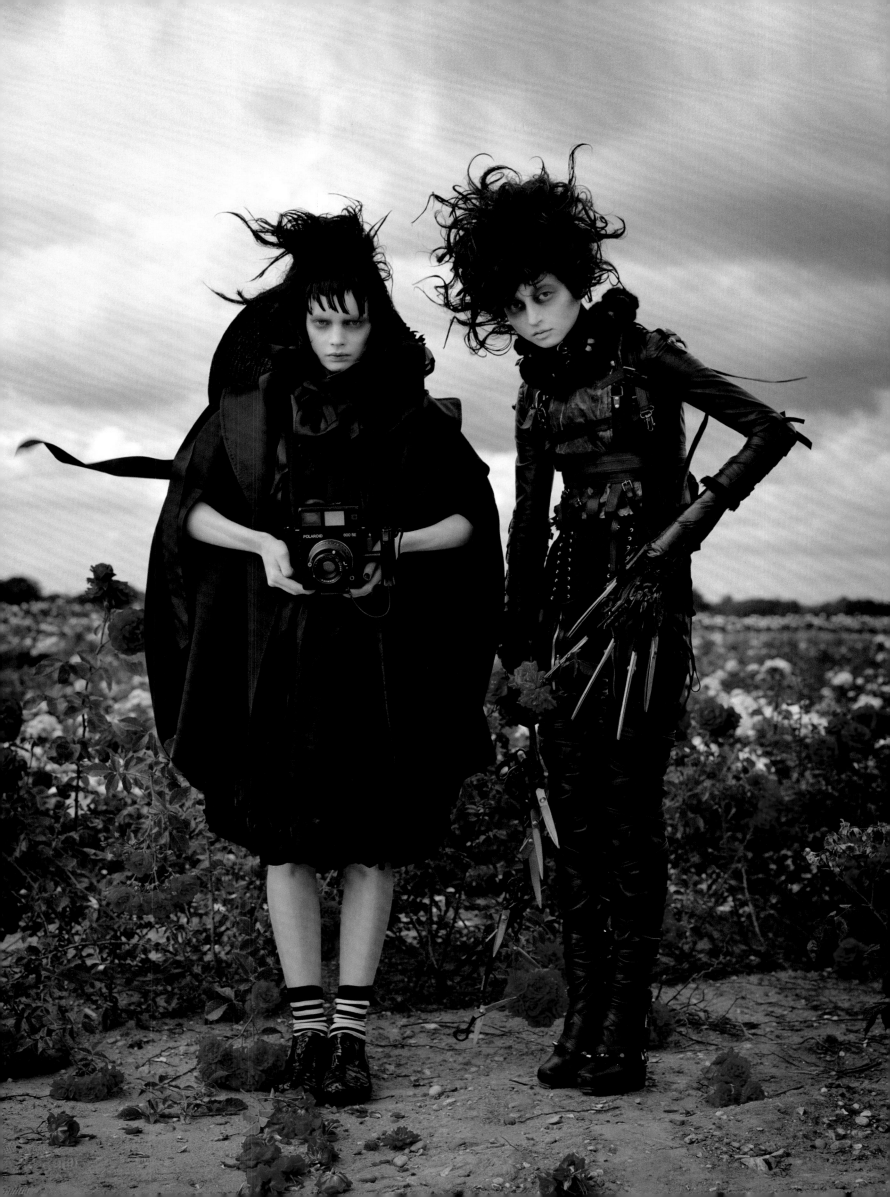

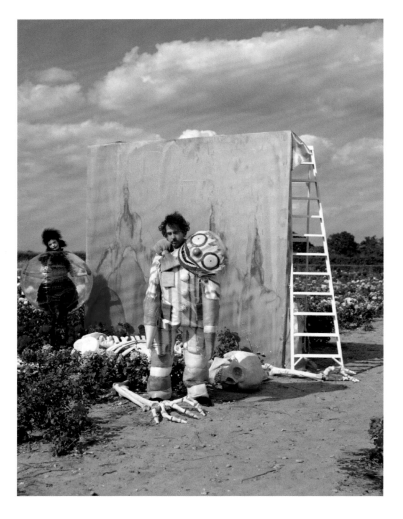

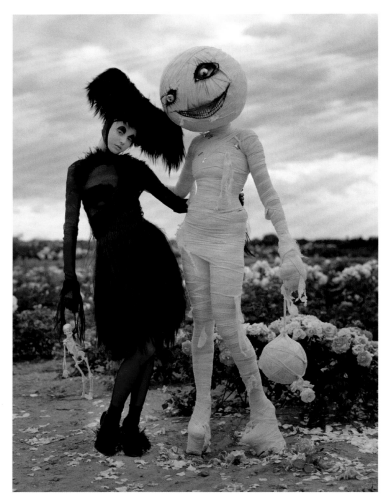

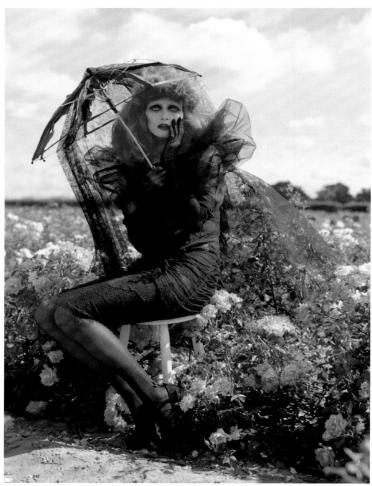

TIM BURTON'S TRICKS OR TREATS

This spread, clockwise from top left: Sophie Srej in Dolce & Gabbana, with Burton in a suit by Shona Heath, Evelina Mambetova in Givenchy by Riccardo Tisci, and Malgosia Bela in Nina Ricci (opposite) and Dolce & Gabbana. *Previous spread, from left:* Bela in Atelier Versace, Srej in Salvatore Ferragamo and Tao Comme des Garçons, and Mambetova in Rodarte and Phi. Photographed for the October issue by Tim Walker, styled by Jacob K.

With a spooky cast more suited to the boneyard than Barneys, Tim Burton guest-edited (and guest-starred in) a fashion story in anticipation of his 2009 retrospective at New York's Museum of Modern Art.

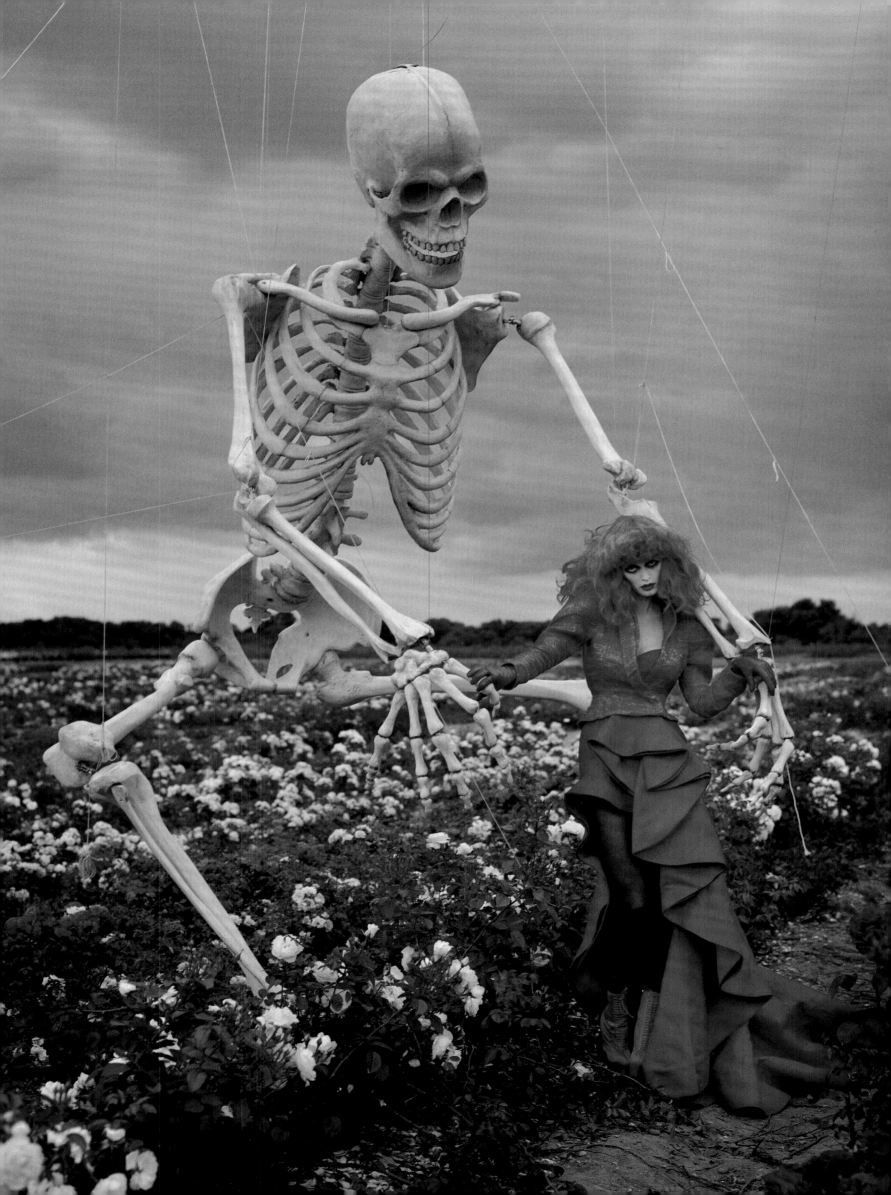

THE IT
JACKET

The actress and style skeptic hits the street in the look of the season, Balmain's bold-shouldered must-have piece

BY CARRIE FISHER
Excerpted from the September issue

WHEN *HARPER'S BAZAAR* ASKED ME to write about wearing the jacket of the moment, a challenging couturelike creation, I hesitated. I've never been a person who spends too much time thinking about what to wear. I'm the same way about food as I am about fashion. To me, food is fuel. I don't like to sit down at a table to eat. I like to grab something, unwrap it, and keep moving. When it comes to clothes, I throw on something and head out the door. Of course, it's nice if it's fairly flattering and covers disquieting parts of the body. As far as that goes, I almost always wear black—which, rumor has it, is slimming. If that's true—and I mean if—I think it's because black makes you semi-invisible. When I wear black, I'm saying, "Isn't that a beautiful tree over there? Check it out!"

So now, asked to wear a Balmain jacket that is the visual equivalent of a gay elf sitting on your shoulder and singing the national anthem at a decibel level generally found at a Metallica concert, for some unfathomable reason, I agreed.

The Balmain jacket is the It jacket. *Bazaar* informed me that it's coveted by a large number of celebrities who have the inside track on what's fashionable: Beyoncé, Victoria Beckham, Rihanna. Beautiful women who are beautiful no matter what they wear. Why do they choose to wear something to exaggerate what is organically exaggerated? Because they *can.*

On the upside, the jacket is black. But now it's time to take the jacket's sinister side to task: *gigantic* pointy, padded shoulders and *silver studs* that trail, Vegaslike, down the front so when you bring the sides together, you conceal whatever peekaboo shirt or push-up bra is lurking lazily beneath.

Of course, this jacket could remain tightly closed only if it actually fit. But when *Bazaar* inquired as to what size clothing I wore, naturally, as an overweight human, I lied. As though if informed of my actual size, they would drop the phone and *howl* with laughter, tears in their eyes.

Therefore, I cleverly informed them that I wore a size 10. Ha! I fooled them! Obviously, all the rumors that my breasts were so big, they arrived in a room minutes before my head were just that—rumors!

Not only was I confronted with an outrageous jacket, it didn't remotely fit. But was I daunted in any way? To be honest, yes. But I took a deep, thinning breath and wriggled my (temporarily) oversize self into this extreme example of outerwear.

Despite the jacket's not closing over my breasts or allowing me to put my arms down comfortably at my sides, I prepared to stride into the world defiantly sporting a garment that has such wide, pointy shoulders that they might as well be wings.

Which brings me to the jacket's other intriguing feature. On the back lurks a glittery emblem—an explosion of silver studs. If that weren't enough (and it is), there are two eyeball-size rhinestones and a pyramid (a pyramid!) of tiny studs flanked by wings! Yup, not only are the shoulder pads winglike, there are actual shiny wings on the back. People wouldn't just look at me and wonder why they had the eerie feeling that they'd seen a younger version of me somewhere before; they would look at me and wonder why I'd let a blind person dress me. I'm one of those rare people who can take a designer dress and make it look as if I got it on sale at Ross.

Now that you have the backstory, the truth is, when I wore this amazing item on the streets of New York, I didn't get such a big reaction. The most common look I got seemed to be one of pity. A look that asked, "Why would someone with her breast size wear something that encourages so much attention? Why didn't she stay at home wearing a Snuggie watching the exercise channel and sobbing quietly before crawling into bed to count sheep, like calories, until she fell asleep, perchance to dream of thinner times, outfitted in more appropriate outerwear?" All this in a look.

SHARP SHOULDERS

Doutzen Kroes in Balmain, photographed for the July issue by Terry Richardson, styled by Brana Wolf.

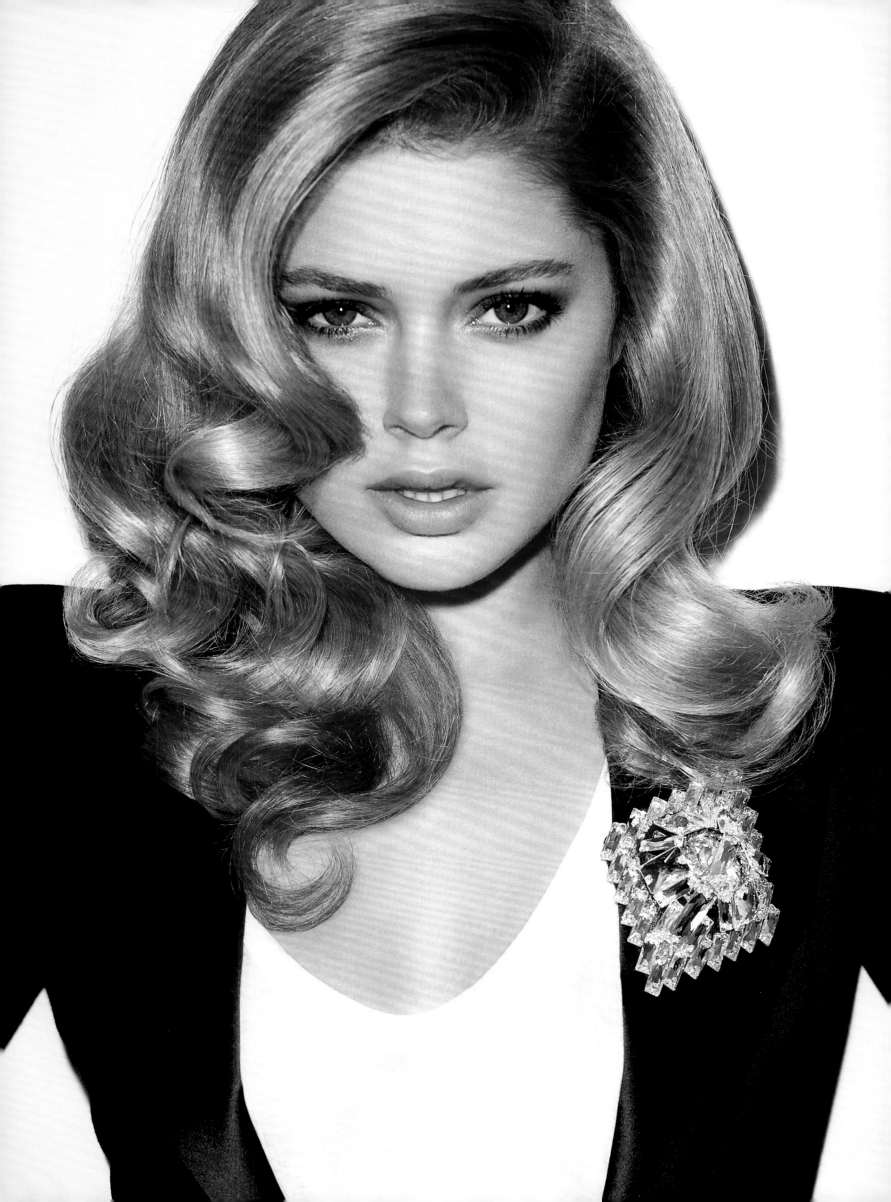

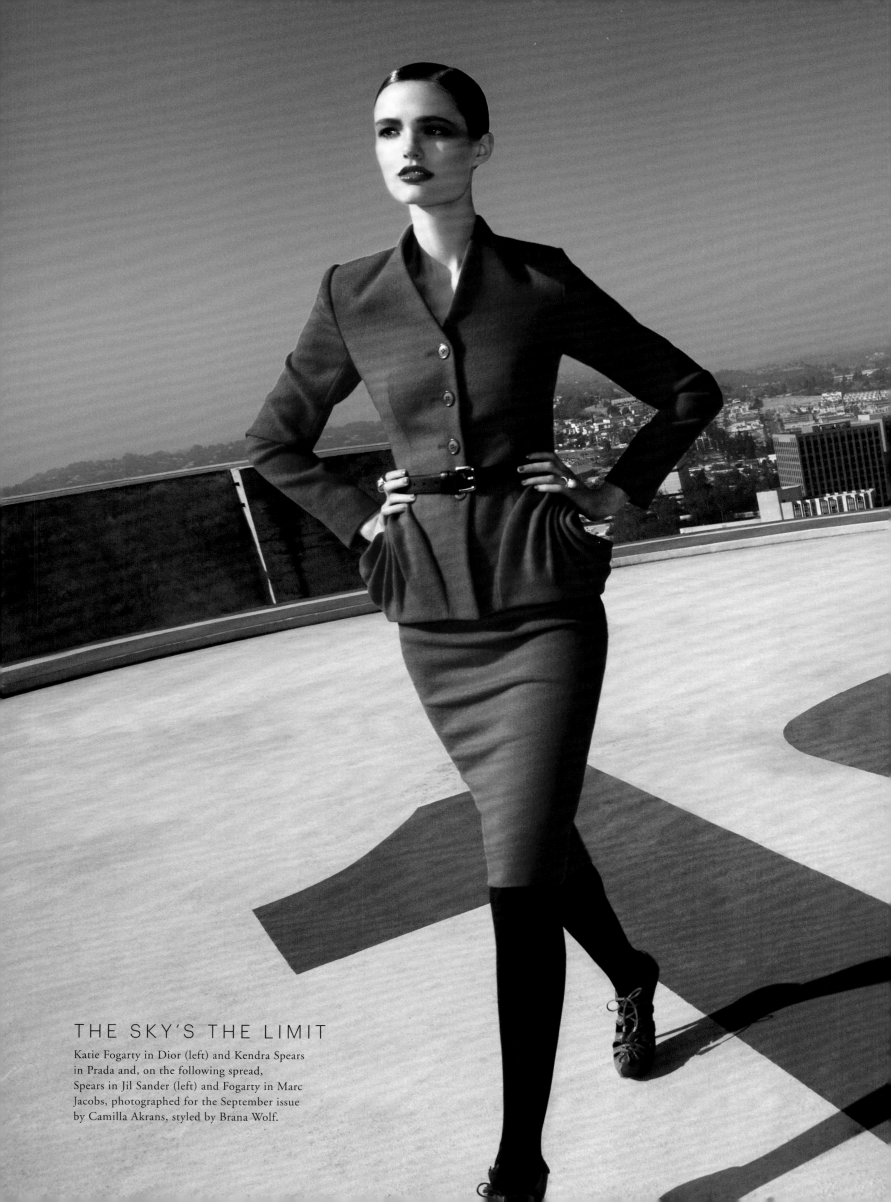

THE SKY'S THE LIMIT

Katie Fogarty in Dior (left) and Kendra Spears
in Prada and, on the following spread,
Spears in Jil Sander (left) and Fogarty in Marc
Jacobs, photographed for the September issue
by Camilla Akrans, styled by Brana Wolf.

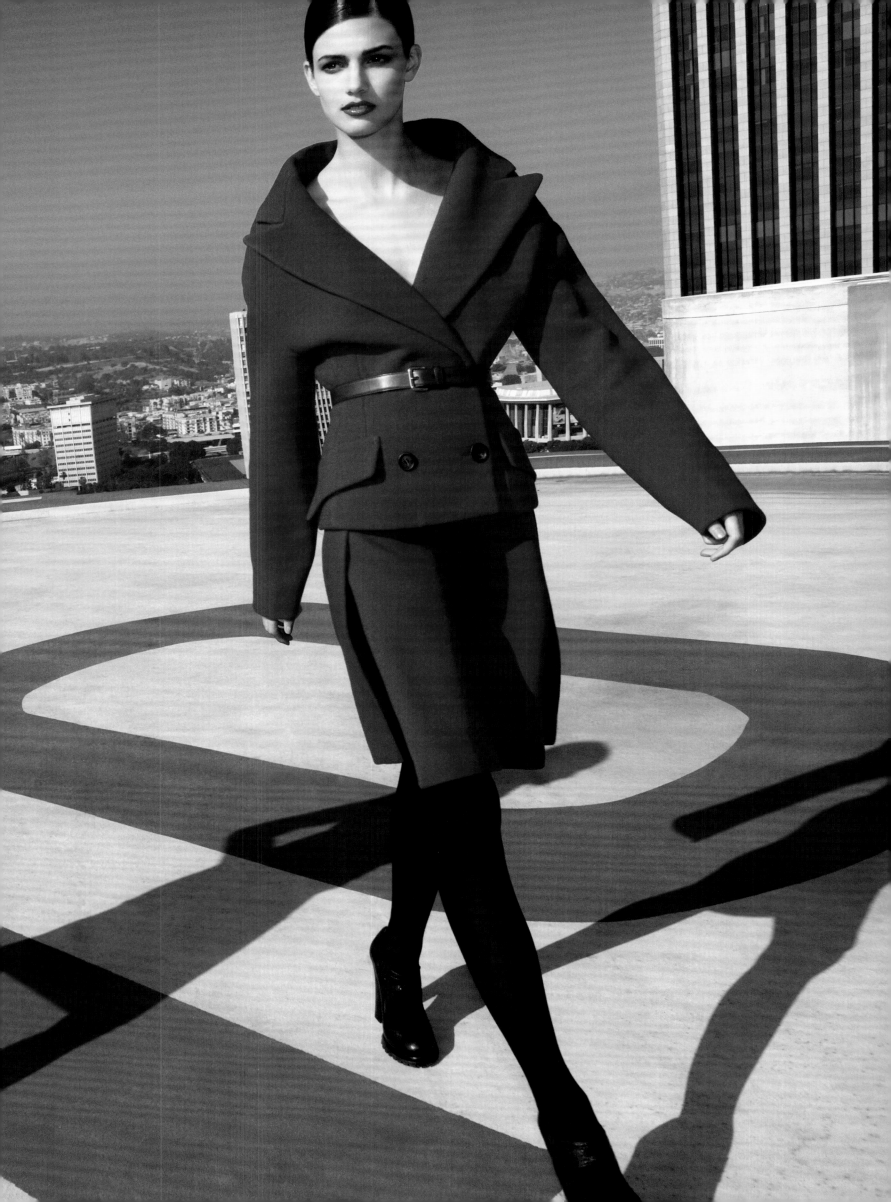

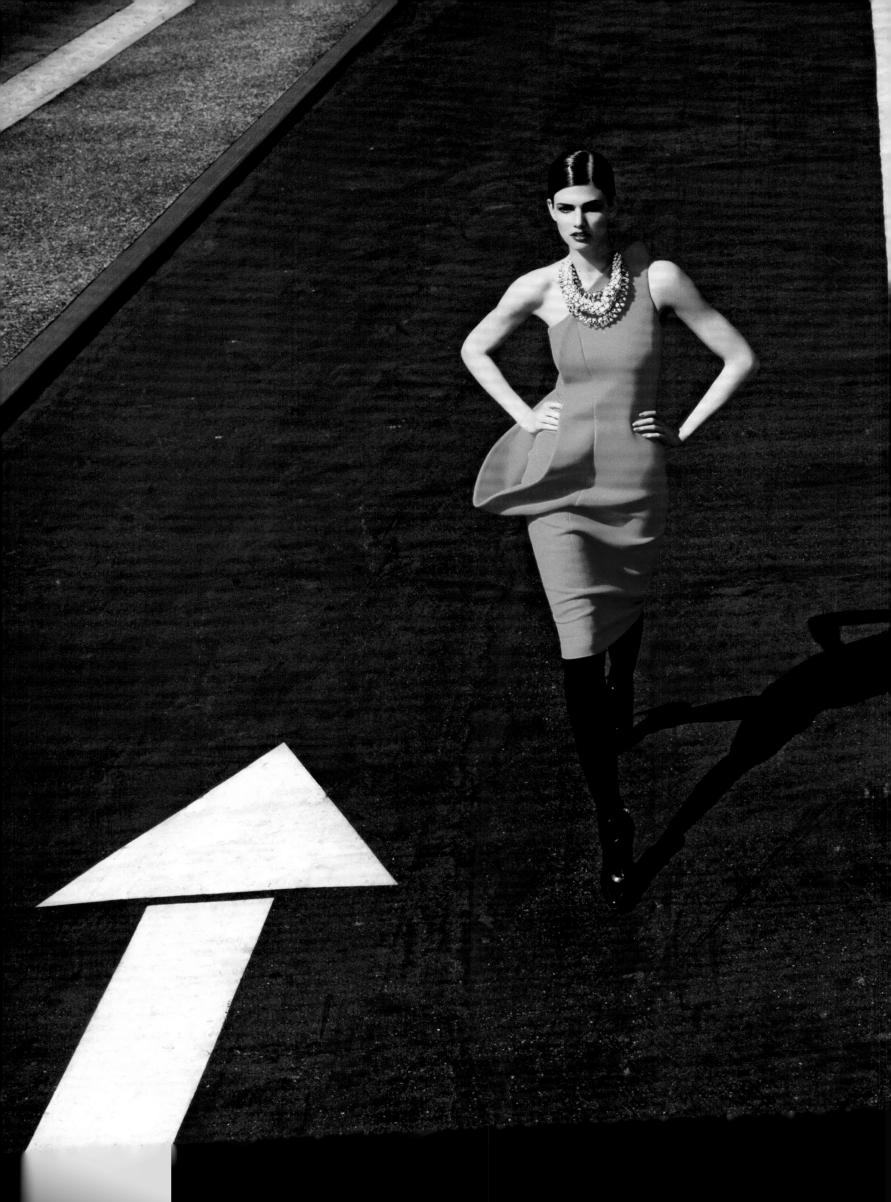

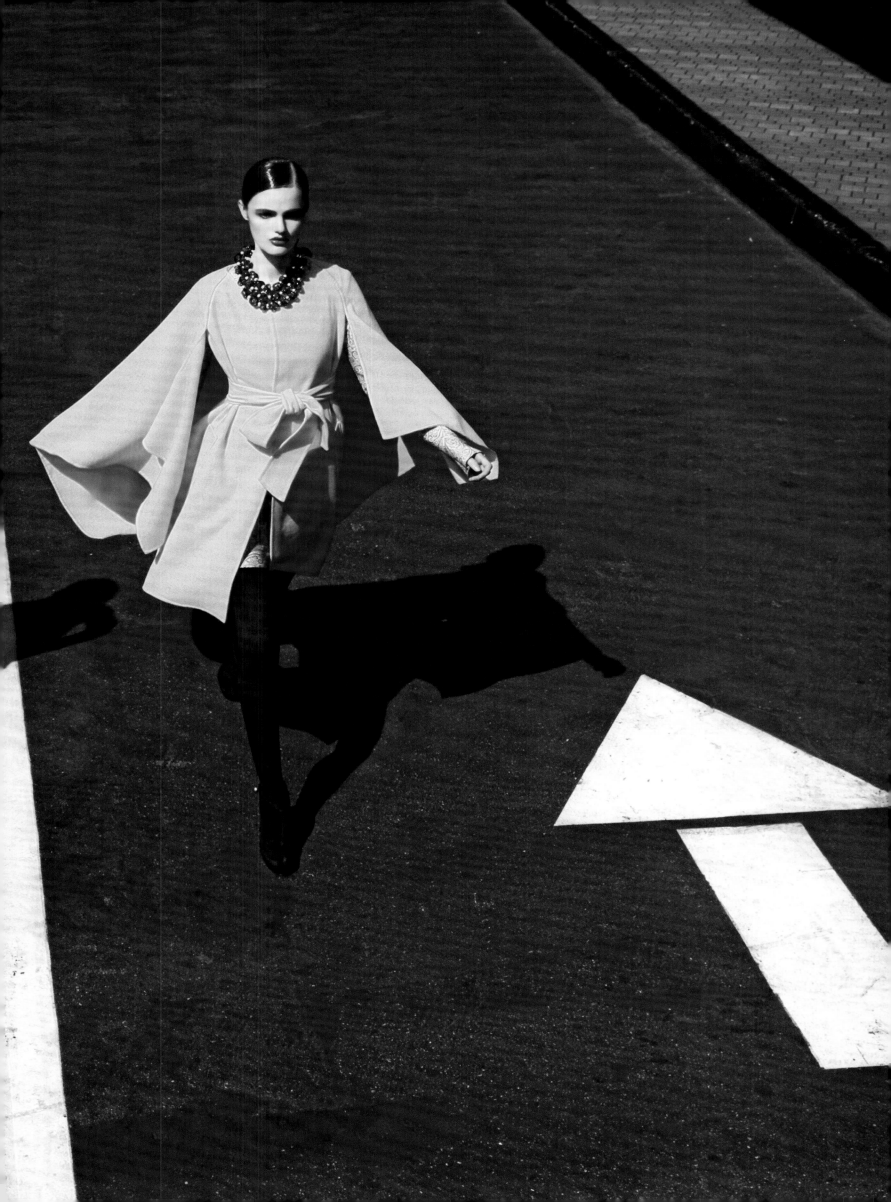

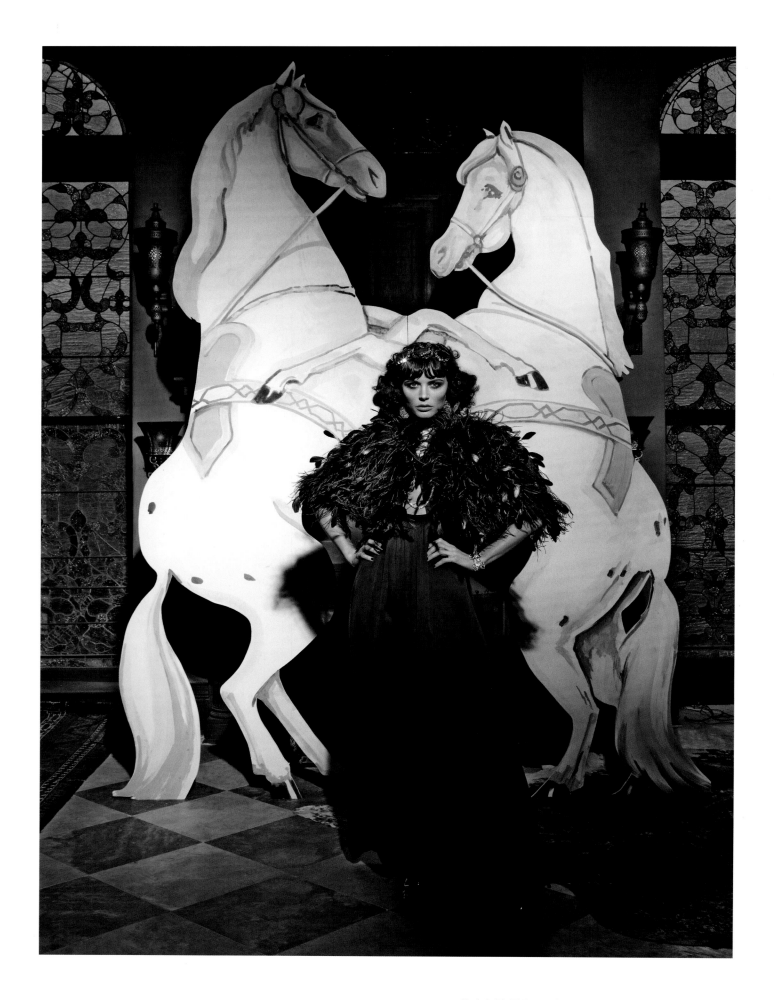

QUEEN OF HER CASATI

Georgina Chapman pays homage to her label's namesake, Marchesa
Luisa Casati, in Dsquared2 (above) and Etro, photographed for
the March issue by Peter Lindbergh, styled by Jenny Capitain.

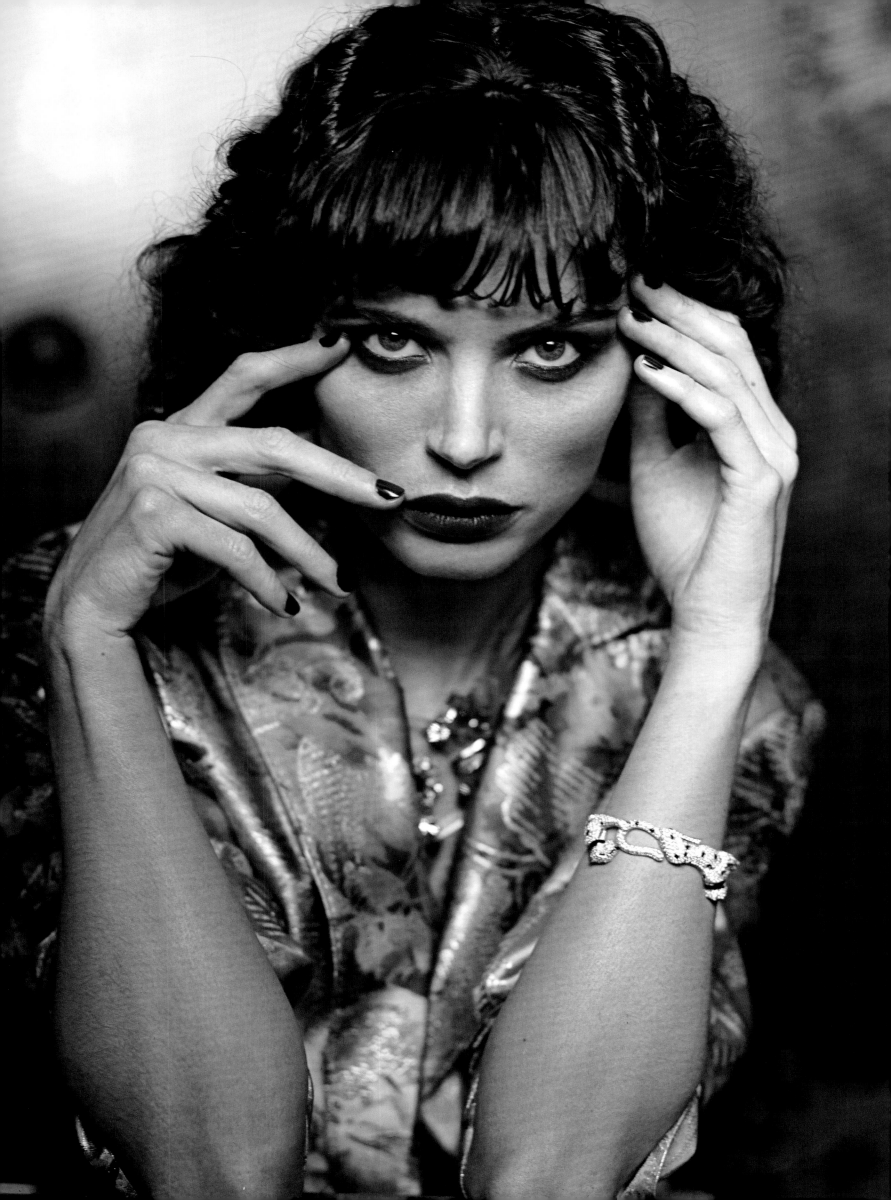

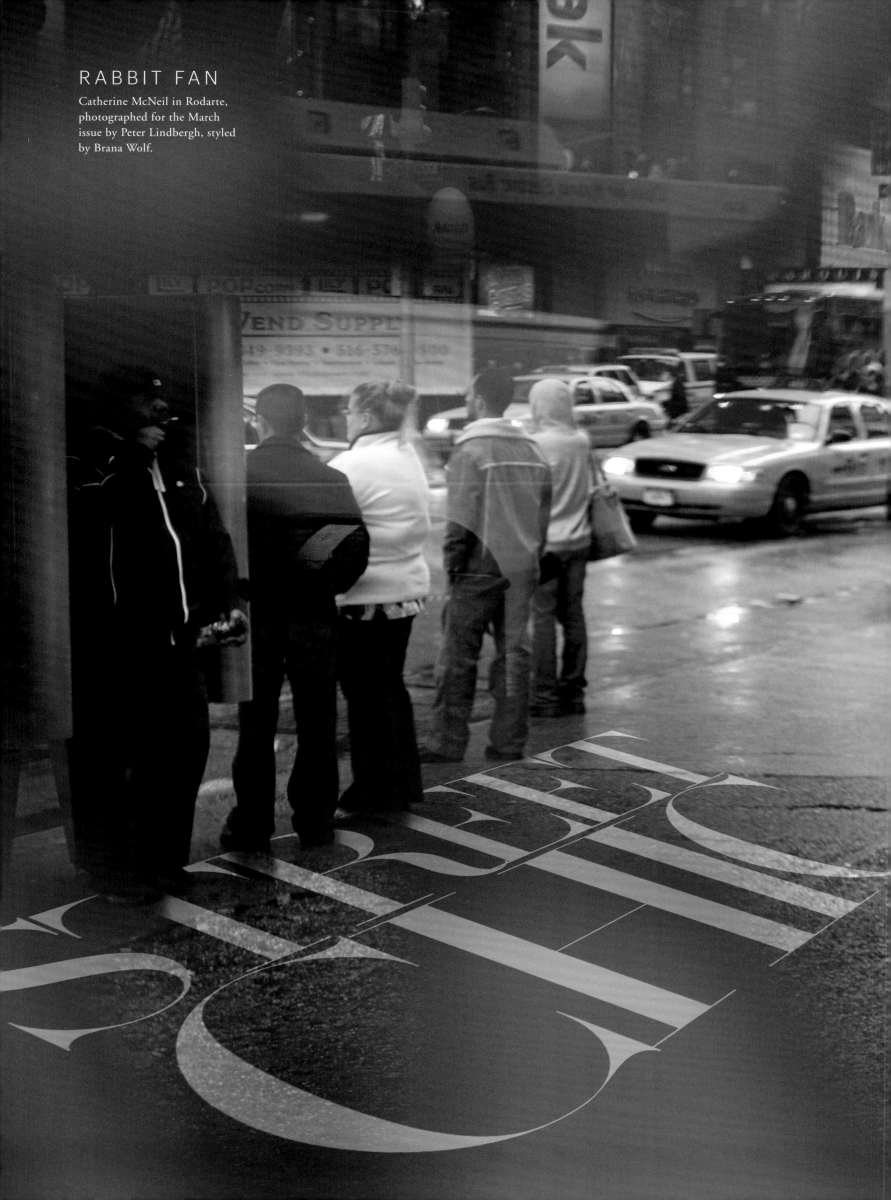

RABBIT FAN

Catherine McNeil in Rodarte,
photographed for the March
issue by Peter Lindbergh, styled
by Brana Wolf.

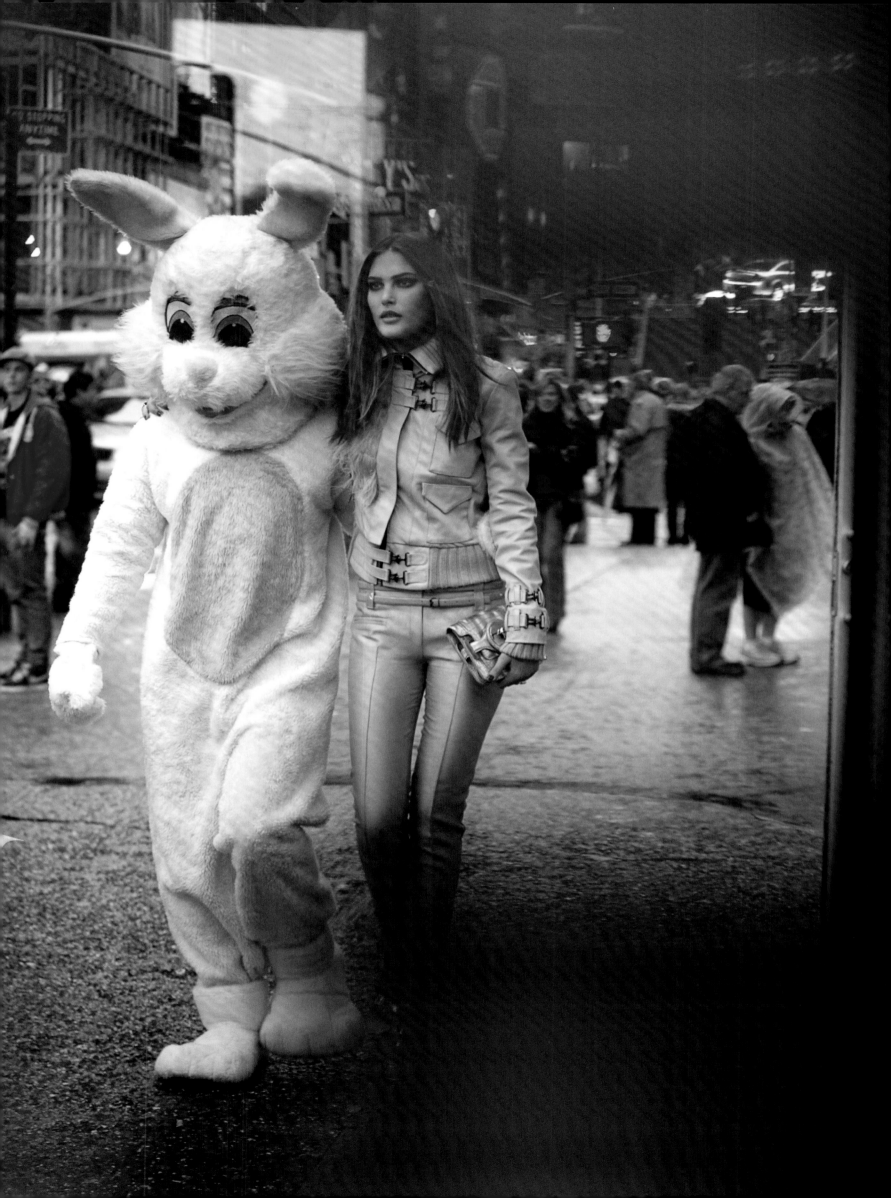

2010

TAKING FASHION TO NEW HEIGHTS

Demi Moore in Alexander McQueen, photographed for the April issue by Mark Seliger,
styled by Rachel Zoe. Winner of a MIN Editorial & Design Award for Best Cover Design, a *Folio*
Ozzie Award for Best Cover, and one of *Time*'s Top 10 Magazine Covers of 2010.

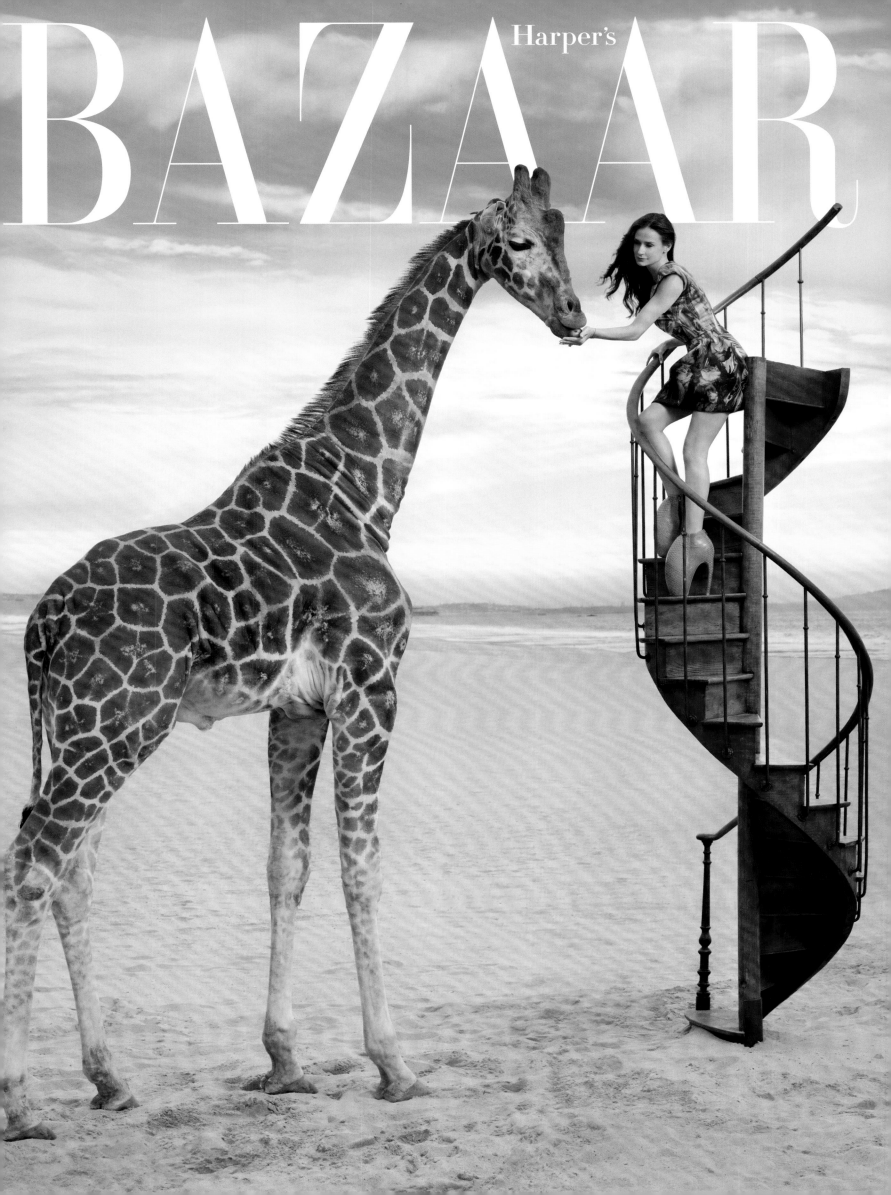

Harper's

BAZAAR

THE NEWS
AT 10

BAZAAR STARTED THE YEAR with a smile. It belonged to Kate Hudson, who, on the January cover, sashayed past a Manhattan flower stand in a feathered white minidress and with a huge grin. Inside, she and son Ryder palled around their downtown stomping grounds as if the whole city was theirs for the playing. In February, Daniel Jackson and Brana Wolf captured the current fashion zeitgeist, notably the clean and clear minimalistic mantra of Phoebe Philo (who triumphantly returned to fashion after a three-year absence) at Céline and the playful cool of Jack McCollough and Lazaro Hernandez of Proenza Schouler.

March took a more renegade, though no less stylish, turn with Peter Lindbergh's portrayal of outlaws Bonnie and Clyde. Dressed in the tailored neutrals of the season, the dashing duo ran afoul of the law but remained on the right side of fashion.

Colorful characters with equally vivid sex appeal have long been a fetish of Spanish filmmaker Pedro Almodóvar. In March, *Bazaar* recast some of his vivid celluloid moments with fashion's favorite faces. Roger Vivier's Bruno Frisoni got caught in a *High Heels*–inspired shoe-down between muses Loulou de la Falaise and Betty Catroux, while Angela Missoni cooked up a scheme to conceal a weapon à la *Volver*. The portfolio coincided with the announcement of a Broadway production based on his film *Women on the Verge of a Nervous Breakdown*.

For September, Jennifer Aniston had the idea to pay homage to one of her heroes, Barbra Streisand, for *Bazaar*. If Aniston, who knows Streisand personally, was worried about her idol's reaction, she needn't have been. Said Streisand of Aniston, "She's a delightful person, and I think she did a wonderful job. If only she had a bump on her nose." (Later, in the December issue, Streisand invited *Bazaar* on an exclusive tour of her estate, which includes a *Hello, Dolly!*–era Main Street, complete with doll emporium and antique shop, in the basement.)

From icon to "I Die," September also had its own murder mystery, featuring Rachel Zoe and a crew of designers trading on one of her catchphrases. Showing how and why they would kill off the stylist ("I only want to kill Rachel when I don't land one of her fabulous clients for the Oscars!" pronounced Vera Wang as she emptied her poison ring into Zoe's drink), the designers changed the conversation from "Who wore it?" to "Whodunit?" Zoe also styled her friend Demi Moore for the April cover on a Dalí-esque surrealist stairway to heaven. Moore graciously agreed to climb the precarious stairs and pose with a giraffe. Shot only weeks before Alexander McQueen passed away, the image of her wearing a dress (not to mention those now-famous 10-inch armadillo heels) from his penultimate collection became a poignant tribute to a fashion genius.

Both Marc Jacobs and Calvin Klein know that adversity builds strength. Along with baring his soul to Klein in an interview, Jacobs bared his body for art photographer Nan Goldin. Said Jacobs, "For so many years, I felt so insecure, so inferior, and I still have those moments, but I have a newfound confidence since I got in shape and changed my diet."

In November, the first lady, Michelle Obama, shared with *Bazaar* her passion for supporting young creative talent, which ranges from members of the Howard University Choir to teenage percussion prodigy Jason Yoder and does not exclude Justin Bieber. "There is some power in the Bieber!" Obama acknowledged.

There's nothing like the power of teenage dreams. Just ask Katy Perry, who looked grown-up and glamorous in December and sealed our subscriber cover with a Swarovski-crystal-studded kiss.

LIP SERVICE

Katy Perry, photographed for the December issue by Alexi Lubomirski, styled by Katie Mossman. Winner of an *Advertising Age* Best Cover award.

Harper's
BAZAAR

COUNTER CULTURE

Kate Hudson in Burberry Prorsum,
photographed for the January issue by
Peter Lindbergh, styled by Rachel Zoe.

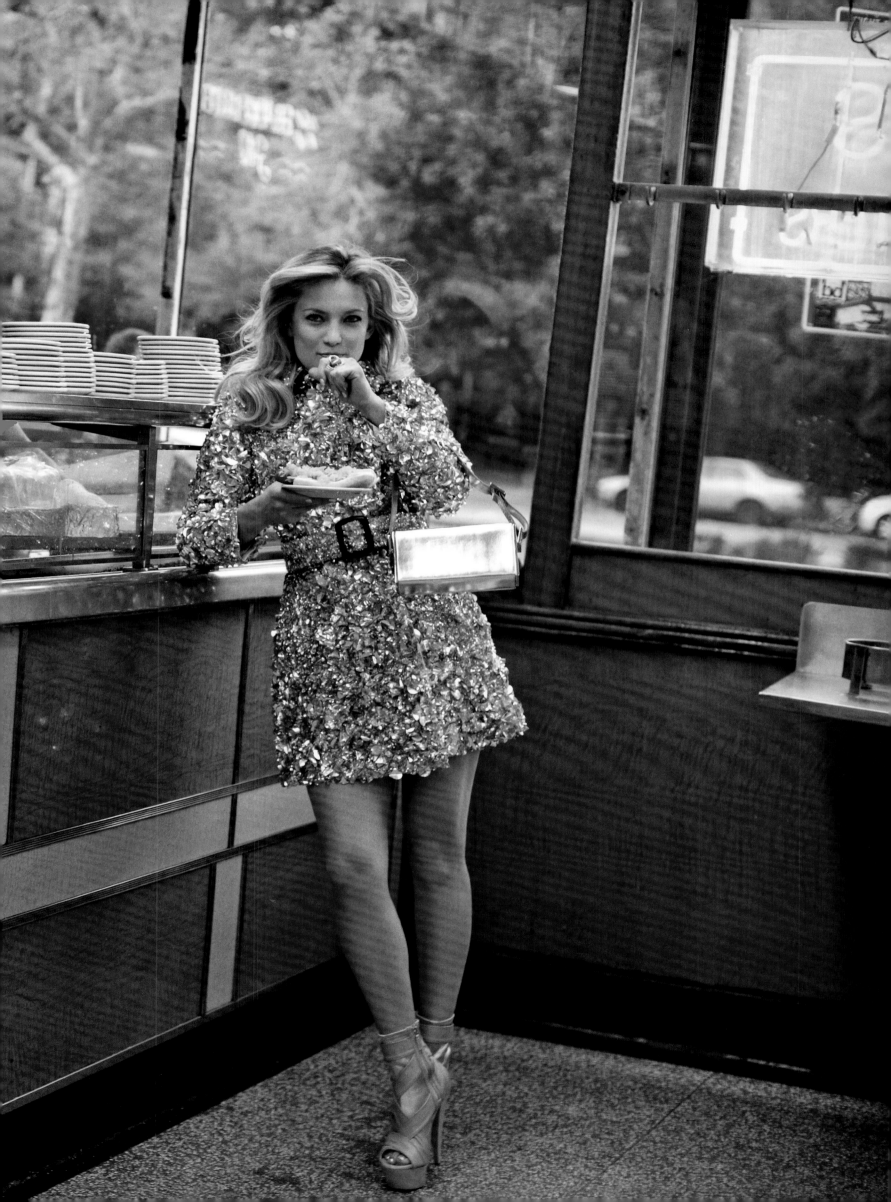

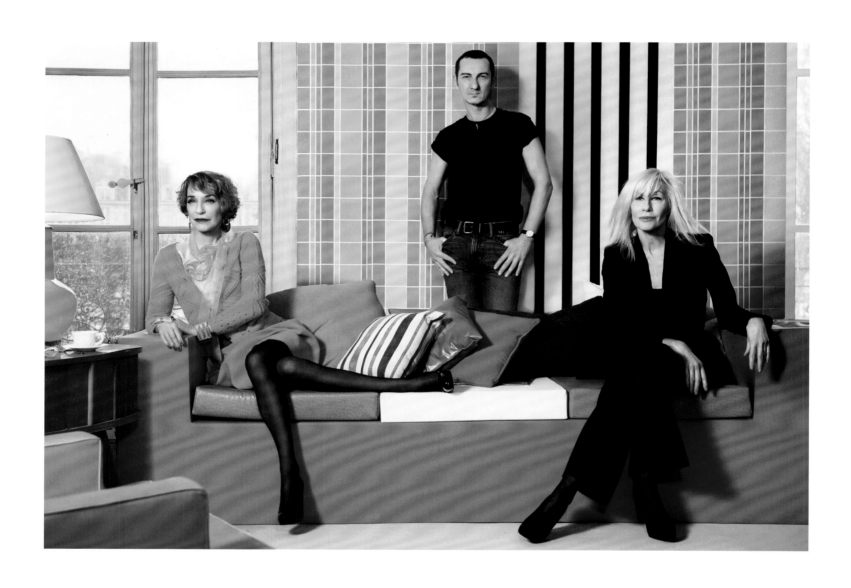

PEDRO'S PERFECTION

Photographed for the March issue by
Jason Schmidt, styled by Katie Mossman.

This page: Loulou de la Falaise in Oscar de la Renta
(above left), Bruno Frisoni, and Betty Catroux in
Yves Saint Laurent, in a scene from *High Heels.*
Opposite: Sonia Rykiel and her daughter, Nathalie,
as *Women on the Verge of a Nervous Breakdown.*
Next page: Angela Missoni does *Volver. Opposite:*
Jean Paul Gaultier and Mariacarla Boscono don
Dark Habits. Following spread: Karl Lagerfeld and
Pedro Almodóvar show some *Live Flesh.*

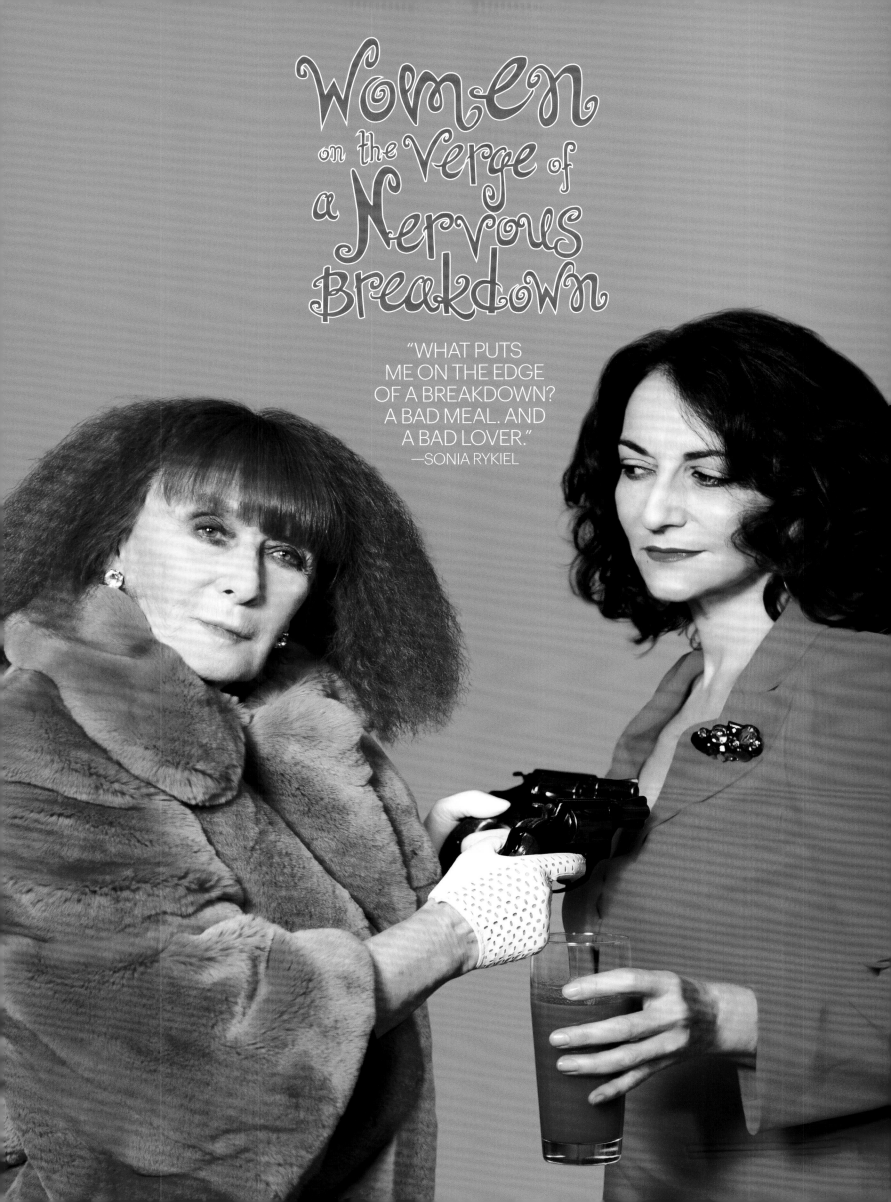

Women on the Verge of a Nervous Breakdown

"WHAT PUTS ME ON THE EDGE OF A BREAKDOWN? A BAD MEAL. AND A BAD LOVER."
—SONIA RYKIEL

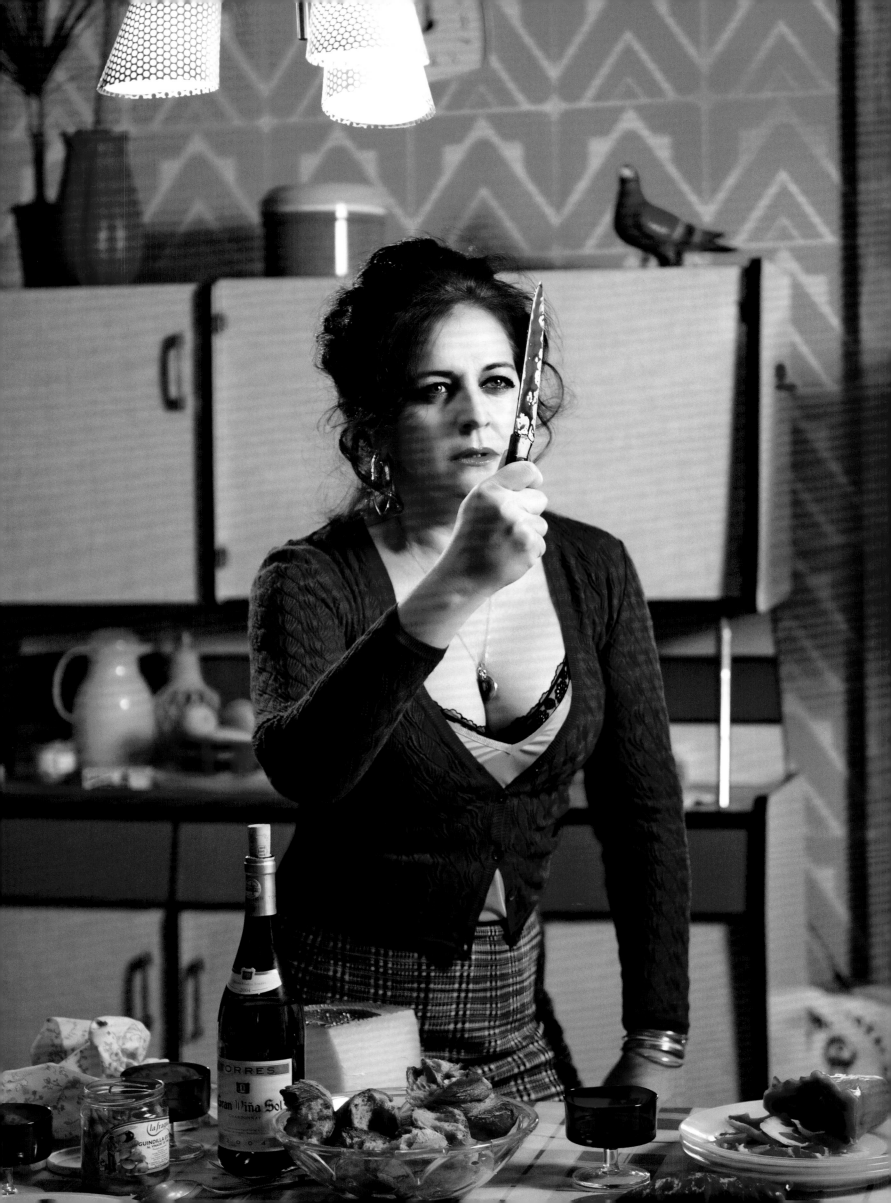

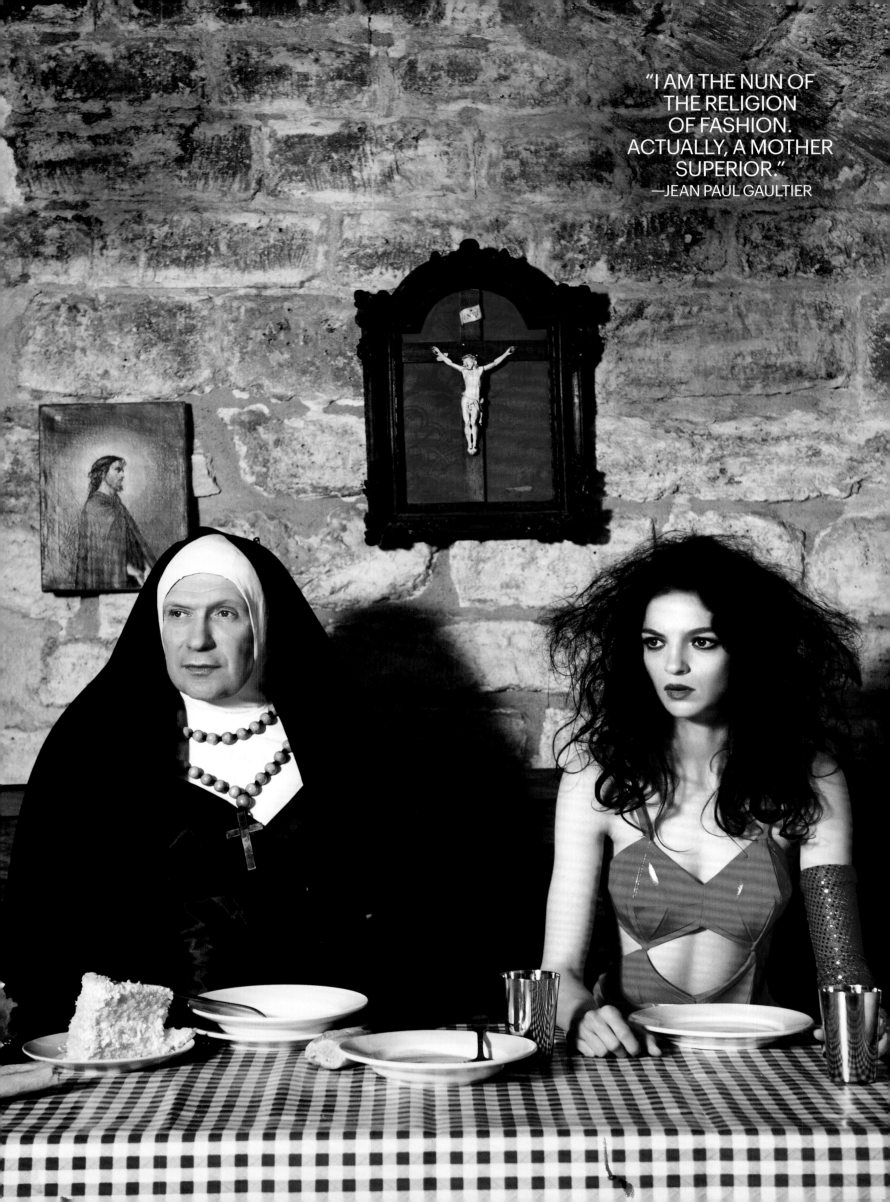

"I AM THE NUN OF THE RELIGION OF FASHION. ACTUALLY, A MOTHER SUPERIOR."
—JEAN PAUL GAULTIER

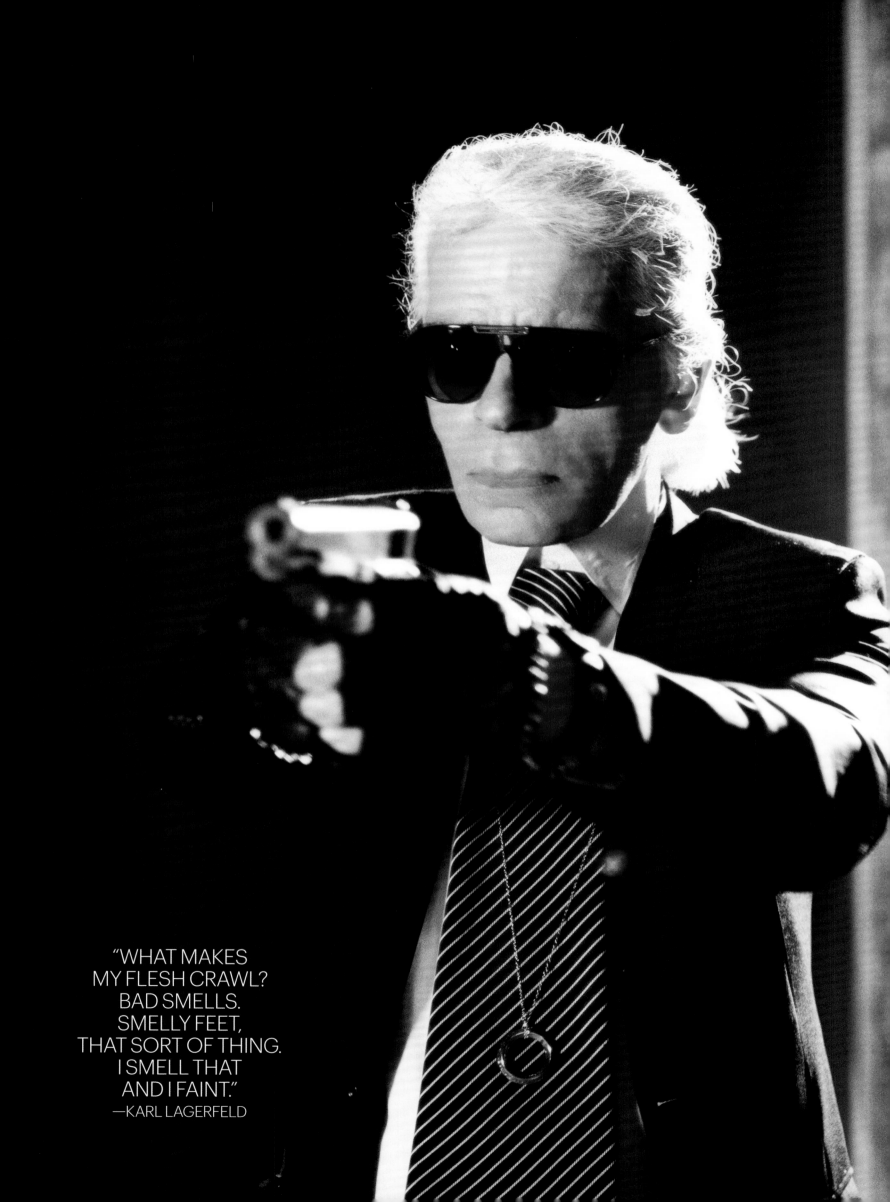

"WHAT MAKES
MY FLESH CRAWL?
BAD SMELLS.
SMELLY FEET,
THAT SORT OF THING.
I SMELL THAT
AND I FAINT."
—KARL LAGERFELD

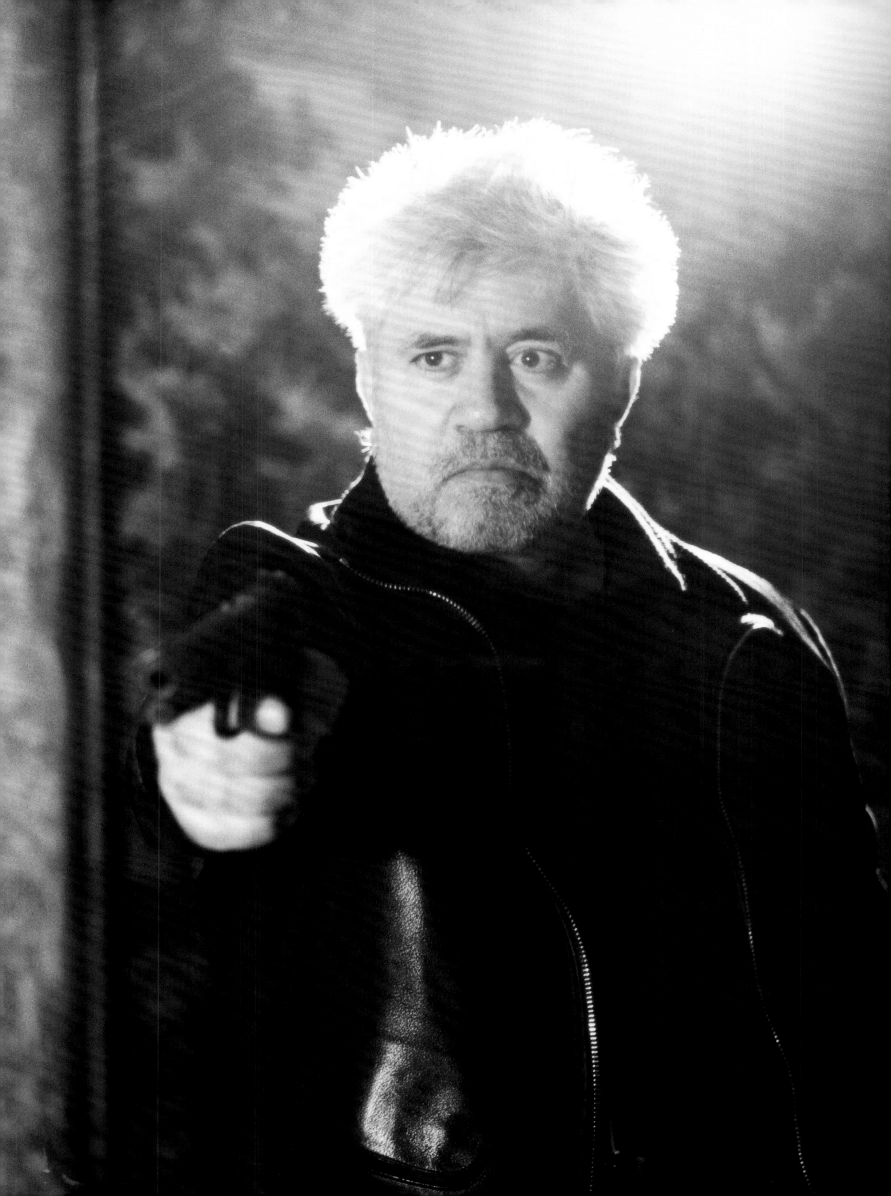

To celebrate the release of her tome *My Passion for Design,* Barbra Streisand, in Roberto Cavalli, opened up her Malibu home to *Bazaar.* Photographed for the December issue by Terry Richardson, styled by Leslie Lessin.

FUNNY GIRL

Opposite page: Jennifer Aniston, photographed for the September issue by Mark Seliger, styled by Katie Mossman.

Jennifer Aniston paid homage to Barbra Streisand. The concept was Aniston's idea, and she selected every iconic element she wanted to replicate— right down to the singer's signature fingernails.

BARBRA'S DREAM HOUSE

BY JAMES REGINATO
Excerpted from the December issue

DON'T BELIEVE ANYBODY who tells you stars are just like us. At home in Malibu, Barbra Streisand installed a shopping mall in her basement. Along a cobblestone-paved, antique-lantern-lit "street," a collection of turn-of-the-last-century-style shops beckons "customers" to step inside. Traffic is heaviest during screening parties, when the Sweet Shop does brisk business dispensing licorice, frozen yogurt, and popcorn to guests. Before going out to a dinner party or a friend's birthday, Streisand likes to duck into the Gift Shoppe to pick up a present—a soap dish or a pair of candlesticks—and tie it up with pretty ribbons at the wrapping table.

Other emporiums include the Antique Shop, the Antique Clothes Shop, and Bee's Doll Shop (in front of which she thoughtfully installed a bench for men to sit while the ladies are inside). The only items missing are the cash registers.

"You can do that if it's your own mall," Streisand explains to me on a September afternoon. Clad in black from head to toe—chenille cap, tank top, cashmere sweater, stretch pants, and boots—she is perched on a sofa in a sprawling 49th-floor suite atop the Sheraton New York, where she is attending the Clinton Global Initiative.

After a day spent downstairs with "Shimon," "Bill," and other world leaders with whom she is on a first-name basis, Streisand, 68, is taking a break to snack on some cheese and talk about her new book, *My Passion for Design,* out now. Lushly illustrated with hundreds of photographs, most of which were taken by Streisand, it lovingly documents the dream homes she spent almost two decades creating.

Like everything on her estate, the shops grew out of years of careful research. On a trip to the legendary decorative-arts museum Winterthur in Delaware, she was fascinated by a series of early-19th-century shops created by curators to display their collections. "Seeing Winterthur's indoor street, I thought how ingenious that was," she remembers. "Instead of just storing my things in the basement, I can make a street of shops and display them."

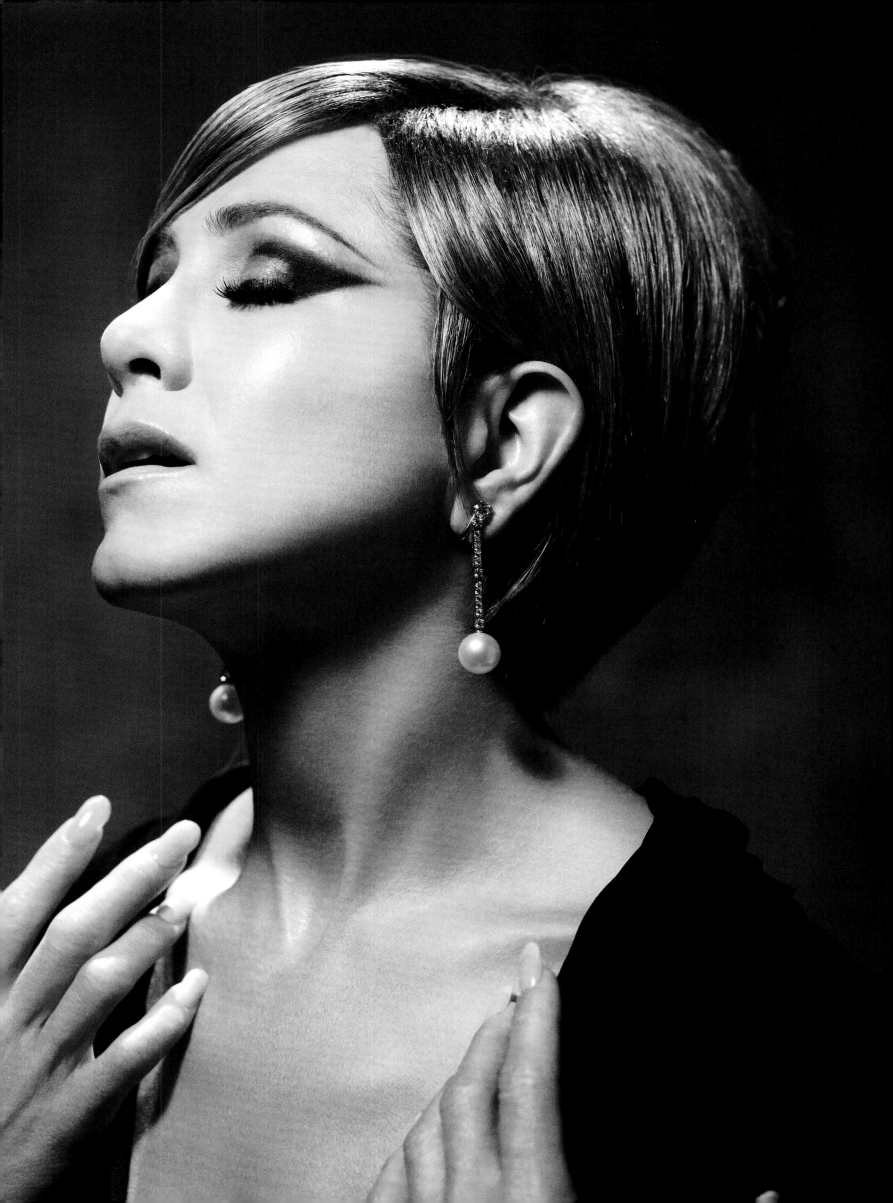

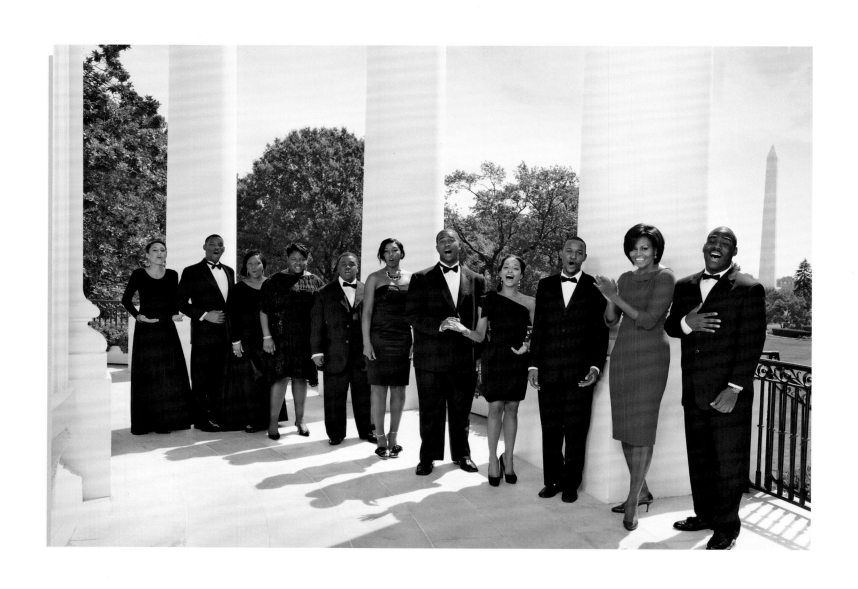

FIRST LADY
OF THE ARTS

Michelle Obama, photographed for
the November issue by Jason Schmidt.
Sittings editor: Mary Alice Stephenson.

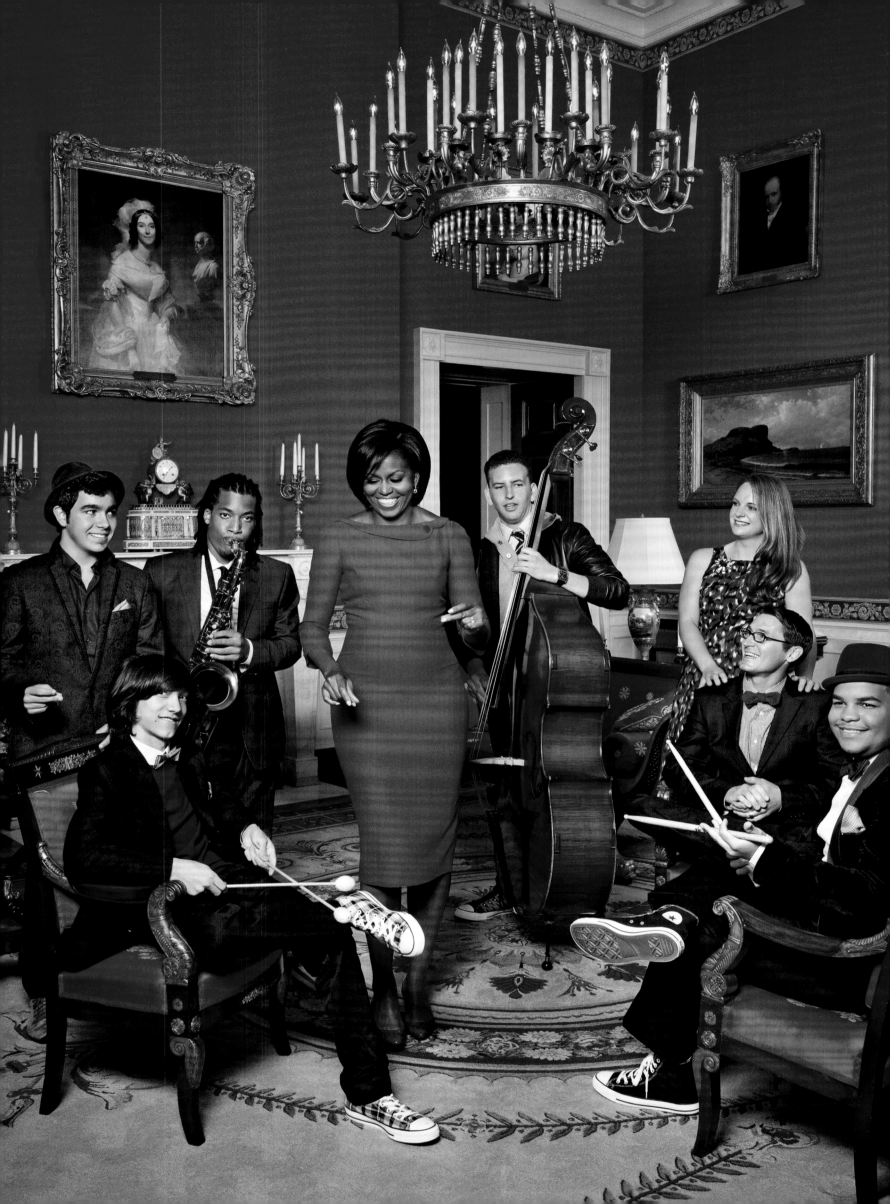

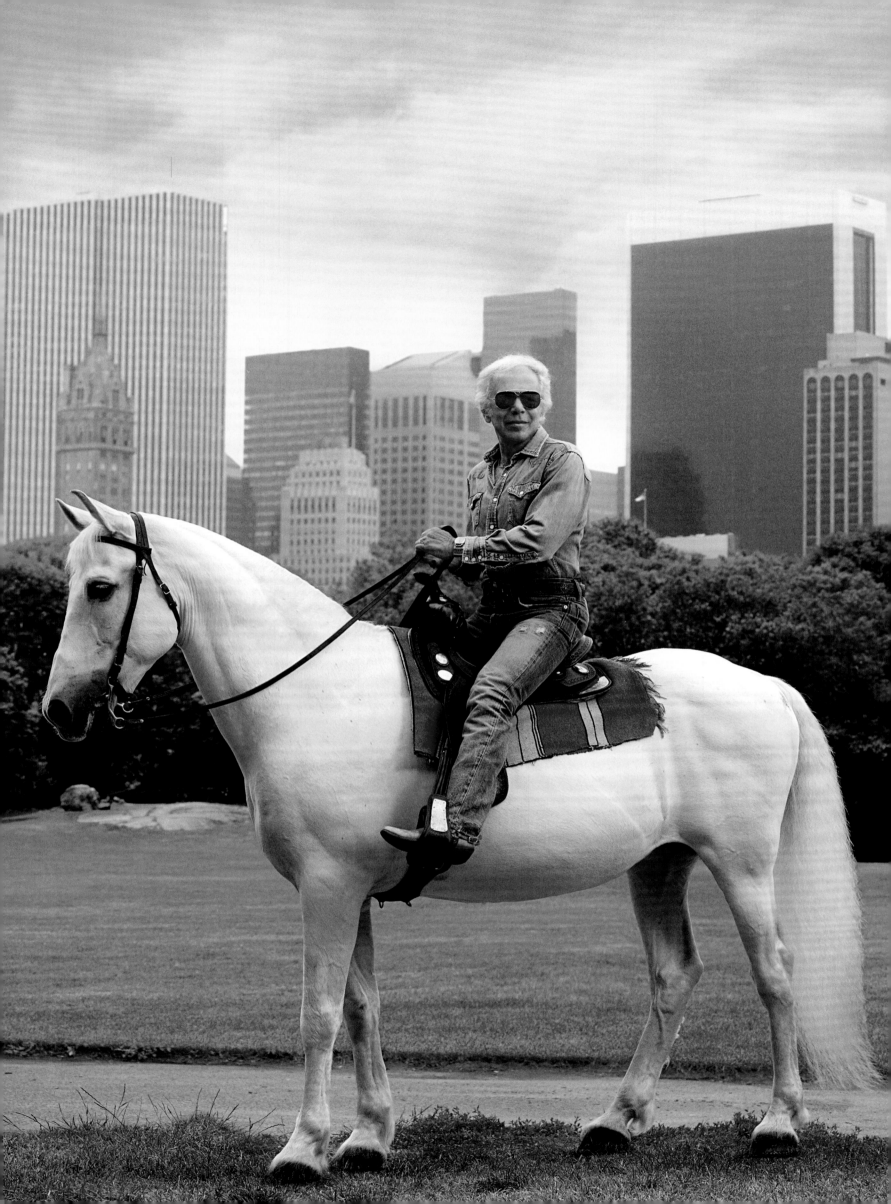

"THE CLASSIEST
AMERICAN COWBOY"

Ralph Lauren, photographed for the September issue
by Mark Seliger. Sittings editor: Katie Mossman.

Never were there more fitting words than these, which
Diane von Furstenberg told writer Anamaria Wilson on the
eve of Lauren's new Madison Avenue manse's opening.

MOST WANTED

BONNIE AND A GUNSLINGIN' **WES BENTLEY** AS CLYDE ARE ON THE RUN IN THE SEASON'S MOST THRILLING **DAYWEAR**

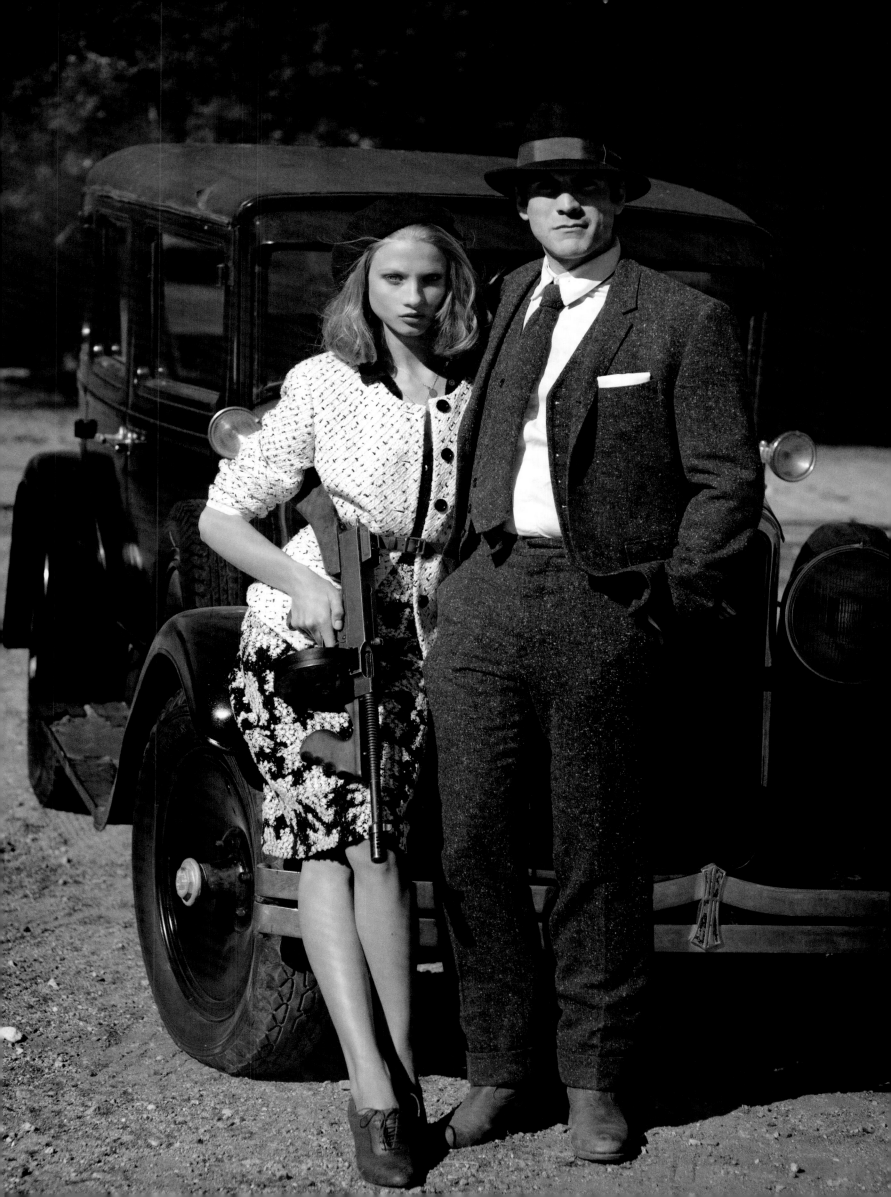

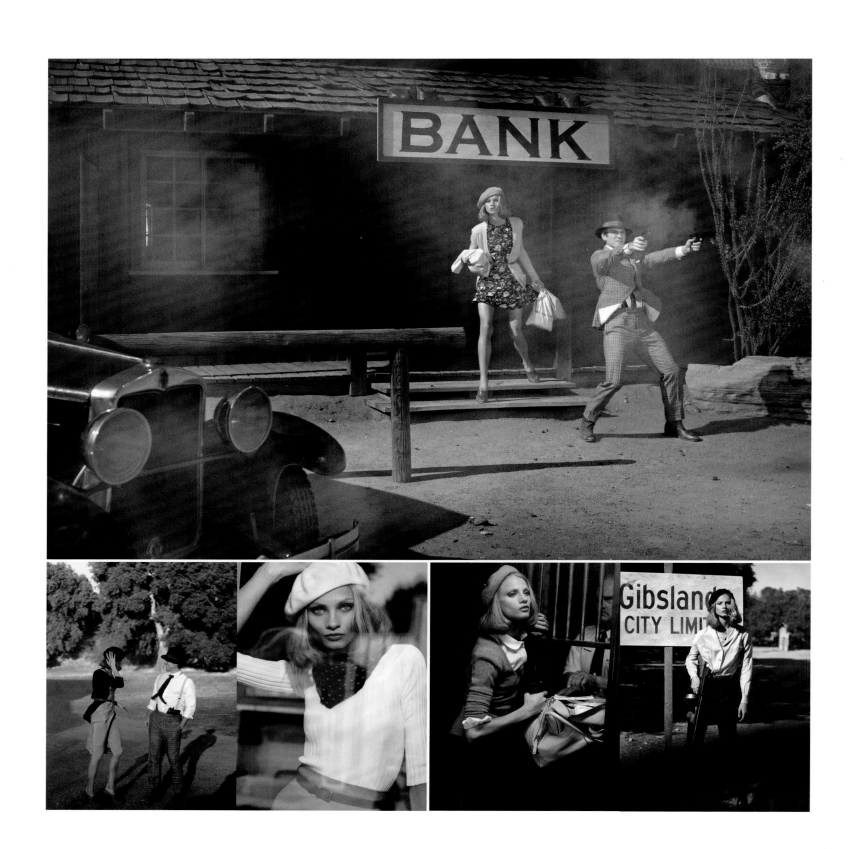

TAKE THE MONEY AND RUN

Anna Selezneva, with Wes Bentley, in Ralph Lauren Blue
Label (top left) and Oscar de la Renta (top right) and, on the
previous spread, Jones New York Collection and St. John,
photographed for the March issue by Peter Lindbergh, styled by
Aleksandra Woroniecka. The previous spread features the original
typography, by *Bazaar*'s design director, Elizabeth Hummer.

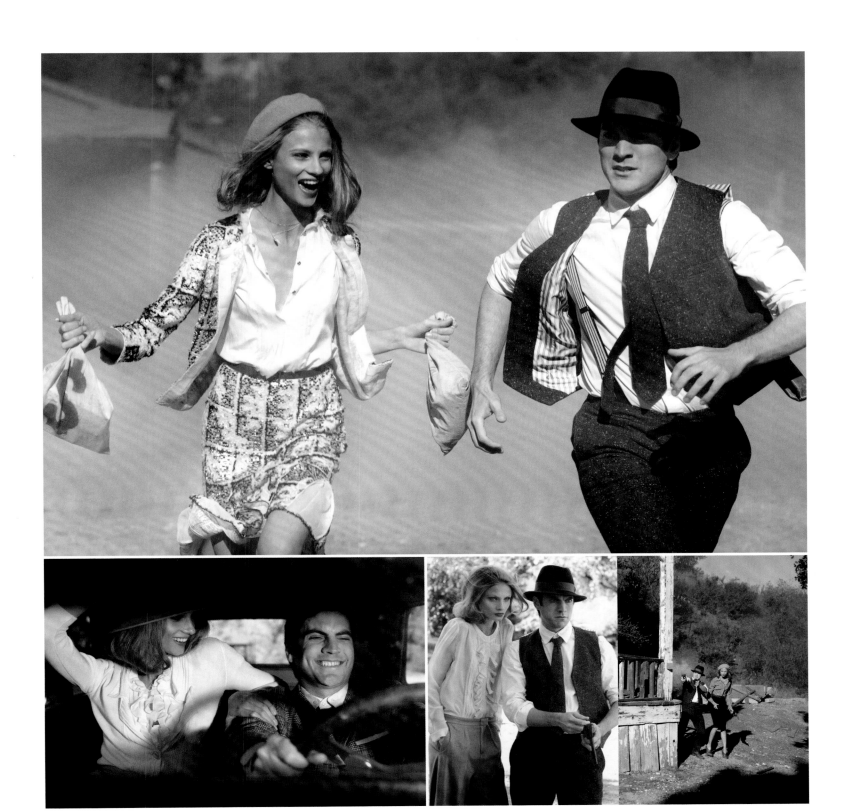

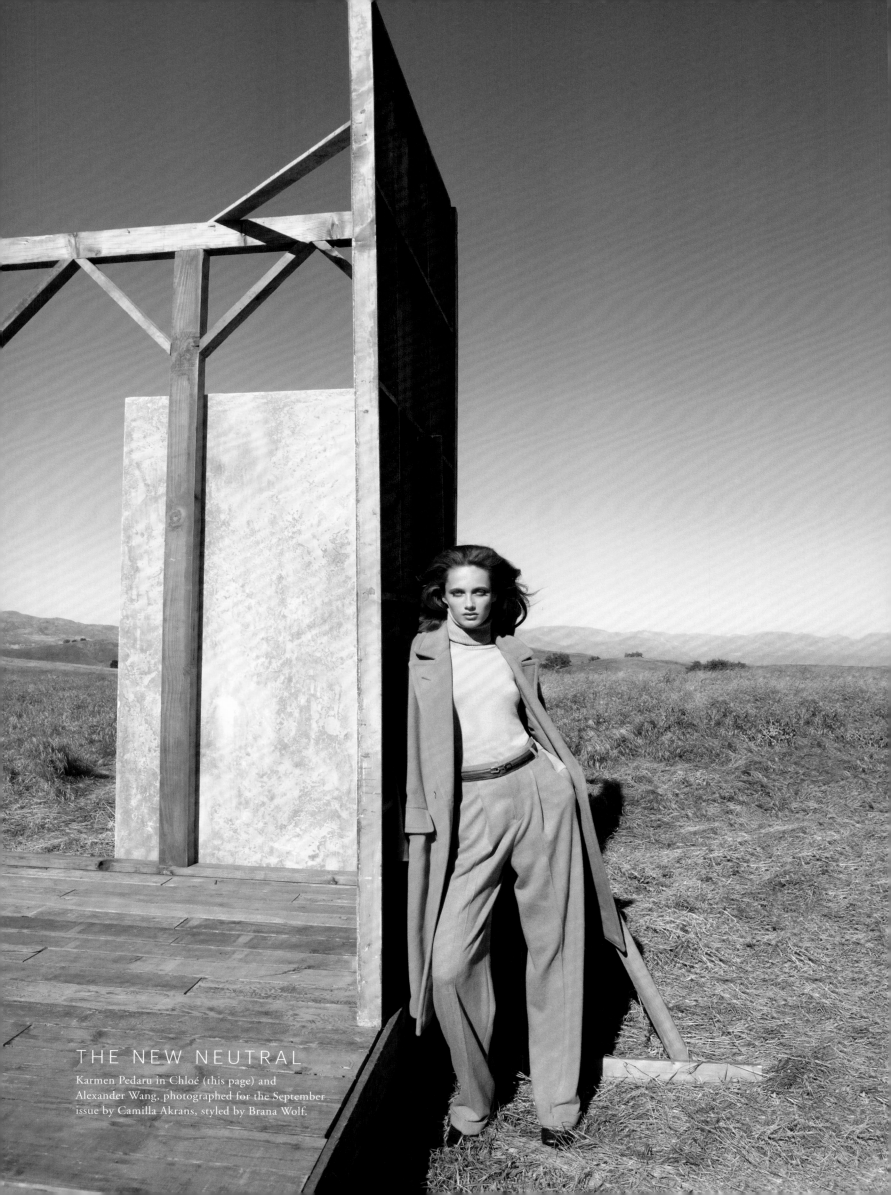

THE NEW NEUTRAL

Karmen Pedaru in Chloé (this page) and
Alexander Wang, photographed for the September
issue by Camilla Akrans, styled by Brana Wolf.

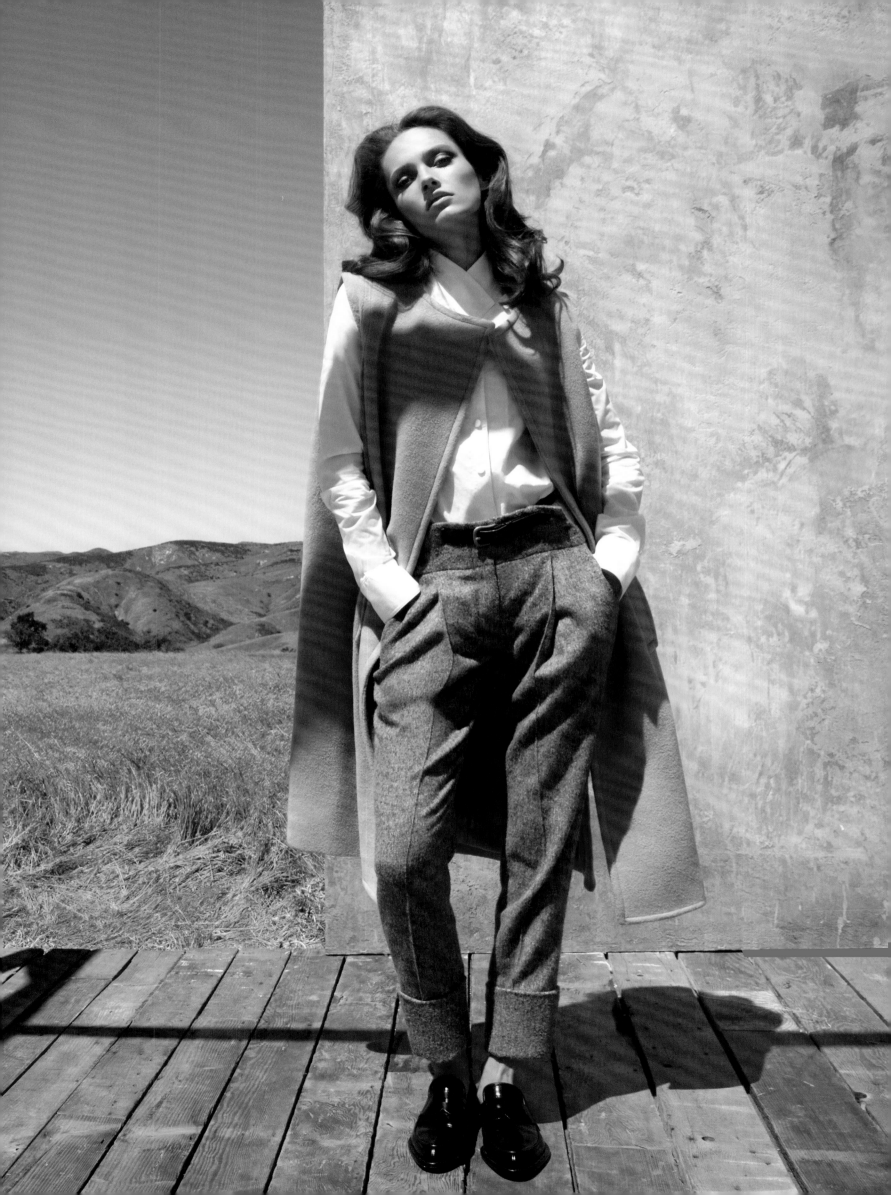

TO DIE FOR

Rachel Zoe with Vera Wang, Calvin Klein's Francisco Costa, and, on the following spread, Michael Kors in their designs, photographed for the September issue by Douglas Friedman, styled by Rachel Zoe. In a nod to her catchphrase "I die," *Bazaar* asked, What if the much-talked-about stylist really did die for fashion? America's top designers went in for the kill.

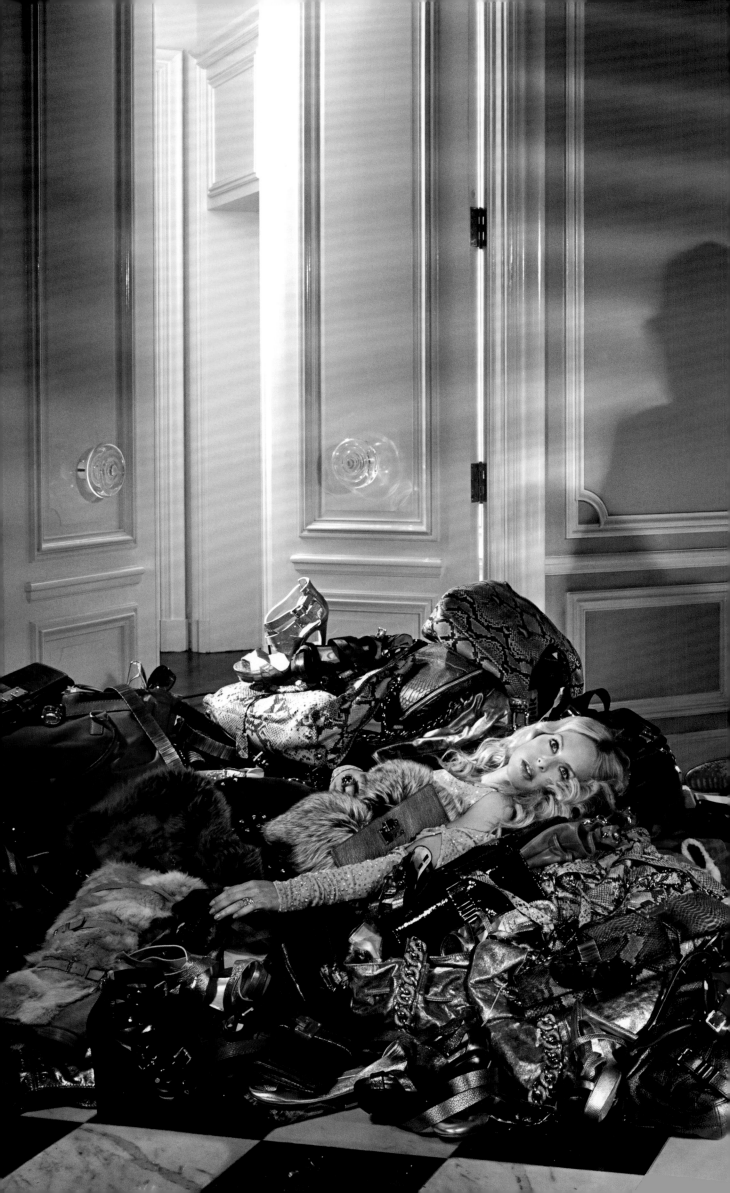

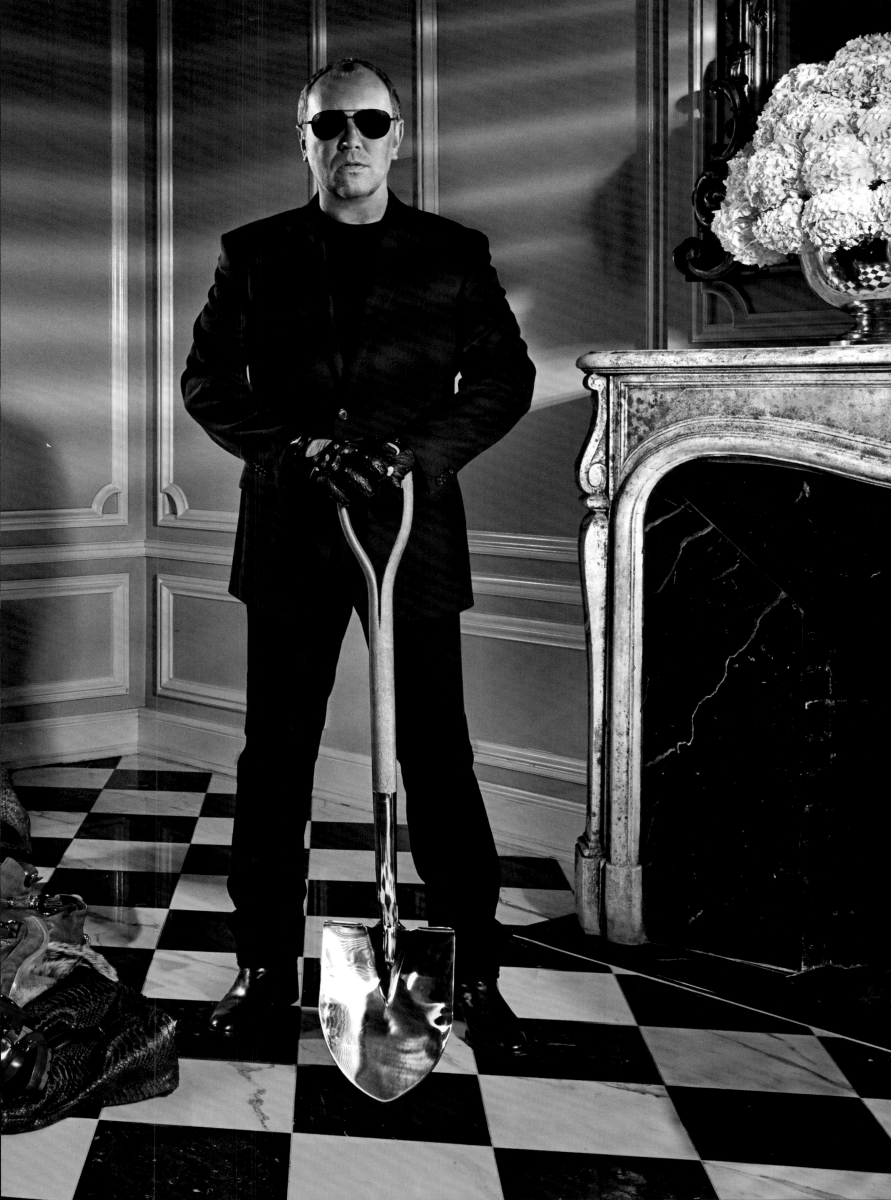

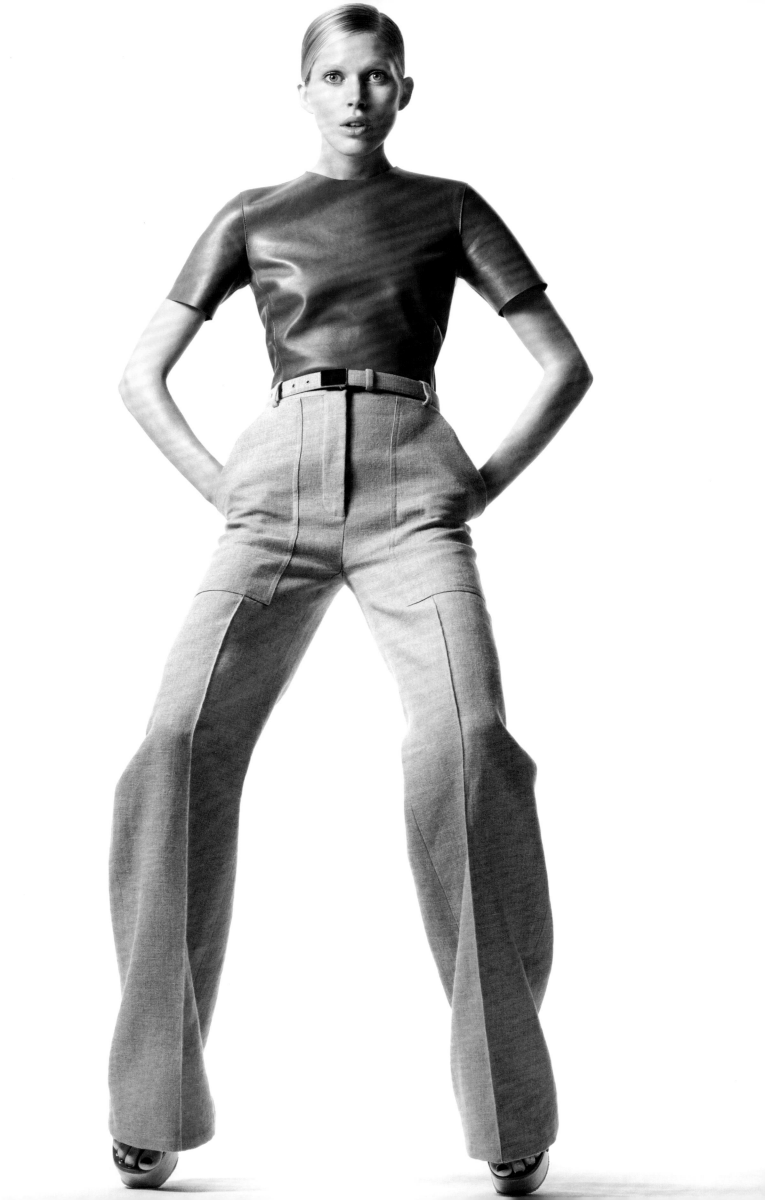

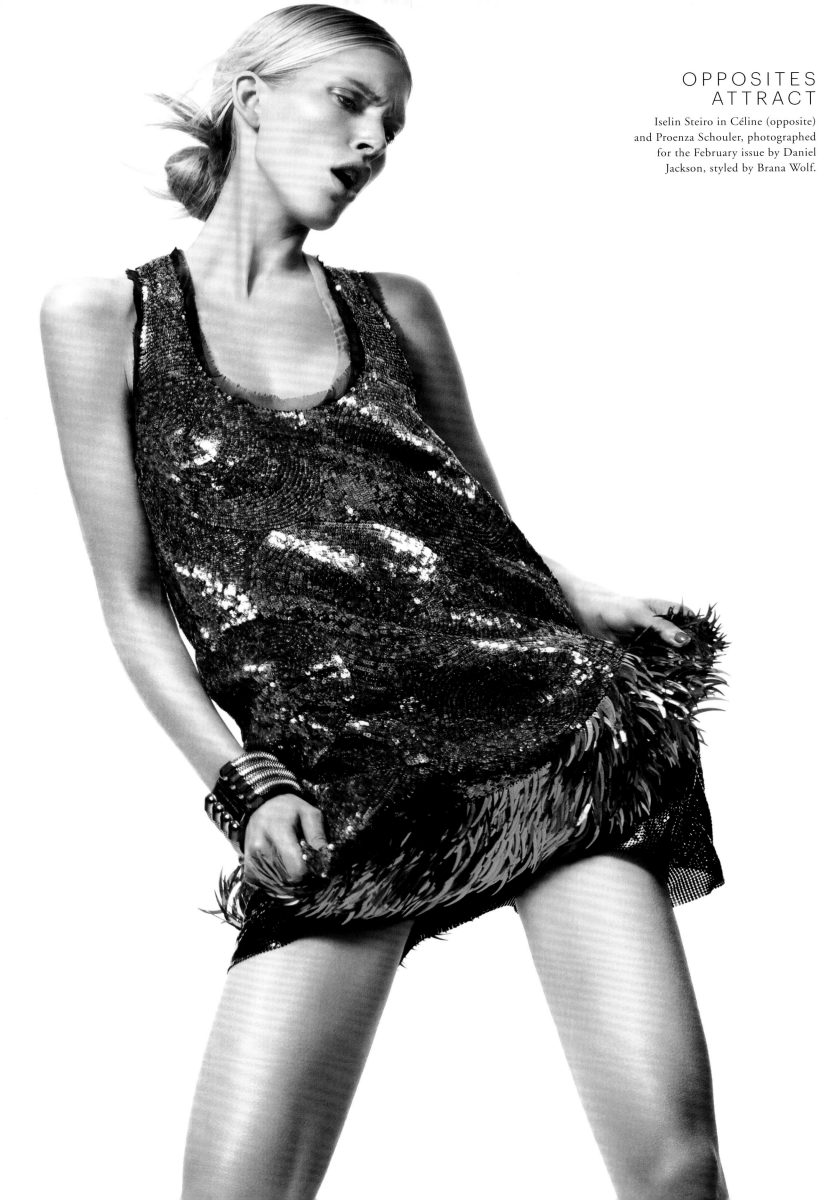

OPPOSITES
ATTRACT

Iselin Steiro in Céline (opposite)
and Proenza Schouler, photographed
for the February issue by Daniel
Jackson, styled by Brana Wolf.

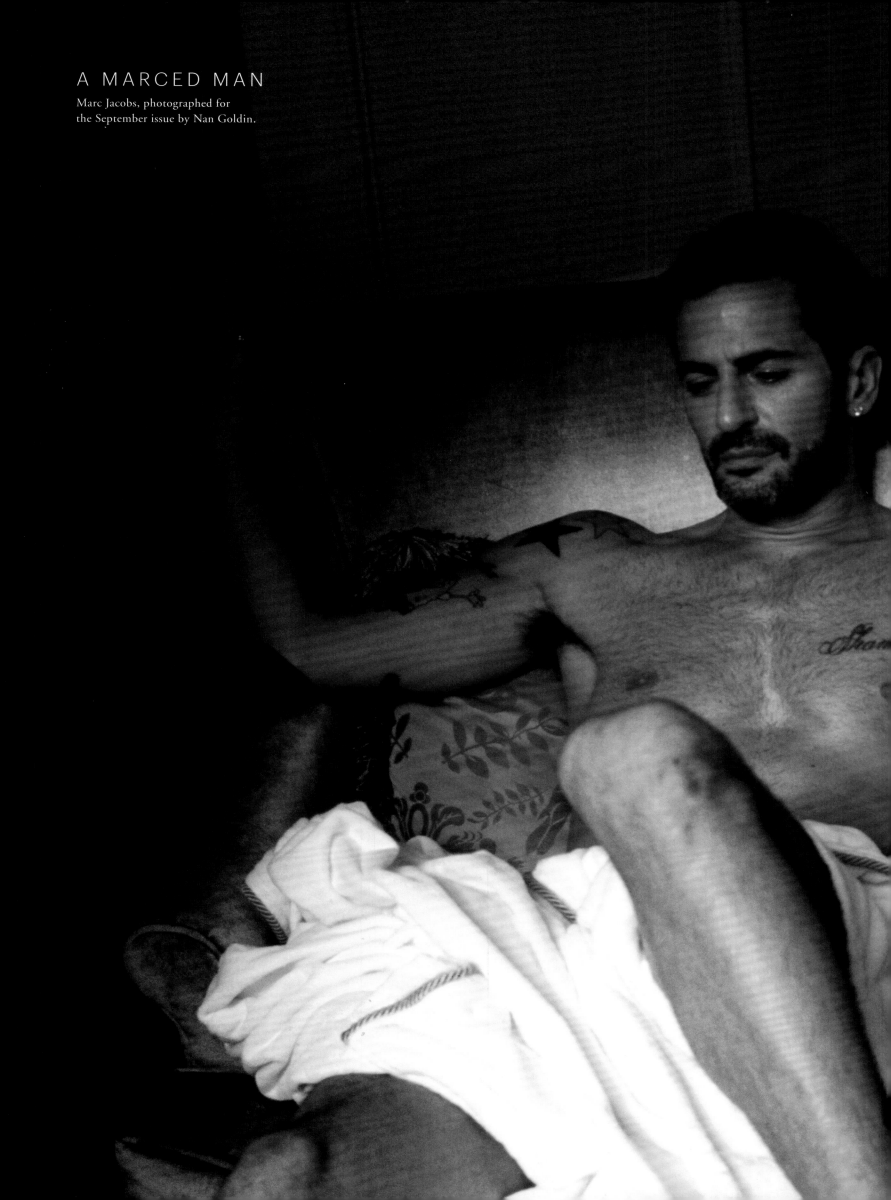

A MARCED MAN

Marc Jacobs, photographed for
the September issue by Nan Goldin.

HAIR-RAISING HEELS

Yves Saint Laurent shoes, photographed
for the September issue by Darryl Patterson,
styled by Ana Maria Pimentel.

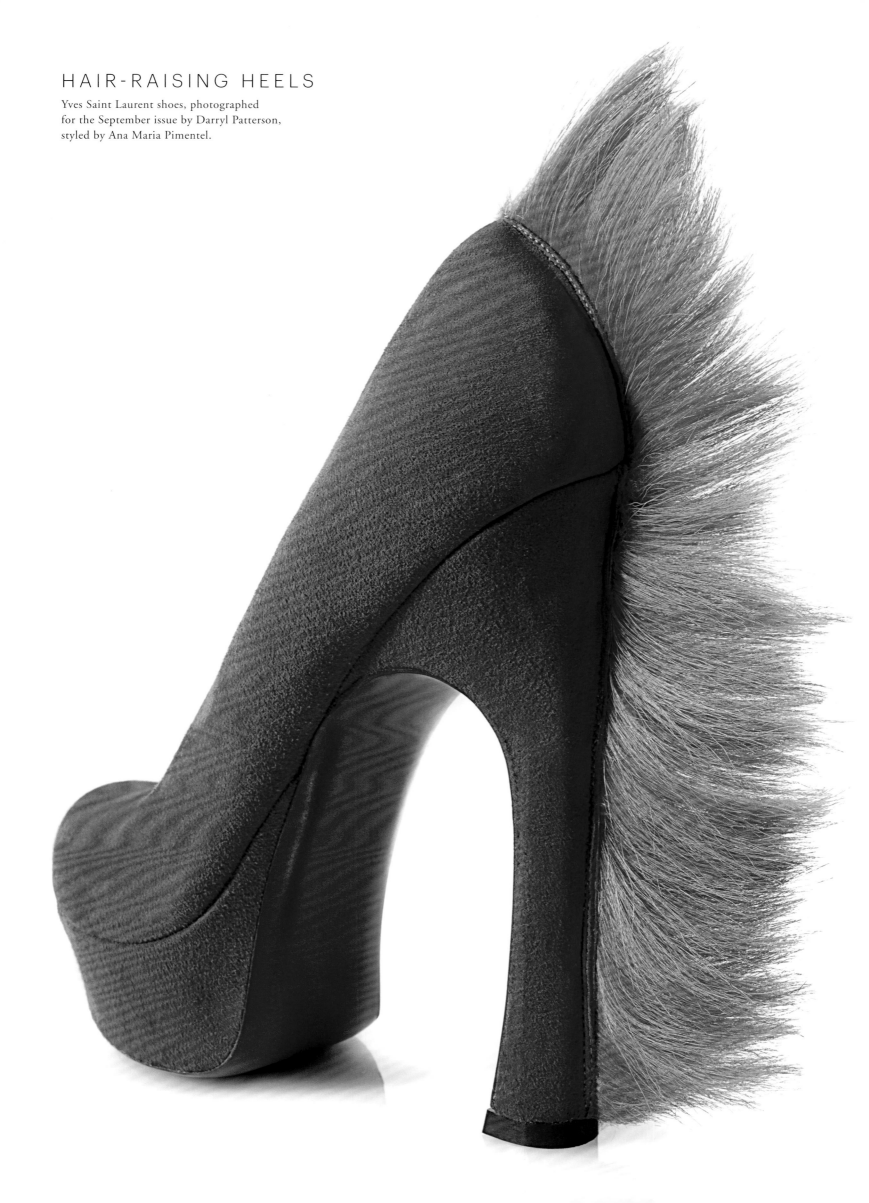

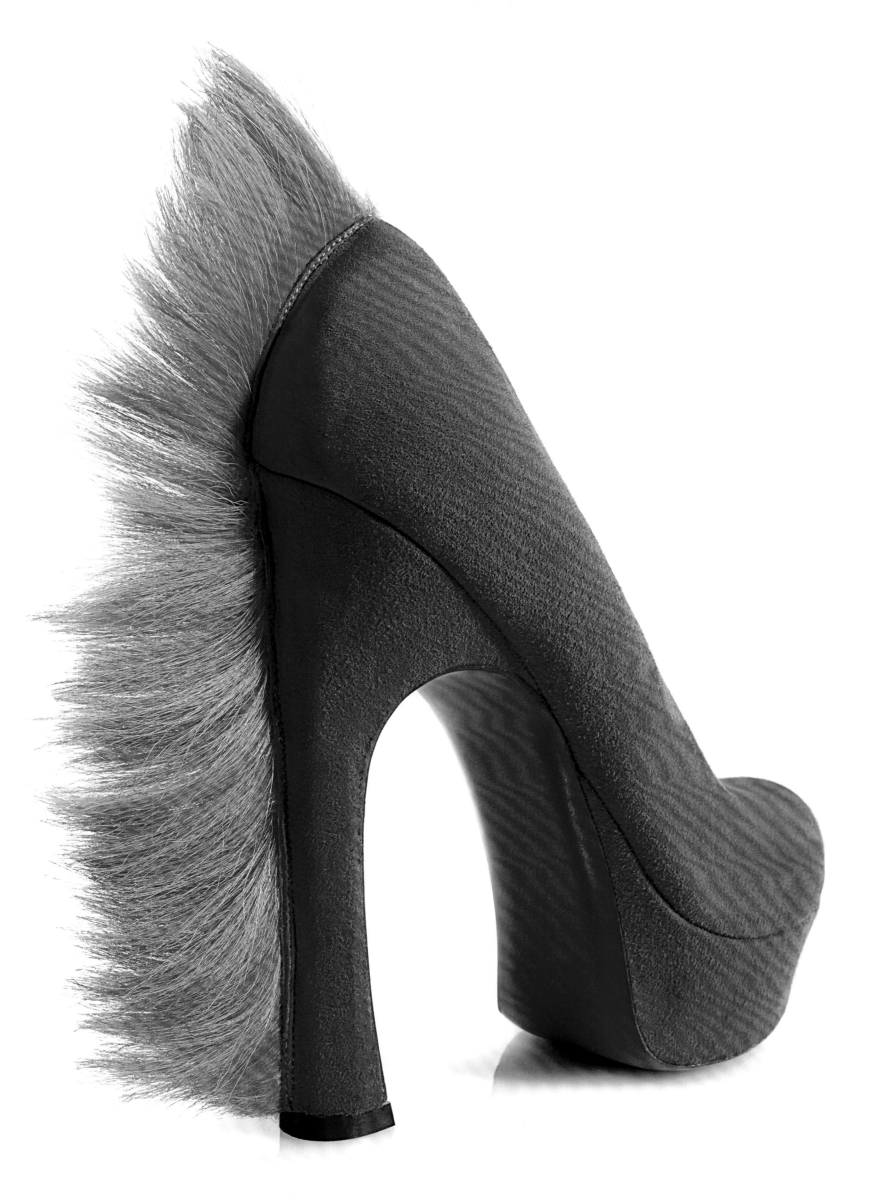

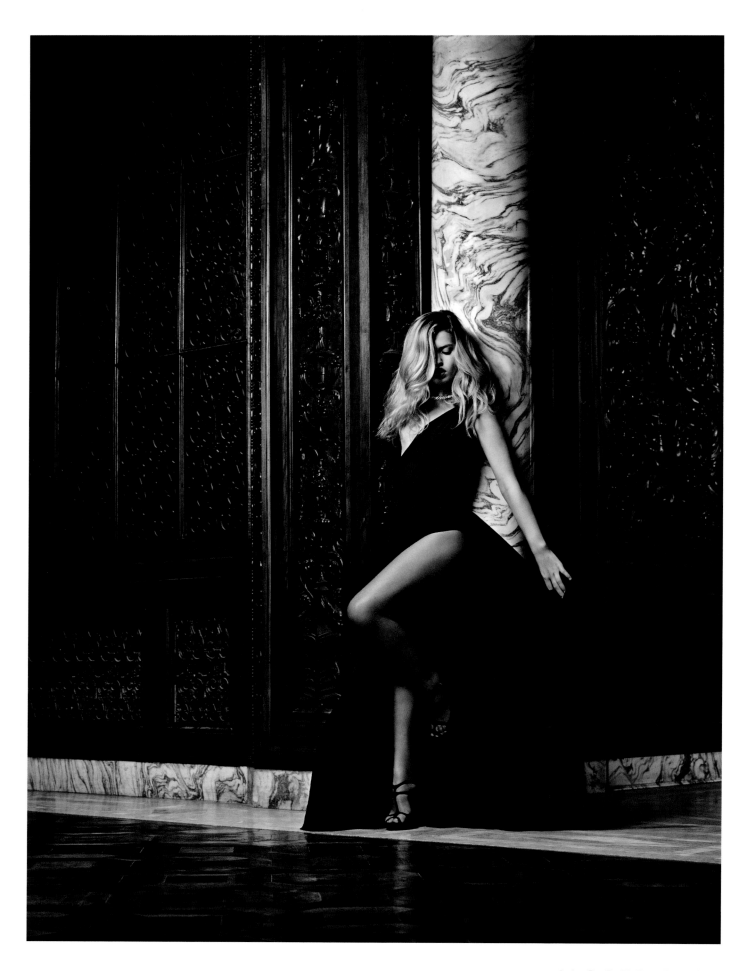

JAGGER EDGE
Georgia May Jagger in Lanvin
(above) and Giorgio Armani, photographed
for the November issue by Hedi Slimane,
styled by Clare Richardson.

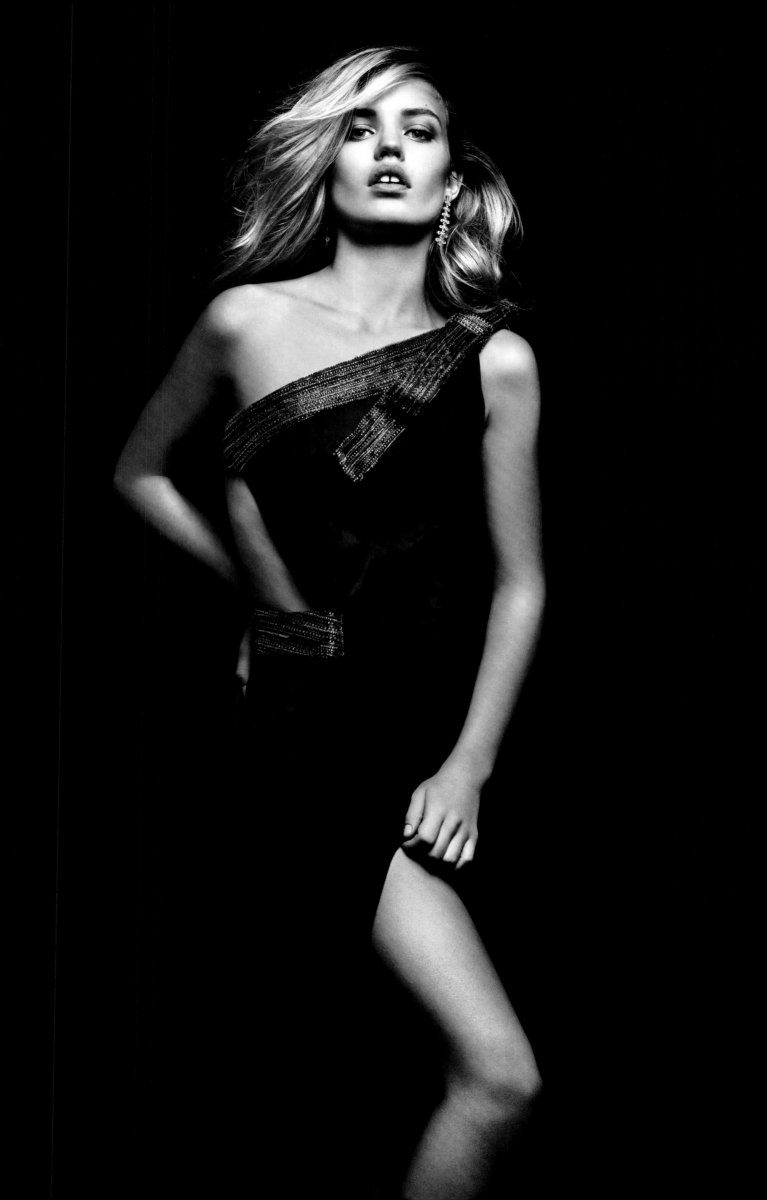

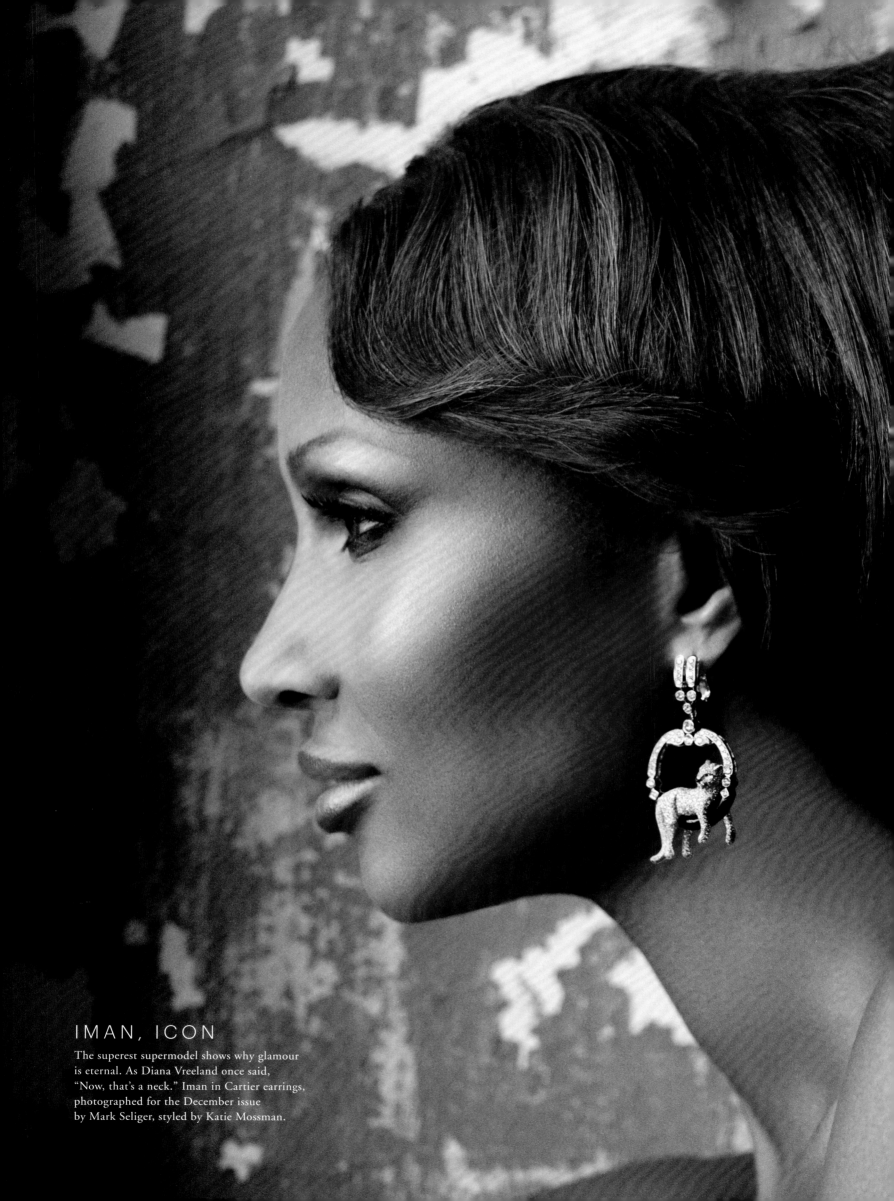

IMAN, ICON

The superest supermodel shows why glamour
is eternal. As Diana Vreeland once said,
"Now, that's a neck." Iman in Cartier earrings,
photographed for the December issue
by Mark Seliger, styled by Katie Mossman.

THE DUCHESS OF WINDSOR'S ROYAL STYLE

The American socialite's sparkling wit and meticulous taste wooed the king of England off his throne—and inspired Madonna to direct a film based on her life

BY SUZY MENKES
Excerpted from the November issue

TO THE MANOR BORN

Gwyneth Paltrow in Givenchy Haute Couture by Riccardo Tisci (opposite) and Dior Haute Couture (following spread), photographed for the May issue by Alexi Lubomirski, styled by Katie Mossman.

THE W AND E STYLE WAS THE ESSENCE OF CHIC. The Duke of Windsor's look was primarily English: three parts aristo to one part eccentric in his mad mix of Prince of Wales checks, baggy golfing plus fours, and Fair Isle sweaters. Meanwhile, Wallis Warfield Simpson's style was quintessentially French, from the time when haute couture ruled the fashion world. On friendly terms with designers like Hubert de Givenchy and Christian Dior's Marc Bohan, the duchess worked to reduce every outfit to its essence, even asking the couturiers to dispense with pockets.

Americans in Europe often brought a gutsy breath of fresh air to Paris salon style, but Jacqueline de Ribes, the society aristocrat, said of the duchess, "She was chic but never casual. Other American society women, like Babe Paley, could be chic in blue jeans. The duchess was a different generation." Her style was urban, and even her visits to the newly fashionable French Riviera revealed her to be, as *Bazaar* editor Diana Vreeland put it, "soignée, not degagée" (polished but not relaxed).

Opinions in European society were divided as to whether the sparkly Simpson, with her snappy wit and harsh laugh, was chic or cheap. Her king adored her for the open spirit he found on his first trip to America as a young Prince Charming in 1919. "American vitality—it is a tangible quality. You can feel it in the air," he said. But to elegant entertainer Noël Coward, the Windsors were vulgar—not least in their showy way of traveling with dozens of pieces of luggage when the rest of the world was struggling to recover from war.

Yet whatever the couple's café-society lifestyle, they were serious about matters of taste. Would the Simpson of today choose only the rigor and restraint of streamlined, no-fuss looks from Jil Sander or Calvin Klein? She would surely add Karl Lagerfeld and his classy wit to her shopping list, for the duchess was drawn to clothes laced with a healthy dose of irony and fun. One Elsa Schiaparelli original featured a surreal lobster pattern climbing suggestively up a dress. Hubert de Givenchy, who became close to the duchess after her husband's death in 1972, remembers making her a cotton dress with wool-embroidered monkeys.

The almost-royal Simpson, who never held the title of H.R.H., was a fan of Dior and never went for the tweedy look—even when it was translated into French chic by Coco Chanel. "The duchess loves Paris because it is not too far from Dior," quipped the duke. The house created an haute couture version of the perfect little black dress beloved by the duchess. Even as an ingenue in her native Baltimore, she had known about the power of simplicity with a dash of glamour.

Back then, it was simply about adding a bright silk sash to a plain dress. But by the time her jewel box was overflowing with offerings from her royal lover, Simpson had reduced her style to a fine architecture with just a touch of decoration. Whether it was her Van Cleef & Arpels cuff bracelet (newly fashionable again) in diamonds and sapphires to match a blue column of a Mainbocher wedding dress or the flamboyant Cartier jeweled flamingo she flaunted on a severe black dress, she had the dash and the cash. Cartier's lithe panther jewels reflected the intense sexual chemistry of the Windsors and expressed their childish lovers' language in the secret messages of passion and desire engraved on the backs. Meanwhile, Van Cleef captured the Simpson wit with a diamond-studded zipper necklace and gave her royal class with a diamond-plume brooch, referencing the emblematic Prince of Wales feathers.

Simpson worked hard at being elegant, punishing herself by existing on little more than a single egg when her weight shot up two tiny ounces. She called on her hairdresser, the famous Alexandre de Paris, to dress her hair every single day. In that absolute dedication to appearance, she belongs to an era when a woman—and especially one brought up among Southern belles—dressed to please, rather than tease, her man. Yet there is something eternal about her style that still resonates today—like the all-consuming passion that caused a king to renounce his duty and his destiny for the unlikely love of his life.

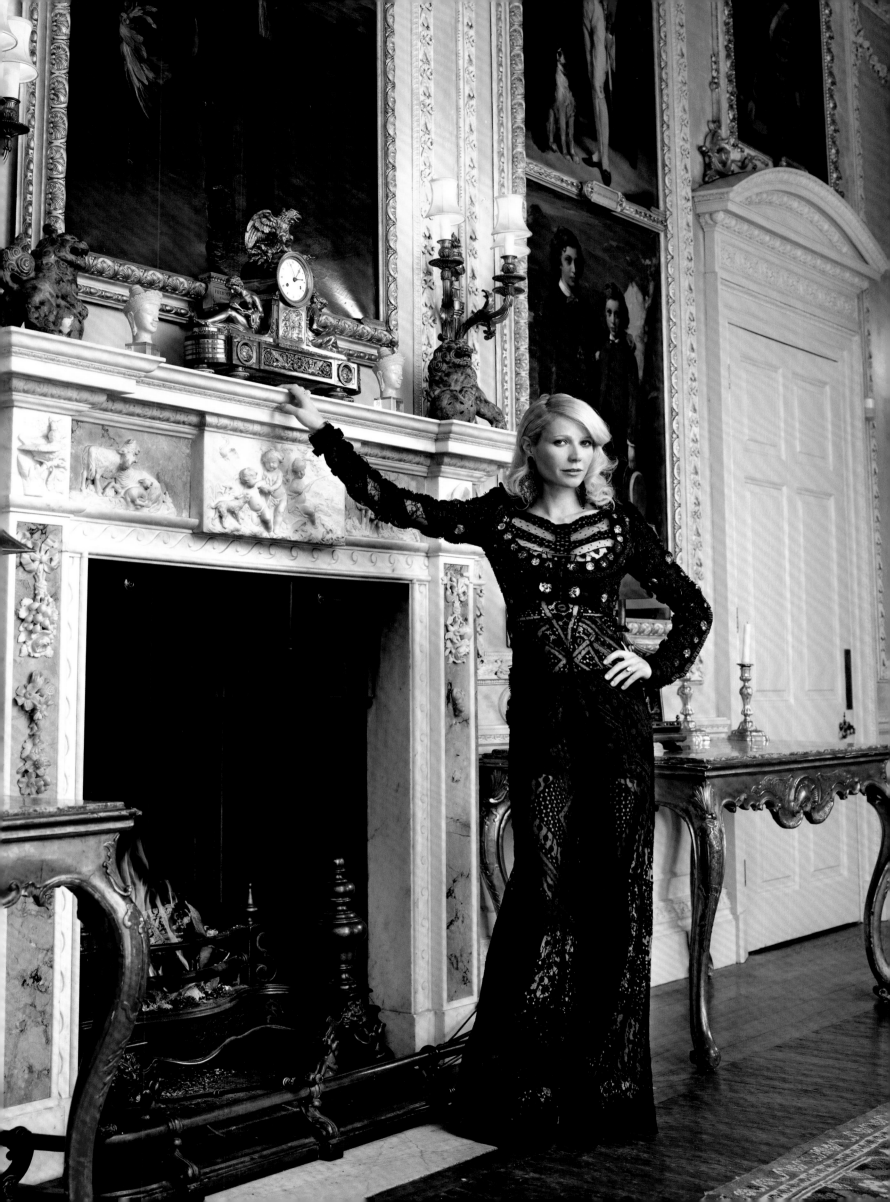

2011

GARDEN GODDESS

Nicole Kidman in Tom Ford, photographed for the February issue
by Alexi Lubomirski, styled by Julia Von Boehm.

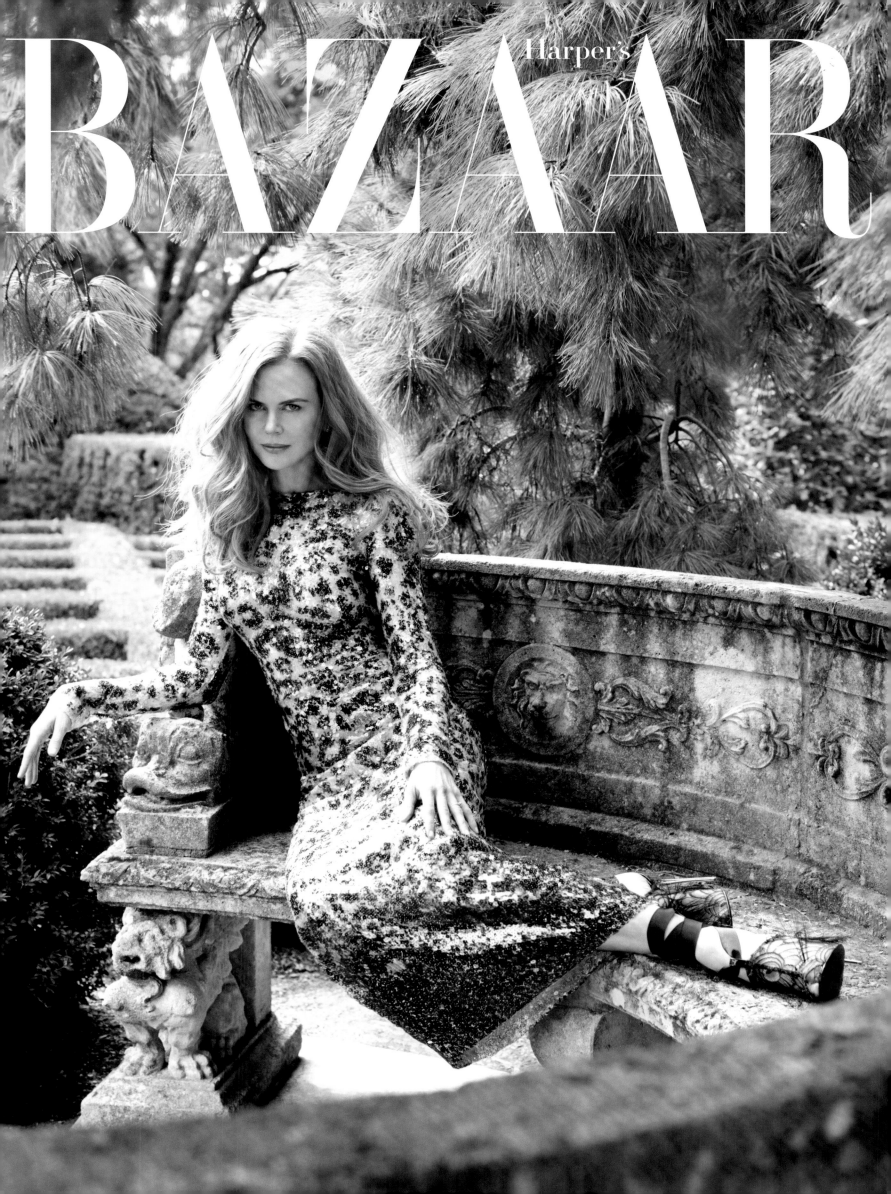

STEPPING INTO THE FUTURE

WHEN IT COMES TO BEING FIRST in service, style, and surprises, as a new decade dawns, one thing is clear: Bailey and Gan will continue their era of elegance. How apropos, then, to have Karl Lagerfeld photograph Lily Donaldson in an *Upstairs Downstairs*–themed photo shoot? Inspired by the BBC revival of one of her home country's best-loved series, Bailey conceived the shoot in early January. Her vision seemed all the more prescient come March, when she walked into the Louis Vuitton fashion show to see LV-clad chambermaids wielding feather dusters on the stairs. Whether by fate or by footman, the session brought a tribute to this most classic class drama.

Inside the January issue, Tom Ford discussed his spring collection and the now-famous fashion show that marked his return to women's ready-to-wear. The show gained attention for its star-studded runway—and the fact that, in an act of Fordian defiance, the show was closed to all but a select few members of the media, and the only photographer allowed to capture it was Terry Richardson (whom Bailey sat next to and helped juggle cameras as he shot).

After all, even Twitter king Ashton Kutcher knows that technology has its place. In January's "Has Texting Killed Romance?" he explored technology's limits when it comes to finding the one.

That's not a problem for longtime loves Trudie Styler and Sting, whom Richardson shot in a series of steamy poses for the February issue—images that made the front page of the *New York Post*.

Just goes to show, when something's good, it stands the test of time. Witness March's designer portfolio that paid homage to the enduring films of Mike Nichols. In the story, Marc Jacobs and Winona Ryder played George and Martha in *Who's Afraid of Virginia Woolf?*, Marchesa's Georgina Chapman and Keren Craig were Katharine and Tess in *Working Girl*, and Diane von Furstenberg was Mrs. Robinson to Prabal Gurung's Benjamin in *The Graduate*. All proved to be fine actors—hardly surprising in this age of multitasking design talents.

But the starring role in our global fashion economy currently goes to China, as referenced by the cover of the March issue, which was inspired when Bailey saw a man in a panda suit feeding a live cub.

Bazaar's take on the image: a panda hand in hand with Magdalena Frackowiak. In a March interview with Laura Brown, Secretary of State Hillary Clinton opened up about her favorite accessory ("I have this Ferragamo hot-pink bag that I adore. . . . I mean, how can you be unhappy if you pick up a big pink bag?"), but it is her work shaping international policy amid fluctuating geopolitics that is her true legacy. Or, as she put it when asked about navigating WikiLeaks, "I should have a jacket that says THE APOLOGY TOUR, because everywhere I go, I'm apologizing for any embarrassment."

Clinton's job is to keep the peace, but a woman who had the luxury of never having to say she was sorry was the late great Dame Elizabeth Taylor. For her 2006 interview for *Bazaar* by Michael Kors, she posed in front of her art collection, wearing her jewels. The photograph marked one of the last times she was ever shot in her home. Just weeks before her death, the March issue of *Bazaar* featured another interview with her by one of her biggest fans, Kim Kardashian.

As further tribute to Dame Elizabeth's enduring style, the Honorable Daphne Guinness, photographed for the March issue by David Bailey, commented to writer Derek Blasberg, "Elizabeth Taylor was never told what to wear or paid to carry a certain handbag." The same, of course, could be said of Guinness herself.

Taylor and Guinness have a kindred spirit in Lady Gaga. Richardson, along with Gaga's dedicated stylist (and newly minted creative director of Thierry Mugler), Nicola Formichetti, worked to capture Gaga vamping in some of the designers she loves for the May issue.

By contrast, Diane von Furstenberg is completely natural in her photograph taken by Chuck Close just six weeks after a skiing accident left her with a broken nose. Featured in the May issue, von Furstenberg's unflinching gaze is a testament to her determination, in business and in life.

Eternal icons notwithstanding, it's clear that the world—fashion included—has changed deeply in the past 10 years. But Bailey and her team will continue to inform, inspire, and entertain their readers through whatever the next decade brings.

DRIVEN IN STYLE

Baptiste Giabiconi and Lily Donaldson,
in Yves Saint Laurent, photographed
for the September issue by Karl Lagerfeld,
styled by Andrew Richardson.

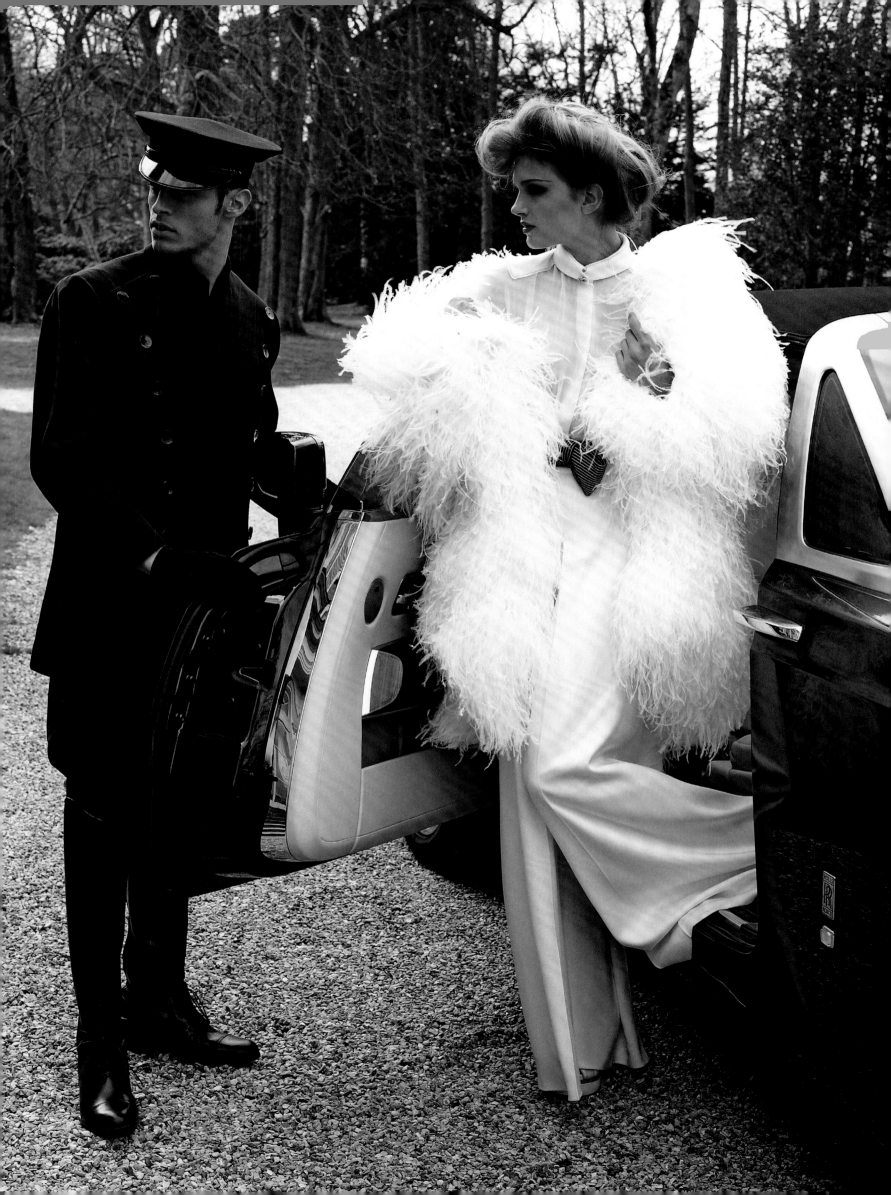

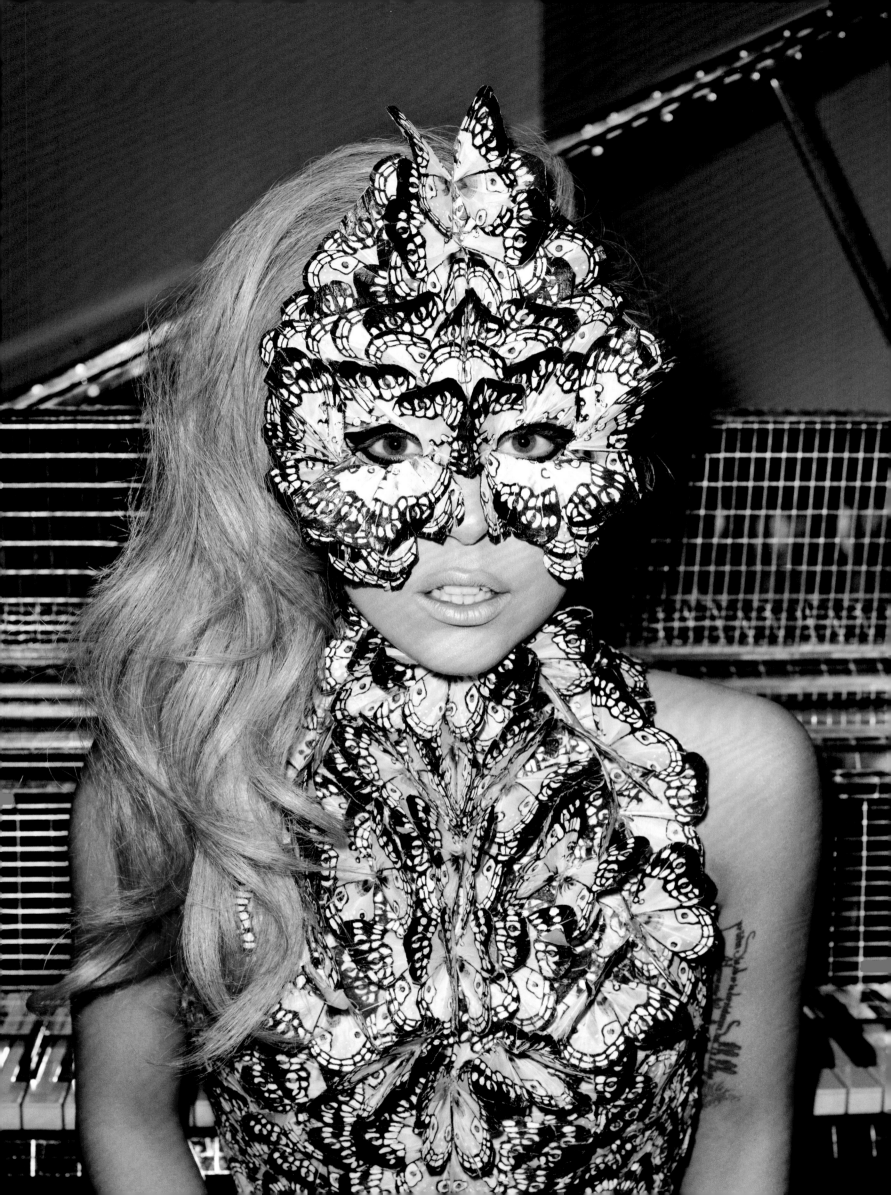

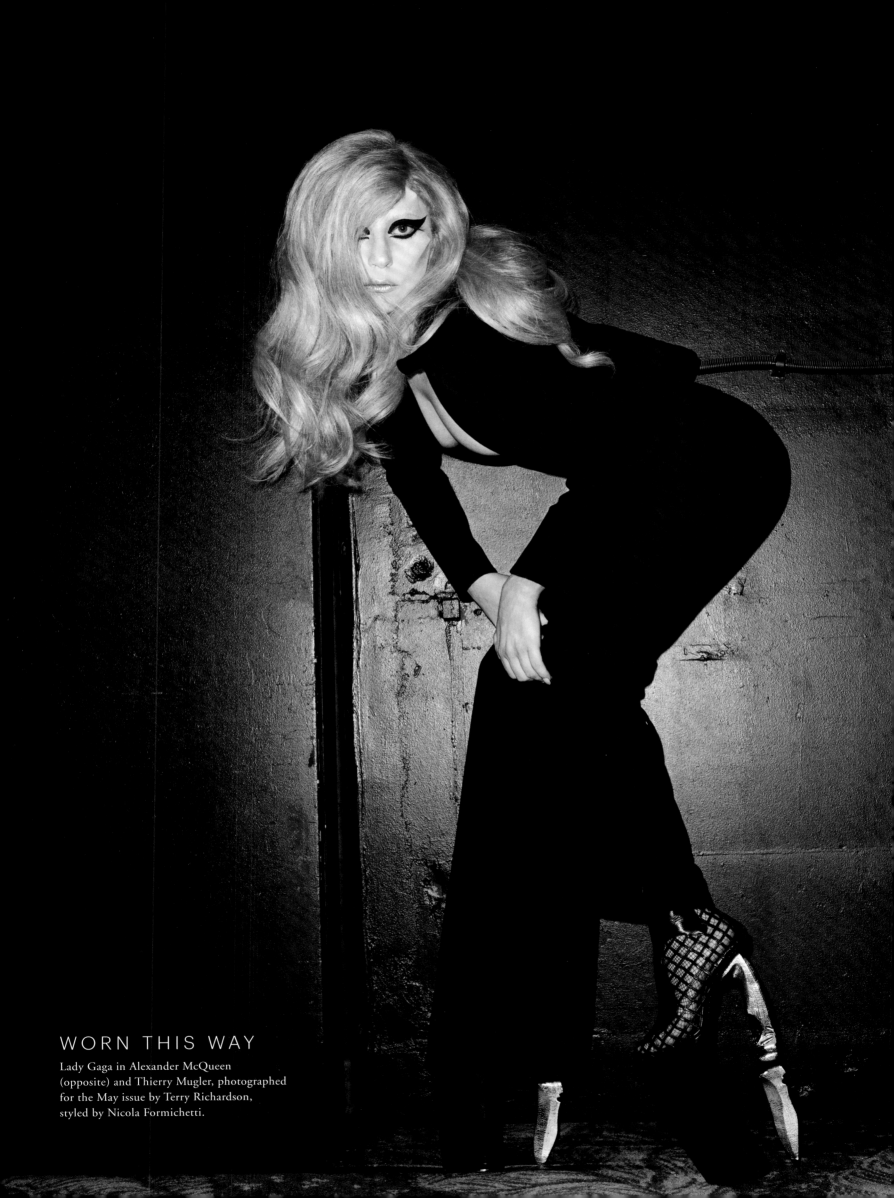

WORN THIS WAY

Lady Gaga in Alexander McQueen
(opposite) and Thierry Mugler, photographed
for the May issue by Terry Richardson,
styled by Nicola Formichetti.

DESIGN DUOS

Above: James Franco and Frida Giannini in Gucci, photographed for the March issue by Douglas Friedman. Sittings editor: Anamaria Wilson. *Left:* Eugénie Niarchos, in Emilio Pucci, and Peter Dundas, photographed for the August issue by Christopher Sturman. Sittings editor: J.J. Martin.

SECOND SKIN

Opposite page: Gertrud in Gucci, photographed for the February issue by Tom Munro, styled by Brana Wolf.

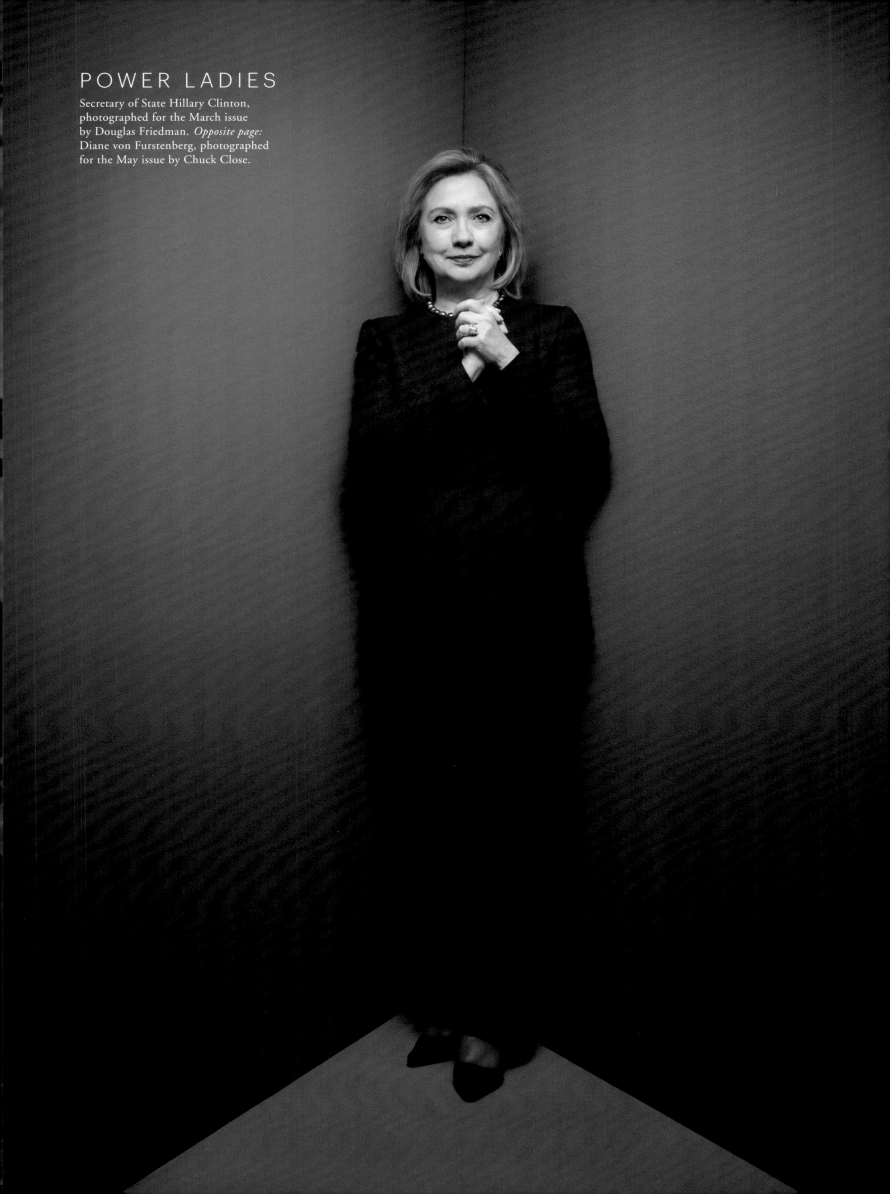

POWER LADIES

Secretary of State Hillary Clinton,
photographed for the March issue
by Douglas Friedman. *Opposite page:*
Diane von Furstenberg, photographed
for the May issue by Chuck Close.

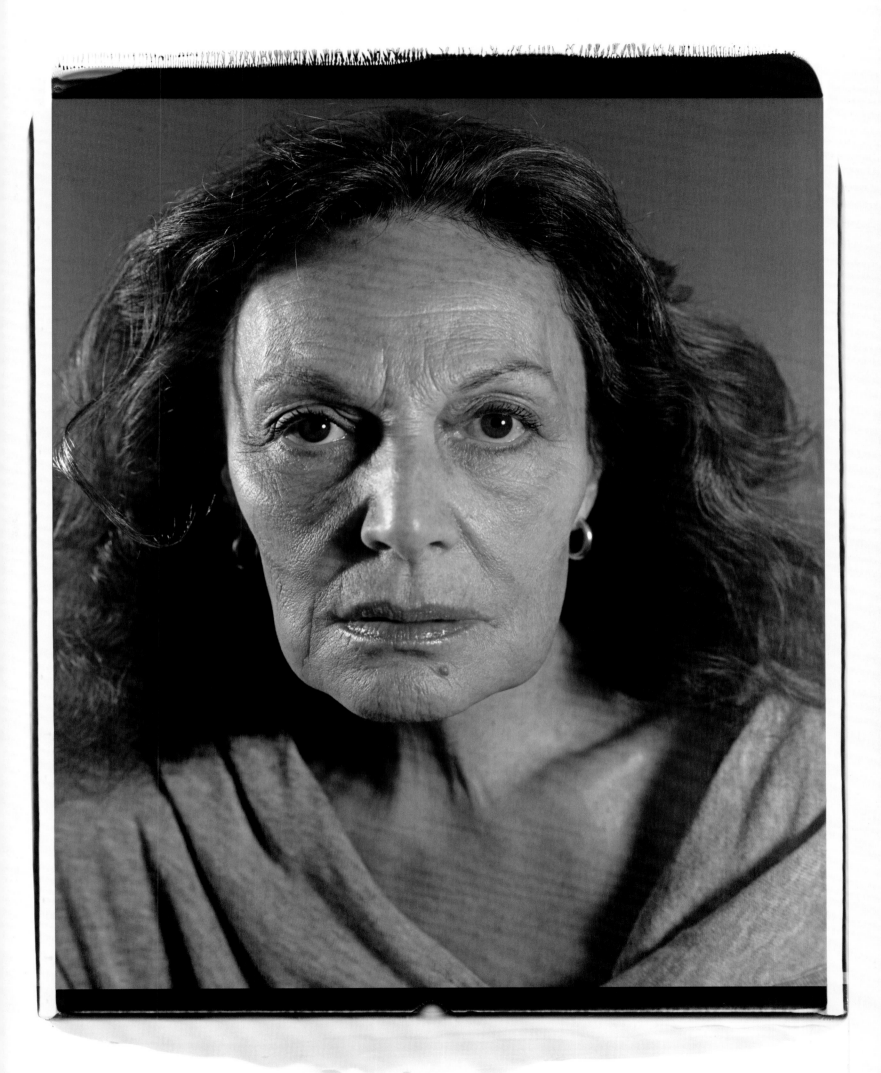

HAS TEXTING KILLED ROMANCE?

Ashton Kutcher asks, in an Internet era, are we losing our ability to really communicate?

BY ASHTON KUTCHER
Excerpted from the January issue

SO CLOSE TO ME

Trudie Styler in Louis Vuitton and Sting in Tom Ford, photographed for the February issue by Terry Richardson, styled by Clare Richardson.

I WAS SHOOTING A SCENE in my new film, *No Strings Attached,* in which I say to Natalie Portman, "If you miss me … you can't text, you can't e-mail, you can't post it on my [Facebook] wall. If you really miss me, you come and see me." I began to think of all of the billions of intimate exchanges sent daily via fingers and screens, bouncing between satellites and servers. With all this texting, e-mailing, and social networking, I started wondering, are we all becoming so in touch with one another that we are in danger of losing touch?

It used to be that boy met girl and they exchanged phone numbers. Anticipation built. They imagined the entire relationship before a call ever happened. The phone rang. Hearts pounded. "Hello?" Followed by a conversation that lasted two hours but felt like two minutes and would be examined with friends for two weeks. If all went well, a date was arranged. That was then.

Now we exchange numbers but text instead of calling because it mitigates the risks of early failure and eliminates those deafening moments of silence. Now anticipation builds. *Bdoop.* "It was NICE meeting u." Both sides overanalyze every word. We talk to a friend, an impromptu Cyrano: "He wrote *nice* in all caps. What does that mean? What do I write back?" Then we write a response and delete it 10 times before sending a message that will appear 2 care, but not 2 much. If all goes well, a date will be arranged.

Whether you like it or not, the digital age has produced a new format for modern romance, and natural selection may be favoring the quick-thumbed quip peddler over the confident, ice-breaking alpha male. Or maybe we are hiding behind the cloak of digital text and spell-check to present superior versions of ourselves while using these less intimate forms of communication to accelerate the courting process. So what's it really good for?

There is some argument about who actually invented text messaging, but I think it's safe to say it was a man. Multiple studies have shown that the average man uses about half as many words per day as women, thus text messaging. It eliminates hellos and goodbyes and cuts right to the chase. Now, if that's not male behavior, I don't know what is. It's also great for passing notes. There is something fun about sharing secrets with your date while in the company of others. Think of texting as a modern whisper in your lover's ear.

Sending sweet nothings on Twitter or Facebook is also fun. In some ways, it's no different than sending flowers to the office: You are declaring your love for everyone to see. Who doesn't like to be publicly adored? Just remember that what you post is out there and there's some stuff you can't unsee.

But the reality is that we communicate with every part of our being, and there are times when we must use it all. When someone needs us, he or she needs all of us. There's no text that can replace a loving touch when someone we love is hurting.

We haven't lost romance in the digital age, but we may be neglecting it. In doing so, antiquated art forms are taking on new importance. The power of a handwritten letter is greater than ever. It's personal and deliberate and means more than an e-mail or text ever will. It has a unique scent. It requires deciphering. But, most important, it's flawed. There are errors in handwriting, punctuation, grammar, and spelling that show our vulnerability. And vulnerability is the essence of romance. It's the art of being uncalculated, the willingness to look foolish, the courage to say, "This is me, and I'm interested in you enough to show you my flaws with the hope that you may embrace me for all that I am but, more important, all that I am not."

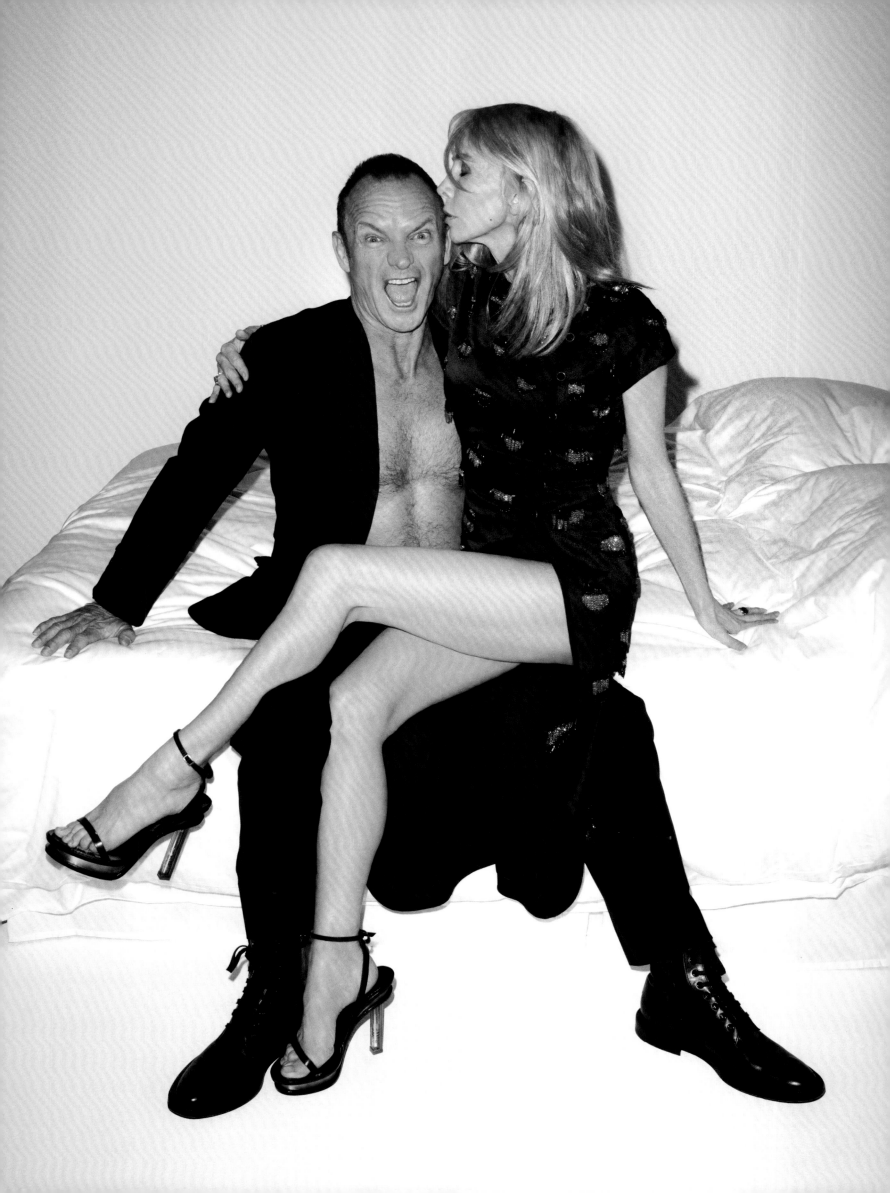

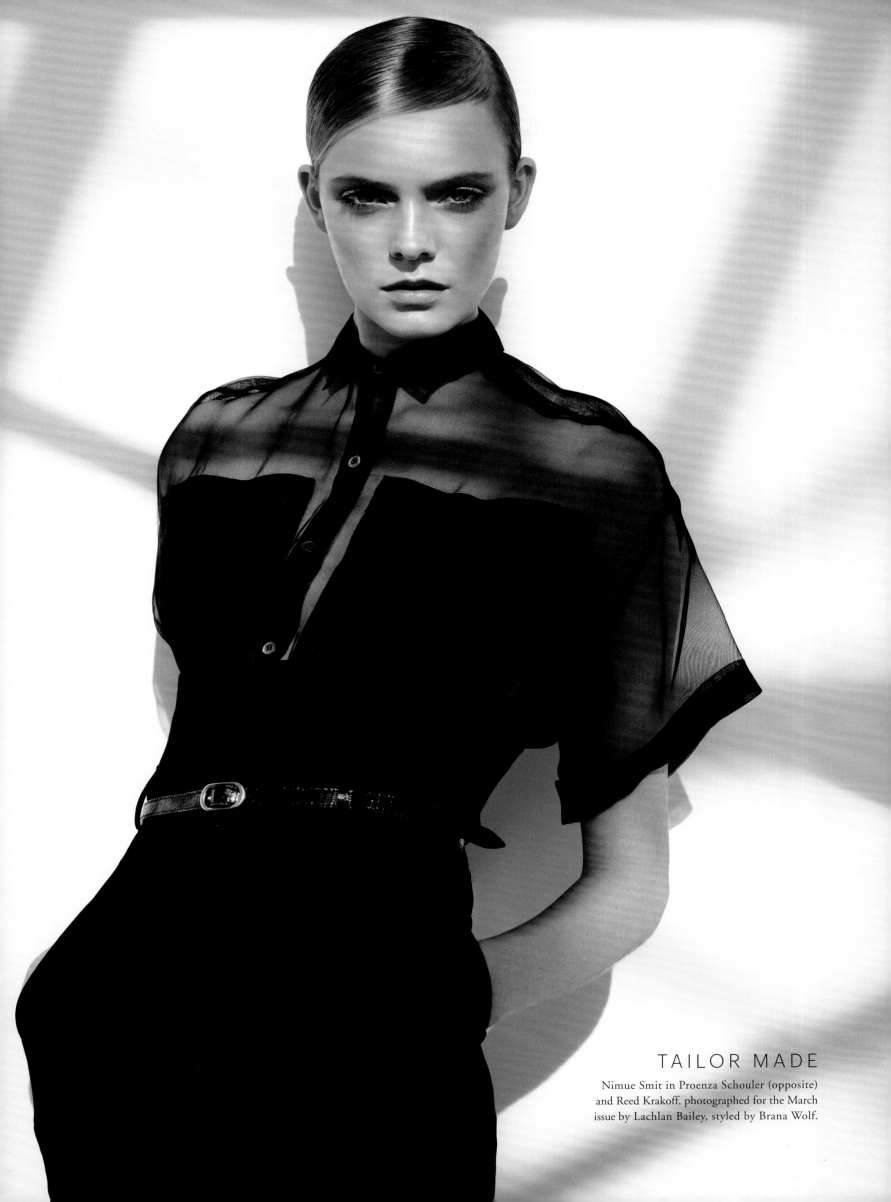

TAILOR MADE

Nimue Smit in Proenza Schouler (opposite)
and Reed Krakoff, photographed for the March
issue by Lachlan Bailey, styled by Brana Wolf.

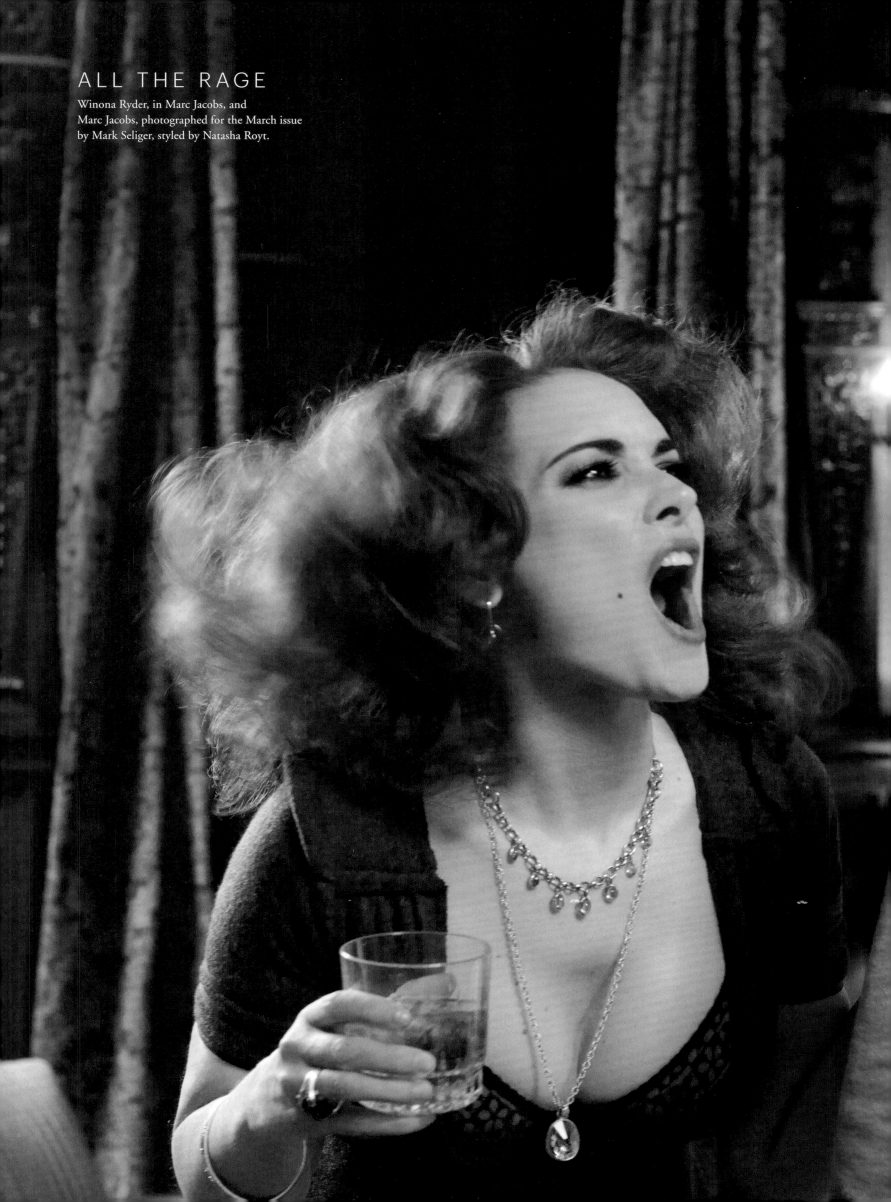

ALL THE RAGE

Winona Ryder, in Marc Jacobs, and
Marc Jacobs, photographed for the March issue
by Mark Seliger, styled by Natasha Royt.

ELIZABETH TAYLOR TALKS TO

Michael Kors about everything from dressing to please men to dreaming about diamonds in this candid interview *Excerpted from the August 2006 issue*

DAME ELIZABETH TAYLOR defines glamour. We fashion people absolutely revere her, so of course I am so excited to meet her for the first time. I arrive at her Bel Air home on a cool spring evening and am led to the white drawing room. It has white walls, a white shag carpet, white furniture, and great art—Matisse, Renoir, Degas, and Modigliani. Dame Elizabeth enters the room, preceded by her white Maltese, Daisy, who sits on her lap throughout my entire visit. Her red cat, Sneakers, runs about. Elizabeth's hair is black and spiky, her lips are scarlet, and she is wearing several diamond bracelets, earrings, and the famous Krupp diamond ring. She is welcoming and warm; she laughs readily. After I give her a violet-gray cashmere shawl for her recent 74th birthday, we sit down on the white couches. Sipping Earl Grey tea, we start to talk. . . .

MICHAEL KORS: There's always a little Elizabeth Taylor in every collection I do. . . . Did you ever imagine that every woman in the Western world might go to work in your slip from *Cat on a Hot Tin Roof*? You invented that look. Every designer does a slipdress in every collection now.

ELIZABETH TAYLOR: But I didn't wear anything under it. You're telling me girls in New York walk down the street in that?

MK: All the time. Sometimes with boots! Do you look at anyone today and think, She has great style or great glamour?

ET: I'm never critical. I think, Good luck to those that are daring. But I've always been very shy. Painfully shy.

MK: But your fashion choices belie that. It's like if you're going to wear something, you are going to do it big.

ET: But I don't really walk the red carpet. I always go through the back door. I go in a car, ready with the stockings, the shoes, and the jewelry. Then I'll change in a trailer. They give me five minutes, and I step out.

MK: They always say that women dress either for themselves, for other women, or for men. What do you think?

ET: I think men.

MK: Do you put pleasing women last?

ET: Men first. Myself. Then other women. 'Cause you *can't* please women. They are horribly critical of each other. And more so if you're famous. *Meow.*

MK: Have you dressed differently for different men in your life?

ET: Yes, I have. Why not please someone you love? Oh, God, it was funny: When I was married to John [Warner], and it was his Senate race [in 1978], the Republican women told me, "You simply cannot wear the purple pantsuit you've been campaigning in anymore." I ended up in a tweed suit. *Me.* Little tweed suits. What I won't do for love.

MK: You are a romantic! After all these years, do you still think of yourself as one?

ET [*quietly*]: I'm afraid so.

MK [*holds up a Bert Stern photograph of Taylor kissing Richard Burton*]: I brought it all the way from New York.

ET: Oh, how *sweet*. Oh, wow, I wish I could have that. [*quietly*] *That's* a kiss. [*Crying, she puts her finger to her mouth, kisses it, then touches Burton's lips in the photo.*]

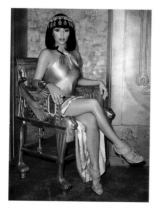

In Taylor's last interview, Kim Kardashian talks to her idol *Excerpted from the March 2011 issue*

KIM KARDASHIAN: You are my idol. But I'm six husbands and some big jewels behind. What should I do?

ELIZABETH TAYLOR: I never planned to acquire a lot of jewels or a lot of husbands. For me, life happened, just as it does for anyone else. I have been supremely lucky in my life.

KK: What's your advice on how to be a queen?

ET: I have never wanted to be a queen! Cleopatra was a role, and I am an actor, so it was fun to play one, but it's not real.

KK: Do you think if Richard Burton were alive today, you'd be married to him?

ET: It was inevitable that we would be married again, but it's not up for discussion.

Top: Elizabeth Taylor in Michael Kors, photographed for the August 2006 issue by Alberto Tolot, styled by Tatiana Sorokko.
Above: Kim Kardashian's homage to *Cleopatra*, photographed for the March issue by Terry Richardson, styled by Clare Richardson.

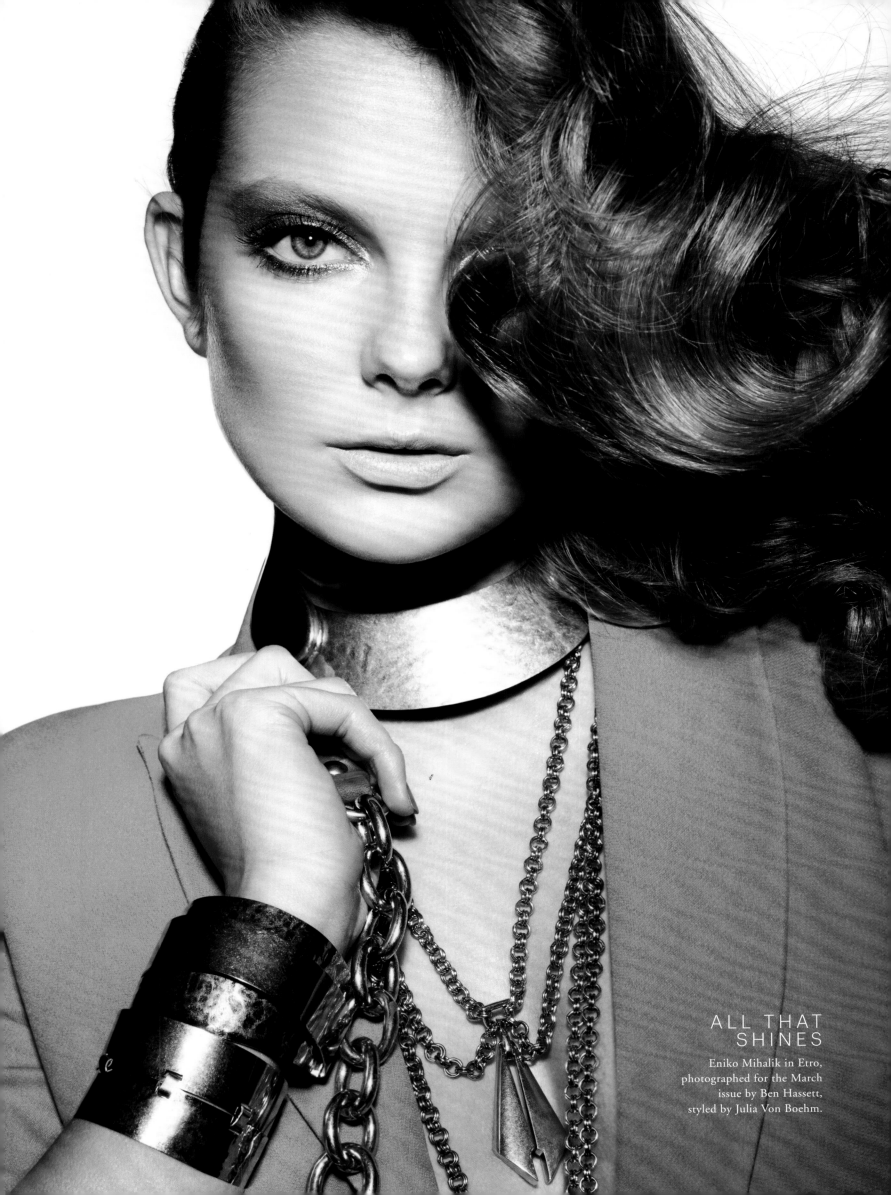

ALL THAT
SHINES

Eniko Mihalik in Etro,
photographed for the March
issue by Ben Hassett,
styled by Julia Von Boehm.

PANDA EXPRESS

Magdalena Frackowiak in Salvatore Ferragamo (above)
and Donna Karan New York, photographed for the March
issue by Terry Richardson, styled by Mel Ottenberg.

THE REAL DAPHNE

Daphne Guinness in Alexander McQueen,
photographed for the March issue by David Bailey,
styled by Derek Blasberg.

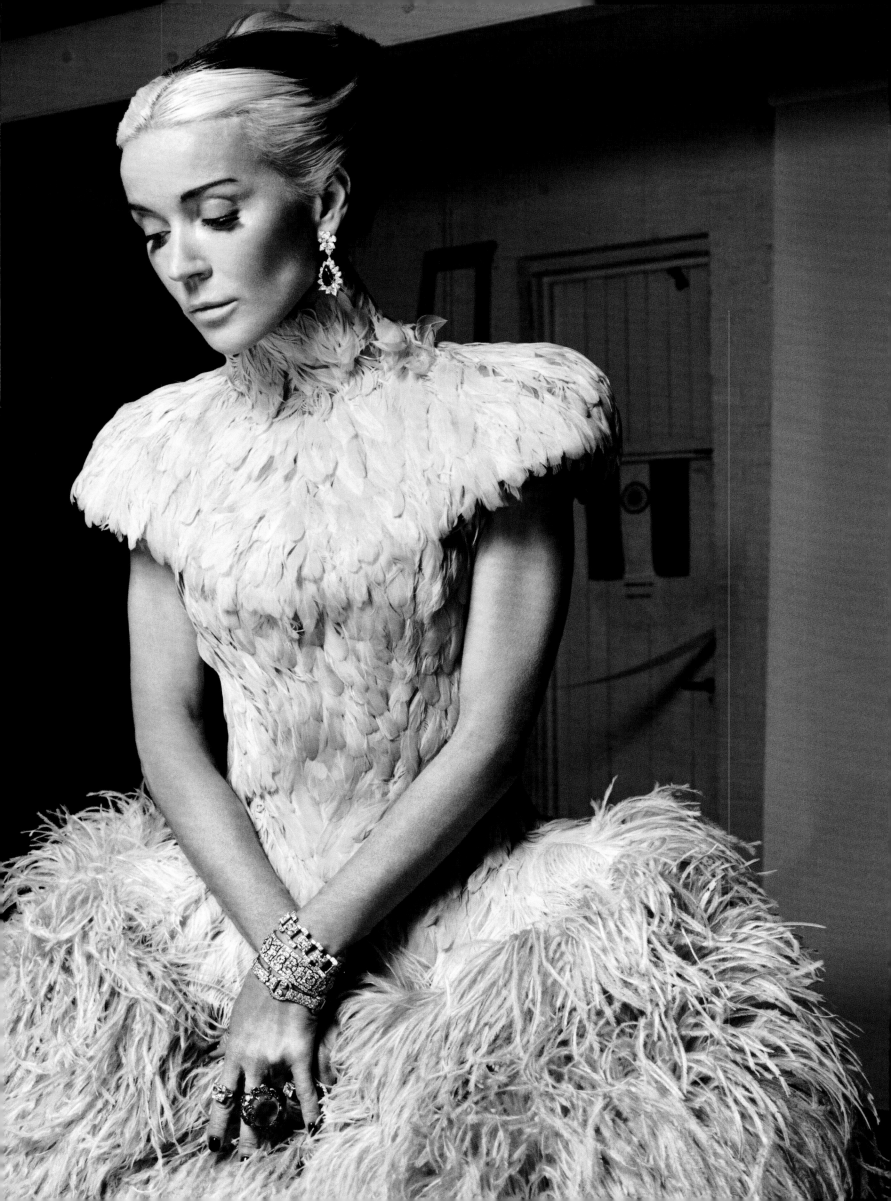

INDEX

ACKNOWLEDGMENTS

THIS BOOK IS A CELEBRATION of not only *Harper's Bazaar's* last decade but also all the extraordinary people who have made it come together over the years. Many heartfelt thank-yous, first and foremost to the legendary Frank A. Bennack Jr., who once gave up his Christmas holidays to employ me. Frank is a great and beloved leader who steers us with his unparalleled wisdom, wit, and warmth. Renaissance man Gilbert C. Maurer is gifted with a brilliant mind, a generous spirit, and the soul of a poet. David Carey is a true visionary who inspires us every day. Michael A. Clinton is an intrepid force whose energy and knowledge has no limit, and Cathleen Black is a powerhouse who always believed in us. Finally, we are forever grateful to the Hearst family.

The list would not be complete without our illustrious publisher, Valerie Salembier. If it weren't for her tireless efforts, we simply wouldn't exist. She and her team, Brian Garnock, Freeda Fawal-Farah, Joseph J. Winter Jr., Renée Moskowitz, and Harry Yee, as well as their Italian counterparts, Luciano Bernardini de Pace and Milo Antimi, are dedicated to our success in every way. And the international team, led by the unmatched Duncan Edwards, Jeannette Chang, Kim St. Clair Bodden, Astrid O. Bertoncini, Susan Benson, Kristen Ingersoll, and Eleonore Marchand—as well as their brilliant predecessors George J. Green and Terry Mansfield—has taken our work around the world, literally.

We are also enormously indebted to Steven R. Swartz, Scott M. Sassa, Jon D. Smith Jr., Mark F. Miller, John P. Loughlin, Ellen Levine, John A. Rohan Jr., Stephen E. Rodgers, Ellen Payne, Scherri Roberts, Eliot Kaplan, and Michelle Hucks, who have always had our best interests at heart. Debra Shriver, who always makes us look good, Lili Root, Jessica Kleiman, Alexandra Carlin, and Adriana Stan deserve special mention for their steady guidance. Eve Burton, Debra Weaver, Christopher Fraser, and Cheryl Merante are an endless resource of solid counsel. James Miller, Liberta Abbondante, and Beth Ifcher connect us to our readers. And the magazine wouldn't get out every month without the expertise of Laura C. Reid, Cathy Merolle, Chuck Lodato, and Ken Pecca.

We like to say it's all about the team, and the team that worked on this book is one of the best. Jenna Gabrial Gallagher's beautiful prose fills the pages. Elizabeth Hummer's sharp eye focused the project, while Melise S. Senaydin brought the design to life. Photo researcher Karin Kato pored endlessly over 10 years' worth of archives to help select our top efforts. Nancy Gillen kept the project on track. Andrea Rosengarten and Lisa Luna worked tirelessly on photo and copy rights. Meenal Mistry brought her sharp editing skills to the book, while Anne Monoky researched extensively. Sarah Strzelec, Victoria Pedersen, Jil Derryberry, and Sara Miller are the brilliant copy-editing and research team behind every word. Nicole Fritton, Ana Maria Pimentel, and Lauren Bernstein helped steer the fashion coverage. Melanie Ryan and Alden Wallace were exacting during the layout process. We would be remiss if we didn't thank Laura Brown and Anamaria Wilson for their editing efforts and, finally, Kristina O'Neill, whose expertise is felt on every page.

This book could not have been possible without the efforts of the rest of our extremely talented staff: Zoë Bruns, Sarah Conly, Ashley Curry, Amy DiTullio, Avril Graham, Megan Hayes, Joanna Hillman, Joyann King, Elisa Lipsky-Karasz, Lisha Vialet Manning, Alexandra Parnass, Gary Ponzo, Jessica Prince, David Thielebeule, Barbara Tomassi, and Amber Vanderzee. Jennifer Dixon, Aaron Leth, Kyra Griffin, and Steven Chaiken deserve a special mention for their endless help and support.

Editor in Chief
GLENDA BAILEY

Creative Director
STEPHEN GAN

Executive Editor
KRISTINA O'NEILL

Design Director
ELIZABETH HUMMER

Executive Managing Editor
ANDREA ROSENGARTEN

Managing Editor
NANCY GILLEN

Contributing Editor and Writer
JENNA GABRIAL GALLAGHER

Designer
MELISE S. SENAYDIN

Photo Researcher
KARIN KATO

Copy Chief
SARAH STRZELEC

Senior Copy Editor
VICTORIA PEDERSEN

Research Chief
JIL DERRYBERRY

Assistant Managing Editor
JENNIFER DIXON

Tony Duquette brooch, courtesy of
Tony Duquette, from the October 2009 issue.

Photographers who have captured fashion's mad whirl for us include Camilla Akrans, Mert Alas and Marcus Piggott, David Bailey, Lachlan Bailey, Richard Burbridge, Chuck Close, Patrick Demarchelier, François Dischinger, Sean Ellis, Douglas Friedman, Ralph Gibson, Nan Goldin, Jean-Paul Goude, Ben Hassett, Hiro, Daniel Jackson, Greg Kadel, William Klein, Karl Lagerfeld, Peter Lindbergh, Alexi Lubomirski, Glen Luchford, Tom Munro, Darryl Patterson, Simon Procter, Terry Richardson, Jason Schmidt, Mark Seliger, David Sims, Hedi Slimane, Melvin Sokolsky, Mario Sorrenti, Christopher Sturman, Sølve Sundsbø, Martyn Thompson, Alberto Tolot, Max Vadukul, Inez van Lamsweerde and Vinoodh Matadin, Tim Walker, Anthony Ward, and Ben Watts. Directors who have shared their vision include Pedro Almodóvar, Tim Burton, David Lynch, and Mike Nichols. And illustrators who have wielded their pen include Chiho Aoshima, Julius Preite, Ruben Toledo, and M. Wartella.

Thank you also to our brilliant stylists, especially the incomparable Brana Wolf and Melanie Ward but also Daniela Agnelli, Alex Aikiu, Anastasia Barbieri, Marie Beltrami, Jenny Capitain, Ann Caruso, George Cortina, Jillian Davison, Nicola Formichetti, Jacqui Getty, Katie Grand, Amanda Harlech, Jacob K, Leslie Lessin, Polly Allen Mellen, Felipe Mendes, Katie Mossman, Mel Ottenberg, Arianne Phillips, Jean-François Pinto, GK Reid, Andrew Richardson, Clare Richardson, Natasha Royt, Nicoletta Santoro, L'Wren Scott, Tatiana Sorokko, Mary Alice Stephenson, Charlotte Stockdale, Julia Von Boehm, Patti Wilson, Aleksandra Woroniecka, Panos Yiapanis, and Rachel Zoe.

As evocative as *Bazaar*'s great imagery are the words penned by writers who consistently contribute to our pages: Lisa Armstrong, Derek Blasberg, Nancy Collins, Simon Doonan, Phoebe Eaton, Carrie Fisher, Robin Givhan, Ashton Kutcher, J.J. Martin, Suzy Menkes, and Rita Wilson. The magazine also values the vital contributions of Candace Bushnell, Ellen DeGeneres, Nora Ephron, Zoë Heller, Cathy Horyn, Arianna Huffington, Alex Kuczynski, Ali MacGraw, Jay McInerney, Susan Orlean, Camille Paglia, James Reginato, Nancy Jo Sales, Jenny Sanford, Patti Smith, Valerie Steele, Ayelet Waldman, and the late Wendy Wasserstein.

And we could never forget those whose names have graced our masthead over the course of the past decade, including Jennifer Alfano, Sarah Bailey, Jenny Barnett, Adam Bell, Susan Boyd, Melissa Ceria, Tavlin Charter, Francesco Clark, Nicole Colovos, Margi Conklin, Kate Criner, Preston Davis, Ruth Diem, Nandini D'Souza, Kerry Diamond, Allison Fabian, Joe Federici, Meghan Folsom, Natasha Fraser-Cavassoni, Merle Ginsberg, Rebecca Guinness, Heather Hodson, Jessica Houssian, Kate Davidson Hudson, Annemarie Iverson, Yuki James, Jessica Karcher, Suzanne Karotkin, Maura D. Kutner, Michele Lavery, Cary Estes Leitzes, Christine Lennon, Anna Levak, Jenny Levin, Cynthia Lewis, Olga Liriano, Tom McKee, Erik Meers, Jennifer Bett Meyer, Laura Morgan, Jessica Mycock, Samira Nasr, Allison Oleskey, Thakoon Panichgul, Kristin Rawson, Esther Roitman, Amanda Ross, Peter Rundqvist, Erin Schulte, Judith Schuster, Regan Solmo, Danko Steiner, Amanda Tisch, Danya Unterhalter, Stephen Walker, Courtney Weinblatt, Jolie Wernette-Horn, Kristen Somody Whalen, Caragh Wilson, Natasha Wolff, and Kristina Zimbalist.

At Abrams, we wish to thank our editor, Eric Himmel, for his vision and inspiration. We like to say Eric is part of the family. After all, his mother, Lillian Bassman, got her start as a *Bazaar* art director under Alexey Brodovitch and went on to become one of the greatest female photographers of all time. We are also grateful to Jacqueline Deval, whose invaluable expertise made this project possible. GLENDA BAILEY & STEPHEN GAN

AWARDS

ACCESSORIES COUNCIL ACE AWARD
Best Magazine, 2007

ADVERTISING AGE
Magazine A-List, 2010
Magazine A-List, 2007

ADVERTISING AGE: THE BOOK OF TENS
Best Covers of 2010, December 2010, photographed by Alexi Lubomirski
Ten Magazine Covers We Loved, August 2006, photographed by Alexi Lubomirski

ADWEEK
The Hot List, 2008

AMERICAN SOCIETY OF MAGAZINE EDITORS (ASME) BEST COVER AWARD
Cover of the Year, December 2009, photographed by Alexi Lubomirski
Best Vampire Cover, December 2009, photographed by Alexi Lubomirski
Best Fashion & Beauty Cover, March 2009, photographed by Peter Lindbergh
Best Fashion Cover, February 2007, photographed by Peter Lindbergh
Best Celebrity Cover, January 2006, photographed by Peter Lindbergh

ASSOCIATION FOR WOMEN IN COMMUNICATIONS CLARION AWARD
Best Overall Magazine, March 2009

FASHION INSTITUTE OF TECHNOLOGY PRESIDENT'S LIFETIME ACHIEVEMENT AWARD
Glenda Bailey, 2011

FOLIO **EDDIE AWARD**
Best Women's Fashion/Lifestyle Magazine, Full Issue, Gold Winner, March 2010
Best Women's Fashion/Lifestyle Magazine, Full Issue, Silver Winner, September 2010
Best Women's Fashion/Lifestyle Website, harpersbazaar.com, Gold Winner, 2010
Best Women's Fashion/Lifestyle Magazine, Full Issue, Silver Winner, September 2008

FOLIO **OZZIE AWARD**
Best Cover, Gold Winner, April 2010, photographed by Mark Seliger
Best Use of Photography, Gold Winner, "Wild Things," September 2009, photographed by Jean-Paul Goude
Best Use of Typography, Gold Winner, March 2009
Best Use of Illustration, Gold Winner, "Surreal Appeal," August 2008, illustrated by Ruben Toledo
Best Use of Illustration, Gold Winner, "The Simpsons Go to Paris," August 2007, illustrated by Julius Preite

LUCIE AWARD, FASHION LAYOUT OF THE YEAR
"Fashion … and All That Jazz," September 2009, photographed by Peter Lindbergh
"Thriller Fashion," September 2009, photographed by Terry Richardson
"Fairy Tales," March 2008, photographed by Jean-Paul Goude
"Metallic Moment," March 2007, photographed by Peter Lindbergh
"The News from Paris," July 2006, photographed by Mario Sorrenti

MIN EDITORIAL & DESIGN HALL OF FAME
Glenda Bailey, 2010

MIN EDITORIAL & DESIGN AWARD
Best Cover Design, Single Issue, April 2010, photographed by Mark Seliger
Best Cover Design, 2009

TIME
Top 10 Magazine Covers of 2010, April 2010, photographed by Mark Seliger

LEAPS AND BOUNDS

Above: Alexander McQueen shoe, photographed for the March 2011 issue by
Darryl Patterson, styled by Ana Maria Pimentel. *Right:* Doutzen Kroes in Hermès,
photographed for the January 2006 issue by Greg Kadel, styled by Brana Wolf.

Harper's Bazaar Greatest Hits additional photo credits: CH 2: DIANA VREELAND Tony Palmieri/*WWD*, 1962 © Condé Nast
Publications. ALI MACGRAW Headshot by Ken Whitmore/mptvimages.com. Illustration by Ali MacGraw. CH 10: DUCHESS OF
WINDSOR François Kollar, *Harper's Bazaar*, March 15, 1940; photograph by Philip Friedman/Studio D. CH 11: ASHTON KUTCHER
Jason LaVeris/FilmMagic. ELIZABETH TAYLOR (*CLEOPATRA*) mptvimages.com. COVER FLAP: Portrait by Michel Dufour.

Library of Congress Cataloging-in-Publication Data

Bailey, Glenda, 1958–
Harper's bazaar : greatest hits / by Glenda Bailey;
creative direction by Stephen Gan; designed by Elizabeth Hummer.
p. cm.
ISBN 978–1–4197–0070–5 (alk. paper)
1. Fashion photography. 2. Harper's Bazaar.
I. Title. TR679.B36 2011
779'.974692—dc22
2011002607

© 2011, Hearst Communications, Inc.
Published in 2011 by Abrams, an imprint of ABRAMS. All rights reserved. No portion of this book
may be reproduced, stored in a retrieval system, or transmitted in any form or by any means, mechanical,
electronic, photocopying, recording, or otherwise, without written permission from the publisher.
Harper's Bazaar is a registered trademark of Hearst Communications, Inc.
www.harpersbazaar.com

Printed and bound in Hong Kong, China
10 9 8 7 6 5

Abrams books are available at special discounts when purchased in quantity for premiums and
promotions as well as fundraising or educational use. Special editions can also be created to specification.
For details, contact specialsales@abramsbooks.com or the address below.

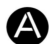

ABRAMS The Art of Books
195 Broadway, New York, NY 10007
abramsbooks.com

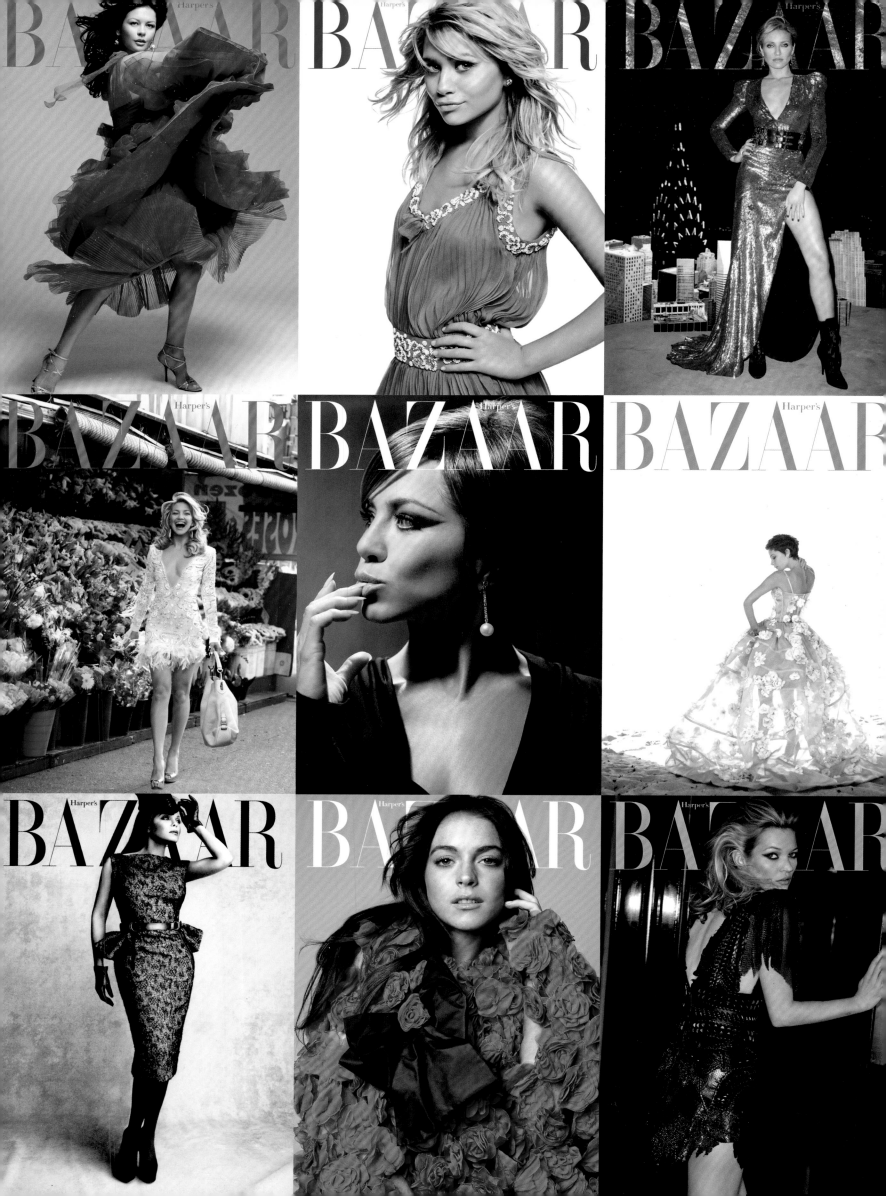